NEW YORK

Slipcase and jacket: Illustration by Ilonka Karasz, originally published on the cover of
The New Yorker, April 21, 1928.

Introduction © Tama Janowitz
© 2005 Assouline Publishing
601 West 26ᵗʰ Street, 18ᵗʰ Floor
New York, NY 10001, USA
Tel.: 212 989 6810 Fax: 212 647 0005
www.assouline.com

ISBN: 2 84323 715 7

Printed in China by Toppan.

Photographs by Kanji Ishii
with photos by Petra Mason

NEW YORK

Introduction by Tama Janowitz

ASSOULINE

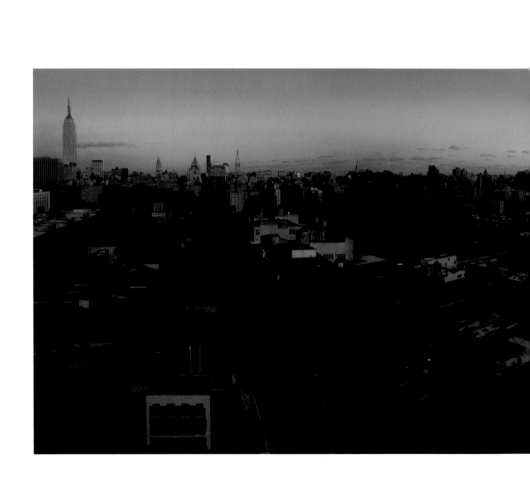

66It's not so much that I'm an American. I'm a New Yorker.99

Willem de Kooning

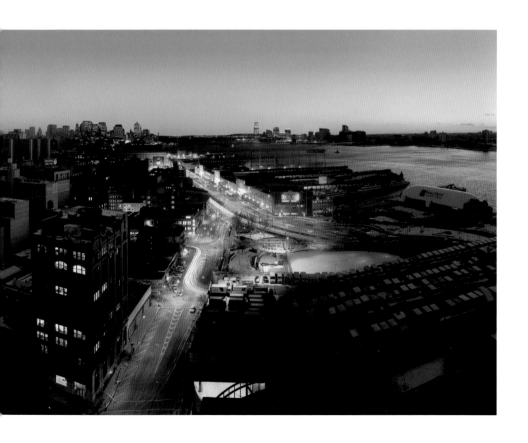

Introduction

What a city! I have lived here off and on, but mostly on since the early 1970s. There were times when the city was on the verge of bankruptcy and life was danger-ous. There were times when there were a lot more homeless people. And times when there were a lot more drug addicts. There were times when real estate was cheap, but...those were the times I had no money. The city is definitely better than it used to be, in most ways. We are a young, diverse mix of people living

here. According to a recent survey, New York City is roughly 45 percent white, 26.5 percent black, 27 percent Hispanic, and 10 percent Asian. About one-third of the population is foreign-born. And the median age is 34. Approximately eight million people live here. There are twenty-six daily newspapers and three of them are in Polish. When we say "New York City," it does not mean Manhattan. It means the five boroughs: the Bronx, Staten Island, Brooklyn, Queens, and Manhattan. Whatever you want to call this place—Nieu Amsterdam, New York, Gotham, the Big Apple, a melting pot—and whatever occurs here, it's always the same. The following is an excerpt from *Harper's* Magazine:

New York is notoriously the largest and least-loved of any of our great cities. Why should it be loved as a city? It is never the same city for a dozen years

altogether. A man born in New York forty years ago finds nothing, absolutely nothing, of the New York he knew. If he chances to stumble upon a few old houses not yet leveled, he is fortunate. But the landmarks, the objects which marked the city to him, as a city, are gone.

Okay, so this was written in 1856. Well, all that is pretty much true today. And those who don't live in New York City...well, they do act a bit peculiar when you say you live in New York. In fact, they can't imagine, why would someone live here? It's dangerous, right? And dirty and...yes, everything changes here, and rapidly too. That's how it's always been. And that's why we like it.

Architecture

In this city, if you turn around they have ripped it down and put up something else. This is a city of commerce that always thinks what's newer is what's better. Of course we have our Chrysler Building, our Woolworth Building, and our Empire State, but so many are gone and in their stead are the Lever Building and the Lipstick, the AT&T, and the Time Warner.

The same building where tenement dwellers once lived at 91 East Broadway was revamped into a hotel; the building that once housed the *Jewish Daily Forward* has now become fancy apartments for sale.

Of course there are still plenty of obscure places around. I remember after Andy Warhol died, there was a lunch following his memorial, and it took place in Billy Rose's Diamond Horseshoe. Billy Rose was this Broadway producer, a kind of entrepreneur of theater

and musical extravaganzas. He used to be so, so famous, but nowadays, I guess you wouldn't find too many who know of him.

Even El Morocco and the Stork Club, fancy nightclubs of the 1950s; Ondine's, Arthur's, and Max's Kansas City of the 1960s; Le Jardin and Studio 54 of the 1970s, all are gone, vanished, though somewhere the music of each era remains.

But anyway. At Billy Rose's Diamond Horseshoe—the space still exists—you had to go downstairs, to an underground room with vaulted ceilings. The place became part of Ian Schrager's Paramount Hotel, and now…it is under ownership as the first ever Hard Rock Hotel, on West 46th Street.

At Andy's lunch there were Debbie Harry, Halston, Francesco Clemente, Yoko Ono, Richard Gere, and other memorable contemporary New York faces. But

you could also feel the ghosts of the past sipping cock-tails and dancing to a big band; meanwhile, Andy's friends, or at least acquaintances, were all there, hav-ing lunch, a kind of wake or celebration of his life: pop stars, fashion designers, and movie stars, and it was something quite special.

Or take the old police headquarters, down on Mott and Mulberry streets. A fantastic building, a kind of Grecian temple only slightly more ornate, absolutely splendid. Now it's apartments. I was once in one; it occupied an entire city block, with high ceilings, beautiful old floors, and gigantic tiled bathrooms.

Here, what is old is always renewed. There's the Starrett Lehigh building, way over west on 26th Street, a massive art deco building a block wide that until recently was dusty and mostly empty. You had to take a creaky freight elevator up to a floor where you crept down a

hall to the ice-cold cement cell of an artist living and working there. Now it's been revamped, with an all hi-tech lobby with doormen and security passes to get through an electronic turnstile.

Or the old bank, on Bowery Street, that was a bank not too long ago. After it closed, fashion shows were held in the century-old space, models emerging from Beaux Arts bronze abandoned cashier booths. And now the bank is a restaurant, where on the weekend tout le New Jersey comes to dine beneath its elaborate moldings.

A garage can become a massive photo studio, with every amenity from cameras to catering available for rent (Industria Superstudio), or a gas station can be transformed into a restaurant (Bowery Bar). And if you don't know what a building once was...you may never find out.

The greatest pleasure in this city, or at least one of them, is to walk and walk and walk. What you will see are amazing buildings: cast-iron buildings that were once sweatshops and factories, beautiful and ornate structures like elaborately frosted cakes made out of metal. Tenement buildings, five floors, no elevators, tiny broken windows, fire escapes spidering up the sides. Skyscrapers that once towered over the landscape twenty stories tall but now—in comparison to the others—have somehow shrunk.

You can find almost anything: a wooden farmhouse; a gracious Stanford White structure that is practically unknown, like the one on Chambers Street near Broadway. Amazing shops, warehouses, and once grand department stores; places boarded up or three-quarters covered with signs and graffiti. The lobbies of buildings: tributes to '50s cool, granite and mirrors, or whimsical curved entrances from a '60s architect.

I like to walk, and walk. Not with a guidebook in hand, though there are plenty that will tell you where to go and what you will see. I have one that dates back to the '30s and describes the twelve-mile walk from the top of Broadway to the very bottom, a walk I have always intended to take and somehow never gotten around to. Instead, I like the accidents and unexpectedness of arbitrarily deciding to make a right and then a left, and so forth.

Fashion

In a way, New York was never quite the fashion capital of the globe: not the way Paris was (once) with the most elegant women in the world and the Real Couture: Chanel, Poiret, Balenciaga, Patou, etc. Not like London in the 1960s with Mary Quant and Zandra Rhodes and Ossie Clark.

Nonetheless, we do have fashion and style of our own. American designers—well, they are New York designers. There's Ralph Lauren, with his all-American looks of the Old West and New England country clubs, whose shop is in an actual turn-of-the-century mansion up on Madison Avenue. There's Calvin Klein, with his clean and healthy-looking American lines, reminiscent of a cool day on the beach; Donna Karan, who dressed the power woman of the '80s—the women who are now running publishing empires or television companies. Norma Kamali, Tommy Hilfiger, Betsy Johnson. Marc Jacobs, who is our Miucci Prada. We had Stephen Sprouse and his op art, Day-Glo candy electric circus. And the looks that are quintessentially New York, though perhaps we can't take all the credit, like blue jeans, baggy or slim, the James Dean look, or the black gangsta rap.

Of course, here is also your street-fashion, which can be classified by neighborhood: the Upper East Side equals blond hair, beige cashmere, pearls, and a Handbag That Says It All. The Birkin Bag, the Hermes croc, Goyard, Gucci, or Chanel. If all the handbags in New York were taken out of their closets and piled one on top of another you would have…another Manhattan skyscraper.

In the early '80s, Upper East Side women wore bright red or pink power suits and were dubbed "ladies who lunched," while the downtown and SoHo communities all wore black. Now Upper East Side, West Side, all around the town, wear black. What is of extreme fashion interest in this city are the black high school kids, hip-hop, bebop, rap, bling-bling, boing-boing, who you see on the subway going home from school and whose ideas of what to wear are always interesting; or the

Asian kids on the Lower East Side, straight from Japan, the boys with blond, slicked-back hair, slim hips, cigarettes dangling à la Jean-Paul Belmondo; and the girls, blond as well, impossibly tiny, wearing huge shoes to make them taller and curious little alien outfits.

You can find the cute things these girls wear on the dark back streets of Chinatown. Or on Fulton Avenue in Brooklyn, where along with the latest in cool sneakers and Royal Filth clothes, you can bring a photograph of anyone or anything and a guy with genuine artistic talent can airbrush a T-shirt of your image!

On weekends there are some of the best flea markets in the world, not for major collectibles, shall we say, but rather for every bit of curious American ephemera and clothing. There are vintage shops and antique fairs, but for the really grand stuff it's always fun to attend an auction at Christie's or Sotheby's.

Transportation

Before they built the Brooklyn Bridge, the George Washington Bridge, and the Verrazano Bridge, and before there were cars, you had to take a ferry. There were horses everywhere: horses pulling carts with butter and eggs, horses pulling fancy carriages, horses pulling buses called jitneys that could hold multiple people. Almost every home of the wealthy had its own carriage house in back where the horses were kept. Well, then time moved on and there were trolley cars. Elevated railroad tracks were erected, and more than one hundred years ago they dug the first subway, which was privately owned. Soon there were subways around the town, which are now sometimes dangerous and often not running or stopped due to a police investigation. Not to mention, there are plenty of rats and even people living in the subterranean system! But the subway is

much better than it used to be… The whole city is, really. The '70s and early '80s were a difficult time for this place, but things have improved a lot since then.

You can see almost anything on the subway, and people ride the cars for hours from the Bronx all the way down through Manhattan and then Brooklyn and Queens. The people on the subway are from all over the world, and are now living in this city. There are guys selling candy, "Not for any basketball team, but for me to make money!" Groups of men playing giant Conga drums, loudly, carrying them from train to train. A woman haranguing a man. A woman in her seventies wearing a frilly pink baby-doll dress, pink patent Mary Jane shoes with ankle socks, a diamond tiara, and sucking on a baby bottle—not during Halloween!

Sometimes it's not worth it to take a taxi, because not only are you missing the Strange Realm of Below

Ground, but you can be stuck in traffic for hours, with the meter ticking and ticking.

Whenever my girlfriend and I took a taxi together, something terrible would happen. A lot of taxi drivers are not…well, the most normal. Some don't speak English, some are just not suited to a nine-to-five job in an office. One time the driver was going straight when we had told him to go downtown, so we both started shouting, "Turn right! Make a right turn here!" And the driver stopped the car in the middle of the intersection and got out of the car. He was around six and a half feet tall, blond and Nordic and young and handsome. He was like a movie star, holding a huge metal chain, which he started to swing, standing in the intersection of Fifth Avenue and 72nd Street. "You gonna tell me where to go?" he said, swinging the chain in circles as he glared at us. "Oh no," we said. So he got back in the car and drove.

Entertainment

So what do people do here for fun? In 1878, Wood's Theater was considered very far uptown, at Broadway and 30th Street; it was popular anyway, because it had a sort of museum attached to it—well, what they considered a museum back then, with a flea circus and a sideshow, meaning women with beards, hermaphrodites, giants, or tiny people.

Or, in the 1880s, Mrs. Vanderbilt gave a costume ball in her French château on Fifth Avenue, to which fifteen hundred of the cream of society were invited. Outside her mansion, a crowd gathered to watch the arrival of the guests. Made up to resemble Louis XVI was Cornelius Vanderbilt in a fawn-colored brocade waistcoat of Reseda with a diamond-hilted sword. Many of the younger girls chose Joan of Arc, older women picked Madame Pompadour, and men favored Cardinal Richelieu.

And then came the quadrilles (the Hobby Horse, the Mother Goose, the Dresden China—how I would love to see these dances performed!). And when the quadrilles were over, the guests got to do the ticklish water polka, along with waltzing, gavotting, and eating: an eight-course meal was taking place upstairs, or you could just go to the buffet.

Well, a hundred years ago, the social season opened in the fall with the horse show at Madison Square Garden and a week later the Metropolitan Opera season commenced. You can still go to Madison Square Garden to see the horse show, although it's not the same place, and more people would rather go for the basketball or ice hockey.

Nowadays, most of the rich people—the women, anyway—are busy organizing benefits. For these events, tickets are purchased, a thousand dollars, perhaps, or

ten or twenty grand for a table in order to raise money for some worthy cause—the Foundation for Art and Preservation for Art in Embassies! The National Center on Addiction and Substance Abuse at Columbia University! The Heather Garden Trust! Save Venice!

To be honest, to join this realm is not so terribly difficult: you can just look in *The New York Times* and it will tell you what benefits are taking place during the upcoming week, and if you want, you, Ms. or Mr. Anybody, could just buy a ticket. New York City—we're democratic, if nothing else! All it takes in this city is to be rich, or famous...or both. And if you're not rich or famous, well then, you can fake it and nobody will mind or even care! And pretty soon, if you keep working at it, you will become rich, or famous, or...

Sometimes in the past I would be invited to one of these events, as the guest of someone who had purchased a

table. First there is the milling around over cocktails, then you're given a table number. There are thousands seated in the room, many different courses, nothing ever tastes very good, and there are long speeches praising something or someone between each course. Not so much fun, but at the end of the evening you get a gift bag.

There is nothing like a gift bag. It might contain a magazine and/or a CD or a DVD. Maybe there's a bottle of perfume, or a silver dog bone in a box. Oh, it's so delightful! And like everything else in life, the richer, more influential, or famous one is, the better the presents.

New Yorkers also have their nightclubs. In 1925, at a place in the Village owned by Barney Gallant, "bottle service" meant sixteen bucks for a bottle of champagne, twenty-five for scotch.

And is there be anyone left who can remember:

> Flexi, the headwaiter with the pointed nose, down at Moria's on Bleecker Street... The Owl Club, which had four booths housing chefs of four nationalities—Mexican, Chinese, Italian, and Negro—and where the waiters would put on a show without any reason. Small's, in Harlem, where the waiters did the Charleston late at night, while carrying fully loaded trays. The Mirador, when the Fokine Ballet was there.
> (*The Night Club Era*, Stanley Walker)

Other names of places long vanished: the Drool Inn; the Furnace; the Hyena Club; the Ha!Ha!; the Bal Tabarin; the Rose Room at the Algonquin, where you could see—on a typical day—Tallulah Bankhead, Noel Coward, Mary Pickford, Elinor Wylie, and F. Scott

Fitzgerald; the Lotus Club; and Siberia, located in a subway station deep below ground.

And New York is still known for its nightclubs, of course: those that don't get going until three in the morning; those that cater or want to cater to movie stars and celebrities; those where crowds gather patiently outside velvet ropes and a doorman, unimaginably powerful, seems to know who is suitable and who Shall Not be Admitted; Russian nightclubs in Brighton Beach where bottles of vodka wait on every table; Indian nightclubs in Queens for (mostly) Indian kids; nightclubs that look about ready to burn down, or those that have been kitted out at a cost of fifty million dollars.

As for me, a hundred years after the Vanderbilt ball, I spent my youth in clubs like Danceteria and Area, the latter owned by the brilliant entrepreneur Eric Goode, way, way downtown, which featured themes and live

people in small glassed-in rooms performing little skits or plays. Eric turned going out at night into an art. There was a swimming pool, too, I think, for performances by mermaids, though I could be wrong...and how I hated that the men always used the women's powder room. What were they doing, crowded in groups in the toilets? I was too plain ignorant to realize that they—men and women—were all piled in there to snort cocaine. I just wanted to put on my lipstick without the opposite sex observing.

There was and is Coney Island, a bunch of amusement parks and rides, for working people, I guess. Once there was Luna Park, a beautiful pleasure dome to be only found in pictures, and Steeplechase Park, where people rode around a track on life-size mechanical horses. Now there are people holding white boa constrictors on the boardwalk and people

screaming as they go up and down the oldest wooden rattletrap roller coaster.

Times Square was never exactly safe, but in the '70s and '80s it was a major porn center. Now it's been fixed up and is a prime tourist attraction: theaters with Disney productions, a supersize McDonalds, a toy store with an indoor Ferris wheel, and shops selling souvenirs of a New York that a real New Yorker...well, what can I say...

You can rent a bicycle that resembles an old-fashioned surrey and that six can pedal at once. There are giant signs almost like you see in Tokyo or Hong Kong, television screens and advertisements everywhere, and crowds of people—simply hordes. There are moments when you just can't get down the street, as tourists simply don't walk the way New Yorkers do. New Yorkers don't amble or dawdle; New Yorkers are

busy, busy and know how to slide around and past people, they never bump into one another. But the tourists....that's another story—they don't have our rhythm!

If you're in dire need of some elbow space with your entertainment, meander into Central Park on a sunny weekend, where there's another street performer stationed every second step. Jazz musicians, pantomimes, jugglers, portrait artists, or, near the Bethesda Fountain, unbelievably fantastic Rollerbladers dancing around to the latest music.

The city used to have thousands of movie theaters, all of them gone now, mostly, except for the big chains and a couple of art houses, and a few of the old Loews theaters that are now churches. Still, a million movies are filmed here, though it's gotten so expensive to make a film in New York that even some of the

big films are shot in Toronto or Glasgow, where producers try to pass off these cities as the real thing even though everybody can see immediately that it just isn't New York.

There are pinball arcades and now video arcades. There used to be opium parlors—such fun! Korean gambling dens, Roseland for dancing, dogs on parade in Central Park.

You could take a tour of parrots who live in Brooklyn (they escaped from an airport forty years ago, survived and multiplied).

Baseball games—the Yankees and the Mets. Tennis championships in Queens, or you can play in the park. Learn rock climbing indoors at Chelsea Piers. Take a class in watercolors at the Brooklyn Botanical Garden. Museums! A sex museum, the new Museum of Modern Art, a TV and radio museum, a transit museum.

Libraries: there's the American Kennel Club Library, where you can look up stuff about dogs; or at Lincoln Center, a performance arts library. You could also go there for opera, dance, concerts, and ballet. Nowhere else on the planet do the newspapers, magazines, and Web sites list so many free events that there is no way you could get to see and do everything.

And music! Jazz clubs—not many of the original ones are left. There was the Cotton Club in Harlem with George Gershwin, the city of ragtime. Now you got your house music and your trance music. You got your rap music. You got an old Chinese guy playing something I think is called an erhu on the subway platform. On any given night in New York City, you could go to hear classical Indian music, or Siberian guys who sing using their throats.

People whose entertainment is to keep alligators,

eighty cats, forty Yorkshire terriers, three hundred par-
rots. There was even one guy with a pet tiger. Hey, who
knows what's going on inside a New York City apart-
ment! Not until the tiger caused trouble (and it wasn't
really trouble, it was just that the owner never cleaned
up after him, so the smell got worse) did the tiger—
and the owner—get caught.

And of course, there's shopping. What you can find
here is...everything. Blocks and blocks in the garment
district selling all kinds of fabrics: hot pink leather
skins, exquisite lace, shantung silk in baby blue or
burnt umber. Or a shop that only sells feathers. M&J
Trimmings sells every kind of ribbon imaginable, crim-
son brocade, delicately embroidered. And buttons,
diamond buttons, plastic buttons, horn buttons—you
never in your life knew there were so many kinds of
buttons!

There are shops selling semiprecious rocks by the string, for very little money, peridot and turquoise, amethyst and tourmaline. Sample sales: you are walking down the street and someone gives you a flier, suddenly you are in a strange building going up and up in a rickety elevator to some little showroom where pocketbooks that would normally cost five hundred dollars can be yours for a mere fifty.

Food

You won't find too many streets in this city without restaurants. And there's barely a country that's not represented. New York has restaurants serving food from Poland, Senegal, Malaysia, Turkey, and Greece. And of course Italy, north and south—and India, north and south. In the mood for Ukrainian? Vietnamese?

You can have kosher food and kosher Chinese food and unkosher kosher food. There is vegan food, and there are restaurants where everything is raw—and people who only eat everything raw. Sometimes there are whole areas with many restaurants serving the same kind of food or from the same country. Brazilian, for example, around West 46th Street, or Chinese in Sunset Park, Brooklyn.

And what about places that used to be but are no more? Delmonico's, where in the 1860s only the very rich could eat, with a menu including *aspic de canvasback,* a salad of string beans with truffles, and truffle ice cream, as well as *selle d'agneau de Central Park* and *potage tortue verte à anglaise*. Sounds okay, though, according to *Secrets of the Great City* (1868), by Edward Winslow Martin:

Living at restaurants begets irregularity in the meal hours, and thus promotes bad health…the cooking at the majority of restaurants is unhealthy, and intoxicating liquors are sold, to an extraordinary extent, as a part of the bill of fare… The principal up-town restaurants are largely patronized by the disreputable classes. Women of the town are there to pick up custom, and men to find such companions…restaurants, like hotels, are the object of the constant attention of swindlers…

There are fancy restaurants where you might meet someone for a business dinner; there are restaurants in hotels; there are stylish and fashionable restaurants. There are good decent plain and inexpensive restaurants. There is street food and street fairs where they sell food. And carts on the streets with hotdogs,

falafel, or warm, flavored peanuts. And little hole-in-the-wall spots where you can have five steamed dumplings or a big plate of Pakistani food for a dollar, delicious!

When I was friends with Andy Warhol in the mid 1980s, in the last few years before his death, we used to go out to the fanciest restaurants a few times a week. Oh boy, did we eat: Le Cirque (the old one in the Mayfair Hotel) and foie gras; Texarkana and pulled pork... Cafe Americana, Brazil, Cafe Luxembourg, most of them are gone or transformed by now. I had never before eaten in restaurants. The constant hovering around the table by masses of trembling waiters and busboys! Endless treats would arrive for all of us, unordered, unasked for, sorbets and small appetizers, *amuse-bouches*; then always after dinner "The manager would like to offer all of you an after-dinner

drink." And so for a long time I thought that was always what it was like to eat in restaurants...

New York and The Arts

Wow, this is one city for the arts. The down-and-out and the well-to-do have always come to this gritty non-stop city and been inspired. It's something about the place... Take all these millions of people from all over the world and squeeze everyone together and...diamonds are formed.

Walt Whitman, Frank O'Hara. O.Henry and Nathaniel West. Edith Wharton and the grand Upper East Side of the early part of the last century. Dawn Powell and the Greenwich Village of the 1930s. Truman Capote and *Breakfast at Tiffany's.* The New York of Isaac Bashevis Singer, the old men eating in the kosher cafeterias on

the Upper West Side. *Shadows in Paradise* by Erich Maria Remarque—one of my favorite books about the New York lives of European refugees in World War II. Edgar Lewis Wallant, *The Pawnbroker*! *The Tenants of Moonbloom*! Henry Miller's New York: the dance halls, ten cents a dance. Christopher Morley's haunted bookshop in Brooklyn. Herman Wouk: Marjorie Morningstar of the classic six apartment on the Upper West Side, Marjorie, who used to be Morgenstern from Queens. John O'Hara and *Butterfield 8* from back when there used to be telephone exchanges and the Butterfield meant a certain neighborhood, so you would have dialed BU8 and then four numbers; or PENNSYLVANIA 6-5000, meaning PE6 and then the number 5000. You knew back then just by calling, what neighborhood the person lived in. Now many New Yorkers don't even bother with home phones; it's

all cell phones and a dozen people on the bus all talking at the same time.

The Washington Square of Henry James, Betty Smith, who wrote *A Tree Grows in Brooklyn.* Damon Runyon and Ring Lardner and oh boy, I have to quit. I have barely made a dent. And here I am, not even attempting to mention contemporary literature. Or children's books: *Catcher in the Rye, The Cricket in Times Square.* My gosh, put them all together and it's like a huge crowd, gathered in Times Square, everyone talking at once. Each book has a tiny voice, recording a vision: This is My New York! No, it's mine!

What about music? The jazz clubs, the great musicians this city produced: Ornette Coleman, Miles Davis, Charles Mingus. Lester Young. Duke Ellington. Louis Armstrong—whose house just opened as a museum in Queens. Dexter Gordon. John Coltrane. It didn't

matter where they had come from, this city was what they played. Clubs open all night.

One time a friend took me up to Harlem on a Sunday in the early '80s to see what was left of some of the spots where jazz was played. Not many, not compared to the heyday of jazz in the '50s and '60s. All my life, dating from childhood, I had been warned, "Never go to Harlem." Never mind that my grandmother had been born there, it was a major danger zone. In the early '70s I was taken to visit the Black Panthers—or what remained of them. They had a run-down house up in Harlem. "Be careful! Be careful! If I say it's time to leave, we have to go at once! It's very dangerous!" the group leader said.

In retrospect, there was no danger, though the Panthers were alleged to carry guns. But the tension was tremendous, mostly because we had been

warned, over and over, "Danger!" And during that same time, I made a friend who lived in Jamaica, Queens, another allegedly terribly dangerous area. When he took me out there to visit his grandmother, I was for the first time aware, self-consciously, that I was the only white person on the streets…

But I am off subject: art and literature. What about painting? Romare Bearden, Larry Rivers, Andy Warhol, Jean-Michel Basquiat, Willem DeKooning and Roy Lichtenstein and Jasper Johns—which allows me to work in a fascinating yet obscure bit of information: Gypsy Rose Lee, the stripper, owned a house on the Upper East Side where she lived with her son (Otto Preminger's illegitimate child) and a whole bunch of Chinese Crested dogs, at that time—the 1950s—virtually unknown and extinct. And, well, after her death, the house was bought by Jasper Johns—who later sold it to the director Spike Lee.

In the years when I first arrived in New York in the early '80s, I had no money (not that I have much now) and by accident I found that on a Saturday afternoon in SoHo (which back then was still run-down cast-iron buildings in which artists were actually living, illegally, and not the fabulous shopping mall it has since become), shabby art galleries on the ground floors were holding openings and anybody could just walk in off the street. Someone would hand you a glass of cheap wine in a plastic cup; someone else might tell you where the party was later on; and week after week the scene—the events—got bigger and bigger, until there was a whole block party going on with the people at one opening spilling out onto the trafficless streets and blending with those from another a few doors down.

Keith Haring was then painting his *Radiant Baby* on the subway and got a job at the Tony Shafrazi Gallery—as a janitor. Then he showed Tony his art and...etc., etc. Or my friend Paige Powell, who gave Jean-Michel Basquiat one of his first shows in her apartment, on the Upper West Side. There were dinners for the artists, in Mr. Chow's on 57th Street or at Indochine, a block below Astor Place on Lafayette. And more parties—at the Polish Wedding Palace, way, way over on 1st Street and First Avenue and East Houston, or thereabouts. It was fun to be here in those days. But for everyone, whether they come from the city or somewhere else, I suppose the best time to be here is when you are young and it seems anything might happen...

The Five Seasons in New York:

Fall

Though the days are still hot, the people return to the City from wherever they have been, in the Hamptons or the Catskills or Europe. The people who have stayed behind are at first annoyed, who is trying to crowd back in? At the same time, everyone is ready. The trees are now looking irritable, it has been too dry for too long, the dust is beginning to fatigue. The children head back to school, and then suddenly, one day, there is a change and it is the crispness of autumn. The air is cooler and the farmer's markets in Union Square and Grand Army Plaza begin to sell the first of the fall apples, brought in from upstate, the Empires and Cortlands and Winesaps, real American apples, tart and juicy, and you can buy plastic bottles of fresh, lovely sour grape juice.

Now the restaurants are crowded, everyone wants to sit outside while the tables are still out. The tulips on Park Avenue, long gone, have been replaced with chrysanthemums, and all up and down Park Avenue, in front of the grand buildings, there's a spicy autumn smell...

The leaves, alarmed, are shocked into colors, yellows and reds and oranges, and everyone is busy scurrying, scurrying, getting their winter things out of storage though it is still far too hot to wear them, and after a few cold days it is Indian summer, a reminder that this is the end for another year.

The hawks migrate overhead, the squirrels no longer eat the nuts thrown to them but hastily bury them in the ground in places never to be found again...

Winter

At last the social season has begun in earnest—not that there is ever a moment, even in the quiet of August, when things are not going on—but now everyone is having a party. Every night there are dinners and art exhibitions, movie premieres, charity benefits, cocktail parties in someone's honor—so many events! It gets dark early and the city becomes a glittering confection; there are lights on 57th Street and down Fifth Avenue. There are giant snowflakes, twirling spinning lights, the stores are full of the loveliest things, the tempting Christmas presents: cashmere bathrobes and hand-tooled cowboy boots, antique emerald rings and tiny prancing kittens playing in piles of paper. Engraved stationery and jars of preserved kumquats, there is food everywhere, windows with pastries and chocolates. It is not really so cold, not

yet, but the fur coats are out as are the high-heeled boots. And in Central Park the ice-skaters go round and round while the whole backdrop of Central Park South and the glittering skyscrapers above are like a gigantic twinkling cake seen from far, far away.

The Extra Season

I really don't care much for January, February, and March, and I guess a lot of people feel the same way because they head off to St. Barths or go skiing in Colorado. But if you are here, there are still things going on all the time.

Sometimes it snows. There are great fluffy piles of it, so much that the cars are completely covered and unable to leave the city parking spots. Everything is clean, wrapped in white, an amazing sculpture of meringue. People take out their cross-country skis and

the dogs wear boots and look embarrassed, and the children carry sleds and plastic discs and even a very tiny hill is now a thing of immeasurable pleasure. The city kids rent ice skates and wobble around in circles on the skating rinks to the music of Strauss concertos and rap songs one after the next, coming through the blue-gray air. And besides, soon it will…Spring. In My New York.

Spring

In spring the days get longer and there is a sense of relief. People shake off their winter coats as if it were time to molt. Little tables are put outside the restaurants, and even when the temperature dips a bit, people still sit outdoors, because it is so amazing to think you have survived.

On Park Avenue hundreds of tulips sprout, waving to the cars as if they are cheering, in every color, and

the trees that had seemed dead in a blink have put out the palest lettuce green tissue-like leaves, as if they realized abruptly that it was time to put on some clothes. The women on the Upper East Side wear thin pink sweaters, soft beige cashmere, and white. Everything in the city seems fresh and new and it is like the contents of a closet hung out to air. There is more room on the subway, the bulky coats and protective gear are gone.

My favorite moment comes in June when the ailanthus trees blossom, covered with tiny yellow blooms that fall everywhere, so richly scented, a musky peculiar smell that once you recognize you will never forget. During spring, living in New York City is like being on a glamorous ocean liner about to go on a trip, with the sense of excitement that unknown adventures are about to happen.

Summer

Suddenly everyone disappears. The city is yours. You can get a taxi, go to any restaurant you wish. Theater, movies, the place seems empty. The long dusty days are like a memory of childhood when summer lasted forever. The tar is hot and everything feels slow, from an earlier era, a different place.

And in the park the children run shrieking through the cascades of silvery water from the sprinklers, such pure bliss. All a kid needs to be happy, it seems, is running water—and for the city kid especially... The tiny silver beads flick through the sky and birds come to take a little bath and get rid of the dust on their wings. The leaves on the trees are now richly mature, big and somber, and the trees look dignified and monumental—they know how essential to the city they are, providing shade, fresh air.

The ice cream truck pulls up with the same cacophonous tune (which has recently been outlawed for disturbing our peace—what peace?) and children beg their mothers for money. You can get every kind of ice and ice cream, soft white stuff flowing into a plastic cup and topped with chocolate sprinkles, pink explosions of strawberry, toffee bars and Popsicles in rainbow layers of color. Then there are the men with ices. Sometimes a man shaves a block of ice and puts it in a pointed cup and then adds the color... The ice so, so cold. Or the Italian ice vendor—for fifty cents he reaches deep into his cart to put a scoop in a cup: mango, coconut, pineapple, cherry...

In summer the museums are empty, you can wander in the cool, darkened halls and stumble out into the light and heat, hours later, and you feel you are alone in this place. But it is a happy kind of aloneness, hot

and still, and in the background the air conditioners roar, a substitute sea pounding an imaginary beach...

A Helluva Town

The past is the present in New York. What was here before is gone, but somehow remains. Like a ghostly image on a burnt-out computer screen, the past is here, but...pretty much forgotten. You can love this city or you can hate it, but most of us feel a little bit of both. Luckily, there's enough positive to keep us here, and the negative is what makes the positive more intense.

We pretty much all get along. We are living here from the Dominican Republic and Haiti; from Michigan and Dakar and North Dakota; from Taiwan and Sri Lanka and Oman. We have come from all over the

world, because we are...desperate. If you are gay and from a small town, you've come to find a place that will accept you; a place where you will fit in. You might be desperate in that you are ambitious: you want to make it as an actor or become a top lawyer. You may be desperately poor and want to earn enough to send home to your family who is even poorer. You might come here because you are desperate to be anonymous, or desperate to be famous. Of course there is crime, and some of it is racial and some of it is violent. But you are in New York: the craziest, fastest, most intense city in the world, and it's not without its drawbacks.

But here Orthodox Jews can live next door to Muslims; a rich woman can marry a poor man; a white woman might live with a black man, or a black woman, or two men might have a baby. In this city, what might be

frowned upon or unacceptable elsewhere is permit-ted—a city that is too, too crowded for anyone to pay much attention. Yes, it's remarkable, but here...we pretty much all get along.

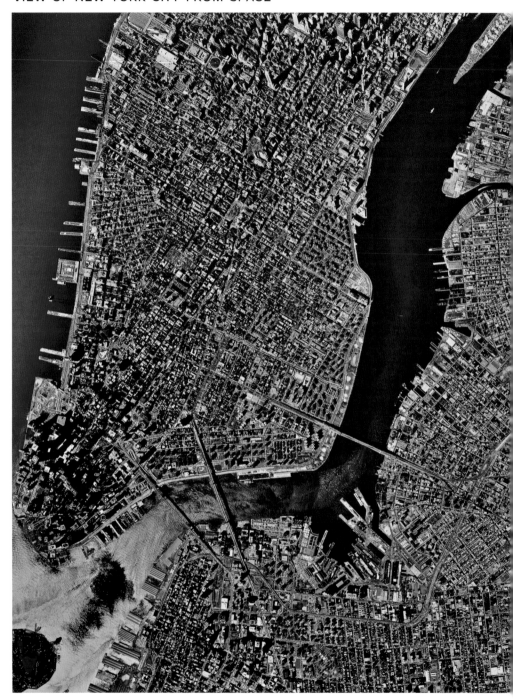

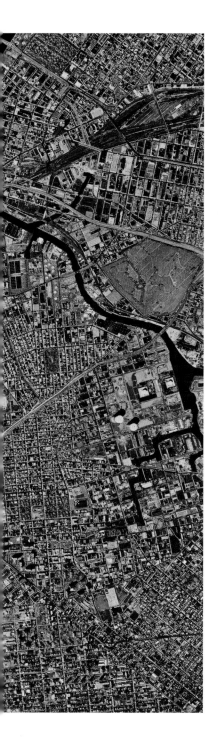

66 New York was an inexhaustible space, a labyrinth of endless steps, and no matter how far he walked, no matter how well he came to know its neighborhoods and streets, it always left him with the feeling of being lost... New York was the nowhere he had built around himself and he realized that he had no intention of ever leaving it again. 99

Paul Auster

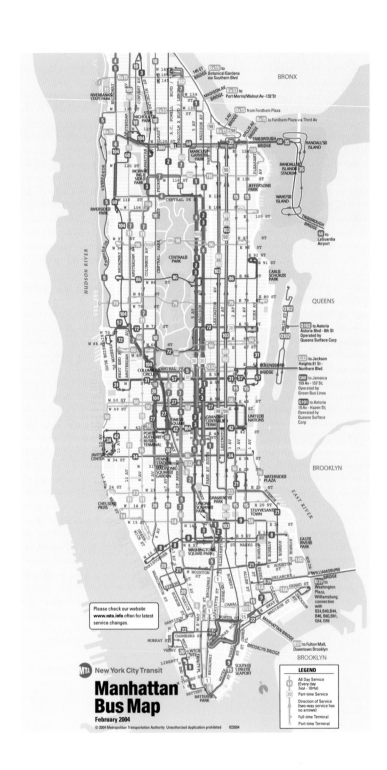

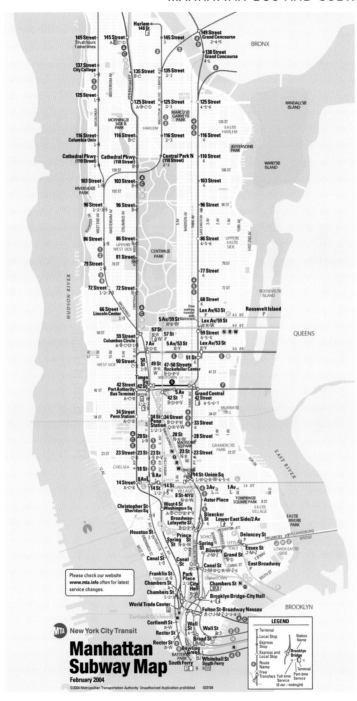

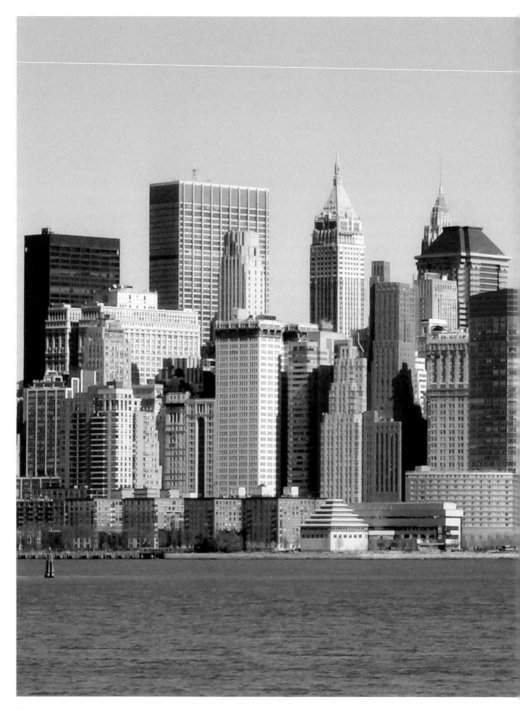

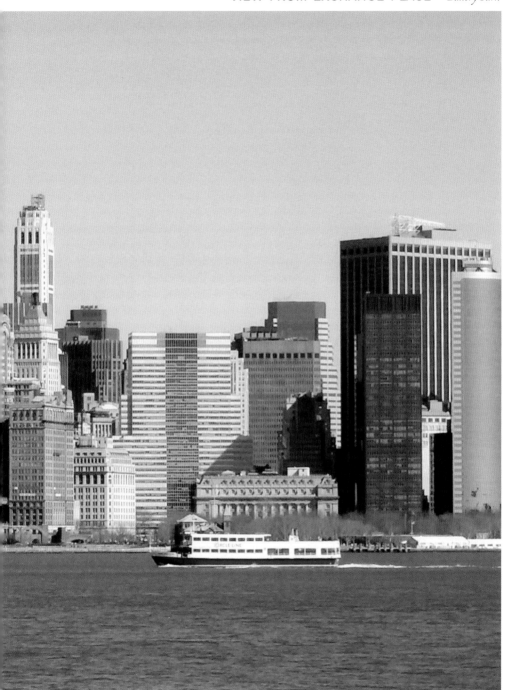

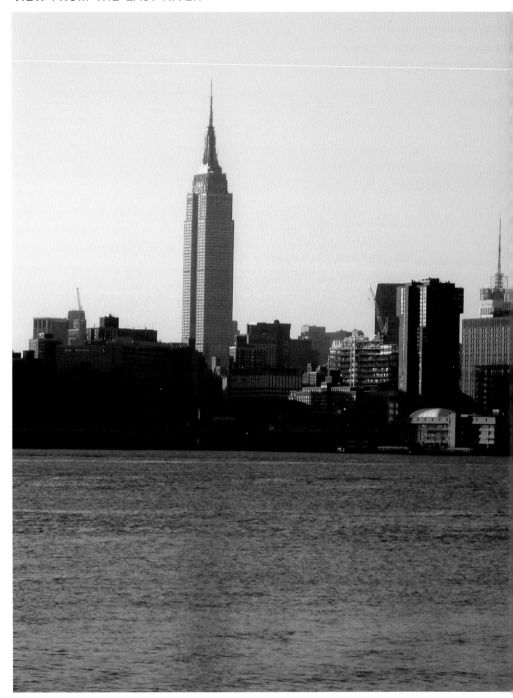

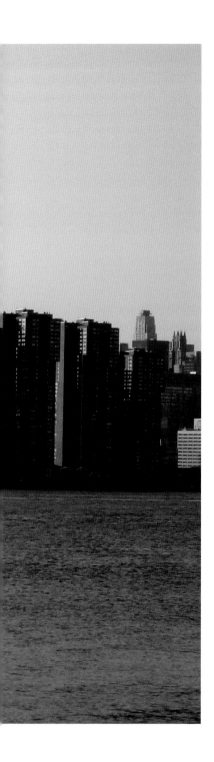

"New York is one of the finest cities I ever saw... Situated on an island, which I think it will one day cover, it rises, like Venice from the sea, and receives into its lap tribute of all the riches of the earth."

Frances Trollope

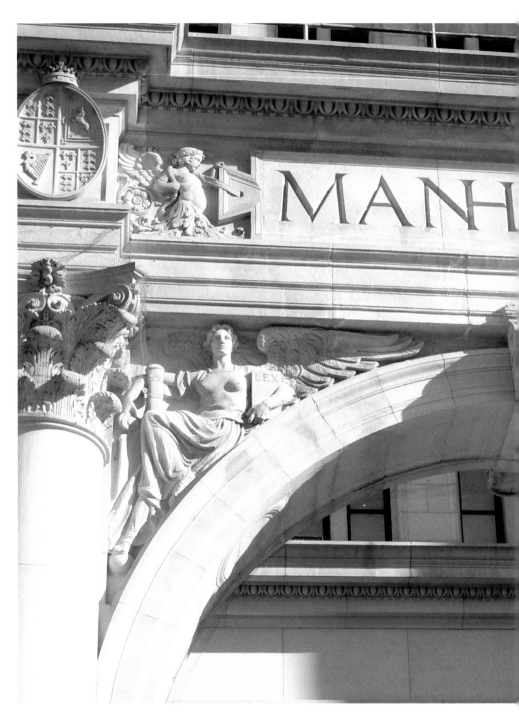

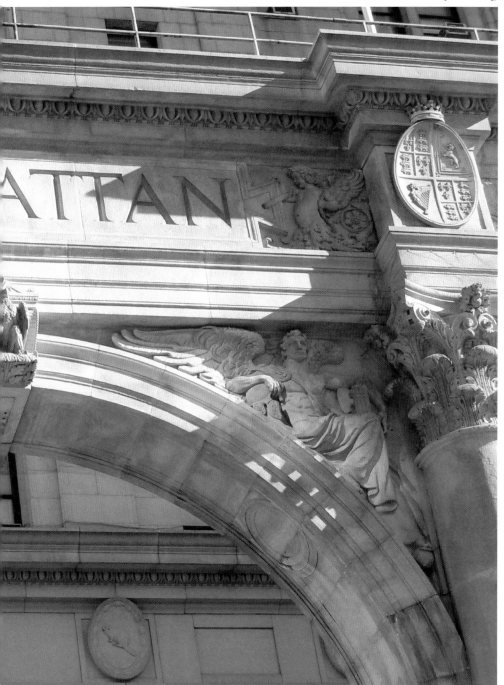

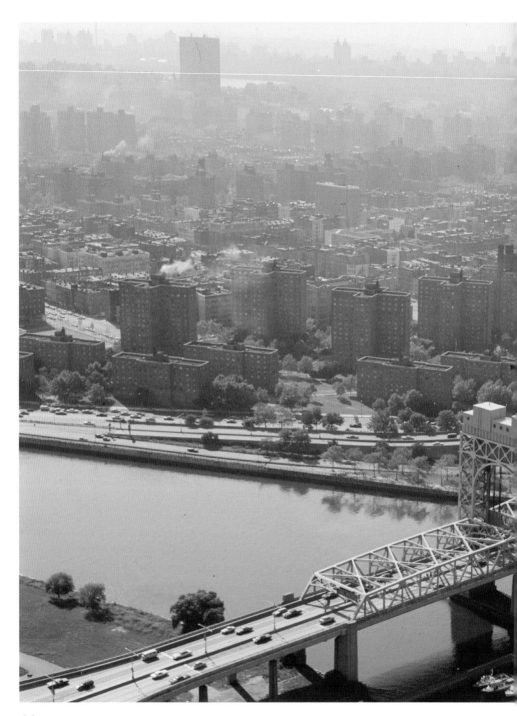

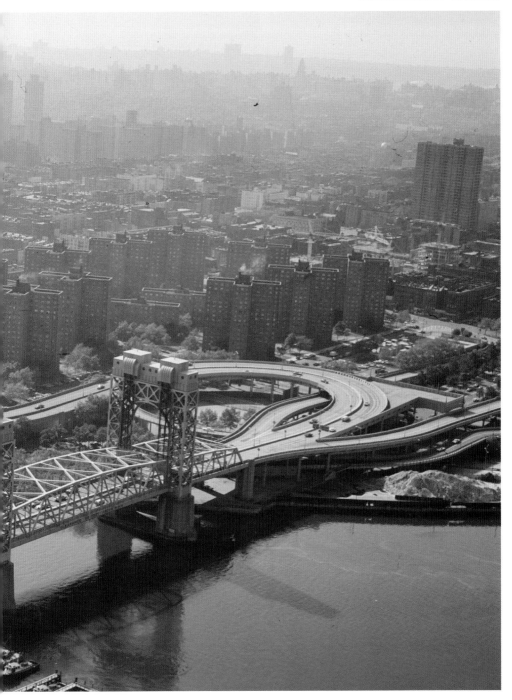

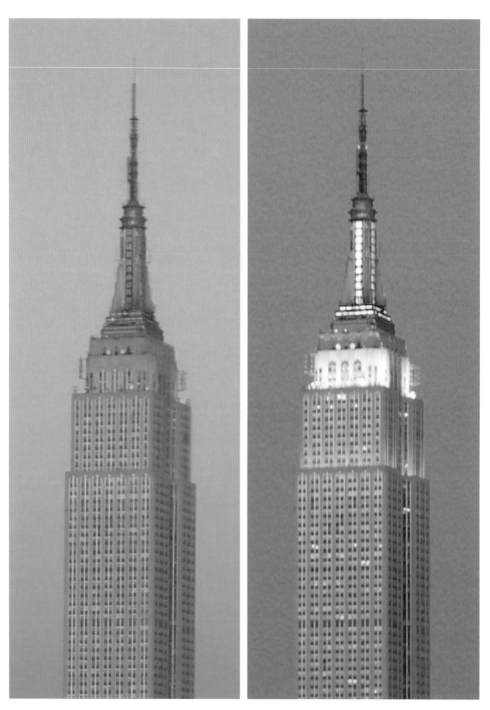

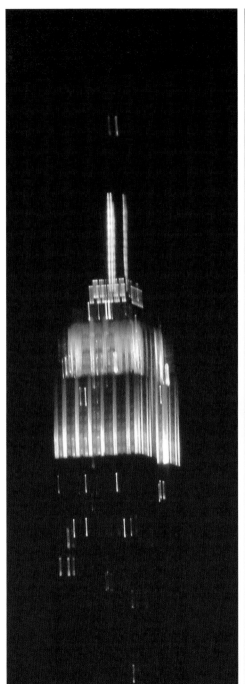
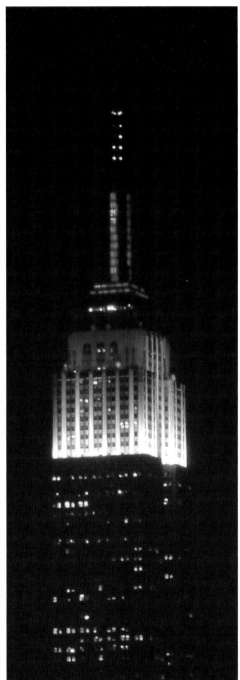

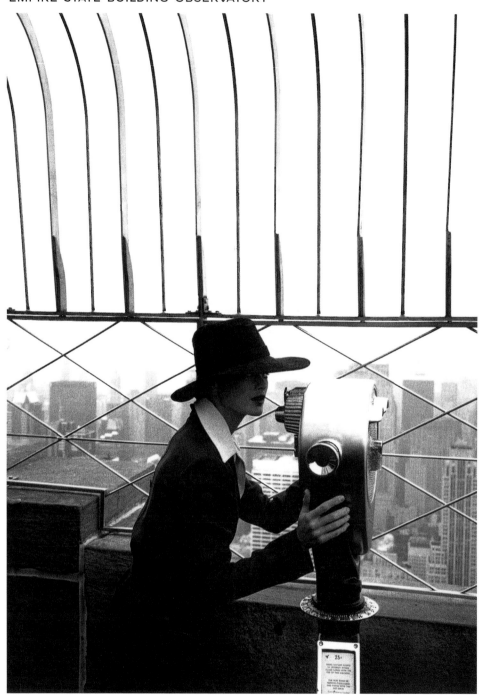

> **"** The beautiful city, the city of hurried
> and sparkling water!
> The city of spires and masts!
> The City nested in bays! My city!
> The city of such women, I as mad
> with them! I will return after death
> to be with them!
> The city of such young men,
> I swear I cannot live happy without
> I often go talk, walk, eat, drink,
> sleep with them! **"**

Walt Whitman, Leaves of Grass

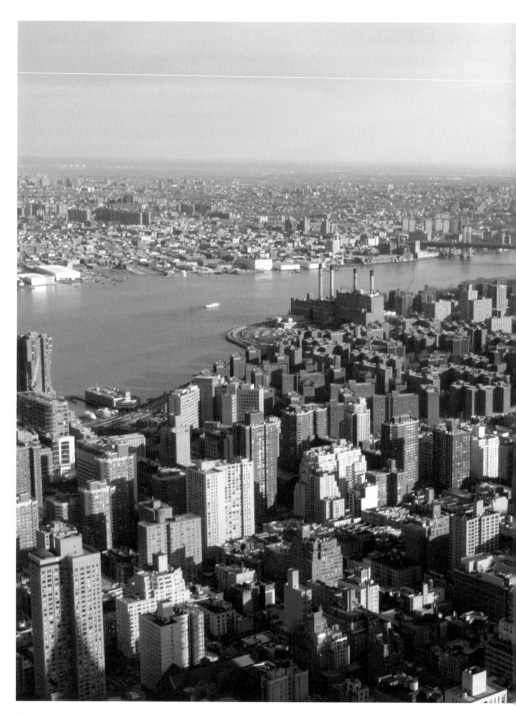

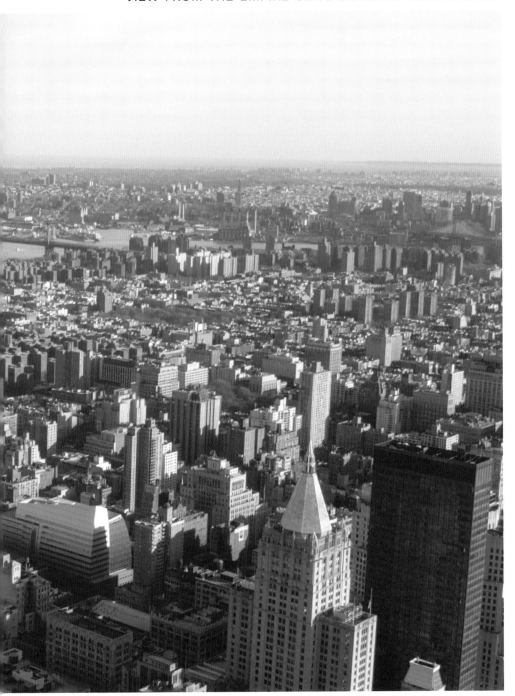

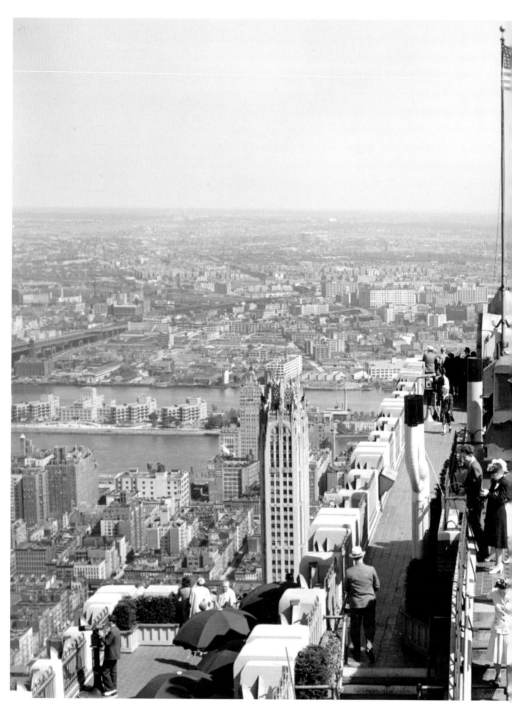

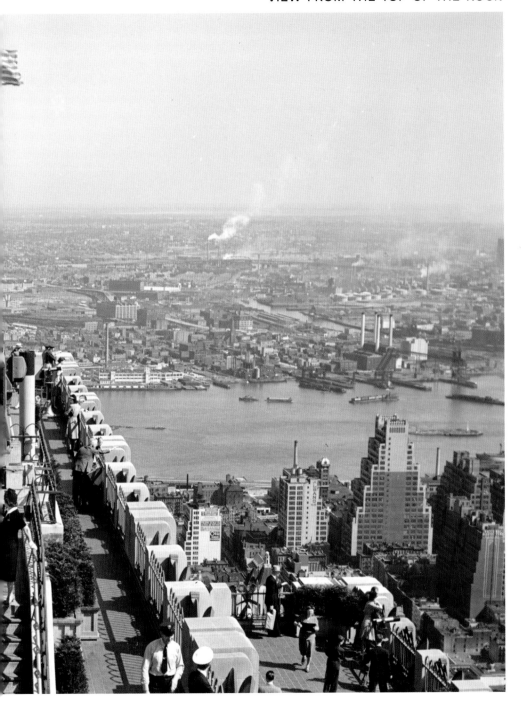

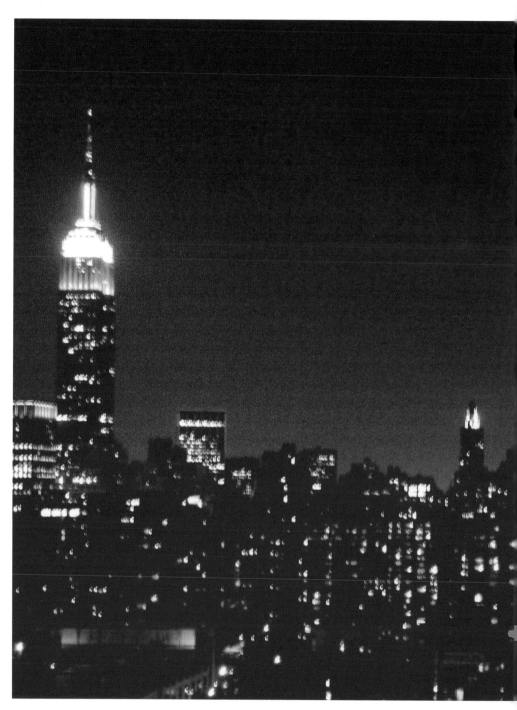

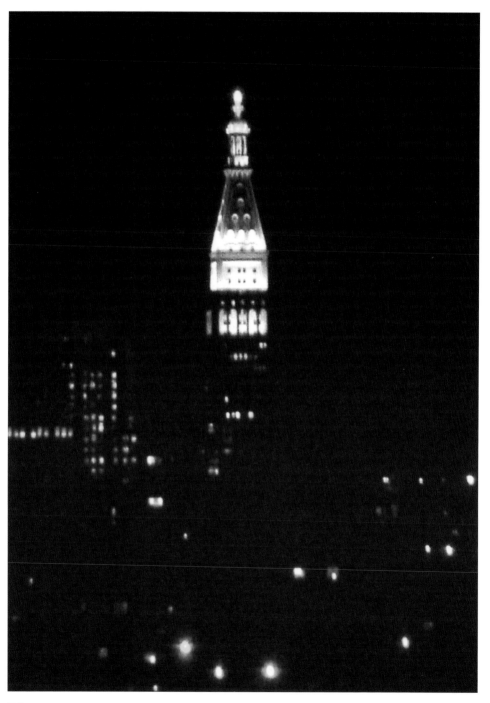

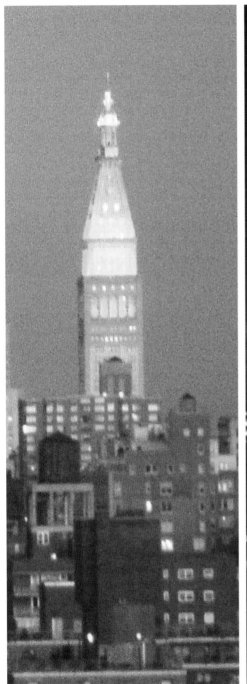
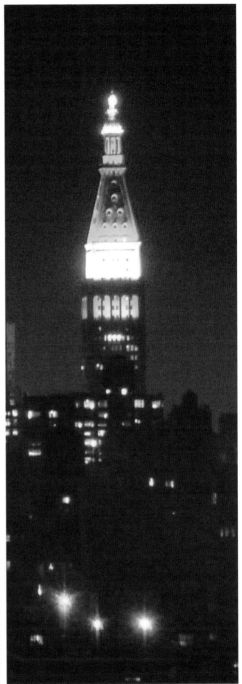

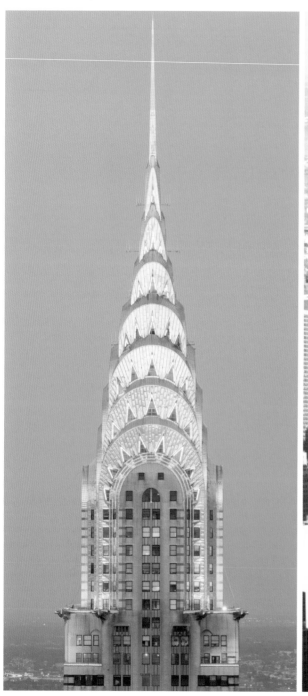
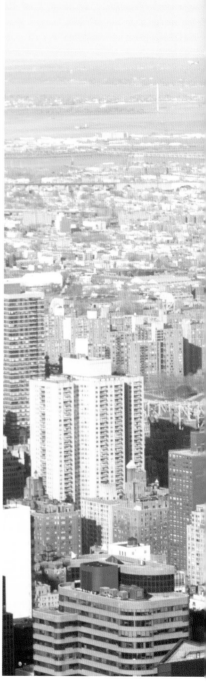

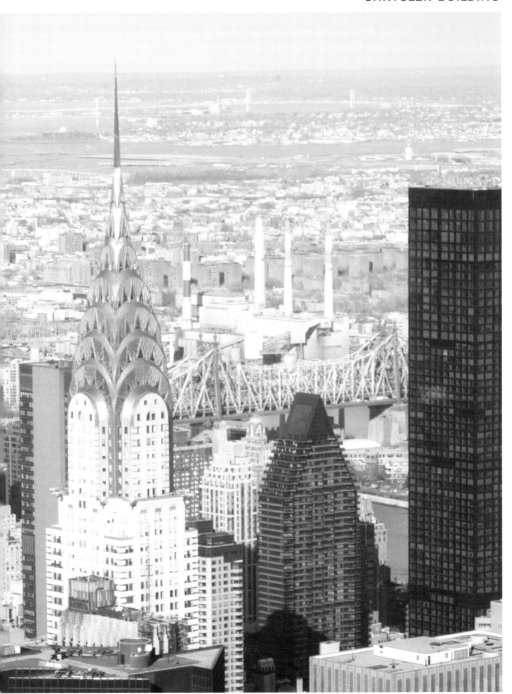

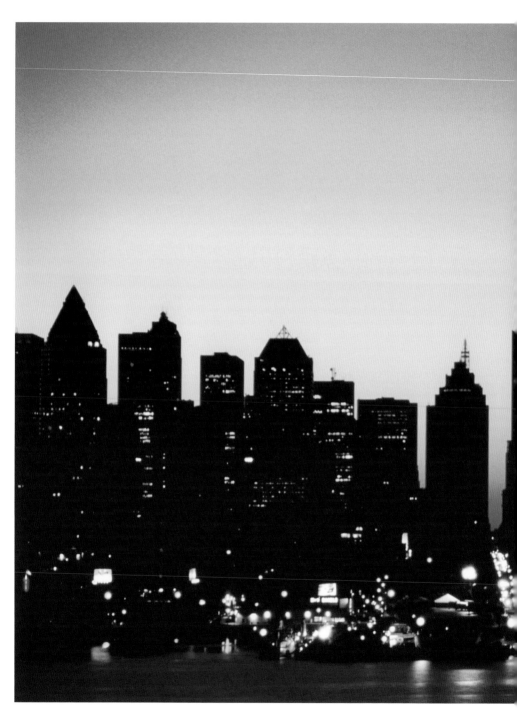

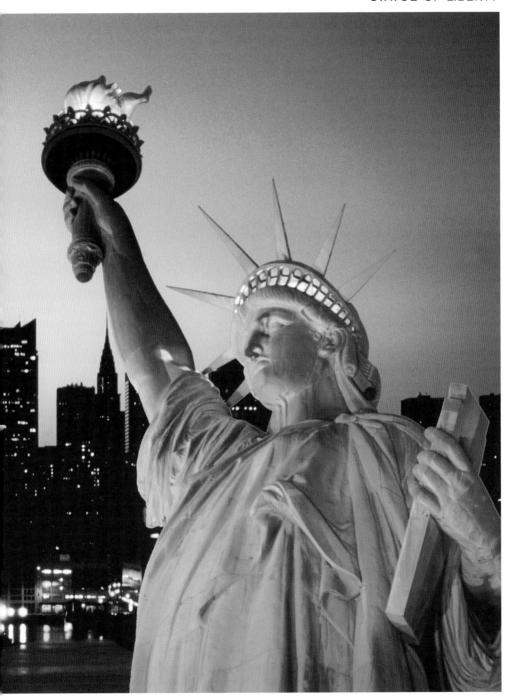

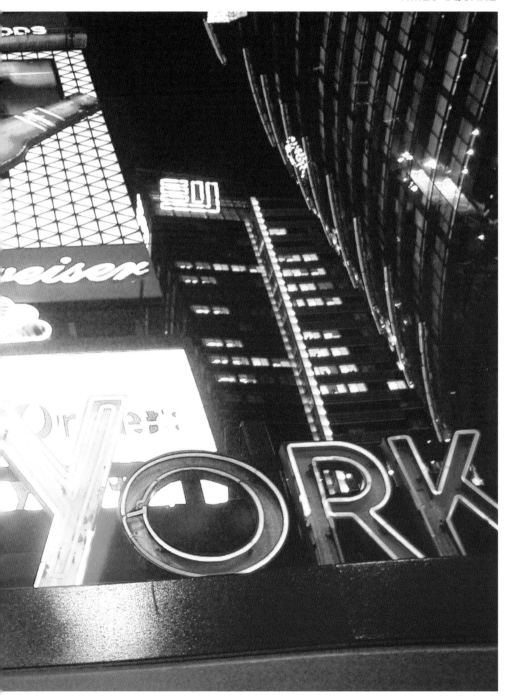

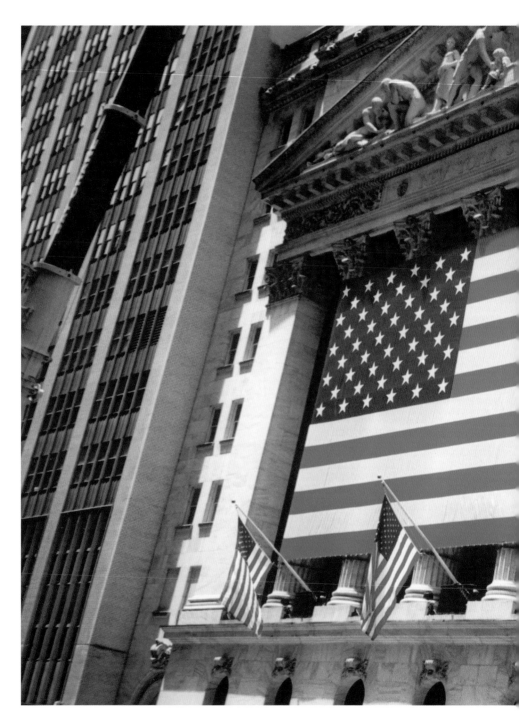

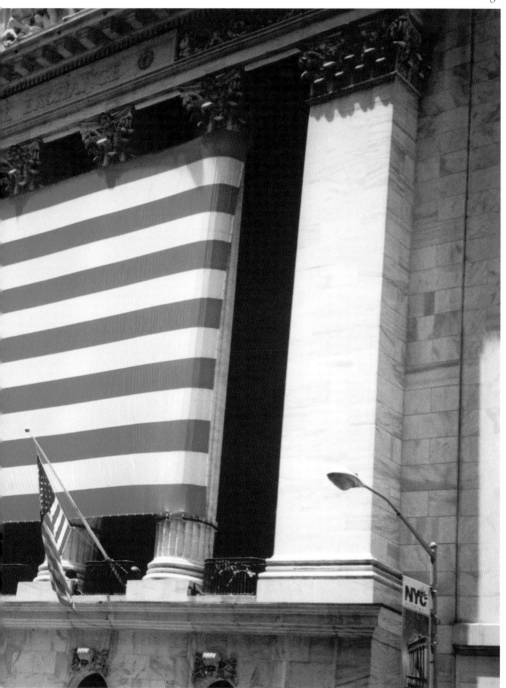

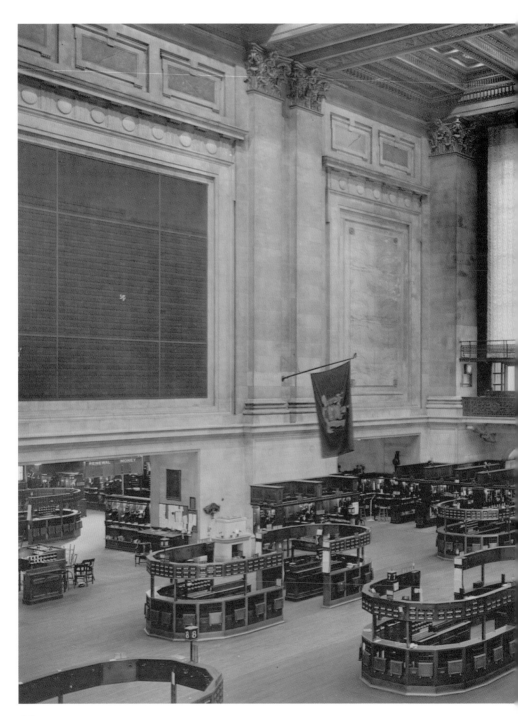

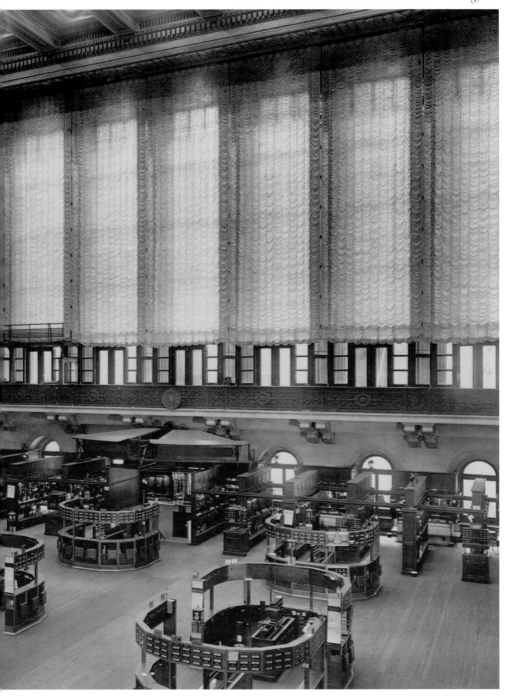

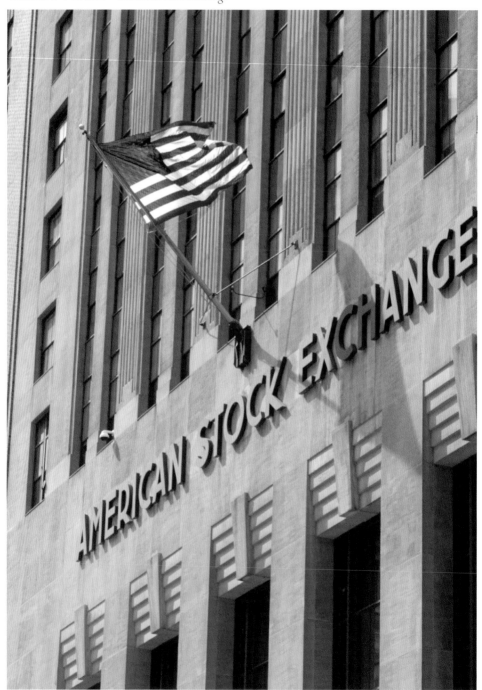

66 When Wall Street sneezes,
the rest of the world catches a cold. 99

Anonymous

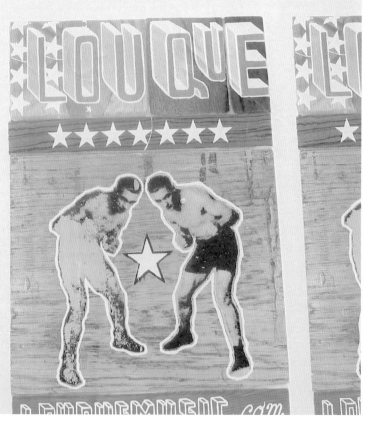

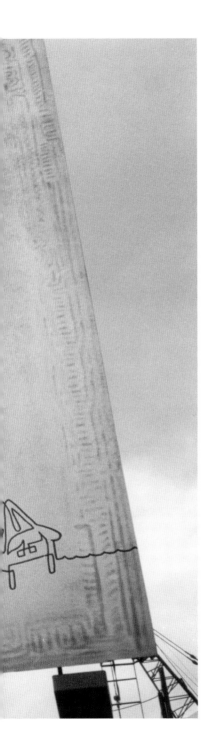

66New Yorkers are inclined to assume it will never rain and certainly not on New Yorkers.**99**

Brooks Atkinson

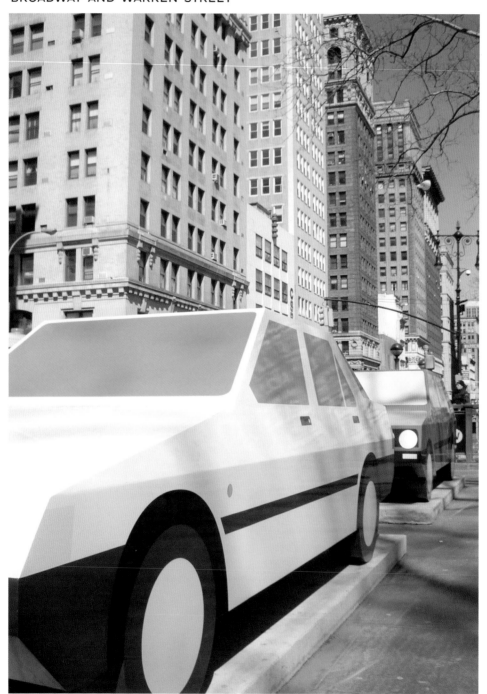

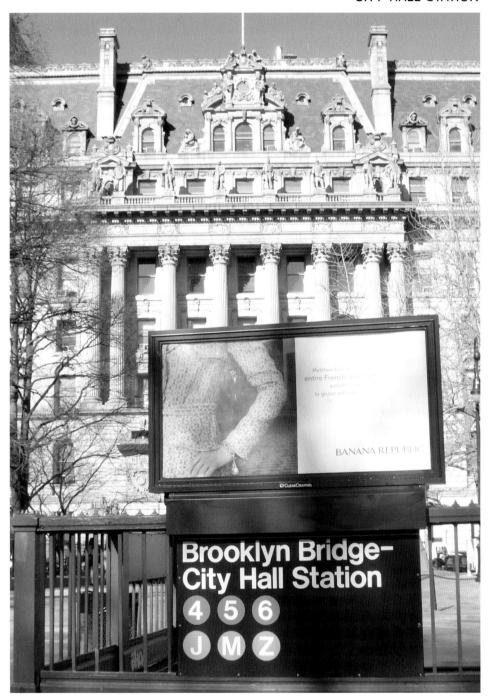

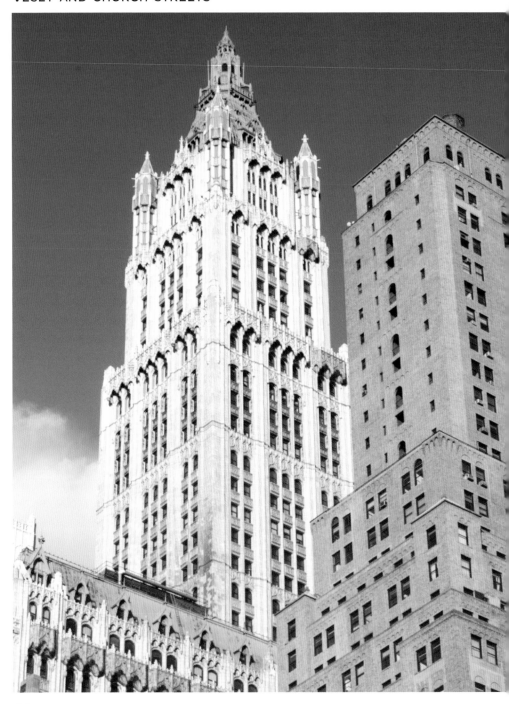

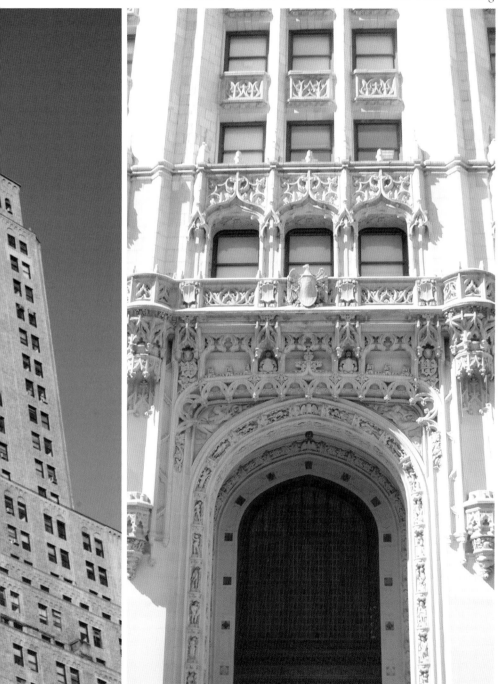

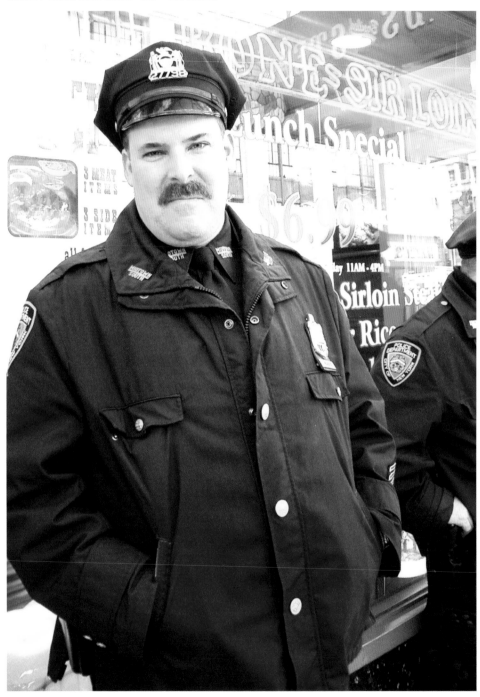

❝ New York is, I firmly believe, the most charitable city in the world. Nowhere is there so eager a readiness to help, when it is known that help is worthily wanted.
Nowhere are such armies of devoted workers, nowhere such an abundance of means ready to the hand of those who know the need and how rightly to supply it.**❞**

Jacob Riis

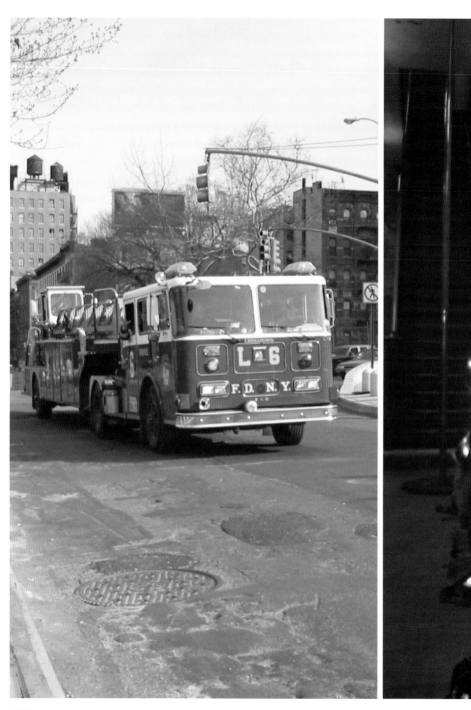

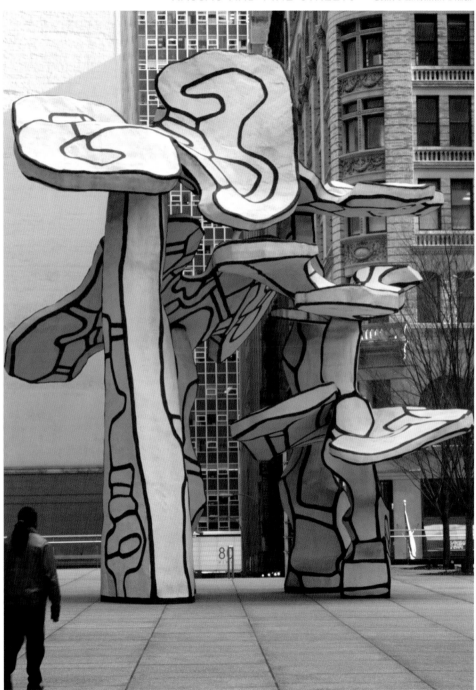

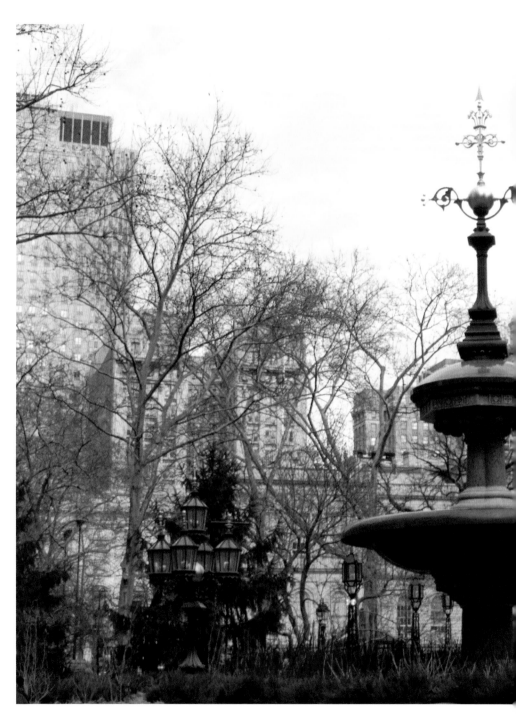

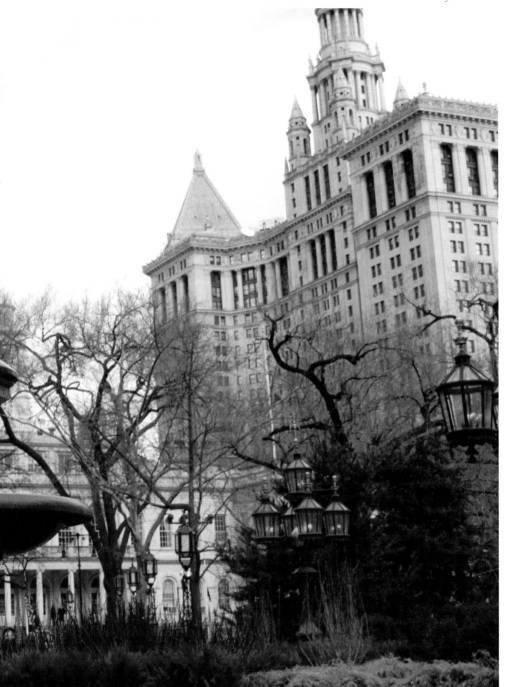

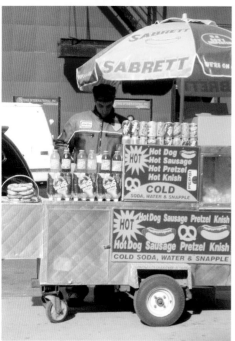
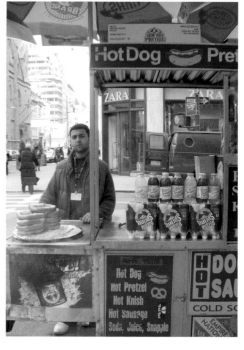

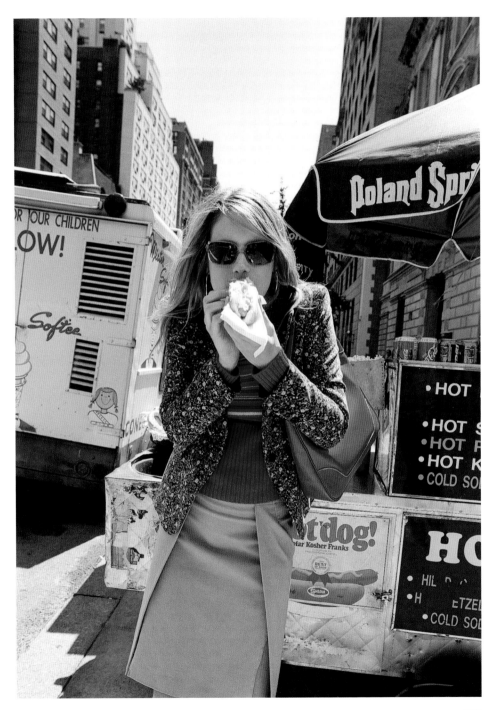

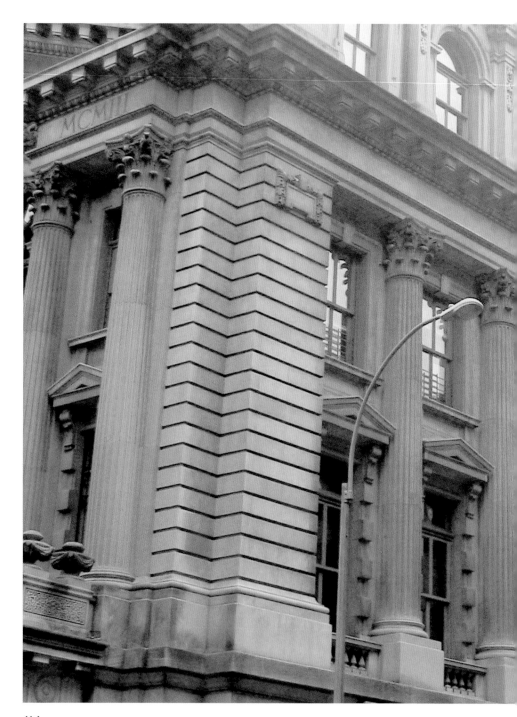

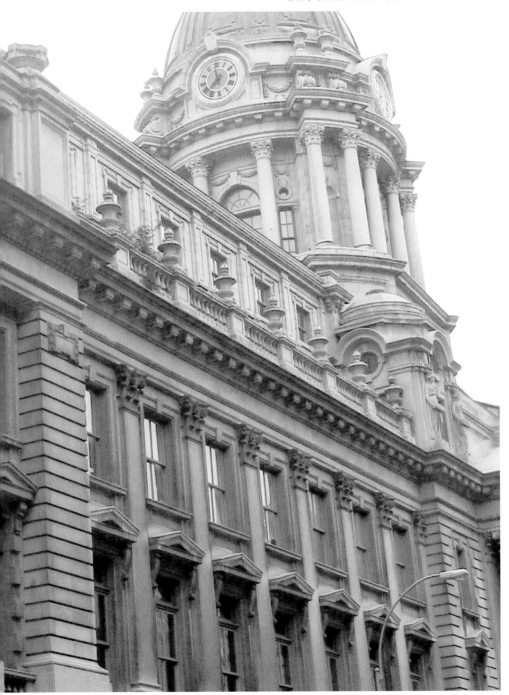

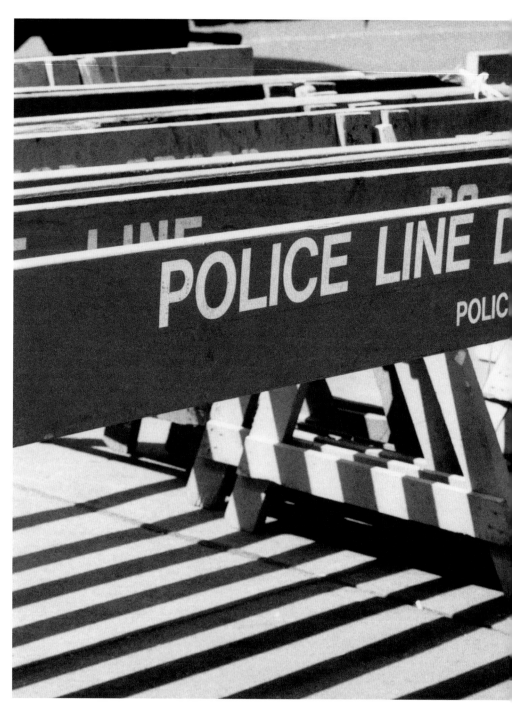

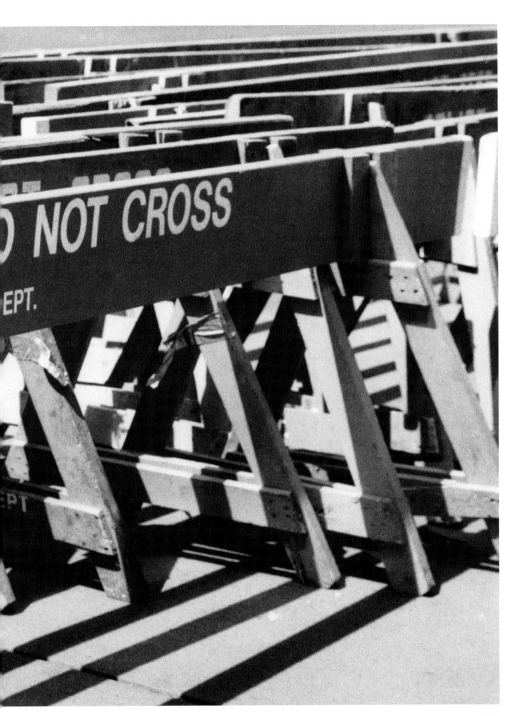

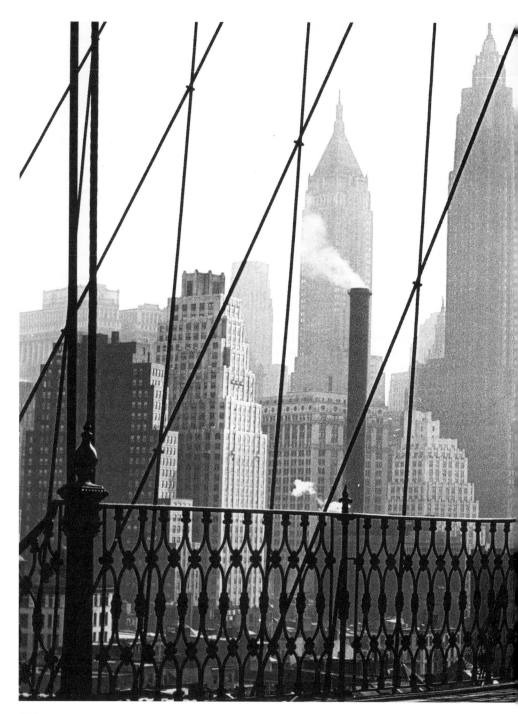

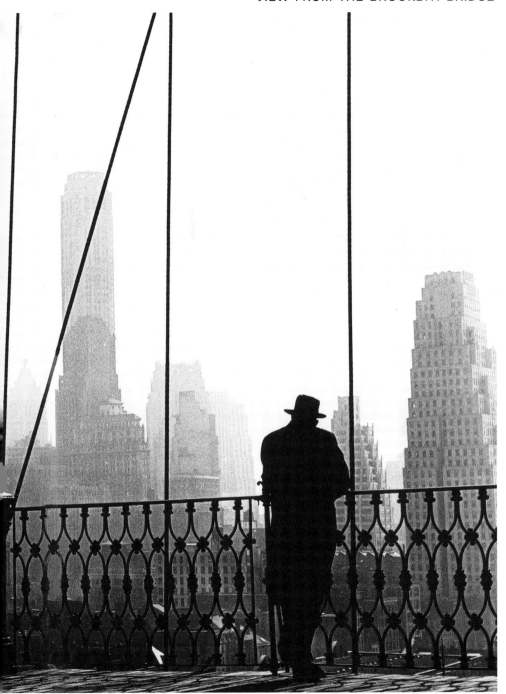

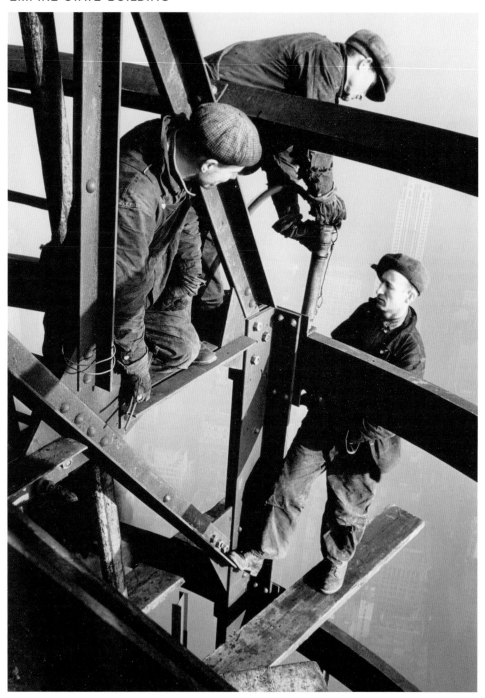

"When you leave New York, you ain't goin' nowhere."

Anonymous quotes

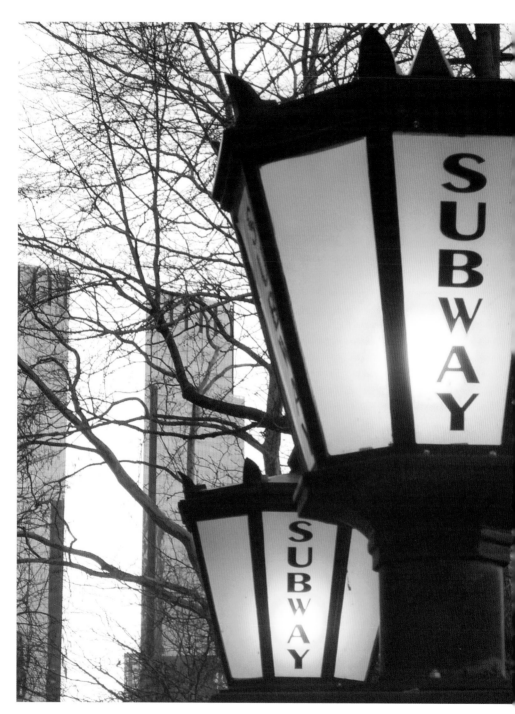

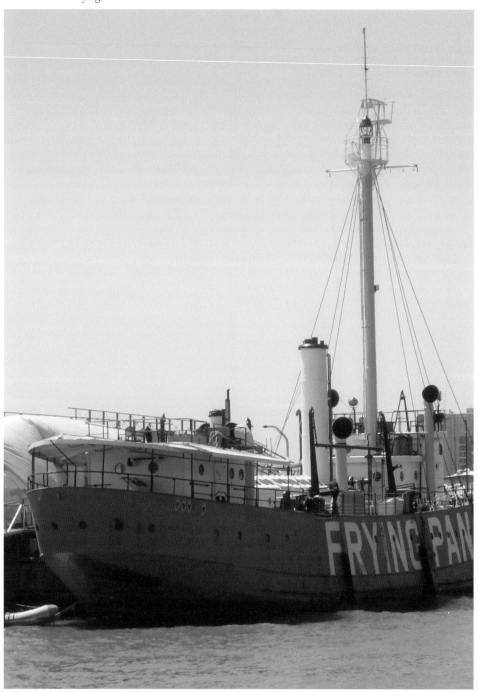

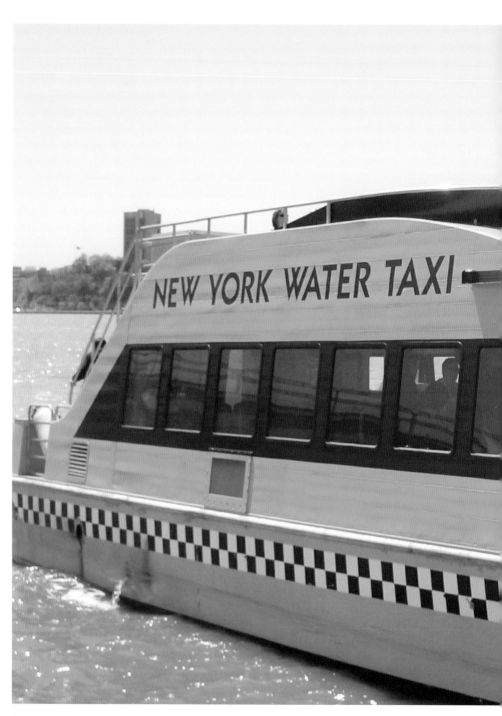

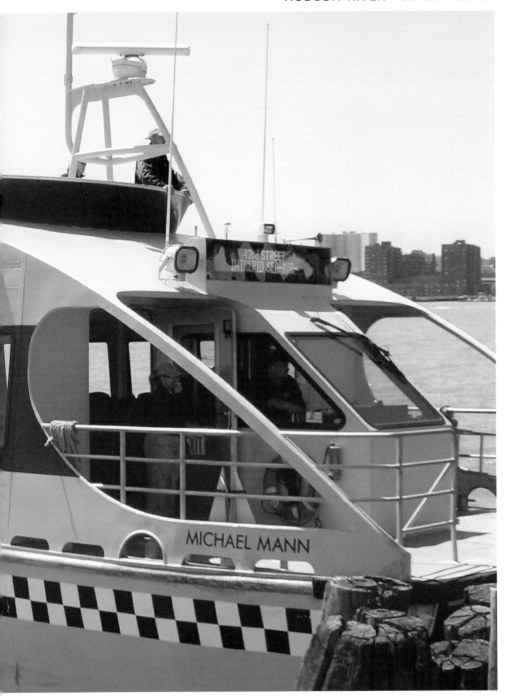

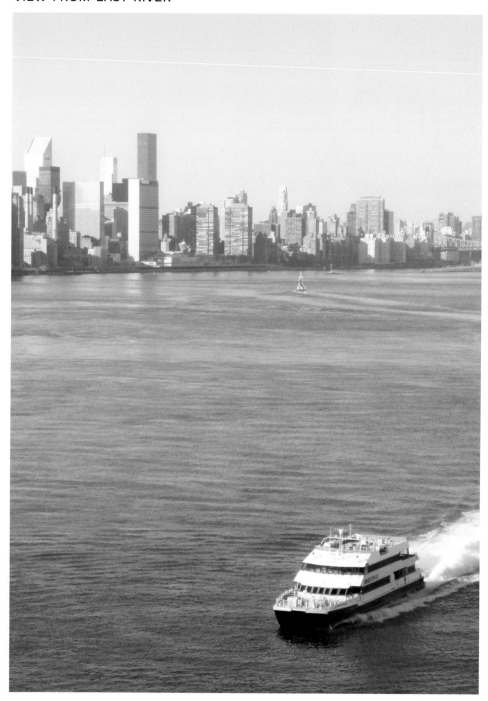

66 Manhattan. Sometimes from beyond the skyscrapers, across the hundreds of thousands of high walls, the cry of a tugboat finds you in your insomnia in the middle of the night, and you remember that this desert of iron and cement is an island. 99

Albert Camus

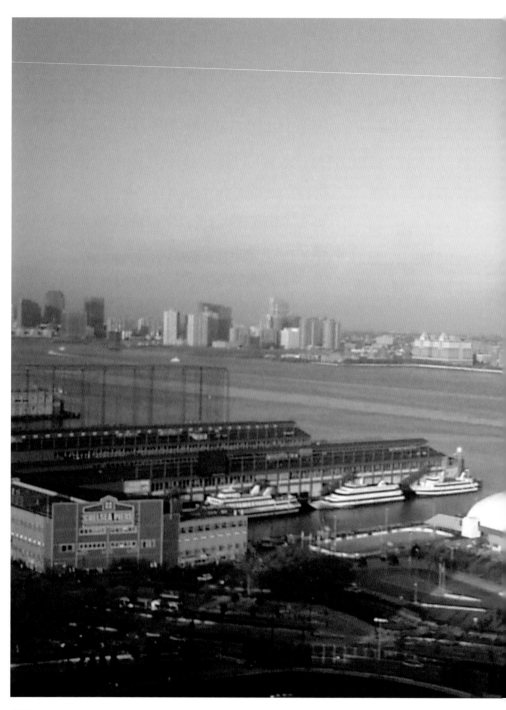

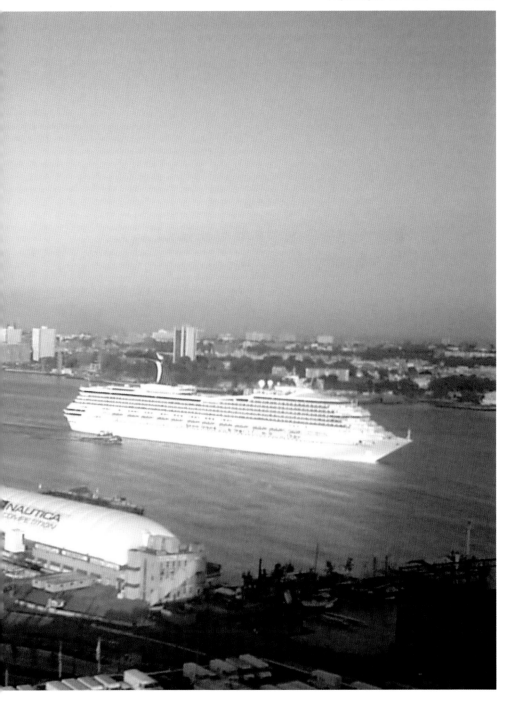

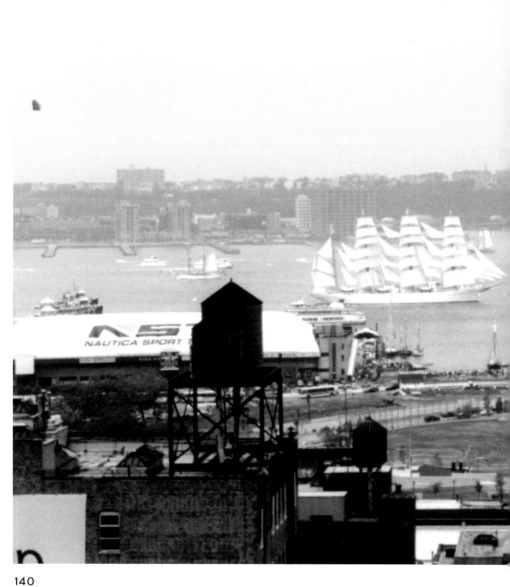

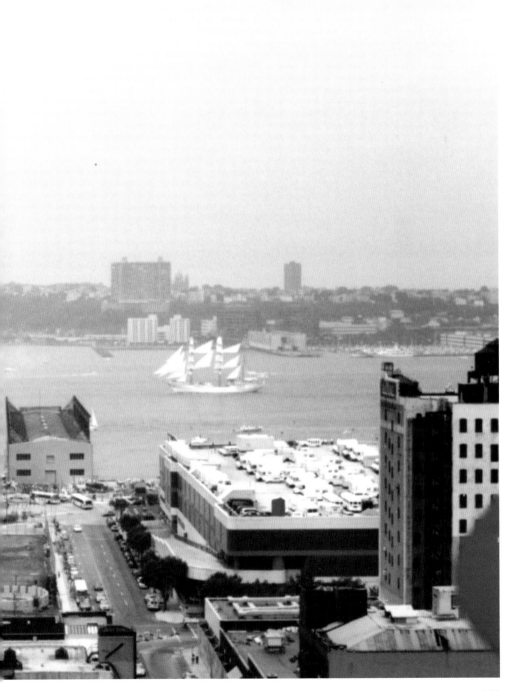

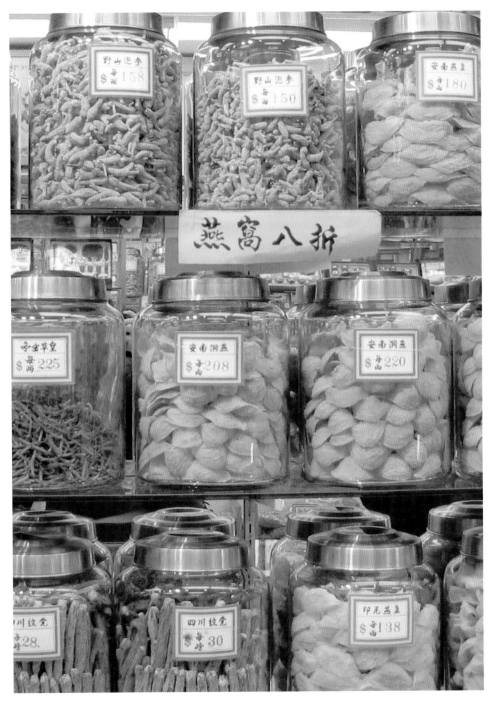

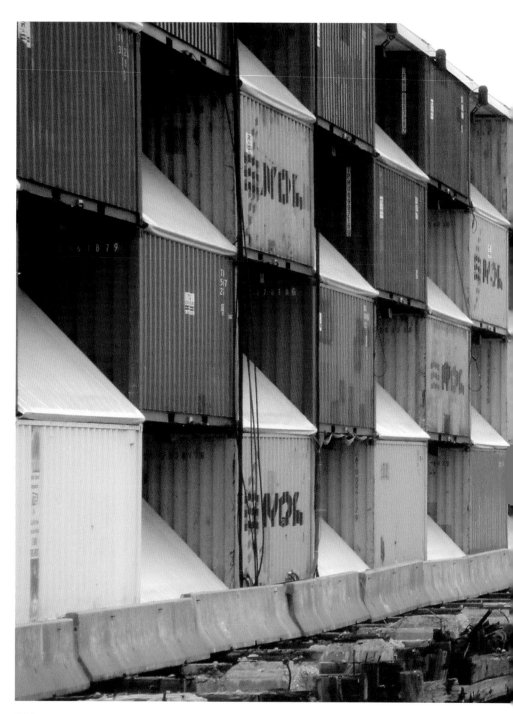

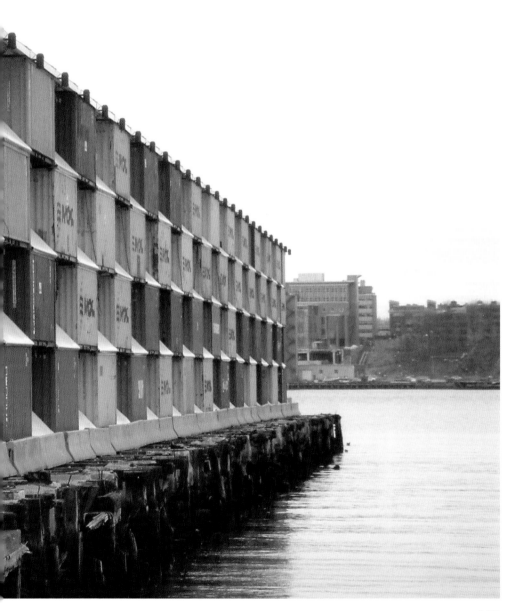

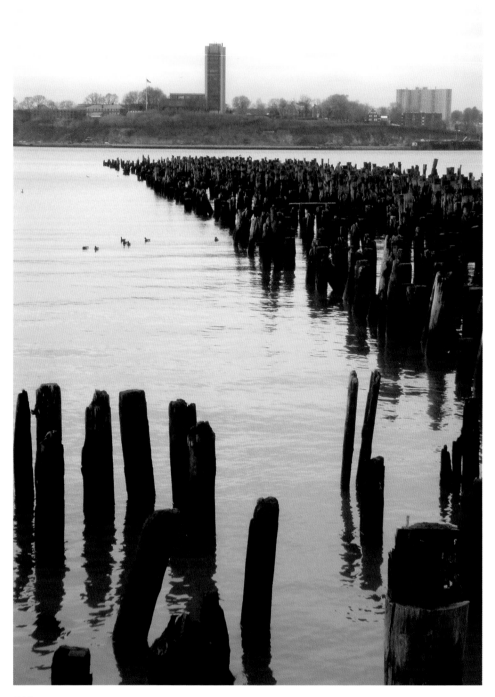

66 So here we are in New York. To a Frenchman the aspect of the city is bizarre and not very agreeable. One sees neither dome, nor bell tower, nor great edifice, with the result that one has the constant impression of being in a suburb. 99

Alexis de Tocqueville

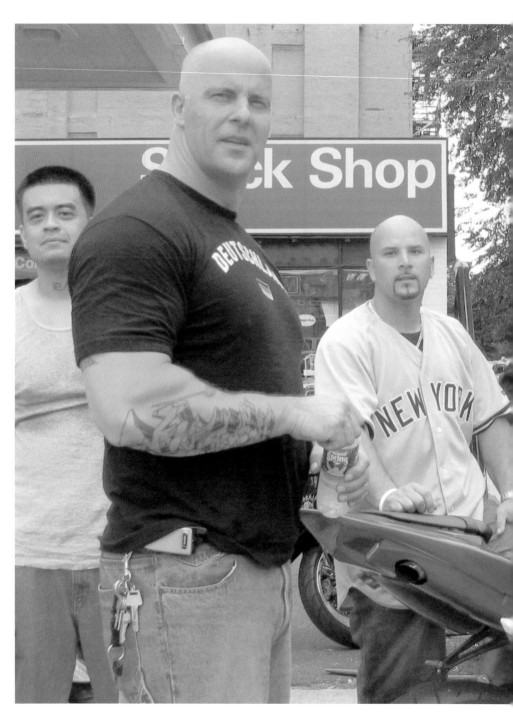

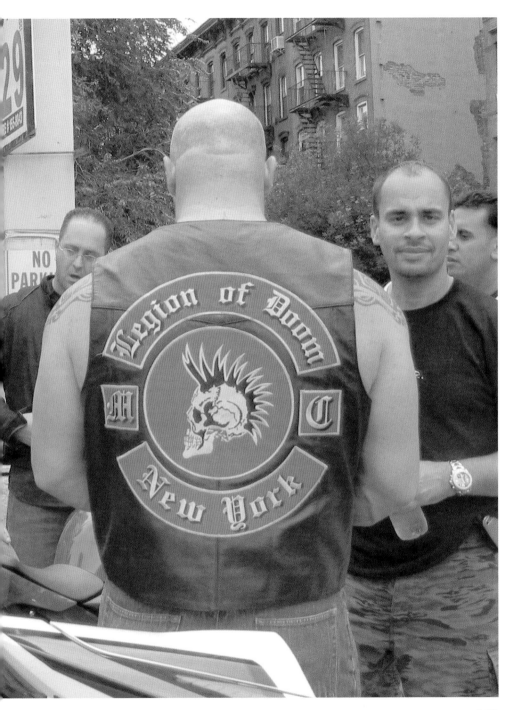

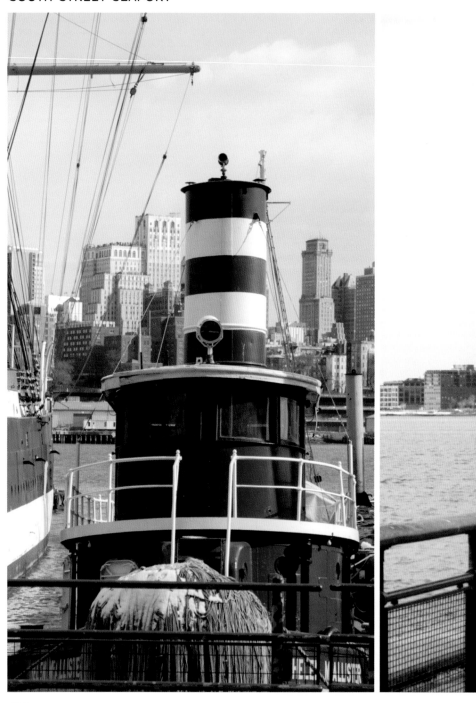

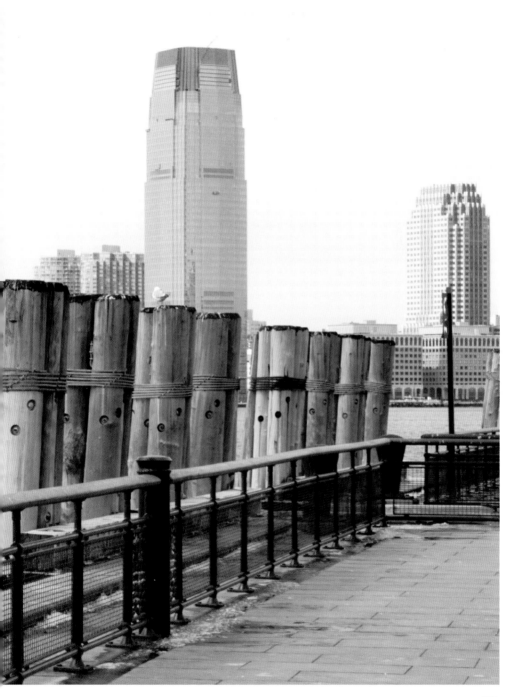

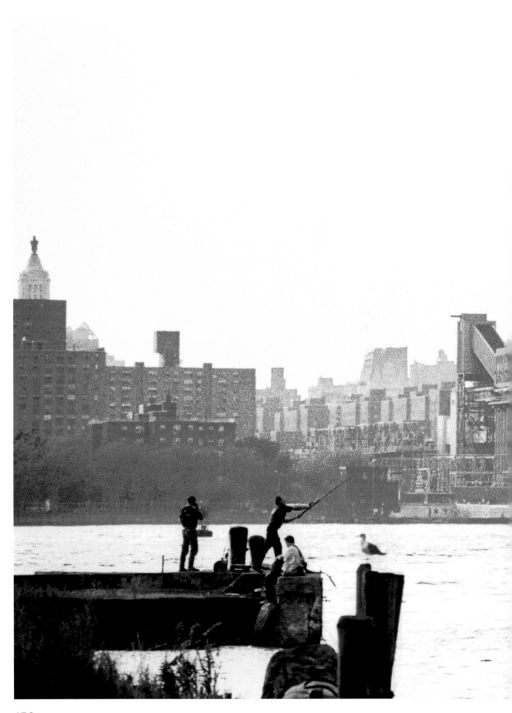

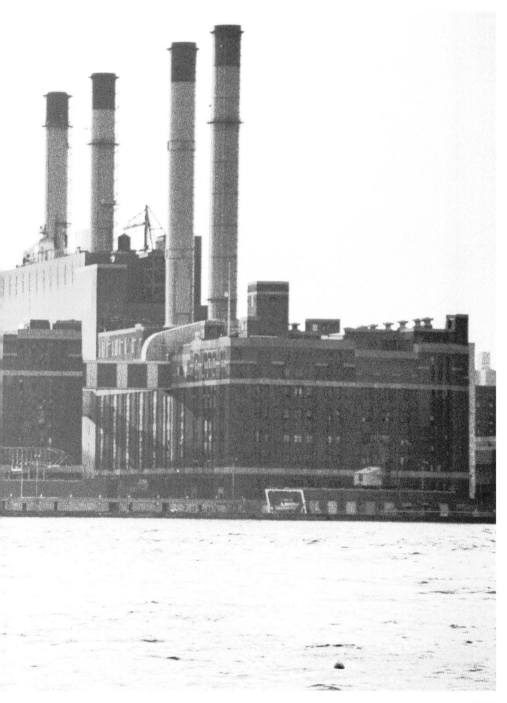

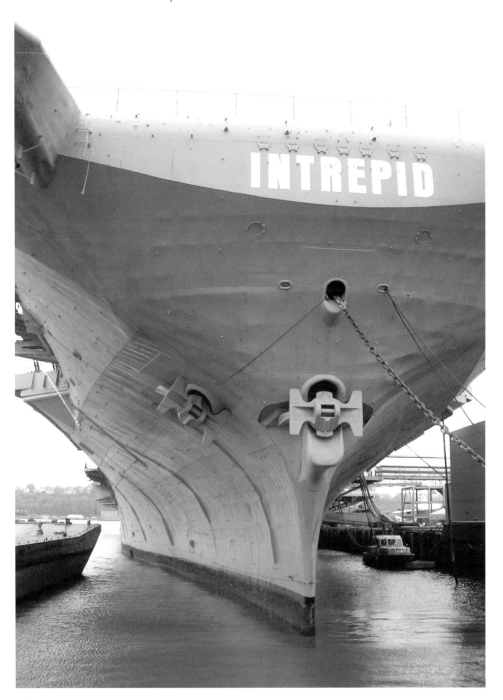

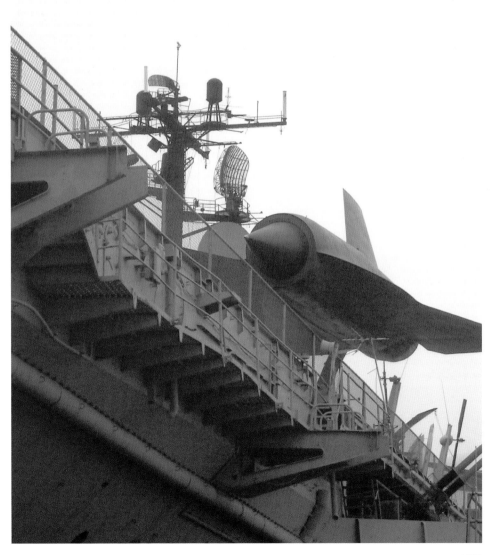

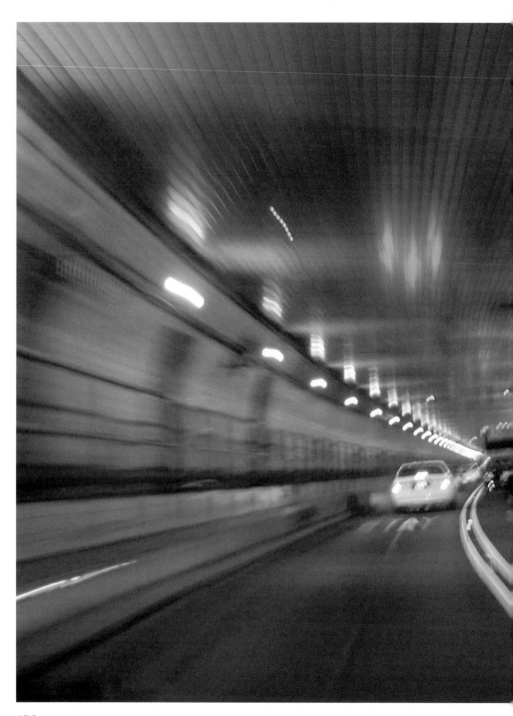

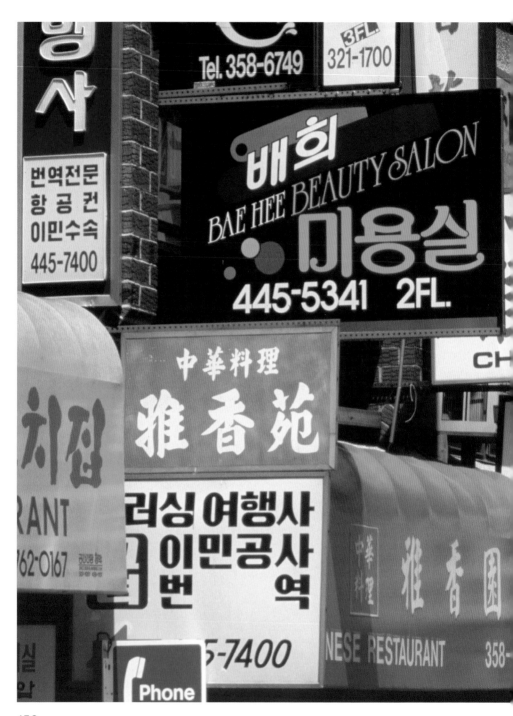

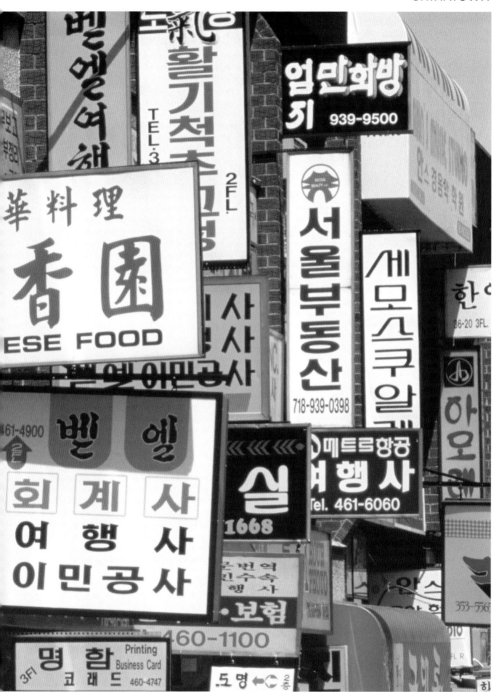

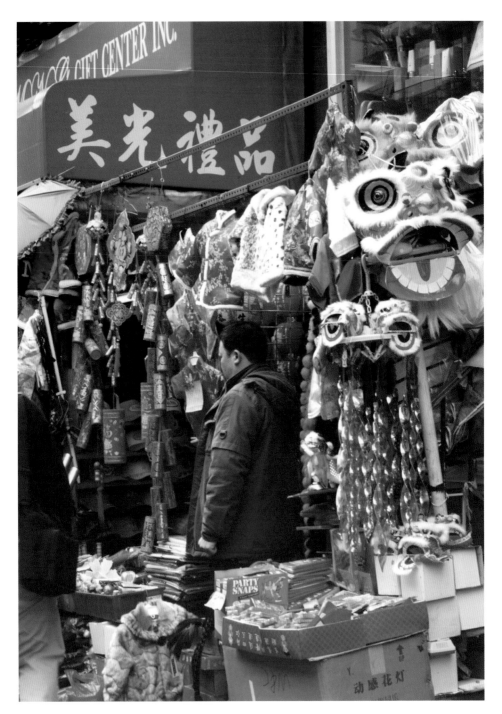

160

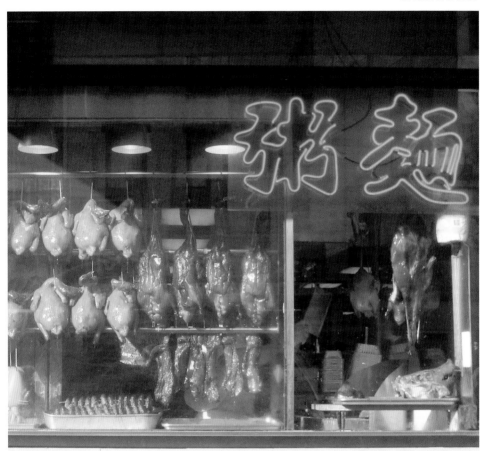

晚　撚　粥　明　承
飯　手　粉　爐　接
宵　小　麵　燒　盒
夜　菜　飯　臘　豬

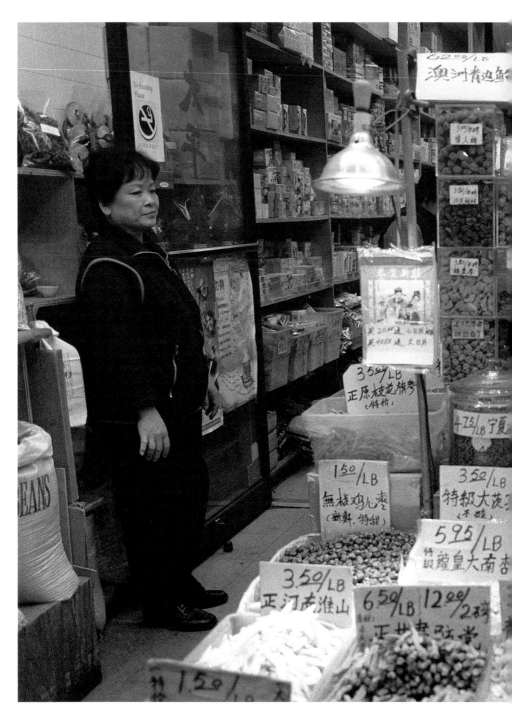

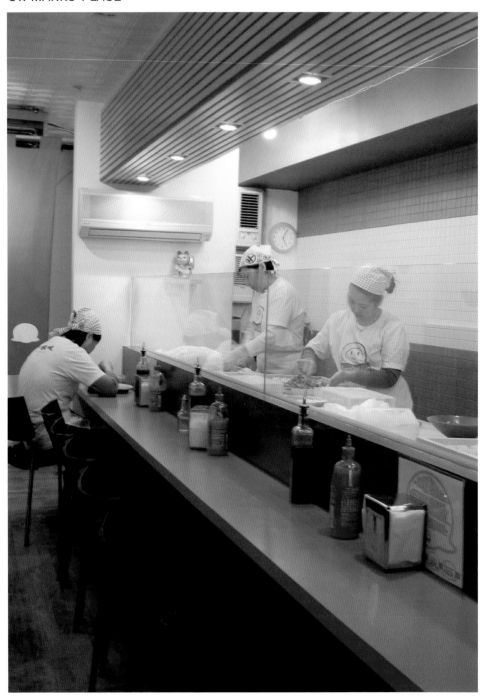

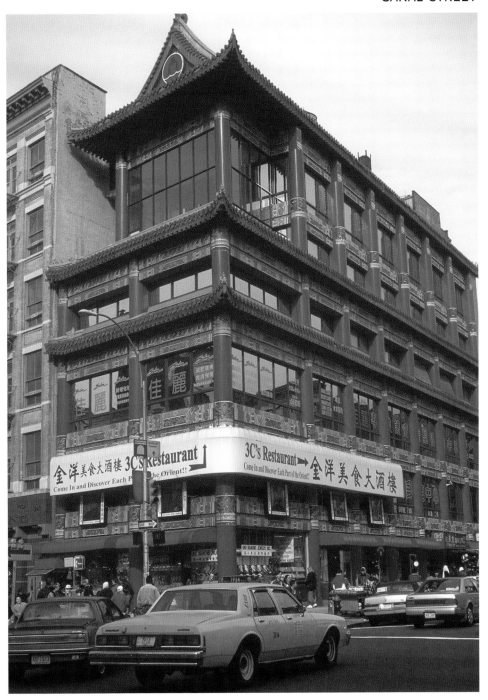

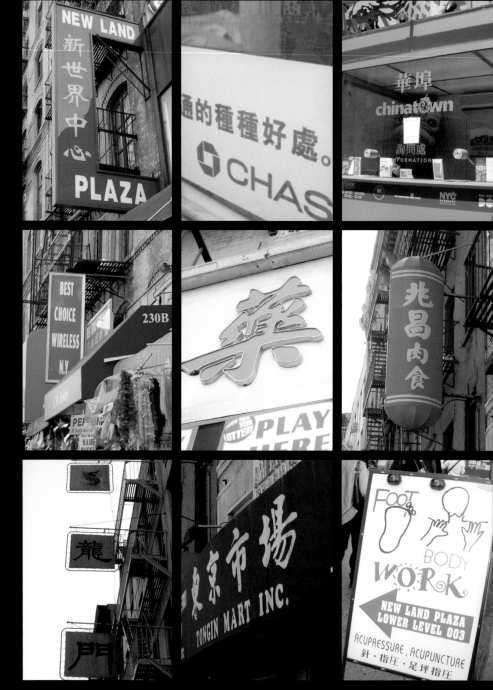

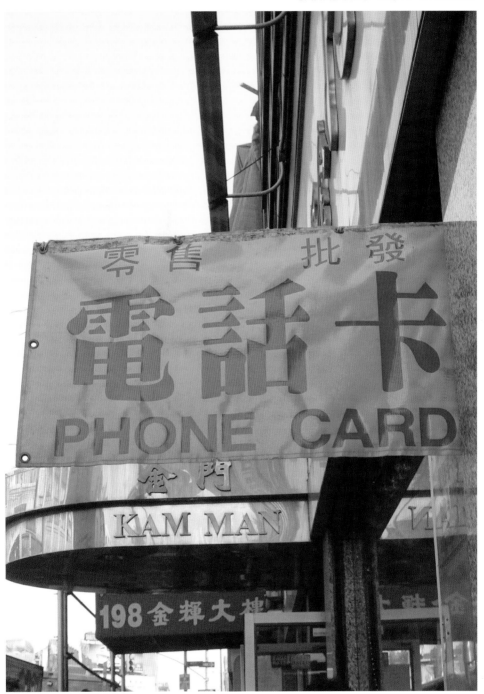

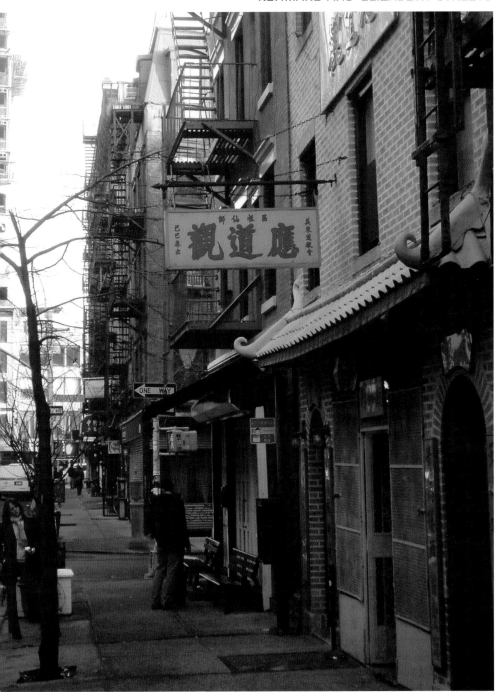

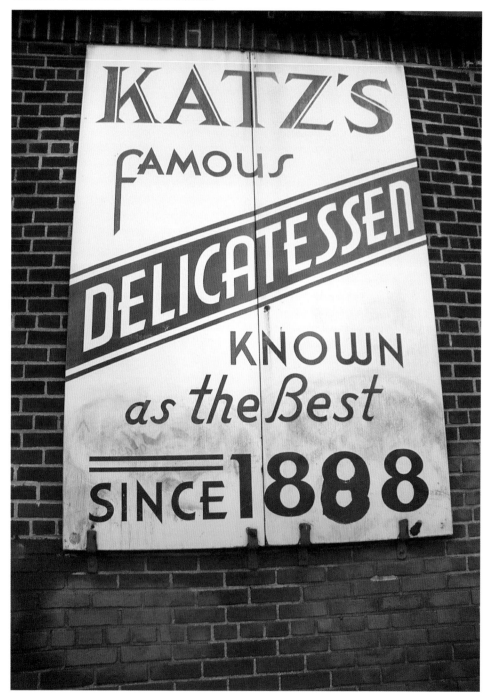

66 Everybody ought to have
a Lower East Side in their life.**99**

Irving Berlin

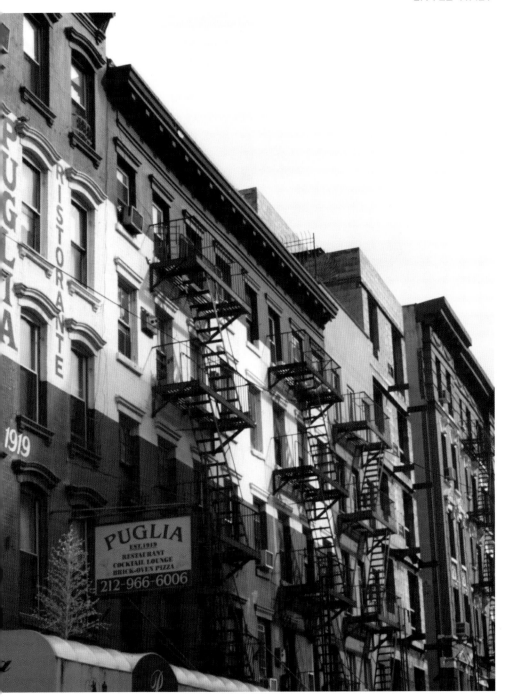

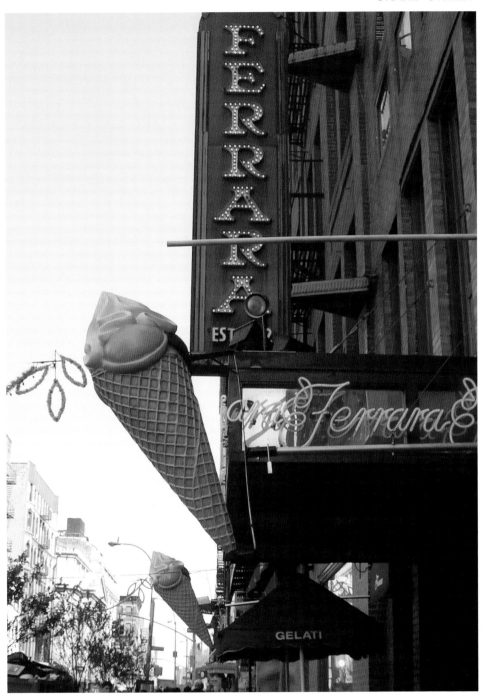

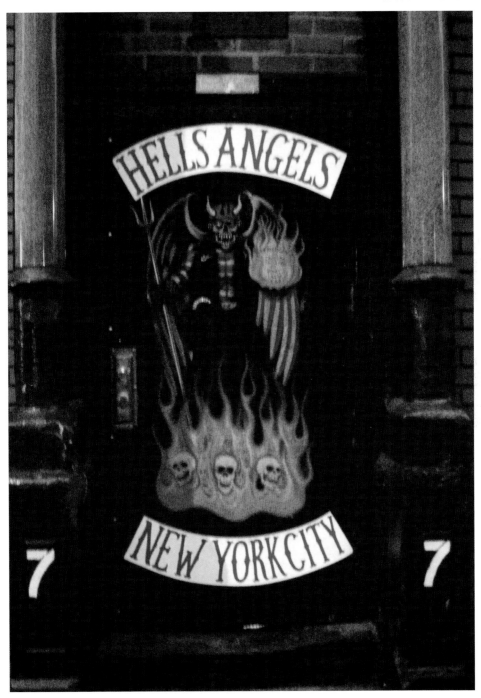

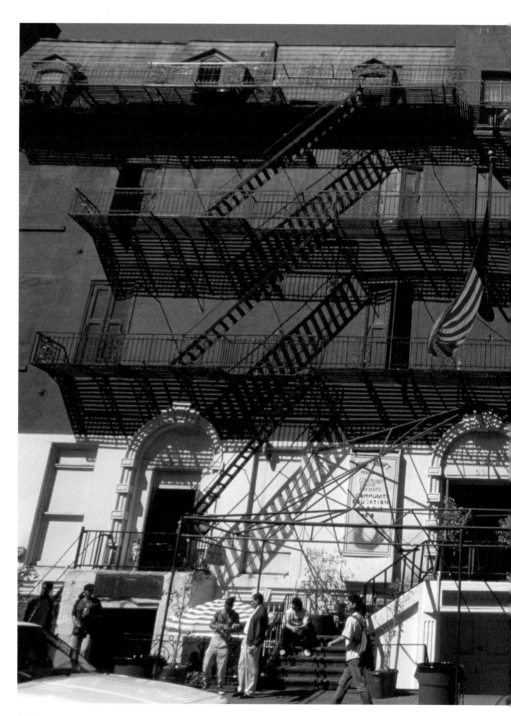

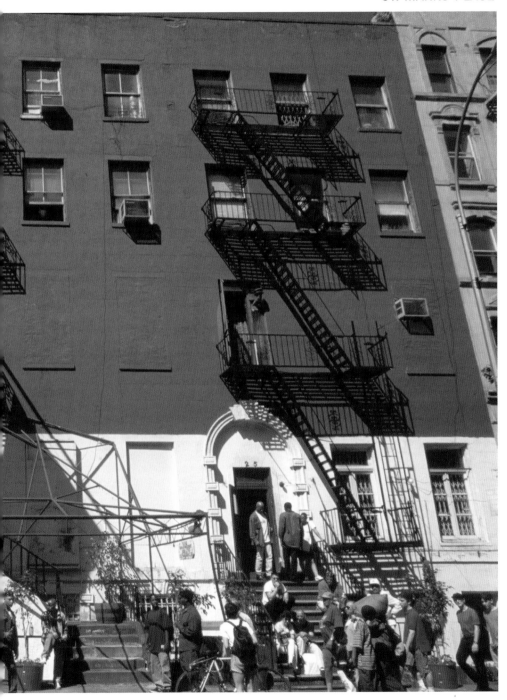

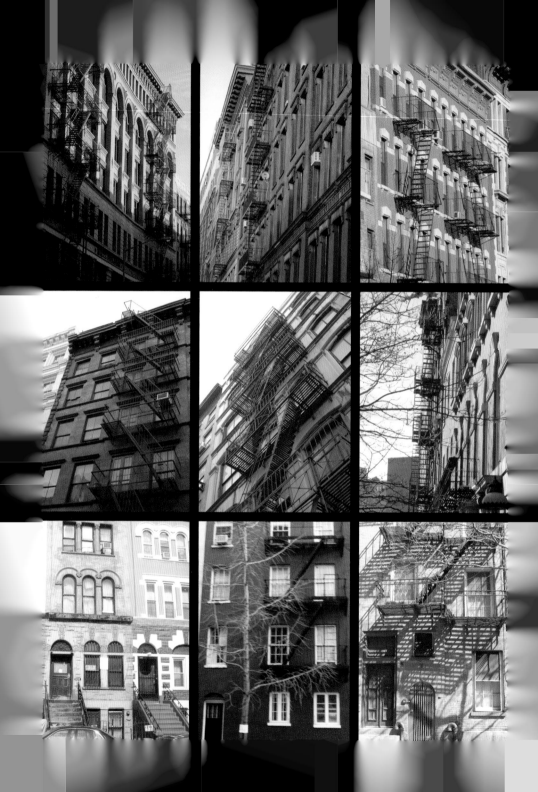

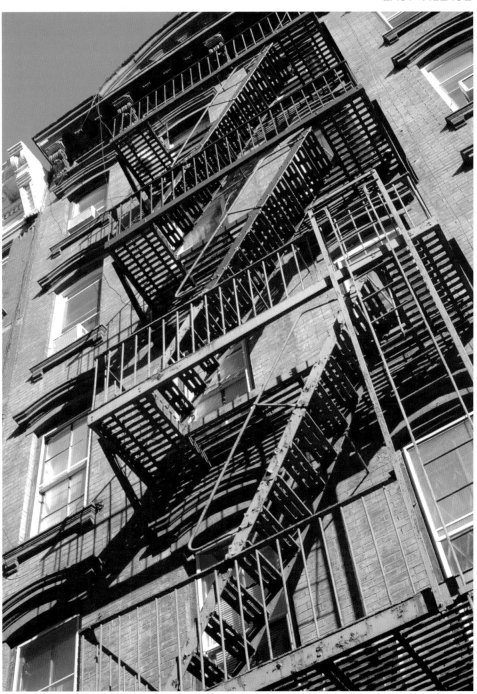

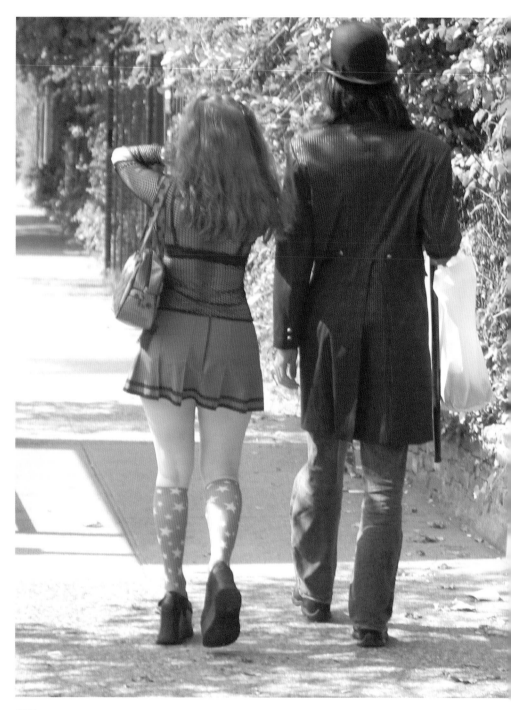

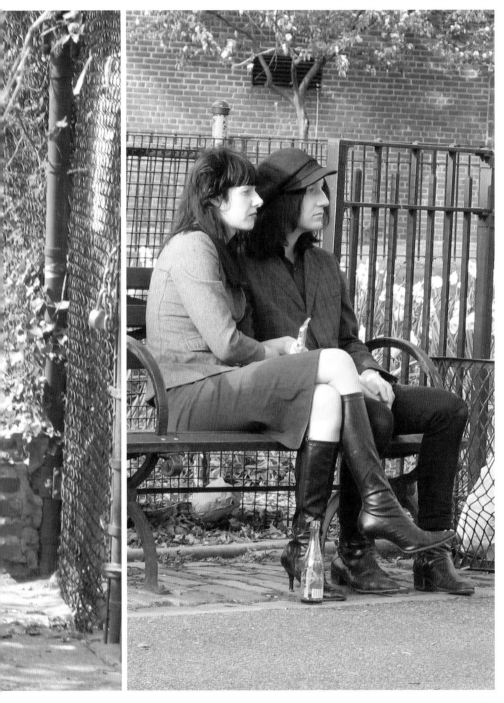

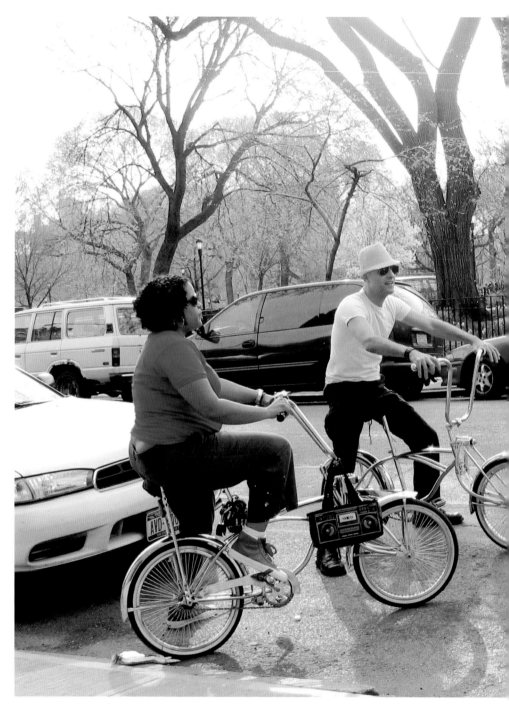

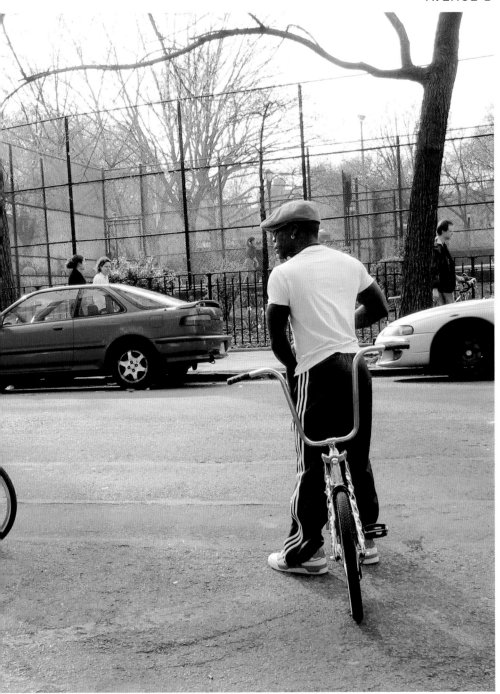

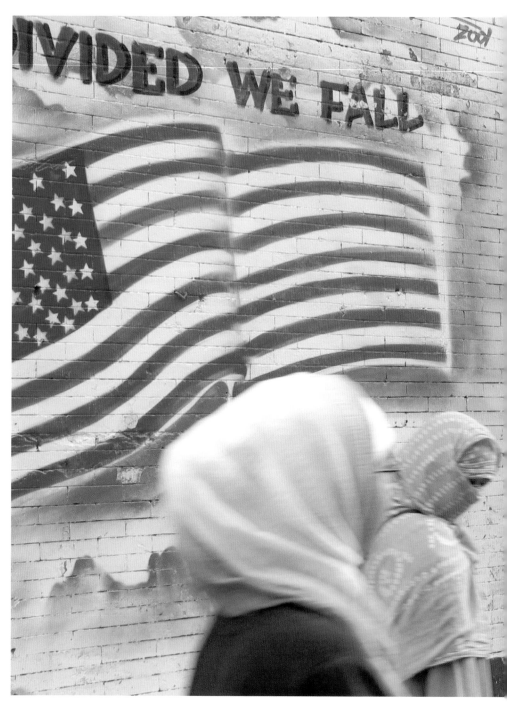

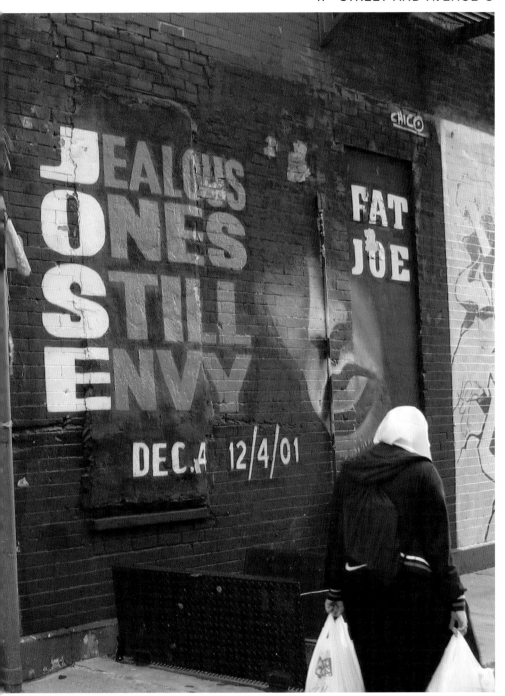

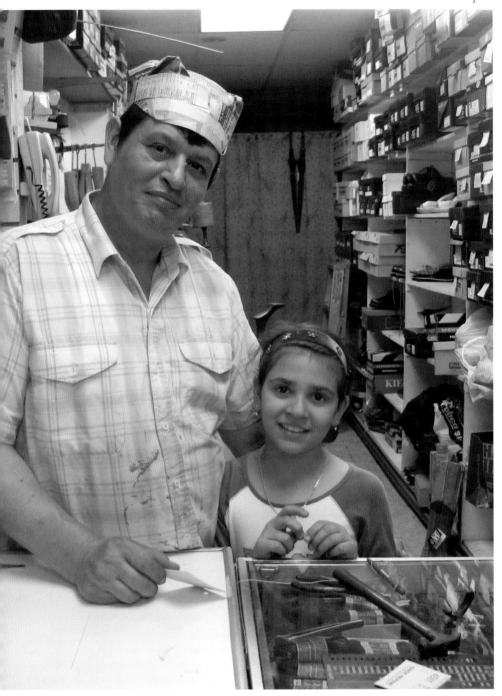

66 Many a New Yorker spends a lifetime within the confines of an area smaller than a country village. Let him walk two blocks from his corner and he is in a strange land and will feel uneasy till he gets back. **99**

E. B. White

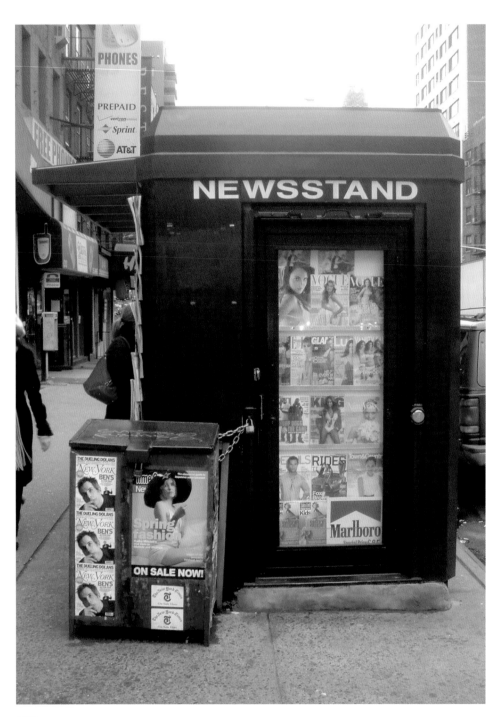

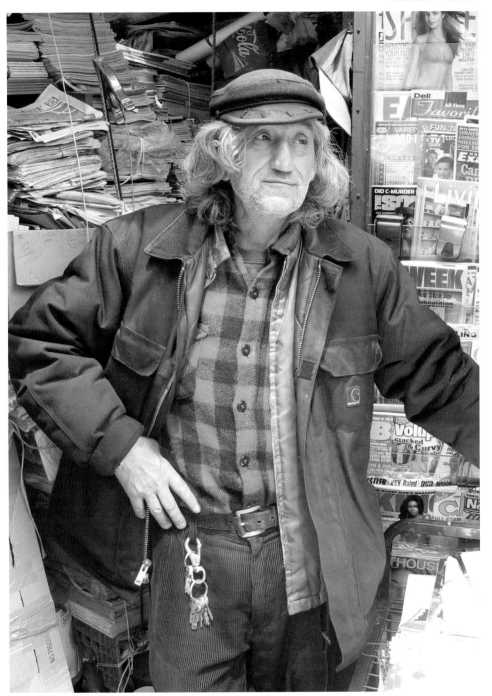

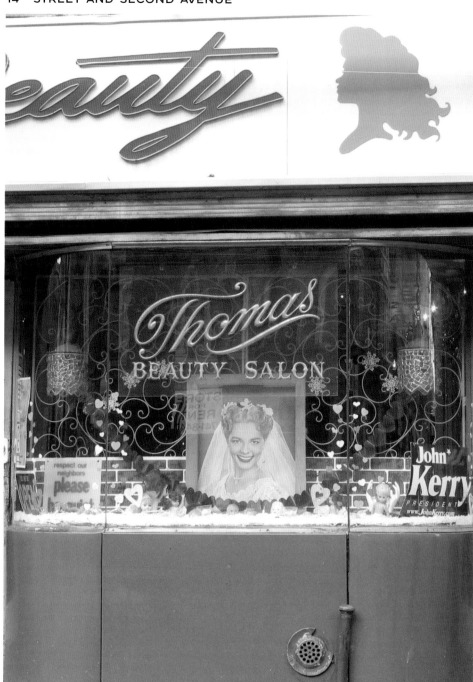

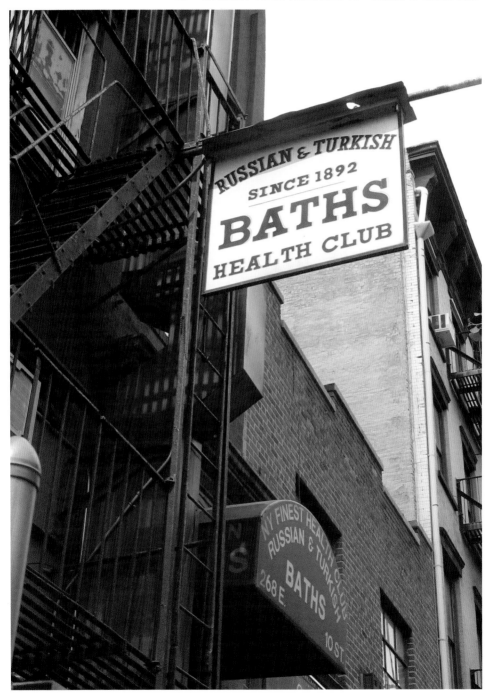

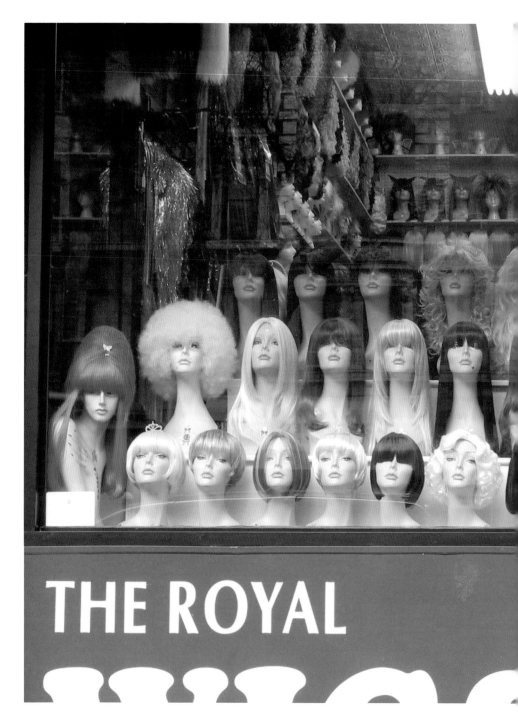

THE ROYAL

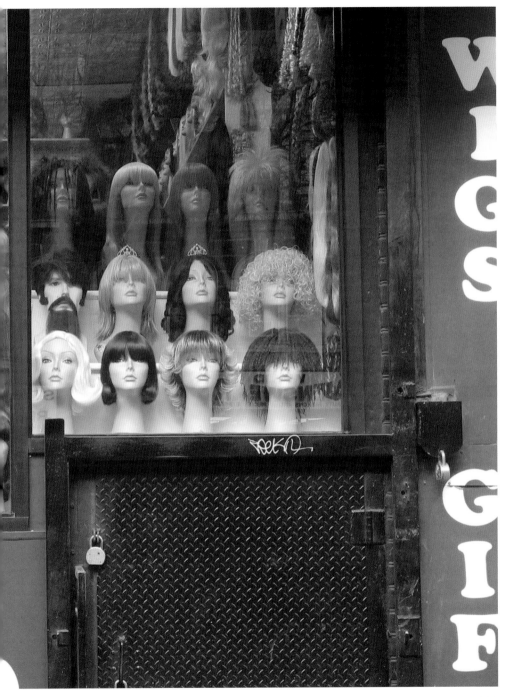

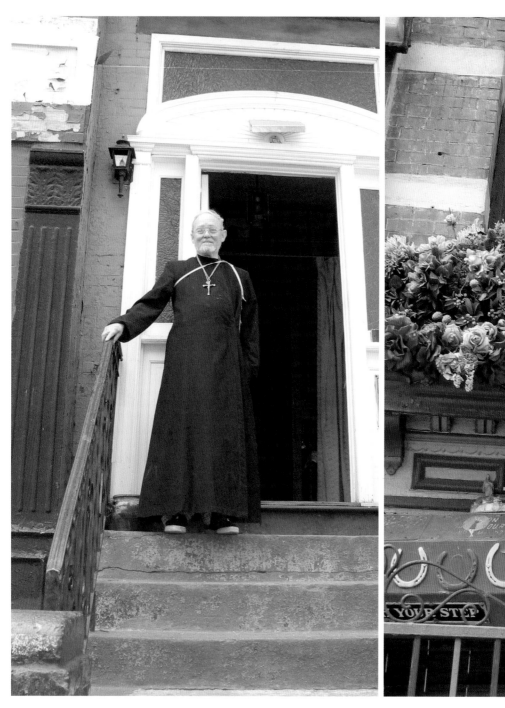

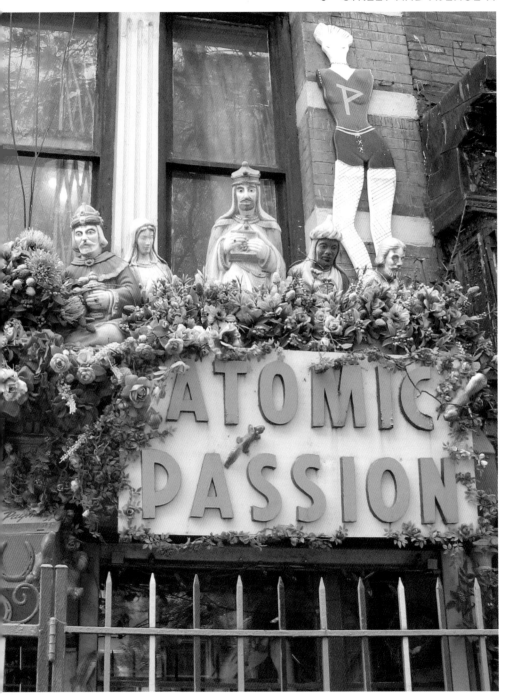

206

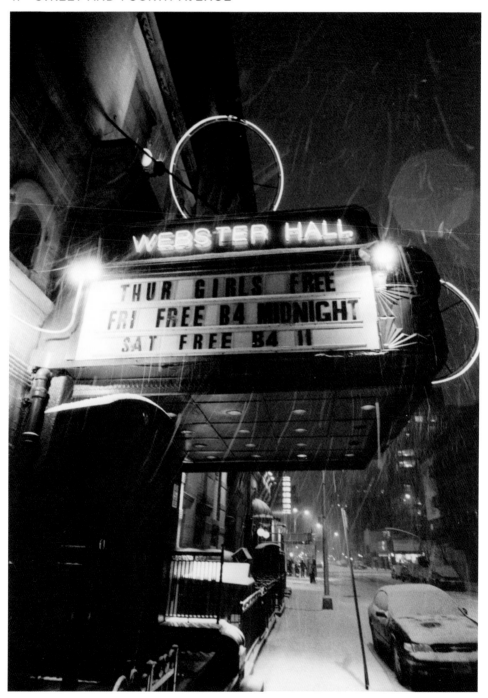

66 No one as yet had approached the management of New York in a proper spirit; that is to say, regarding it as the shiftless outcome of squalid barbarism and reckless extravagance.
No one is likely to do so, because reflections on the long narrow pig-trough are construed as malevolent attacks against the spirit and majesty of the American people, and lead to angry comparisons. **99**

Rudyard Kipling

66 The thing that impressed me then as now about New York . . . was the sharp, and at the same time immense, contrast it showed between the dull and the shrewd, the strong and the weak, the rich and the poor, the wise and the ignorant . . . the strong, or those who ultimately dominated, were so very strong, and the weak so very, very weak—and so very, very many. 99

Theodore Dreiser

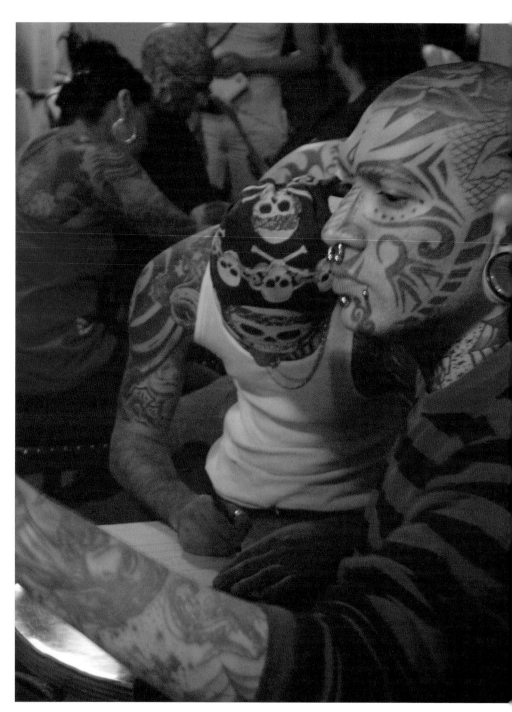

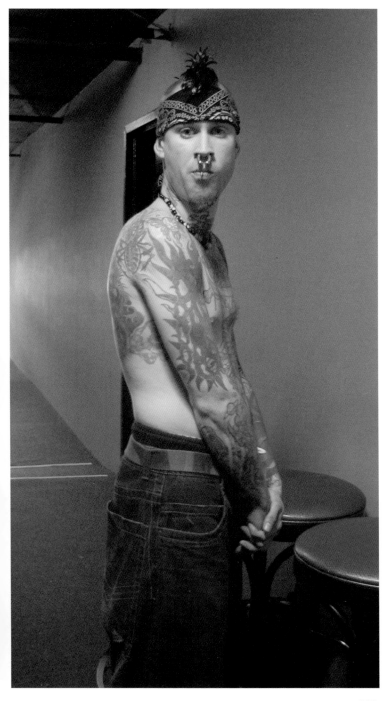

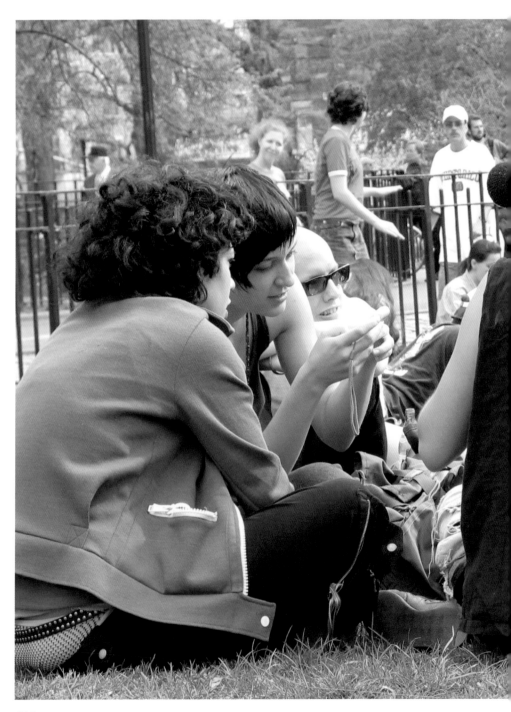

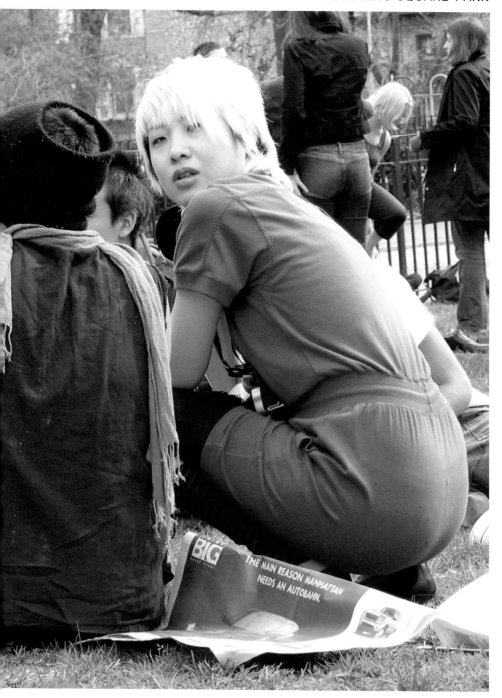

THE MAIN REASON MANHATTAN
NEEDS AN AUTOBAHN.

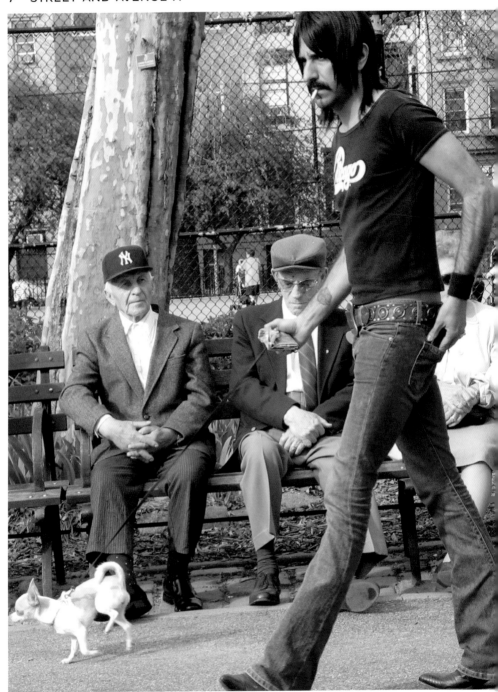

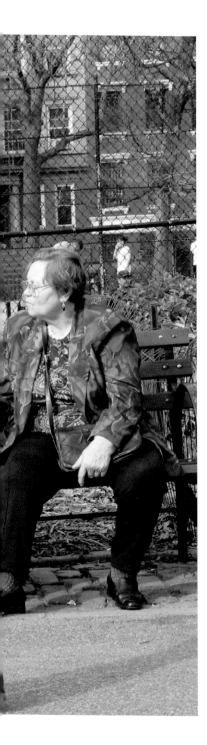

❝ Every person
on the streets
of New York is a type.
The city is one big
theater where
everyone is
on display.**❞**

Jerry Rubin

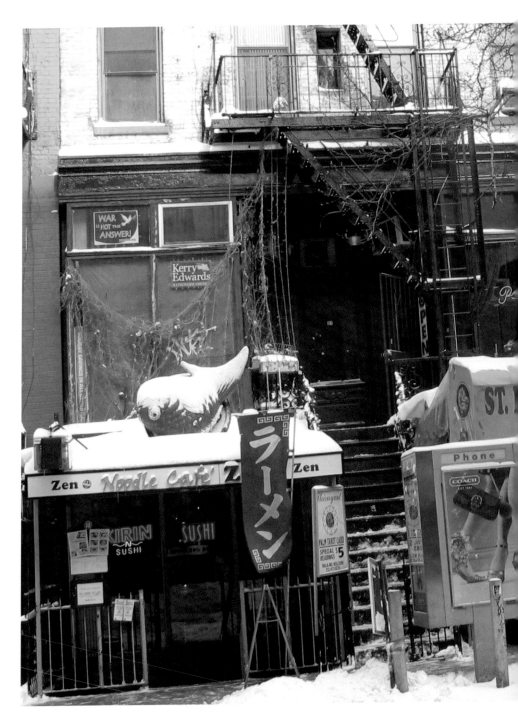

218

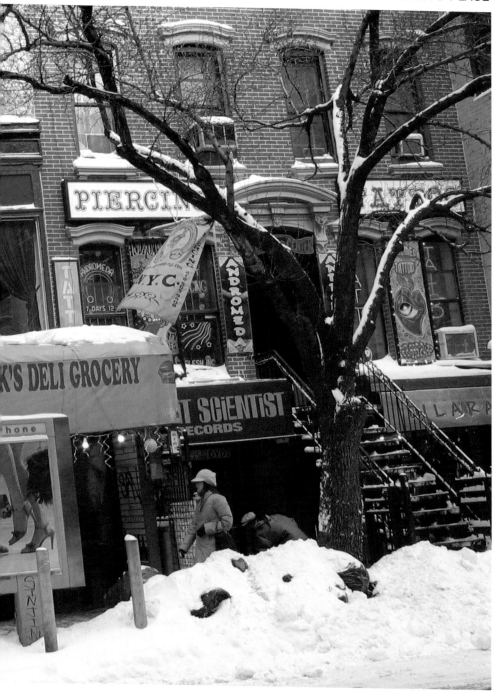

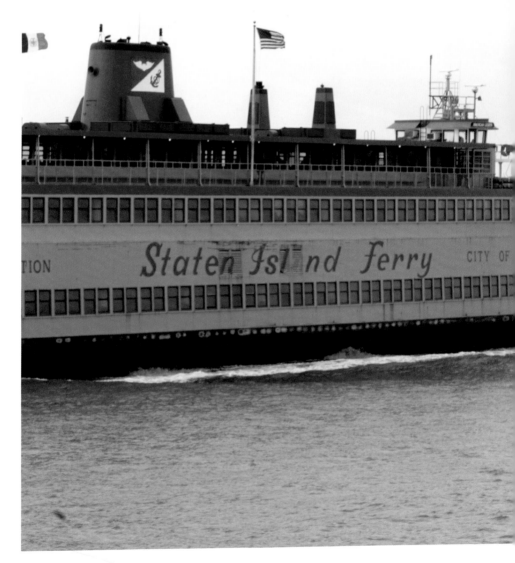

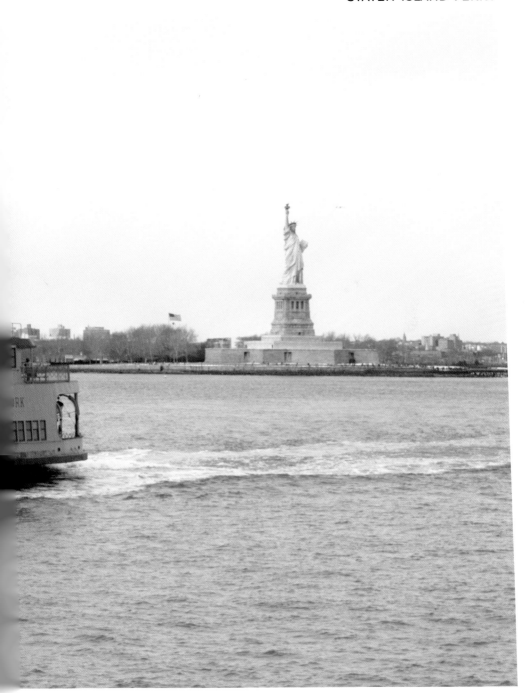

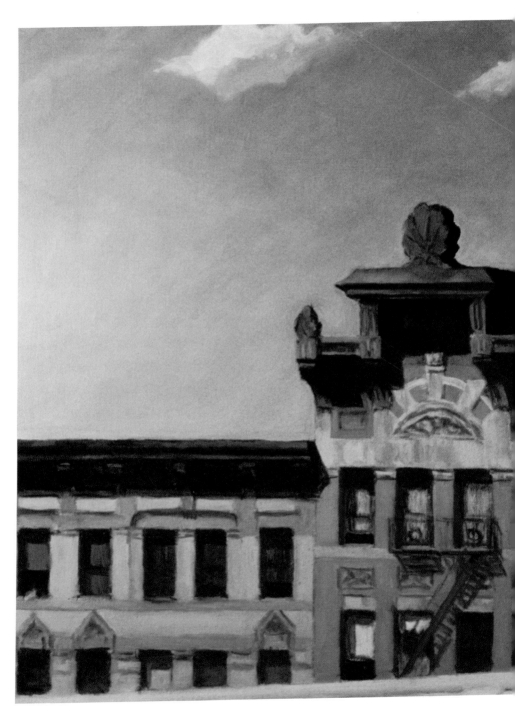

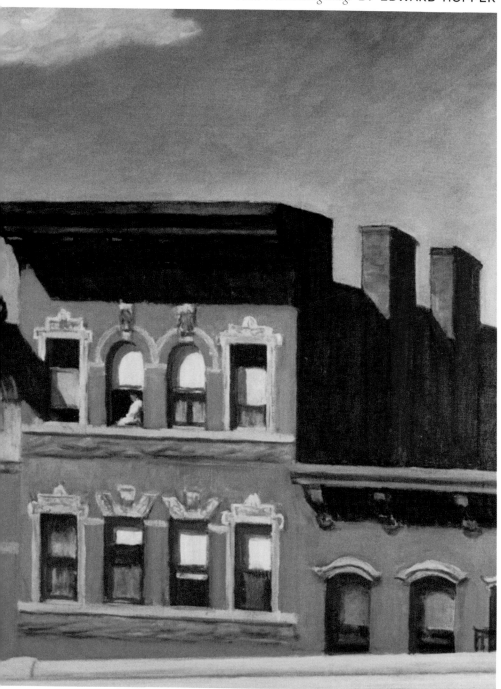

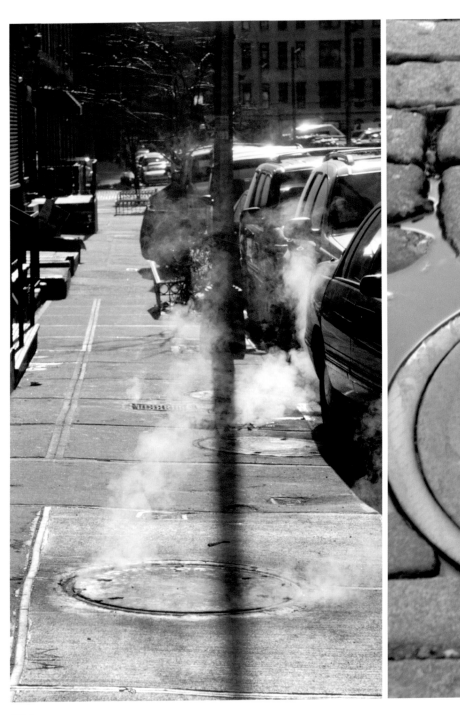

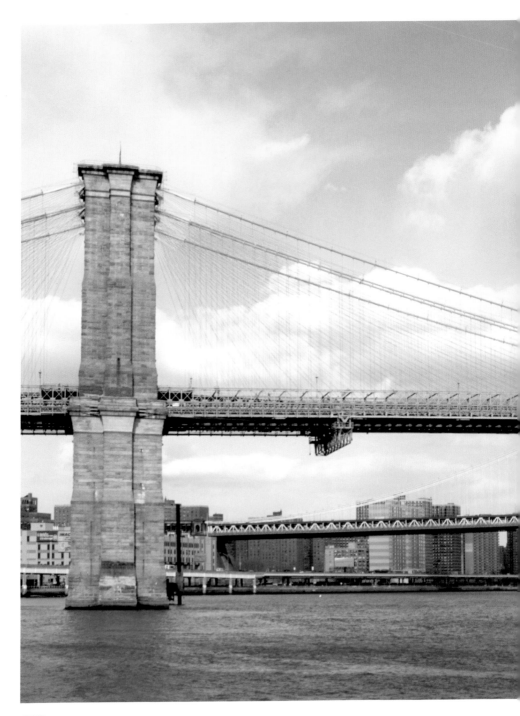

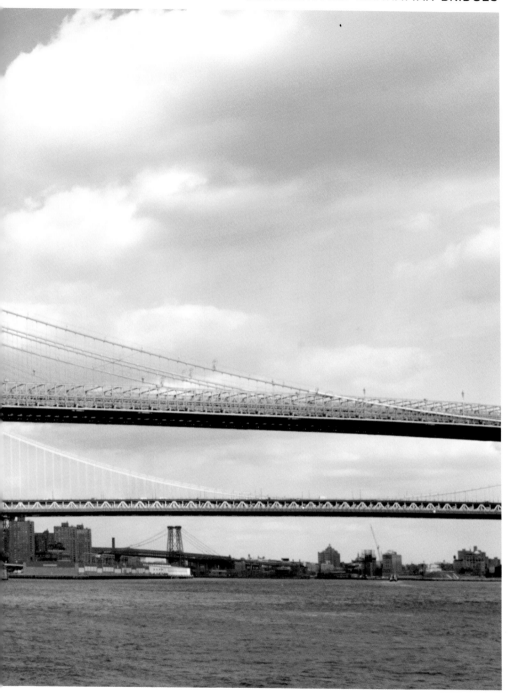

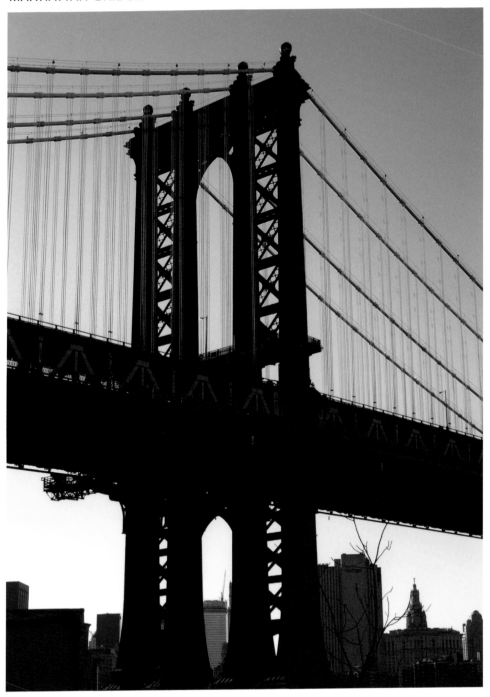

66 You can take a boy
out of Brooklyn,
but you can never get
Brooklyn out of the boy. **99**

W. T. Ballard

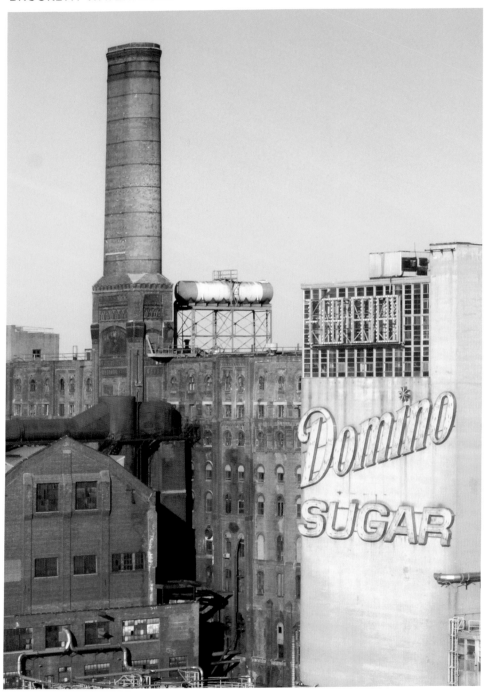

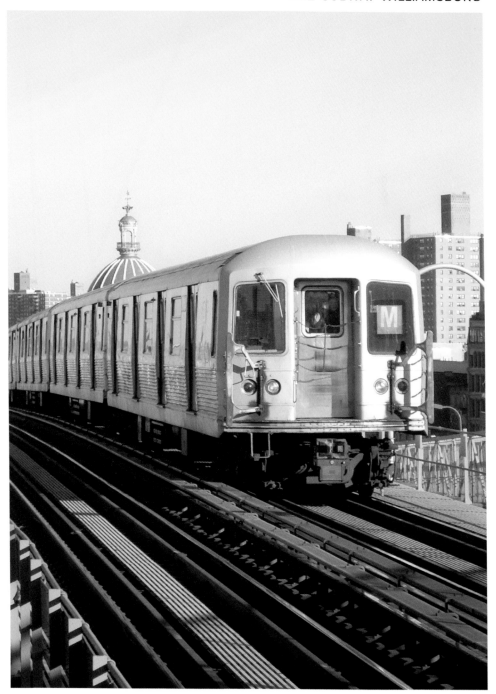

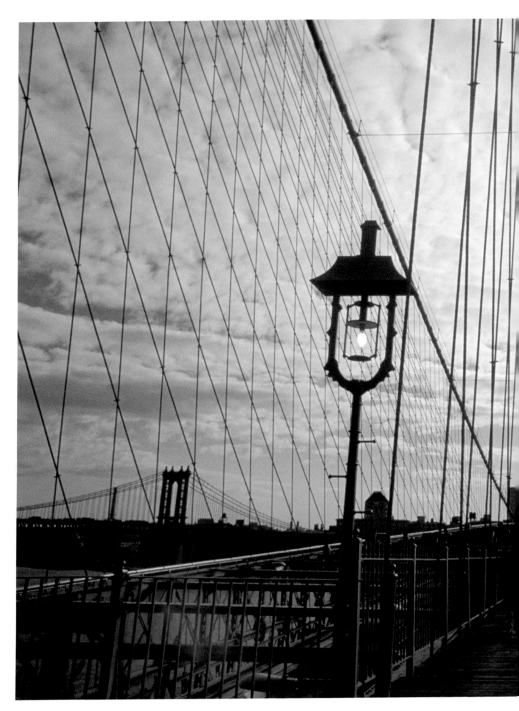

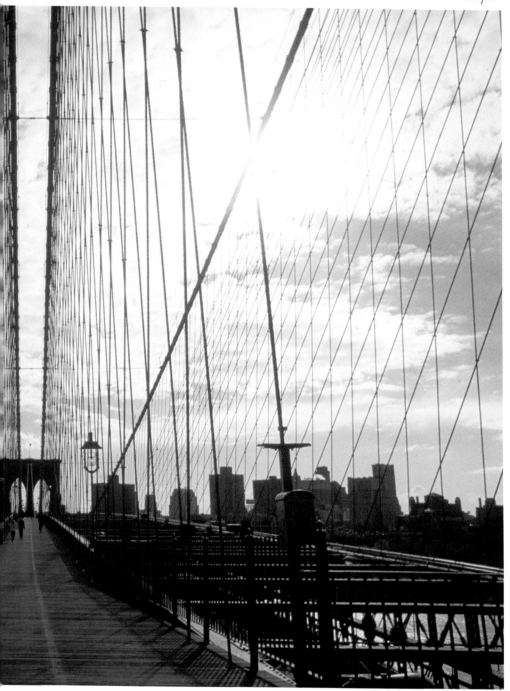

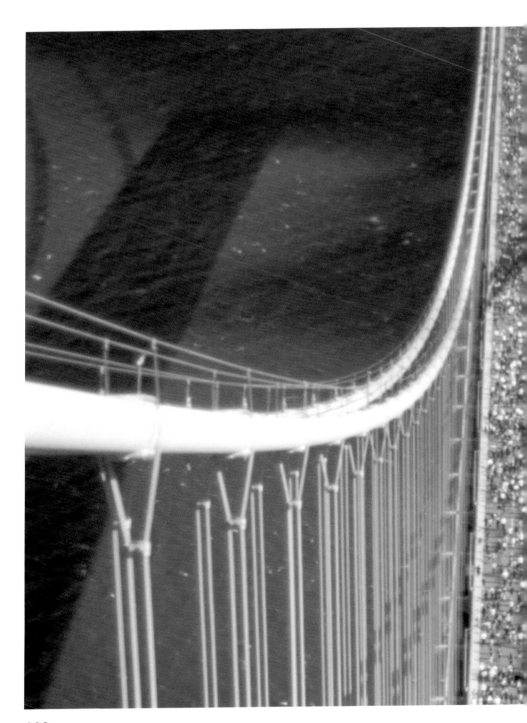

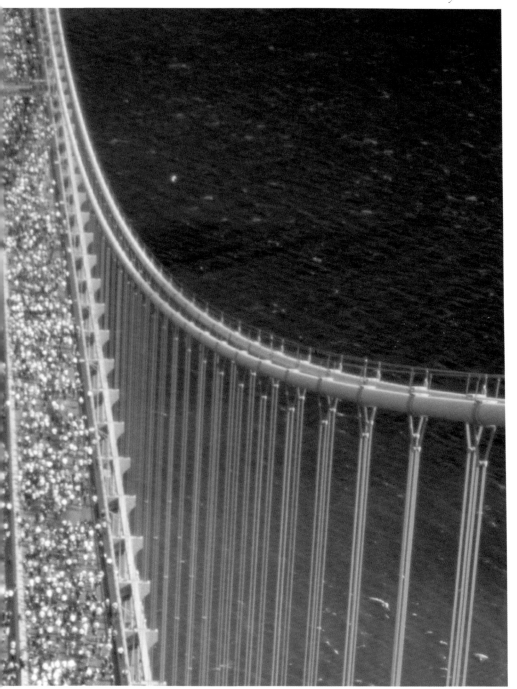

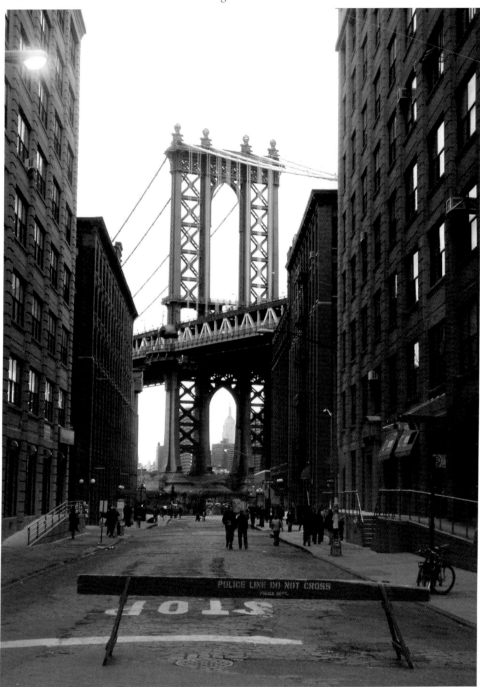

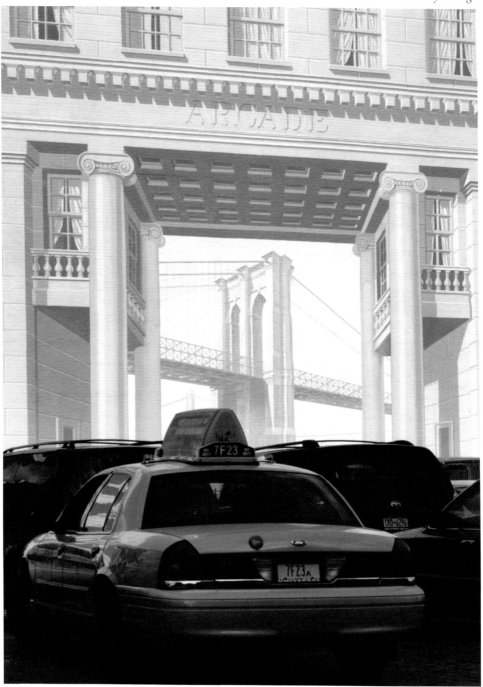

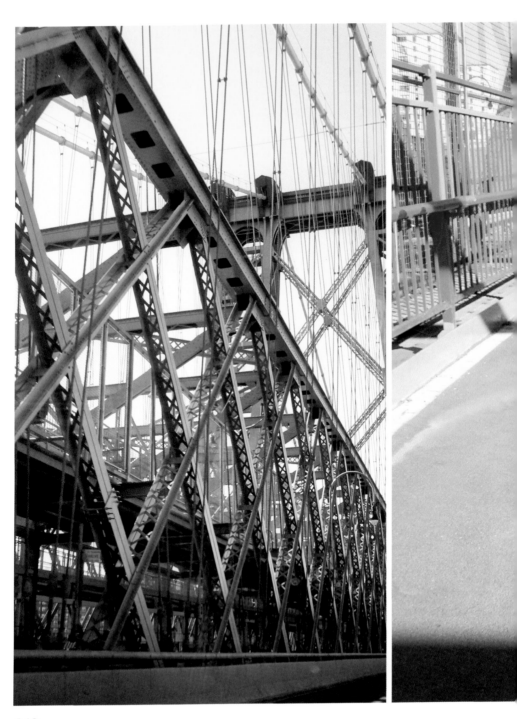

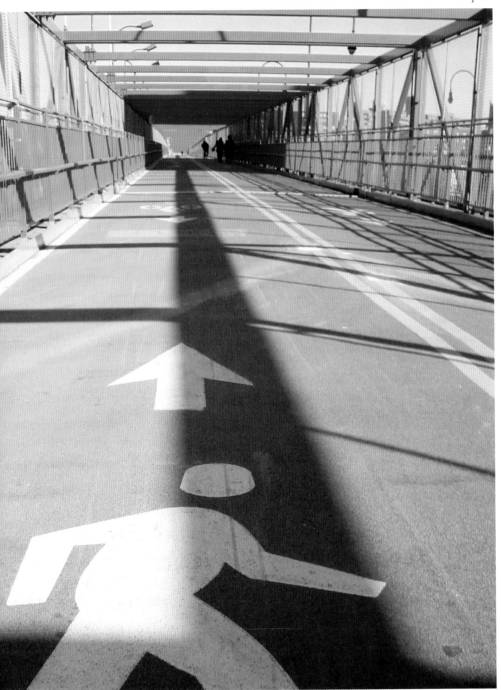

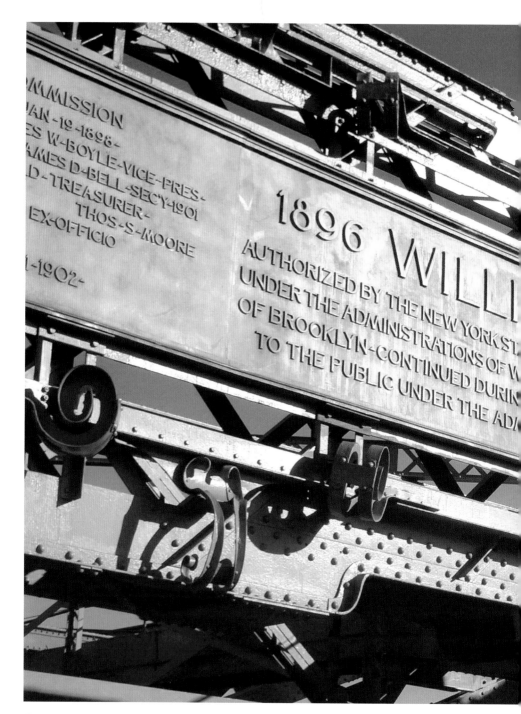

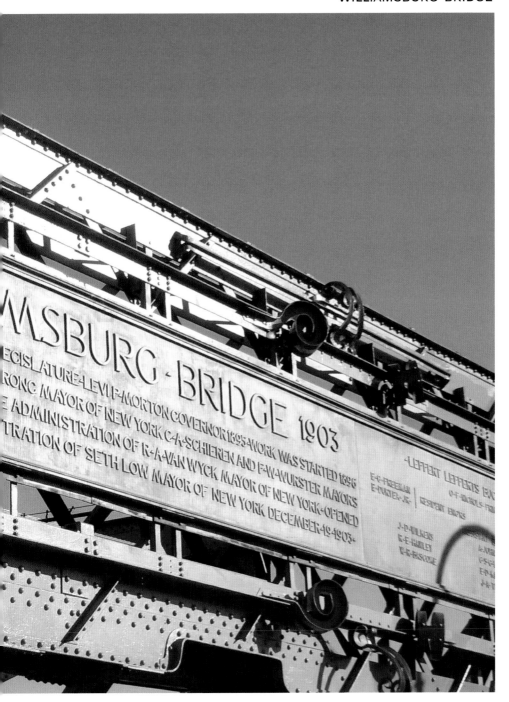

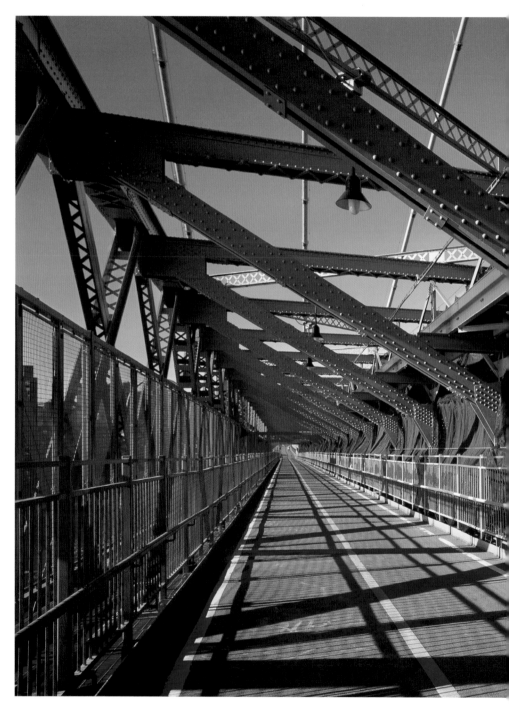

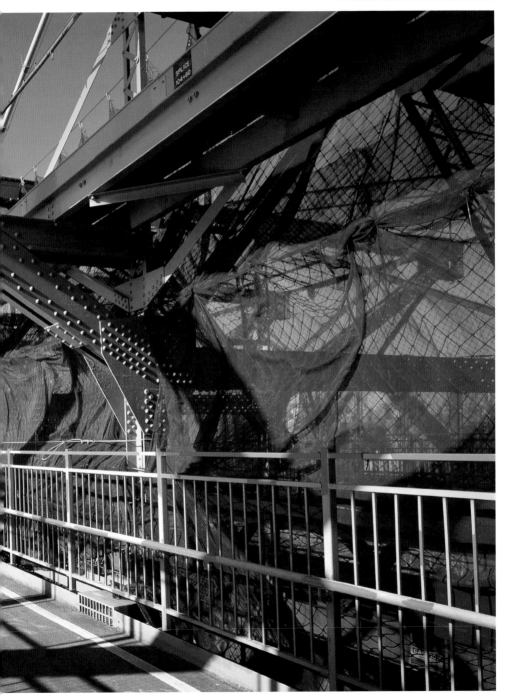

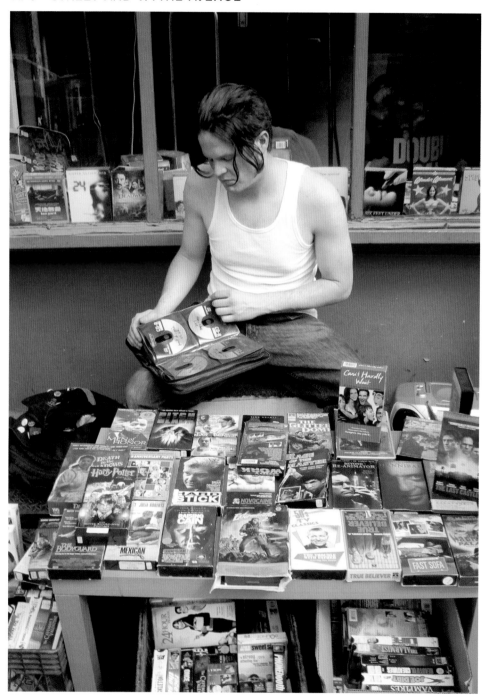

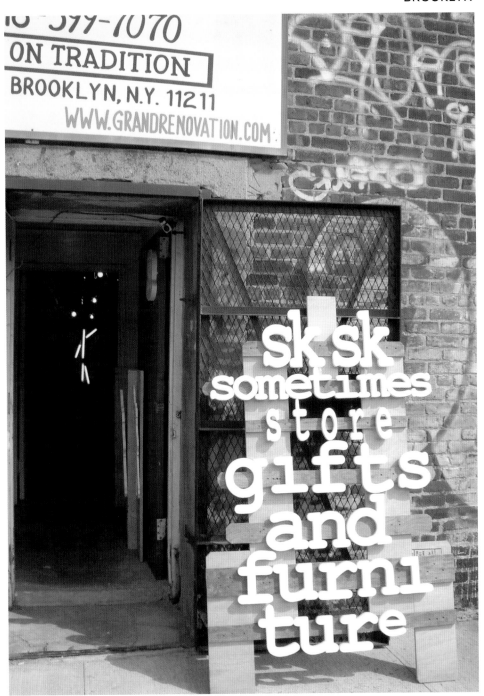

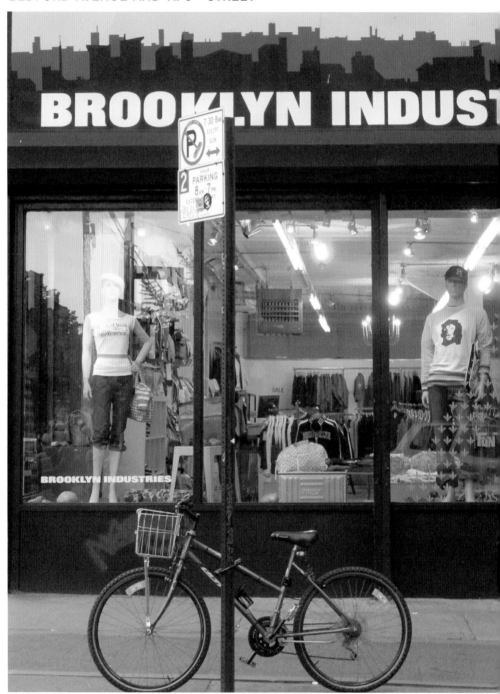

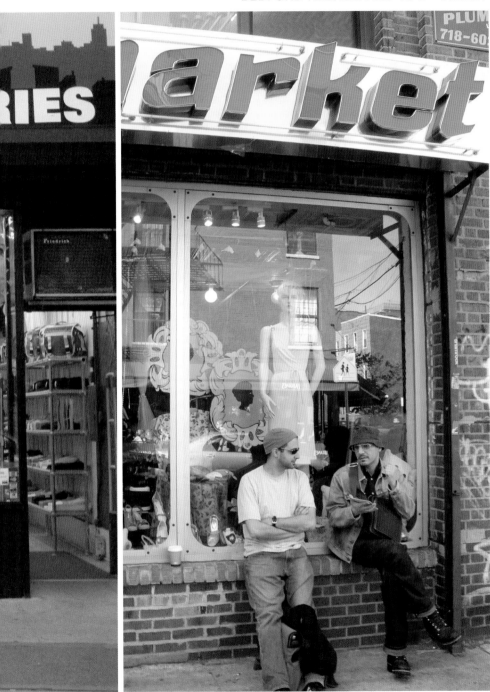

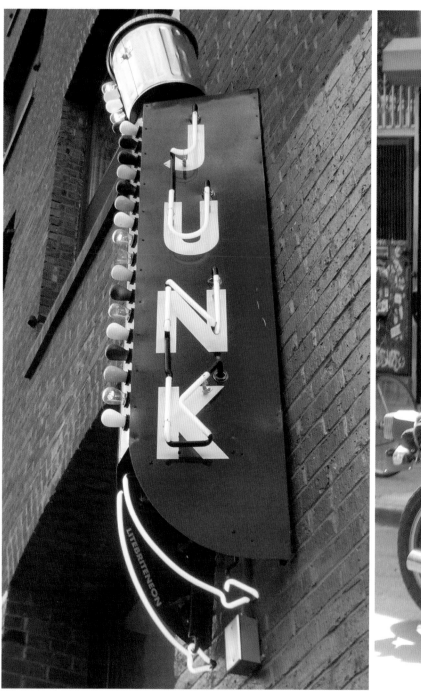

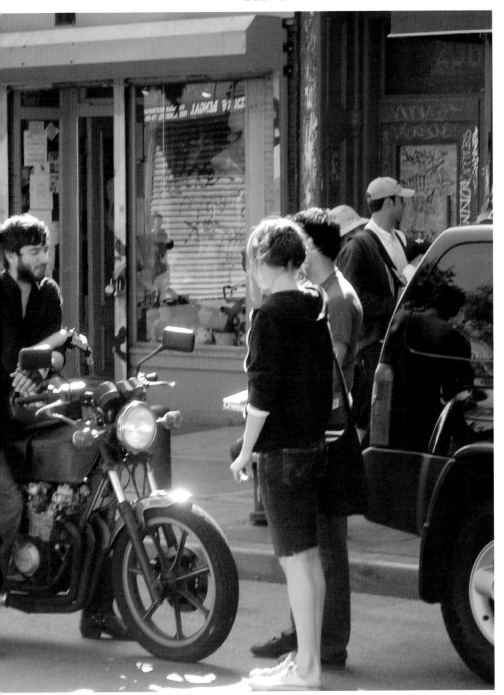

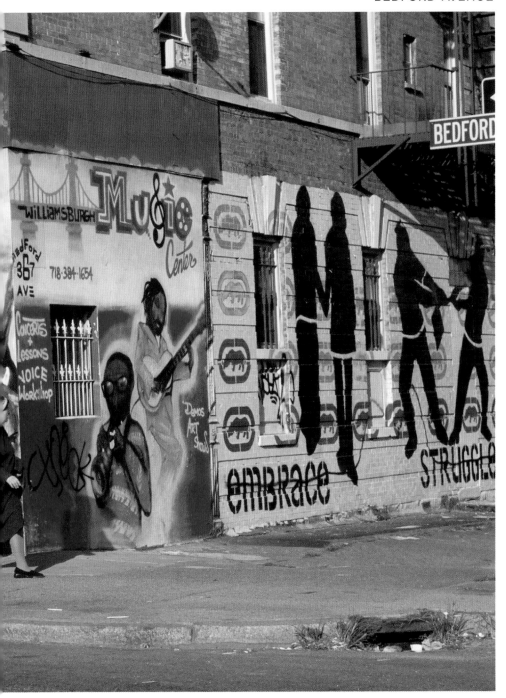

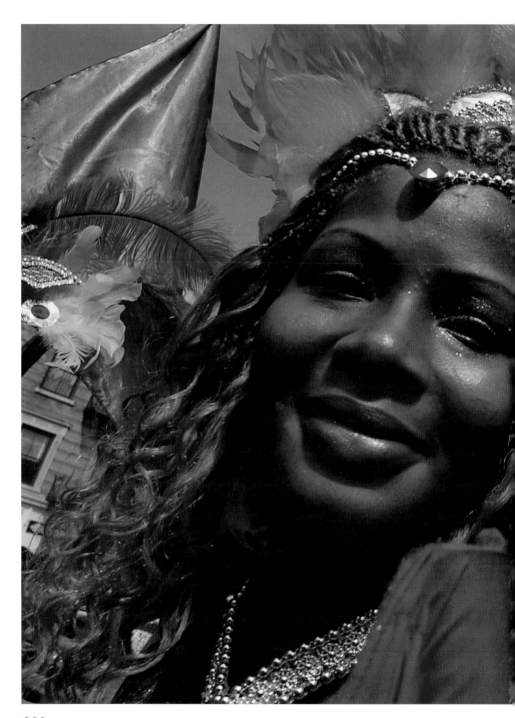

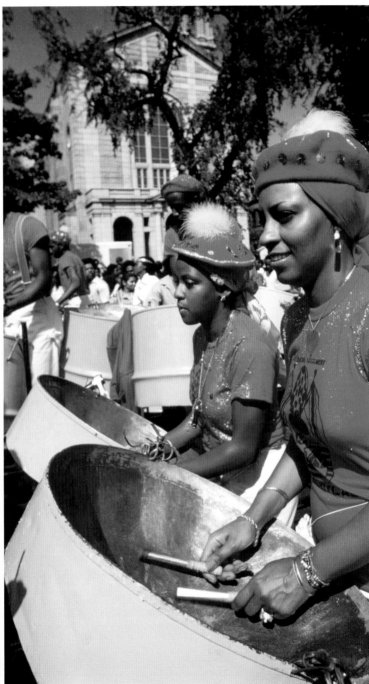

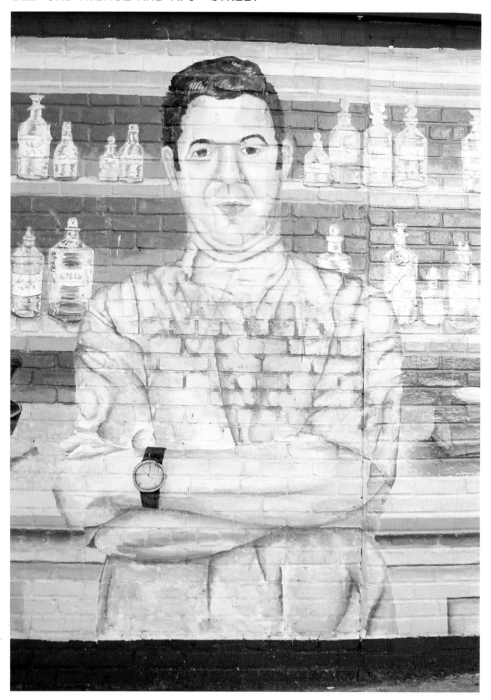

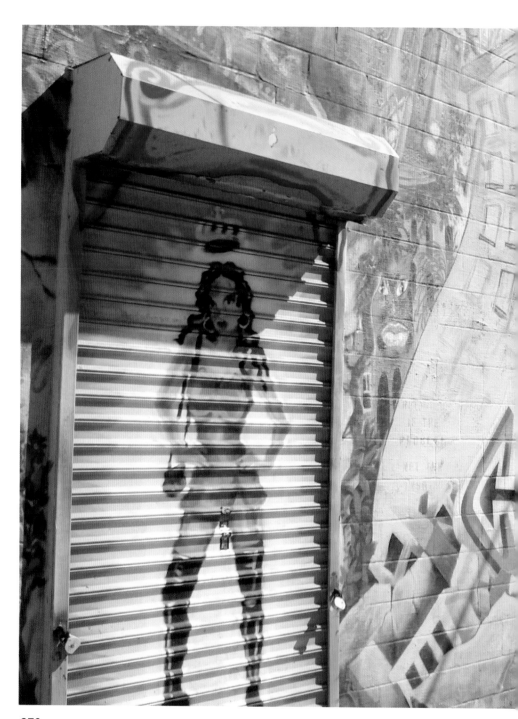

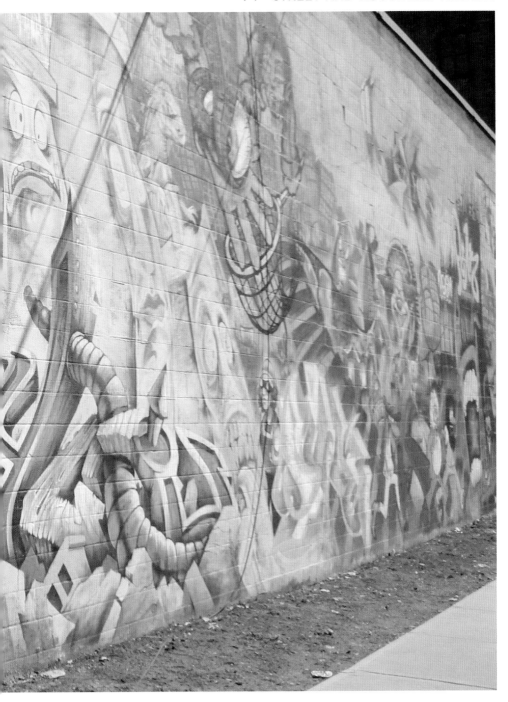

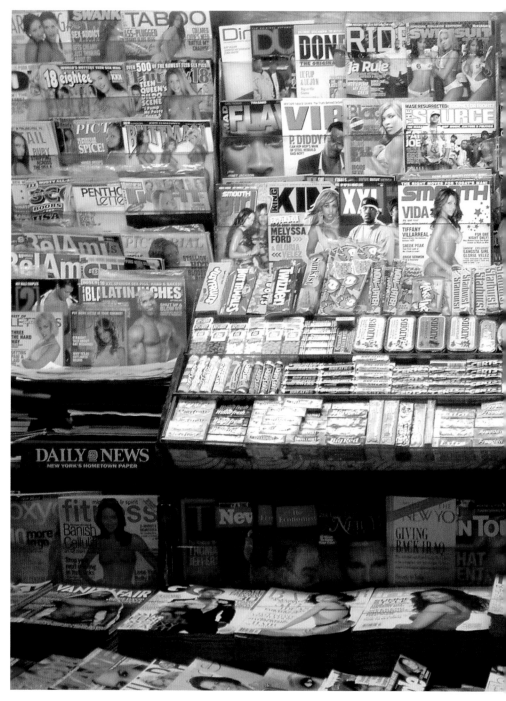

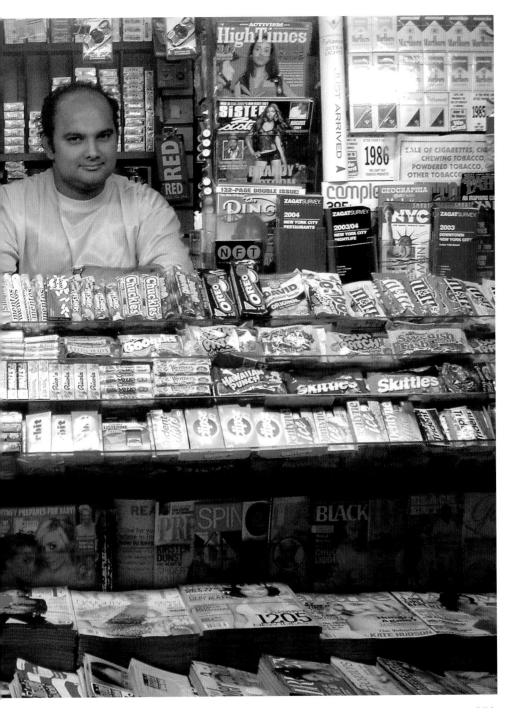

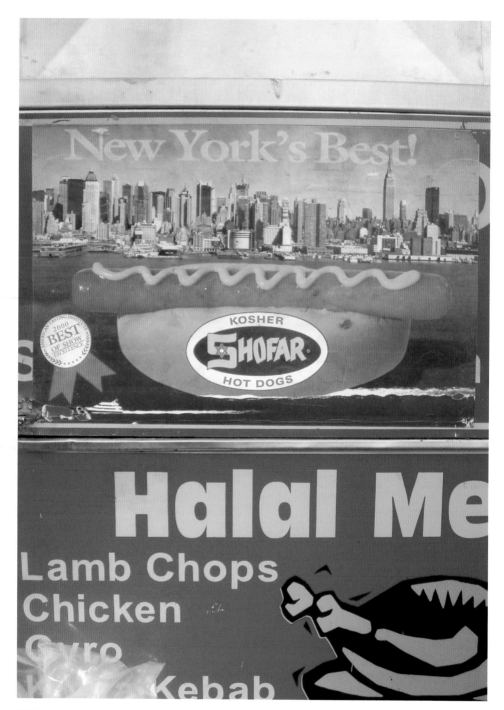

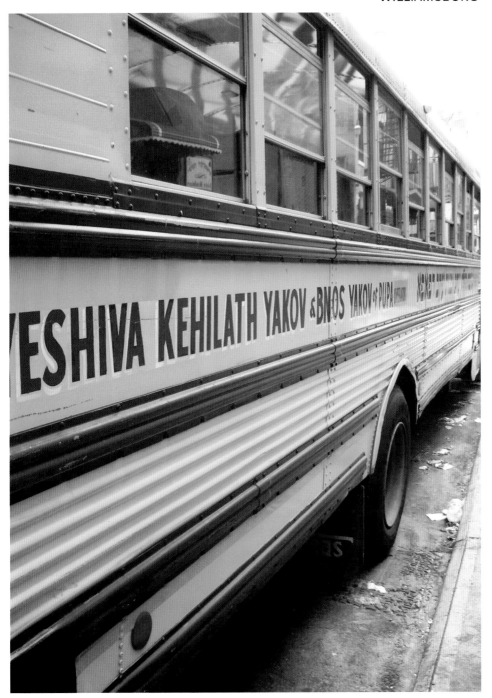

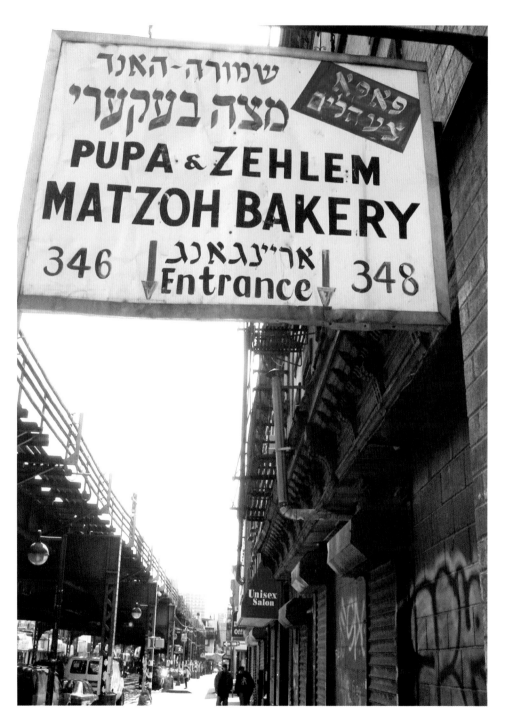

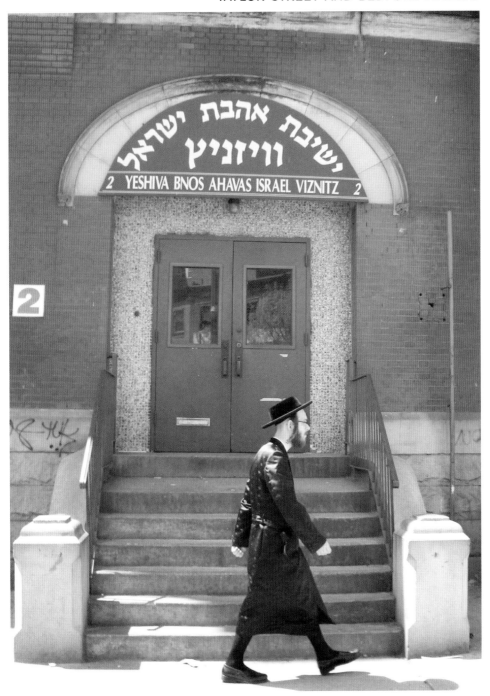

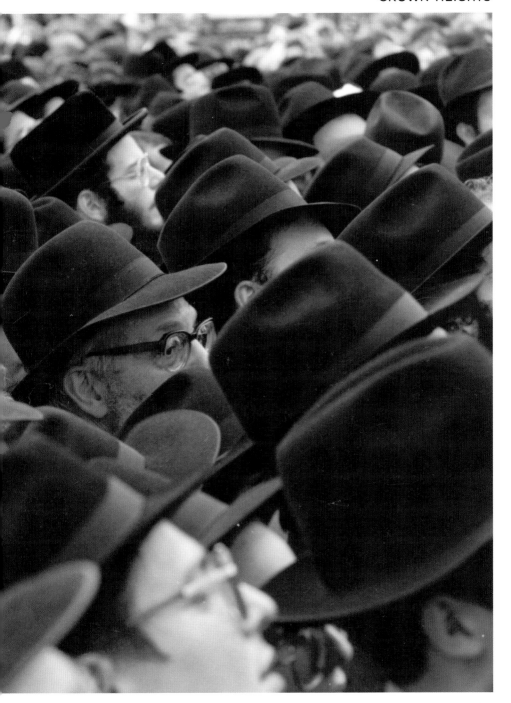

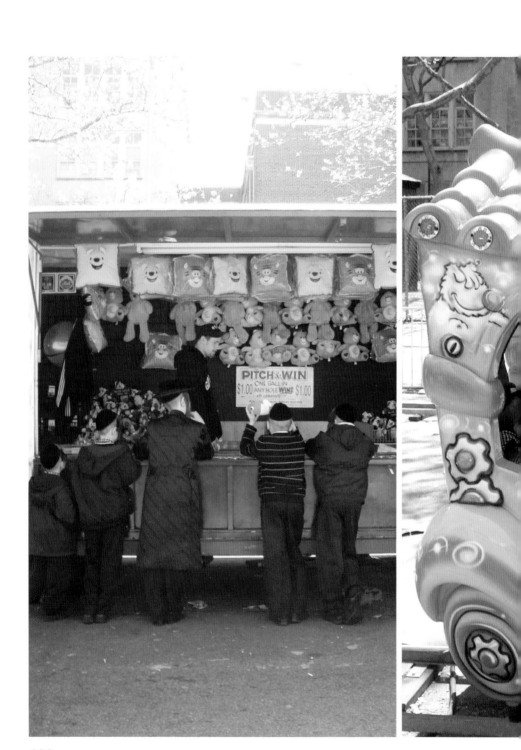

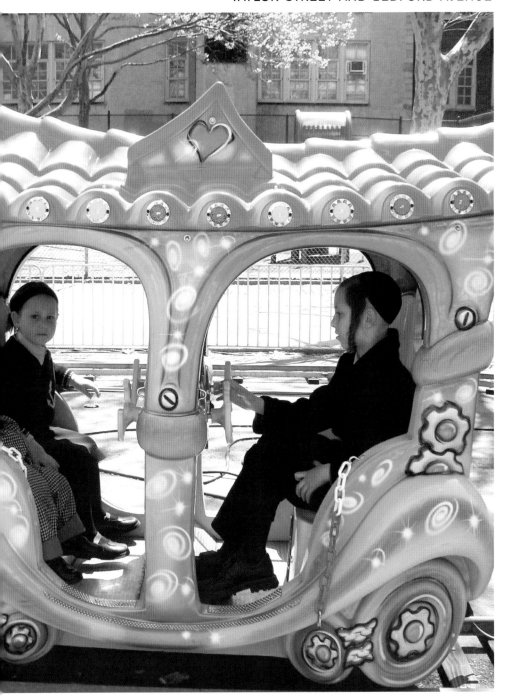

66 When you leave New York, you are astonished at how clean the rest of the world is. Clean is not enough. **99**

Fran Lebowitz

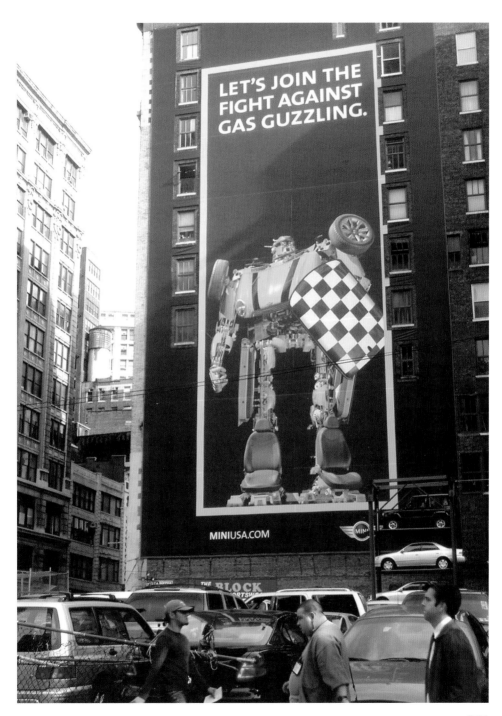

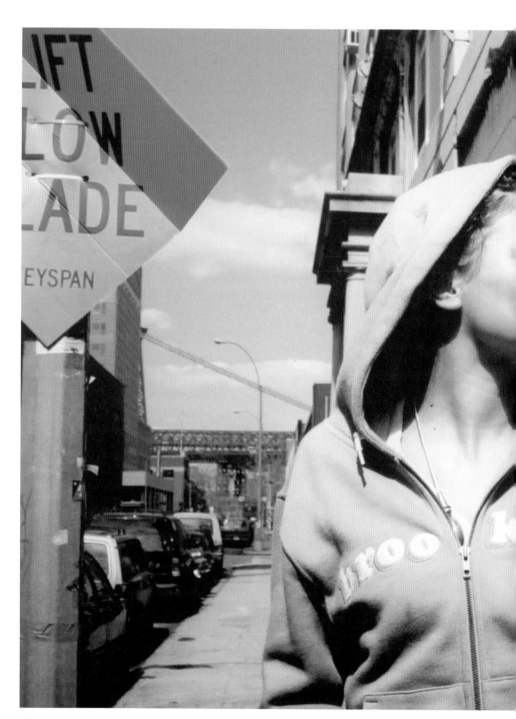

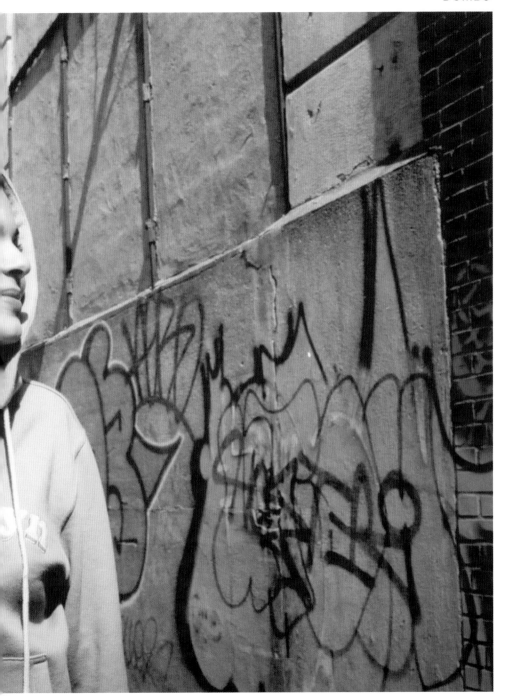

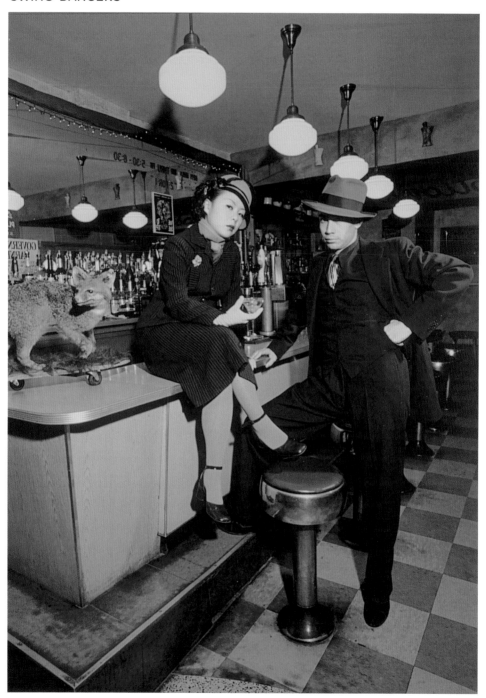

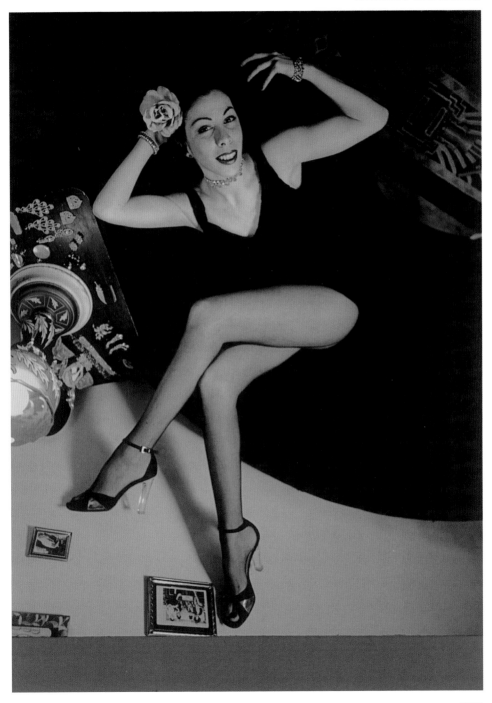

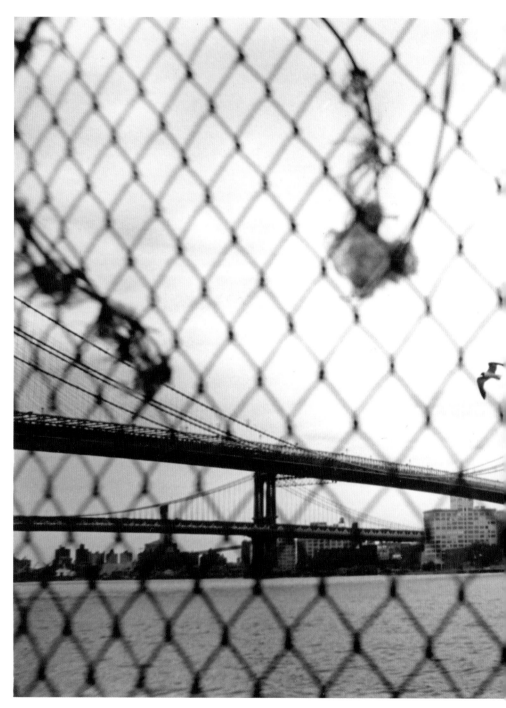

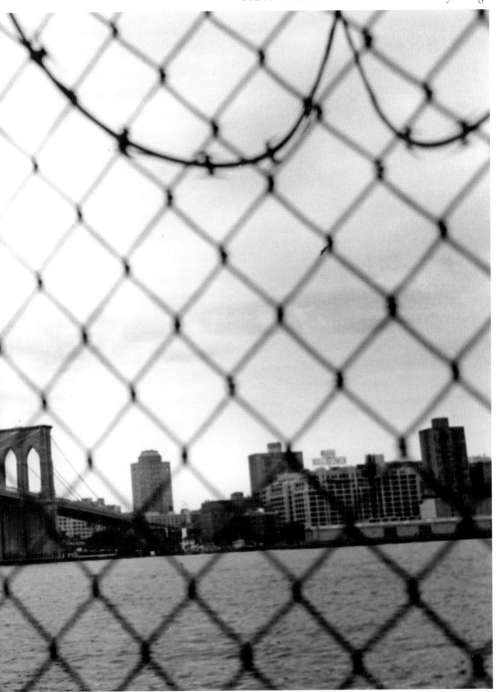

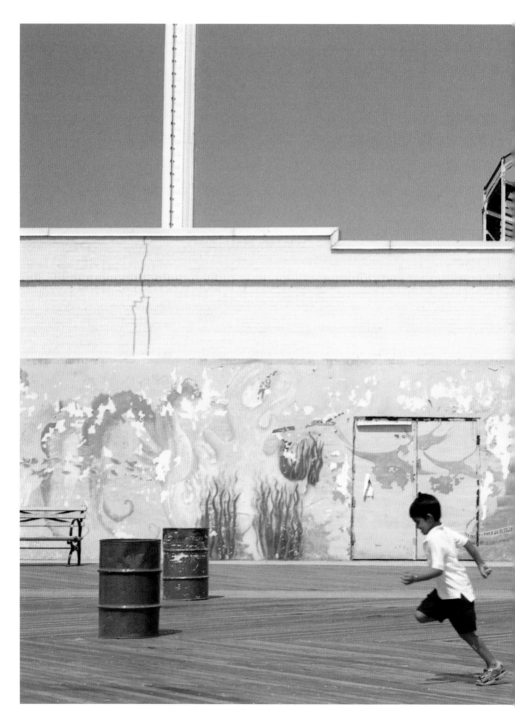

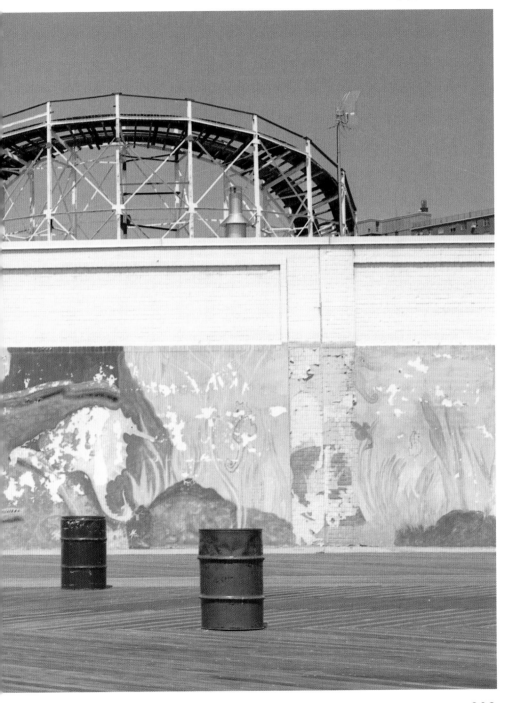

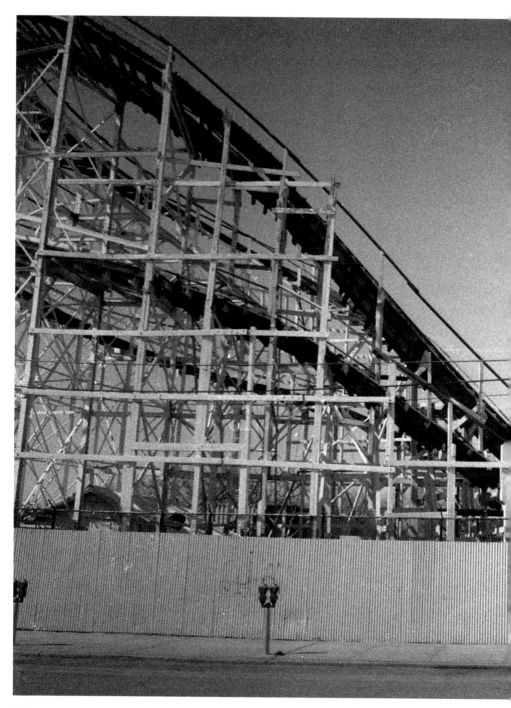

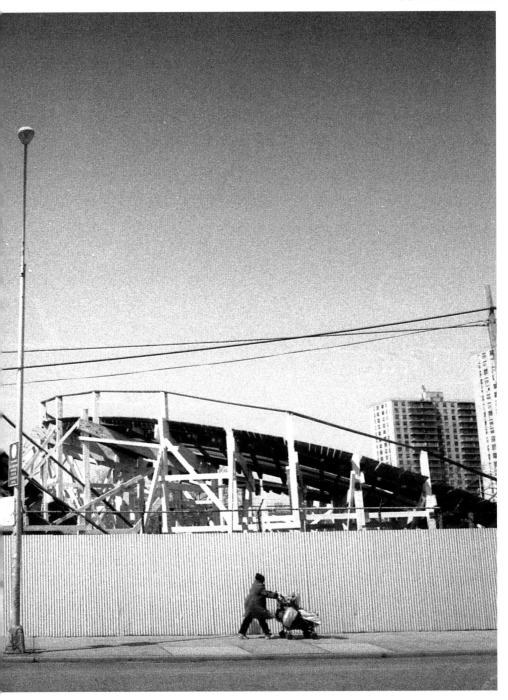

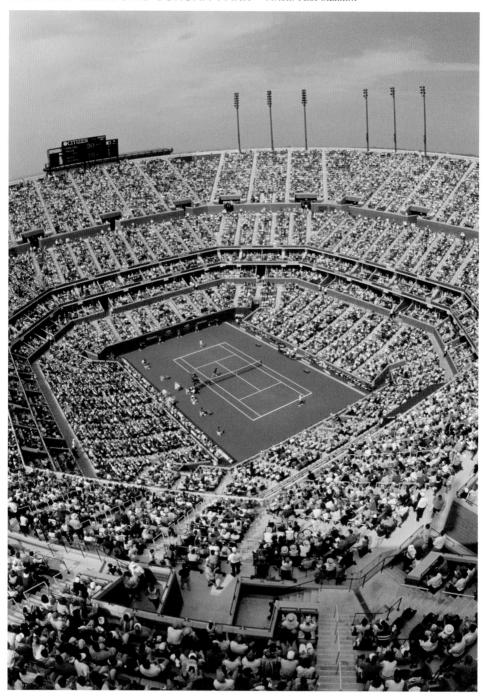

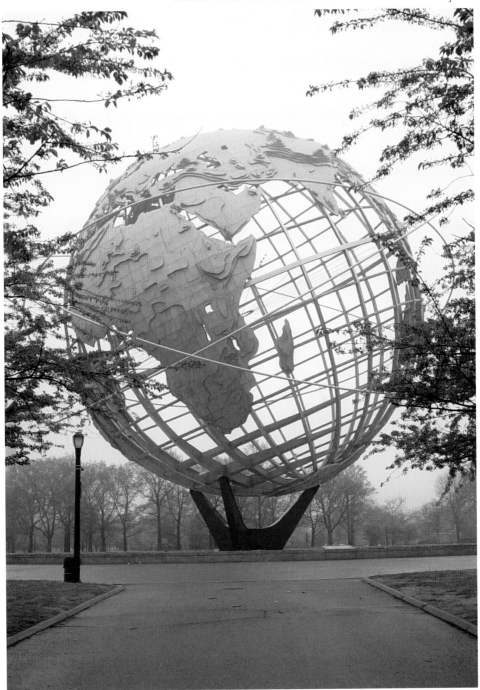

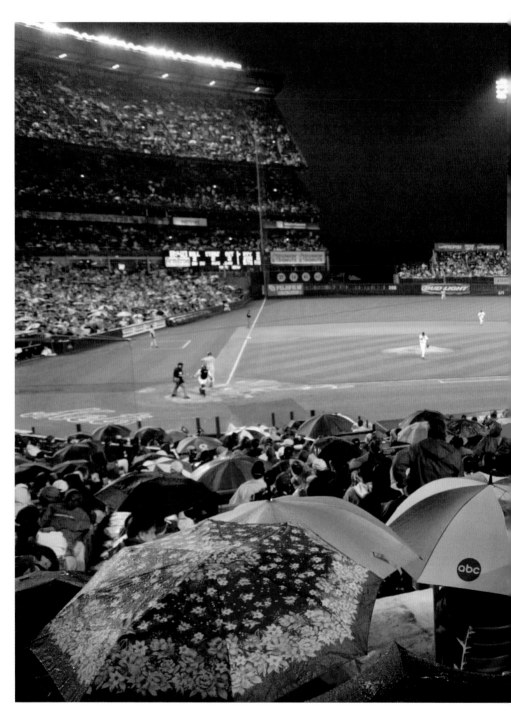

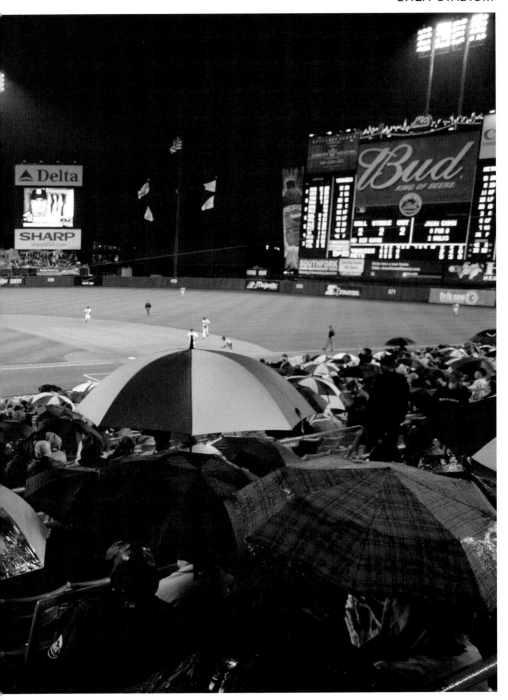

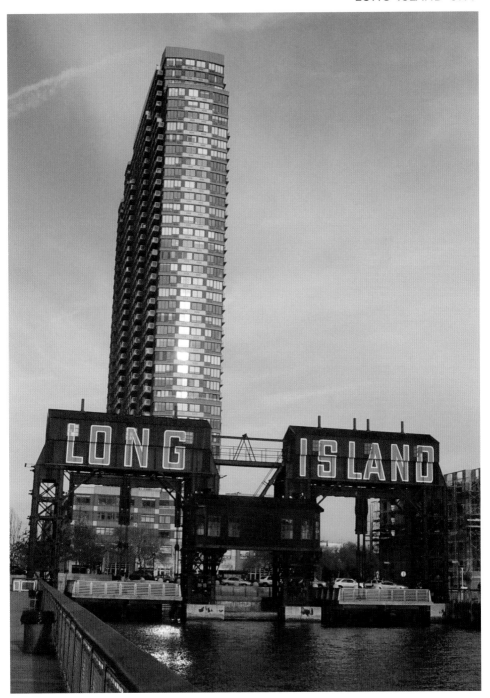

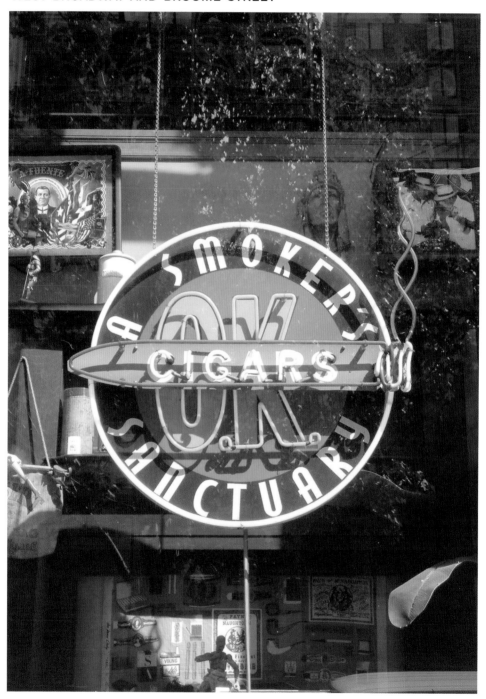

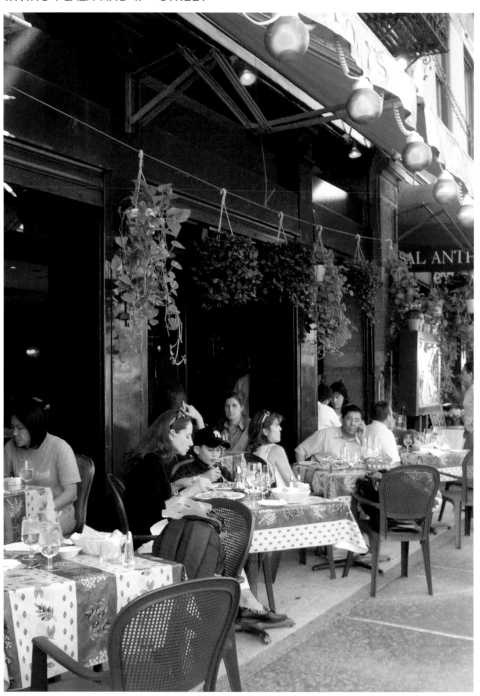

66 It is altogether an extraordinary growing, swarming, glittering, pushing, chattering, good-natured, cosmopolitan place, and perhaps in some ways the best imitation of Paris that can be found (with a great originality of its own).**99**

Henry James

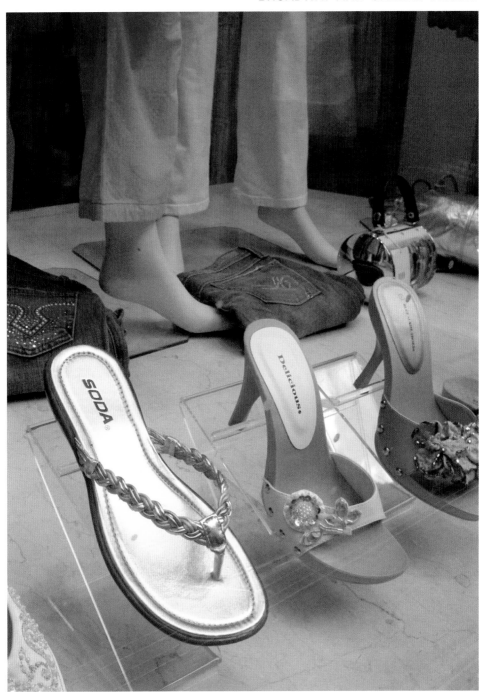

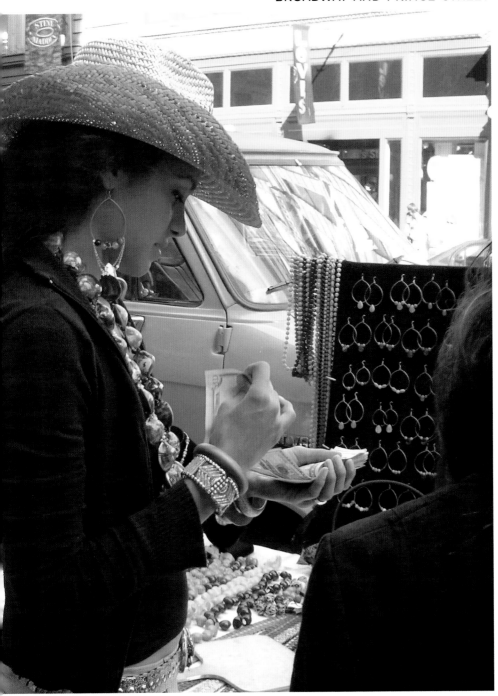

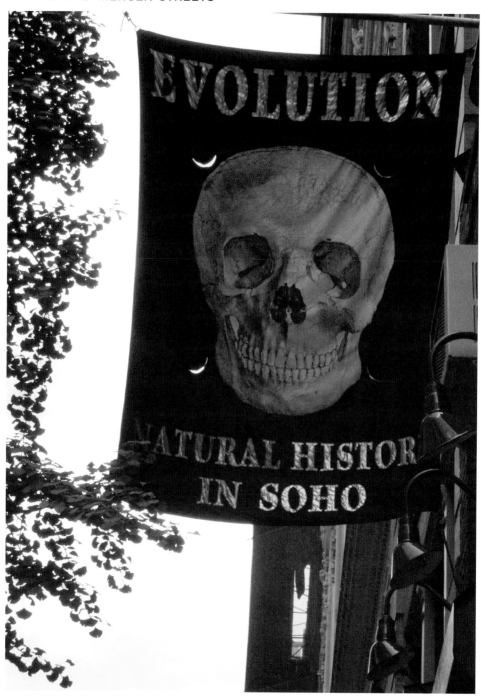

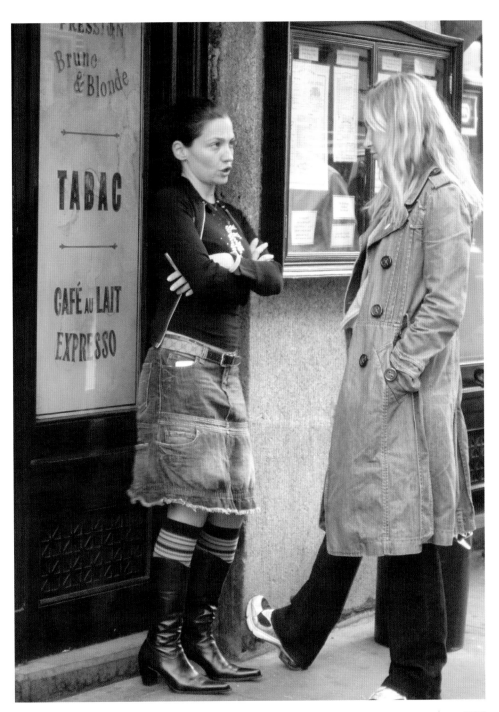

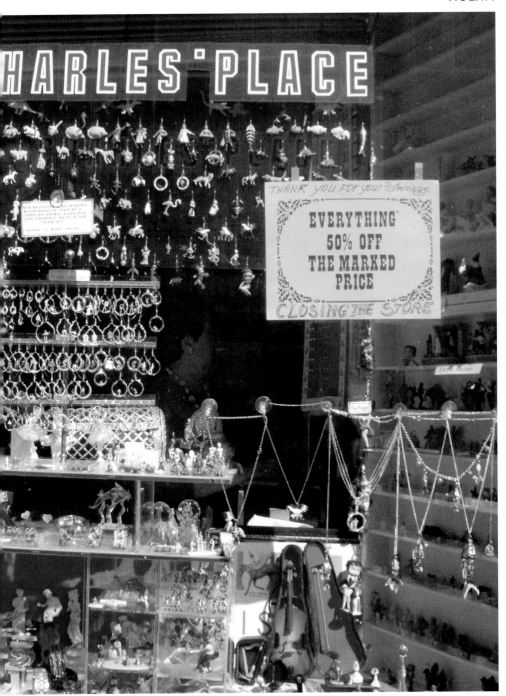

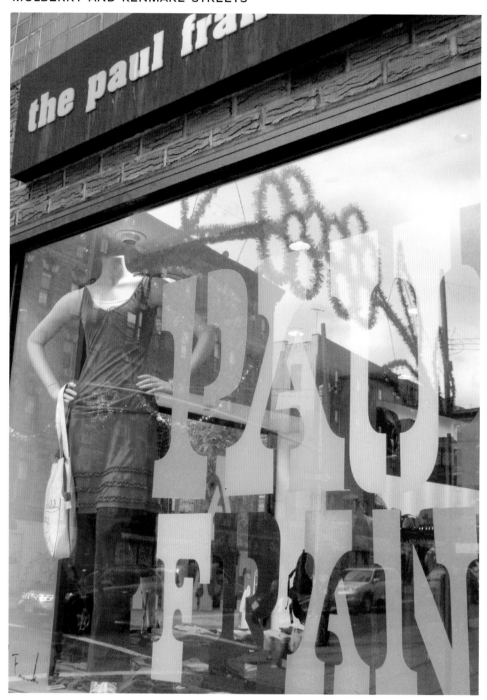

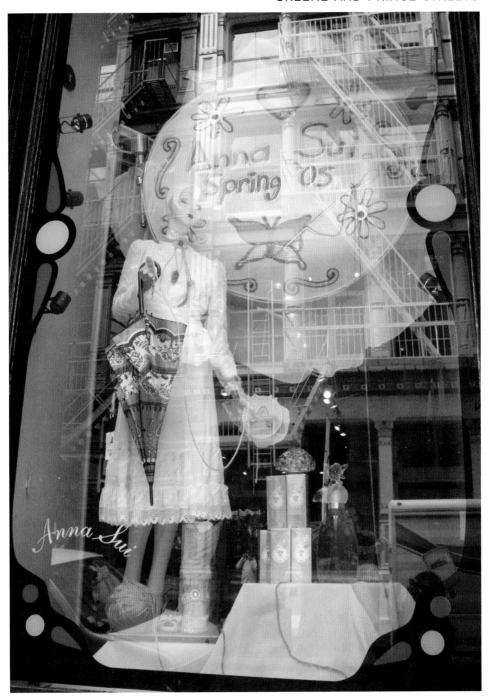

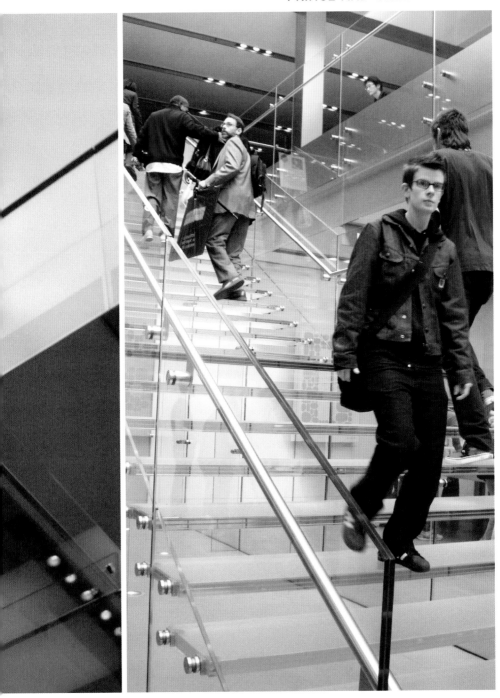

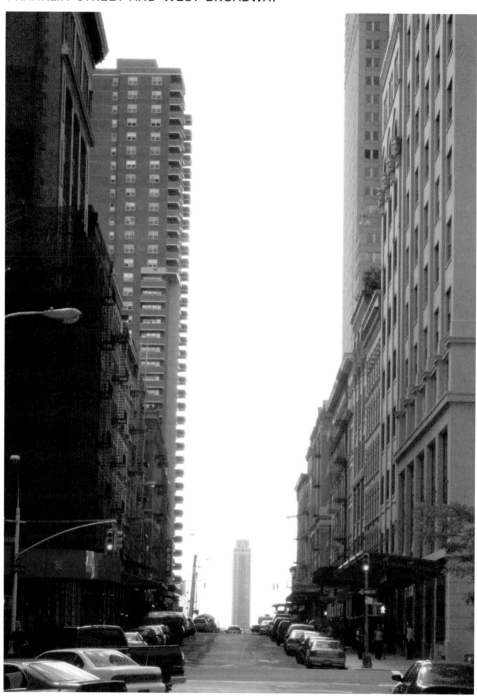

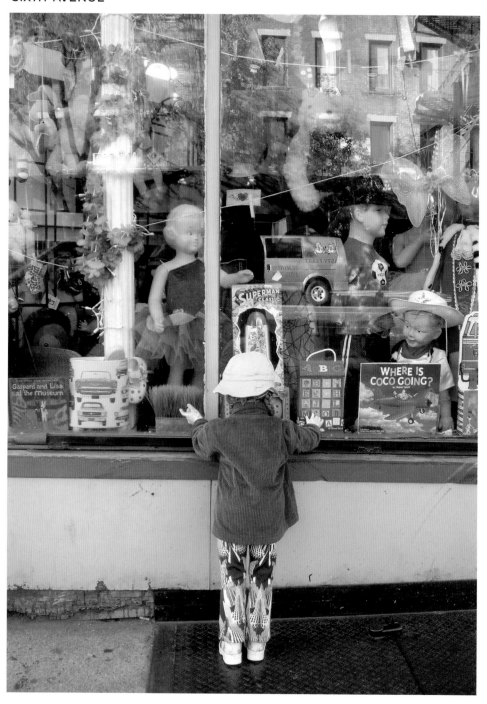

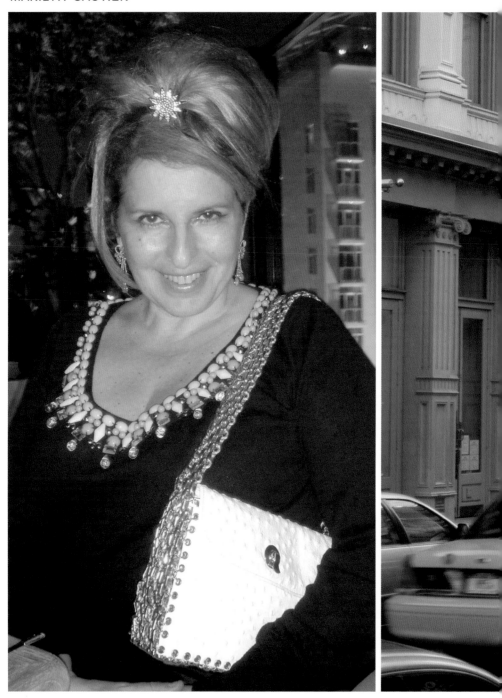

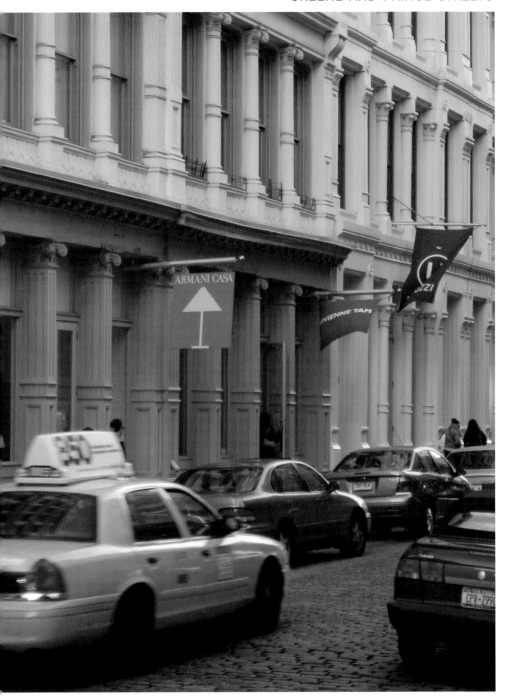

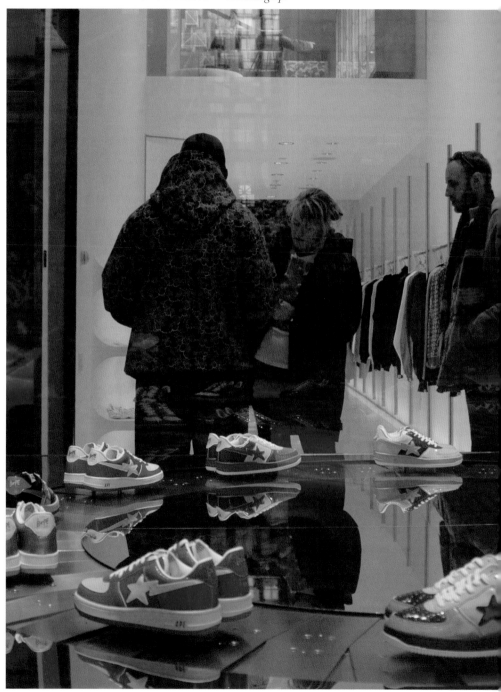

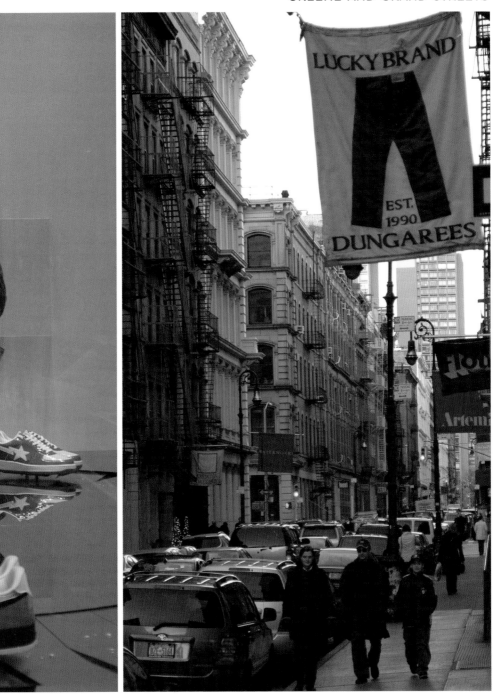

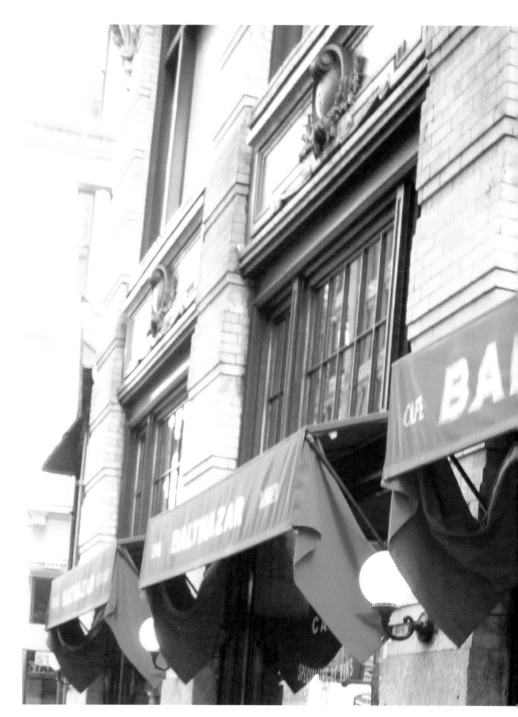

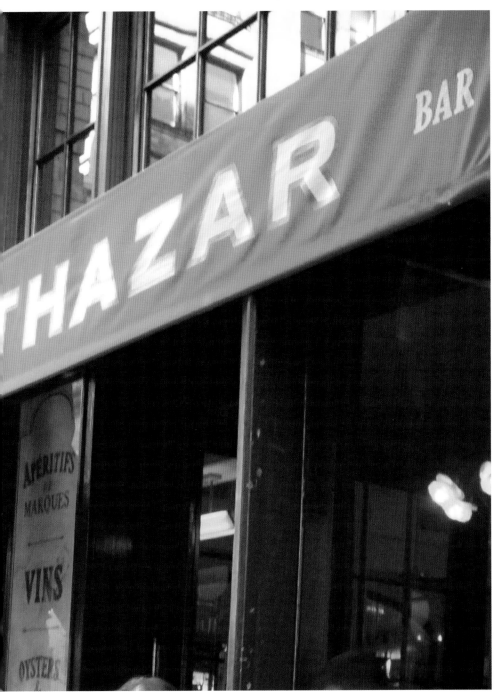

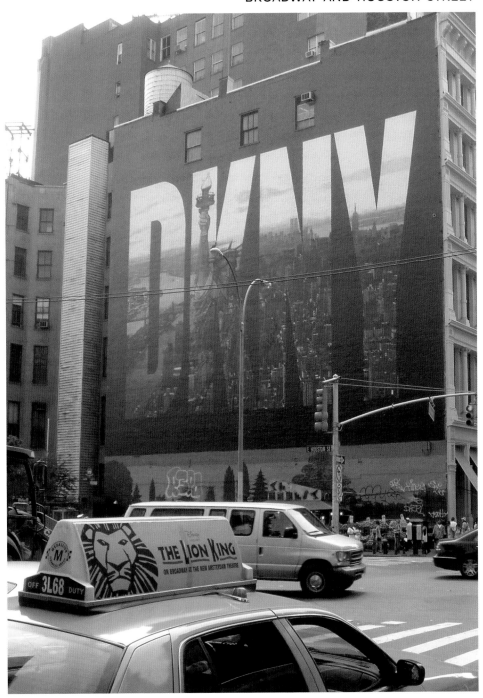

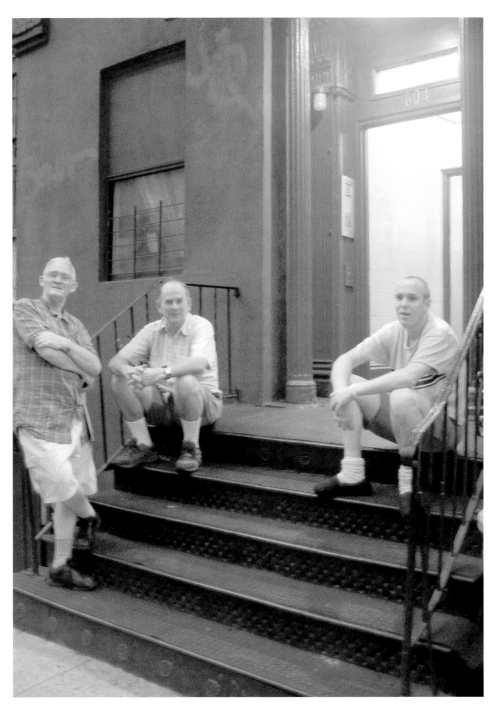

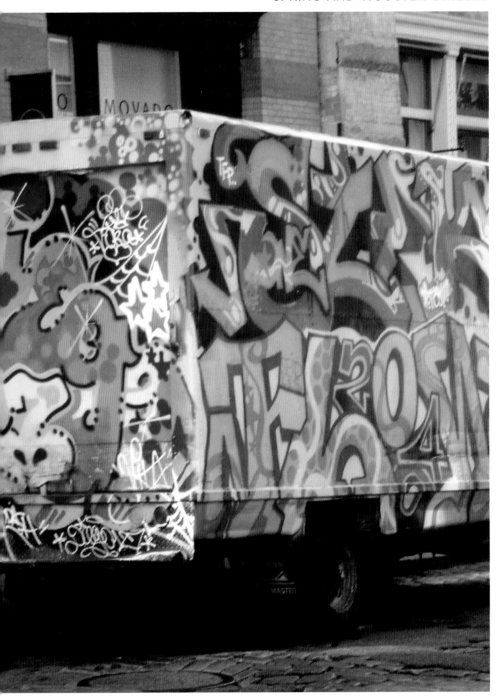

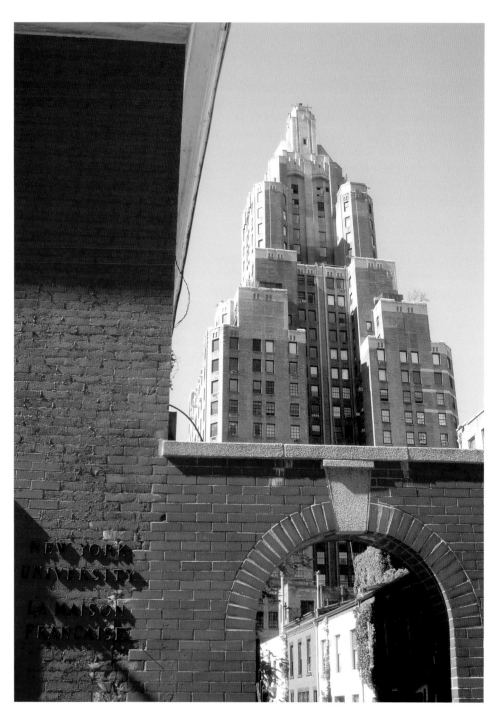

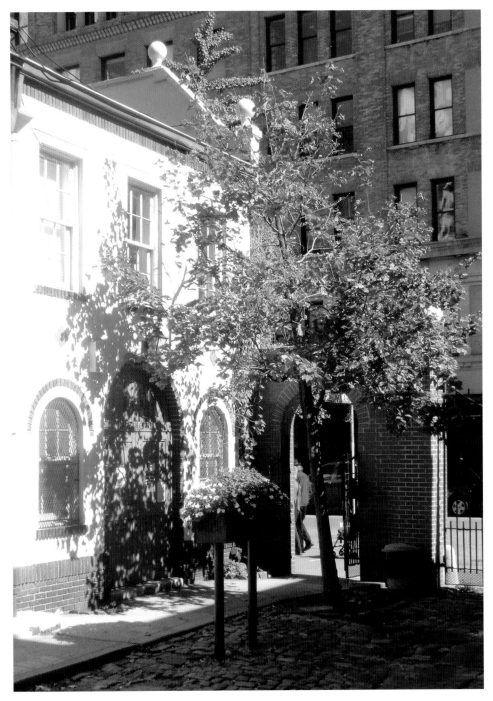

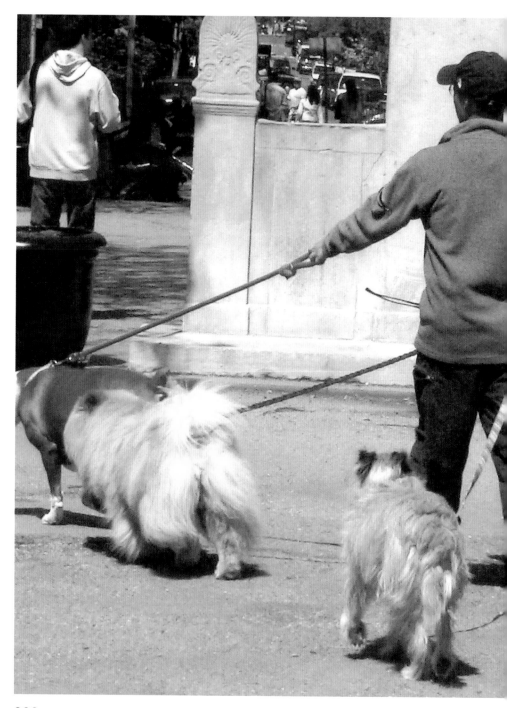

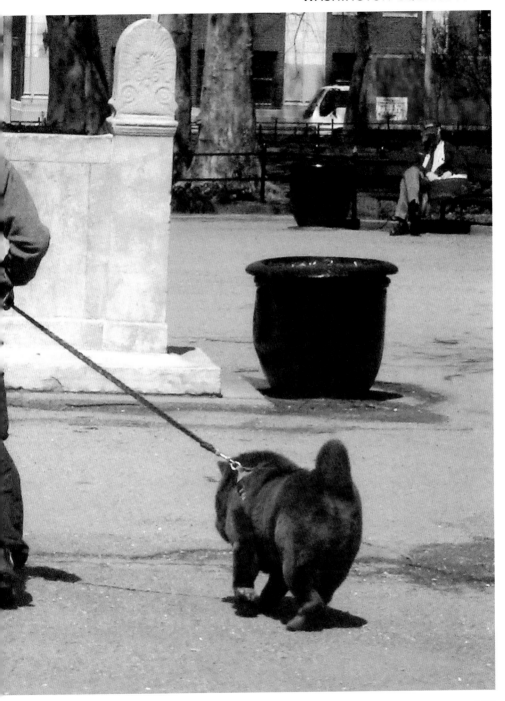

66 Other cities
consume culture,
New York creates it.99

Paul Goldberger

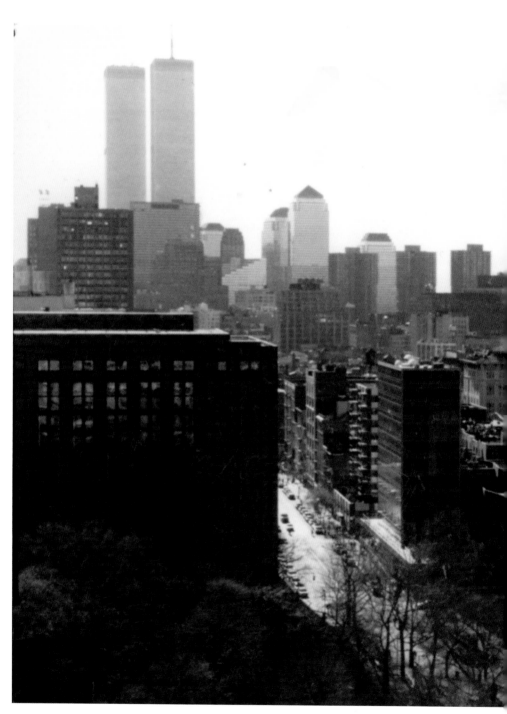

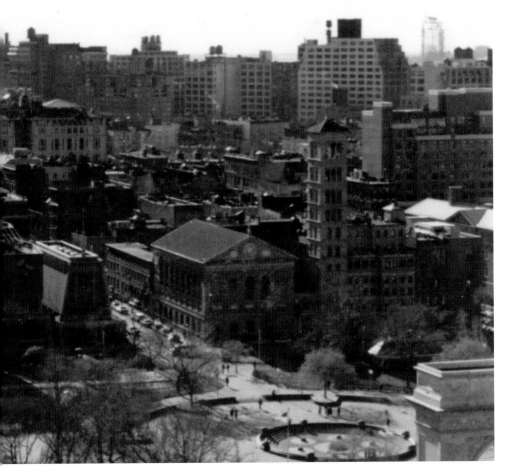

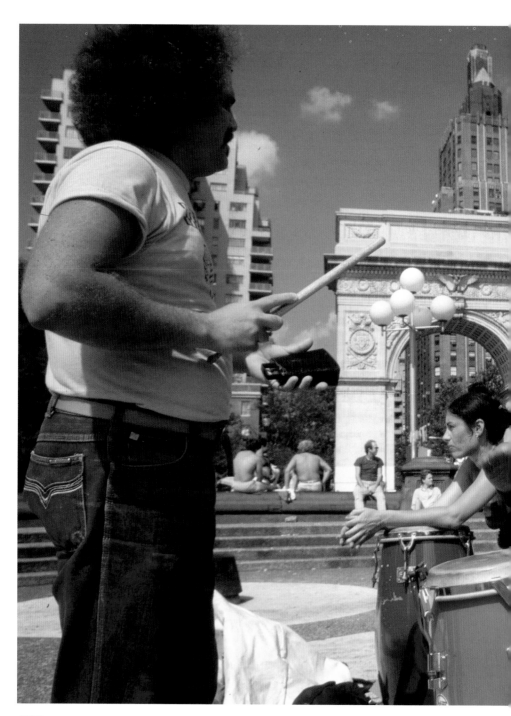

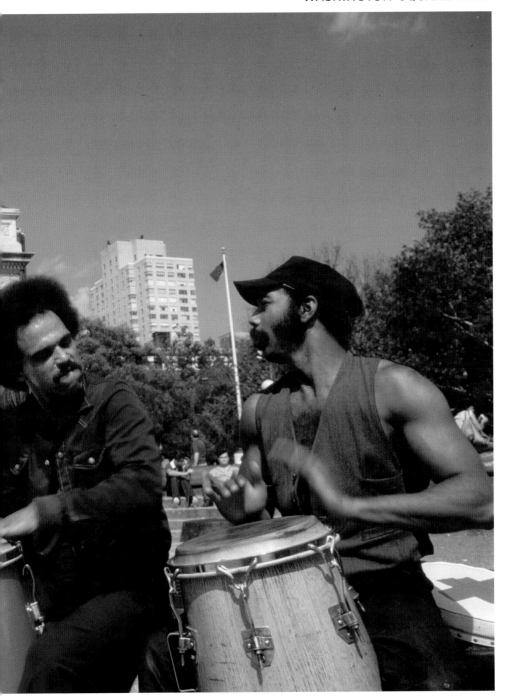

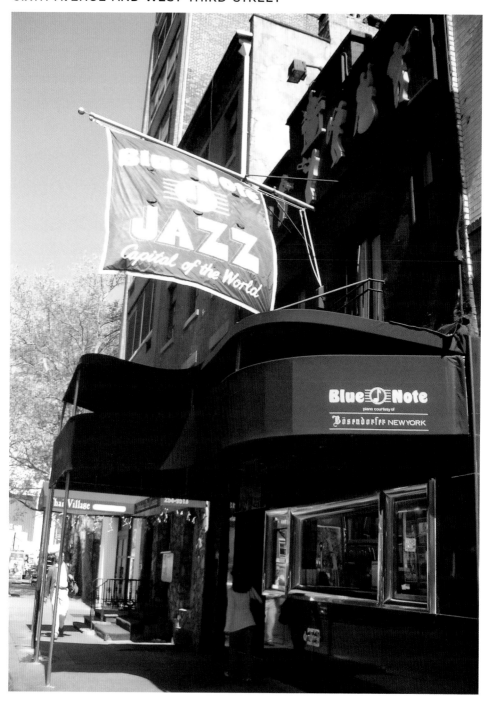

Tourists bringing pictures to sell
To artists in their annual disposition.
Civilians telling cops to move on
Coffeehouses that sell randy
In their coffee cups
Eugene O'Neill insisting on coffee
Walt Whitman cruising on MacDougal
Ike & Mamie drunk in Minettas
Khrushchev singing Peat Bog Soldiers
In the Circle (with a balalaika)
Everybody kissing & hugging squeezing
Khrushchev & Eisenhower a big fat kiss
The world an art
Life a joy
The village come to life again
I wake up singing
I that dwell in New York
Sweet song bless my mouth
Beauty bless my eyes.

Tuli Kupferberg
"Greenwich Village of My Dreams"

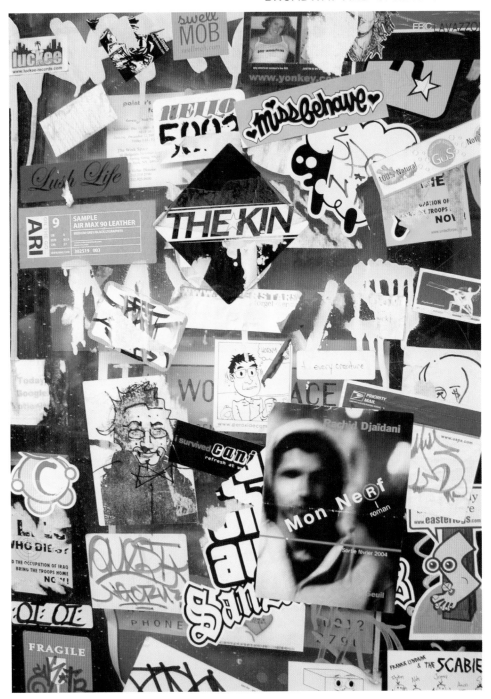

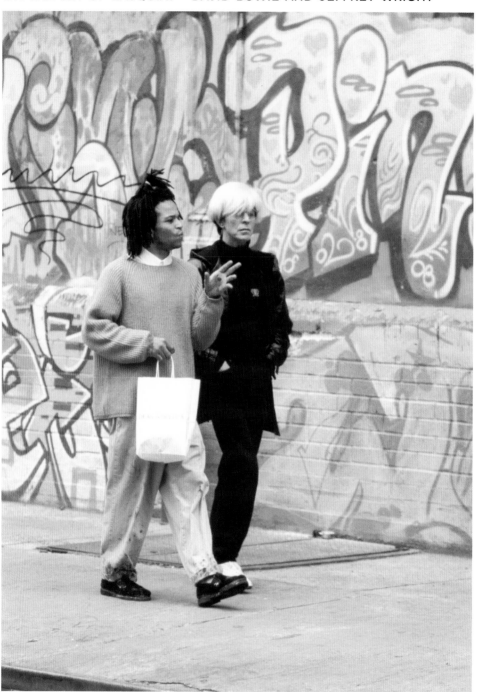

66 There are two million interesting people in New York and only seventy-eight in Los Angles. **99**

Neil Simon

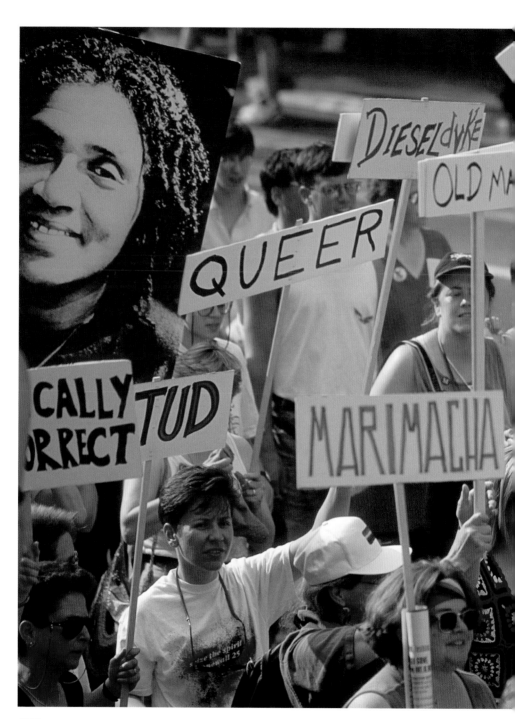

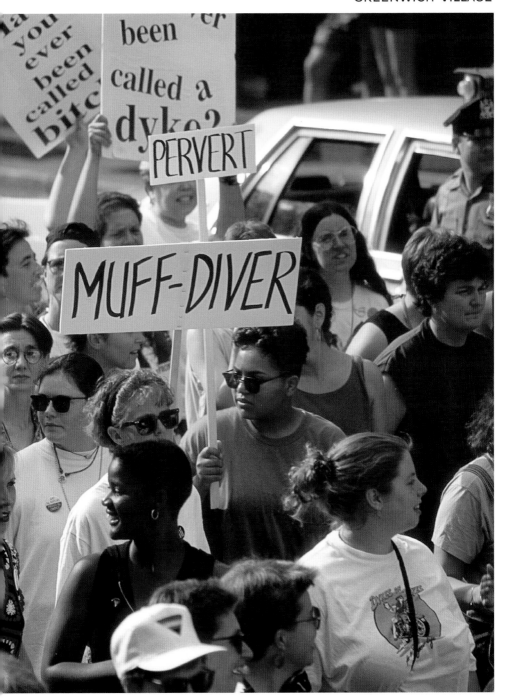

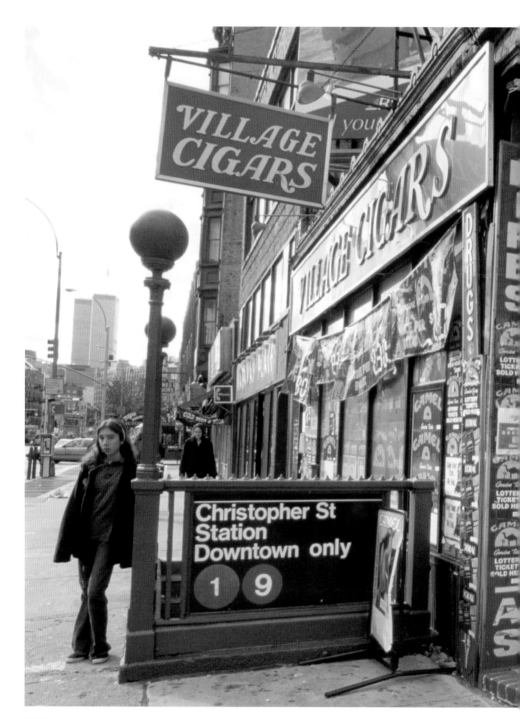

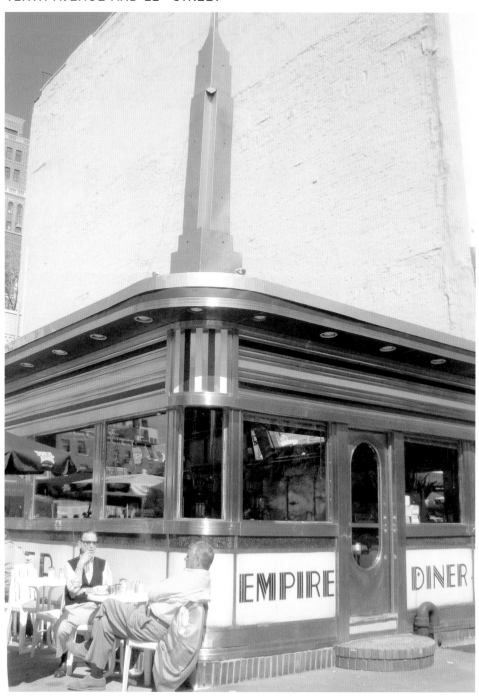

chocolate bar

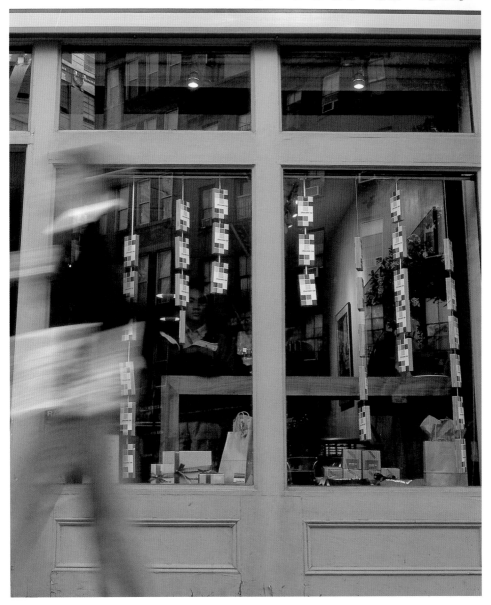

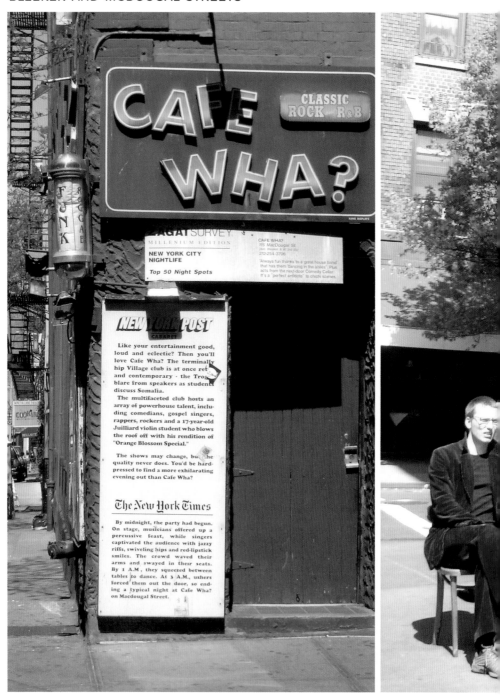

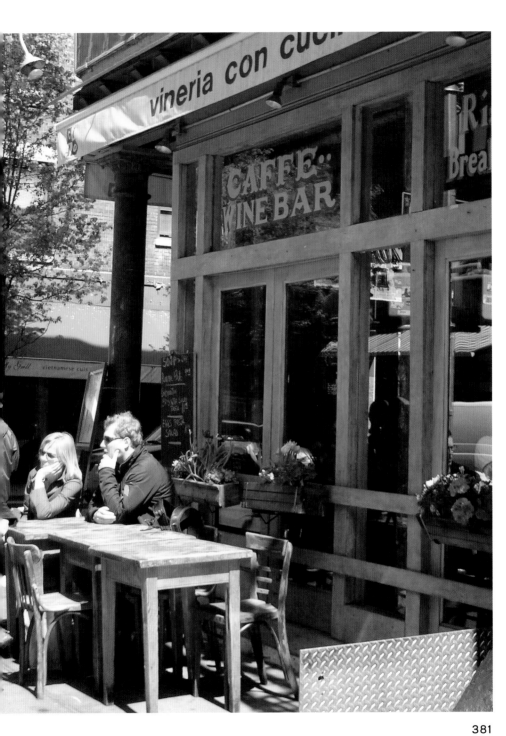

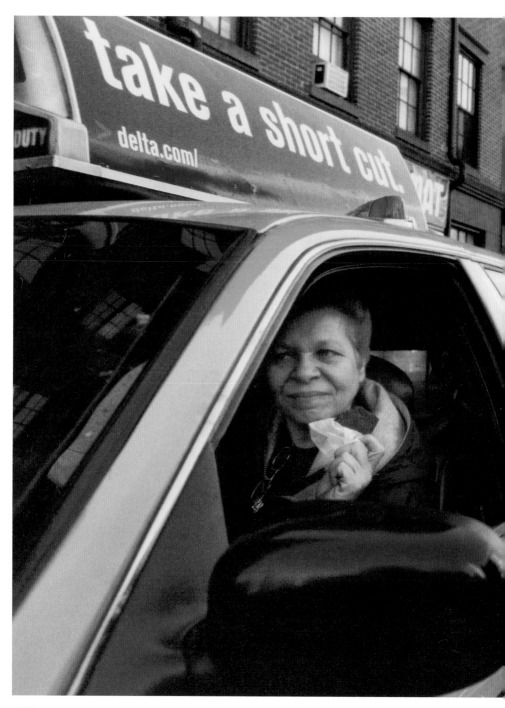

383

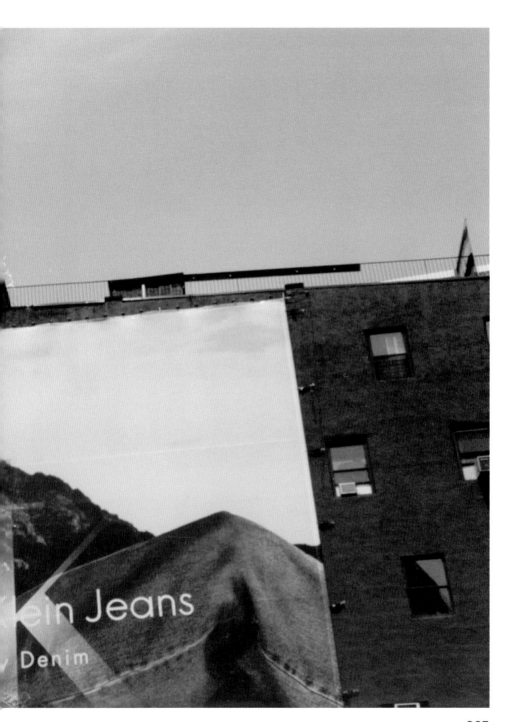

66A hundred times
I have thought
New York is
a catastrophe
and fifty times:
It is a beautiful
catastrophe.**99**

Le Corbusier

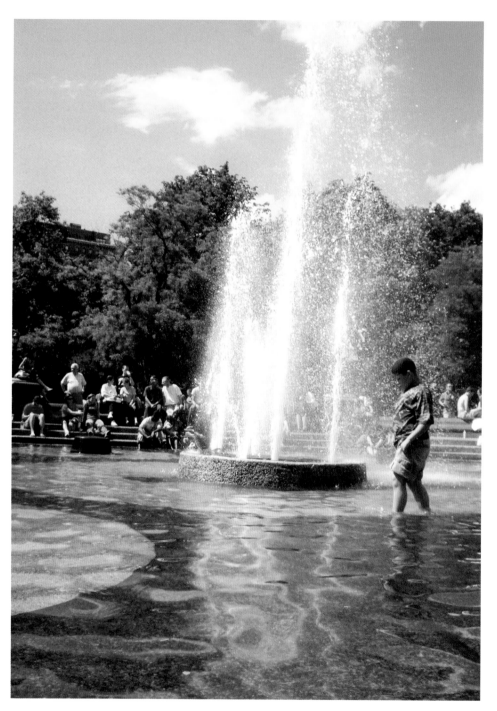

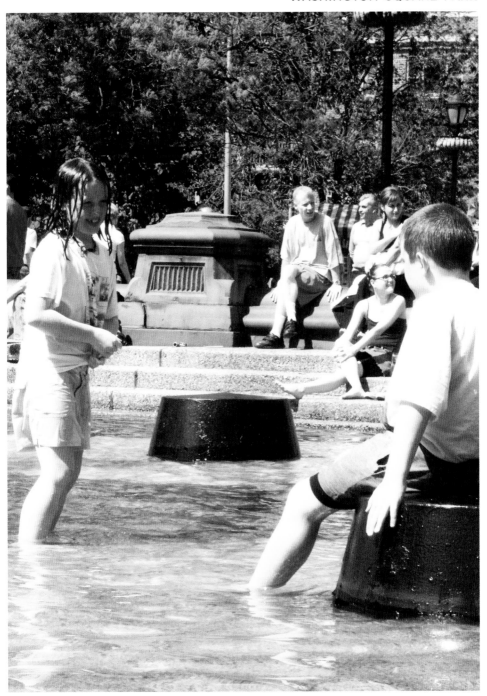

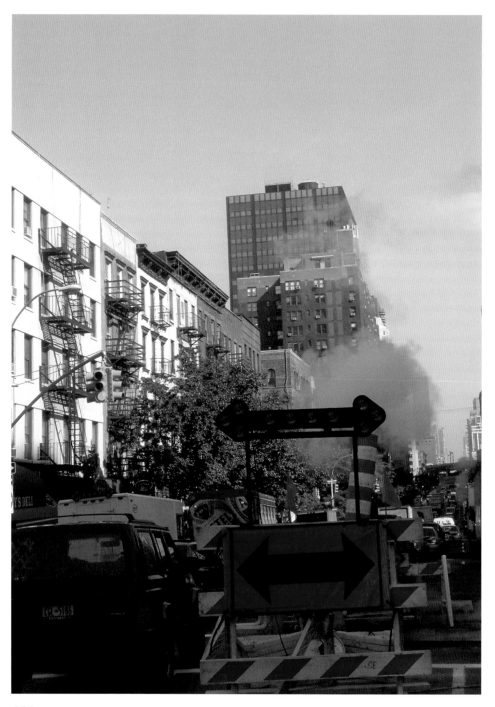

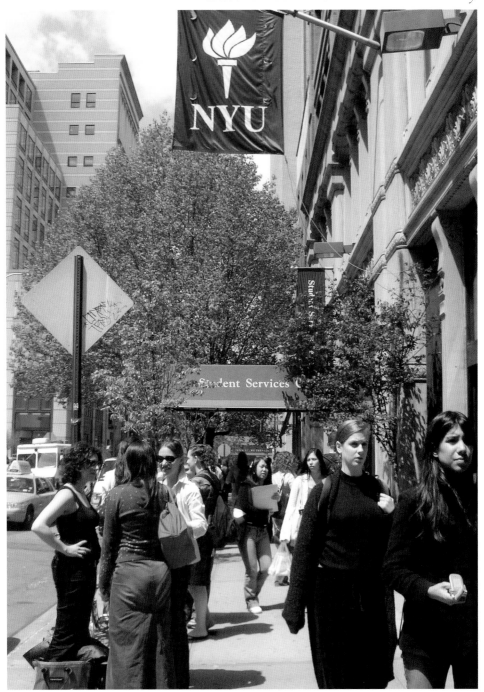

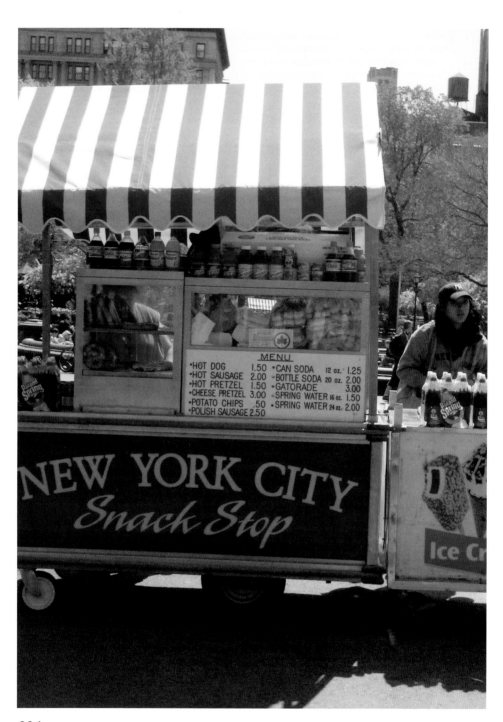

MENU

- HOT DOG 1.50
- HOT SAUSAGE 2.00
- HOT PRETZEL 1.50
- CHEESE PRETZEL 3.00
- POTATO CHIPS .50
- POLISH SAUSAGE 2.50
- CAN SODA 12 oz. 1.25
- BOTTLE SODA 20 oz. 2.00
- GATORADE 3.00
- SPRING WATER 16 oz. 1.50
- SPRING WATER 24 oz. 2.00

NEW YORK CITY
Snack Stop

Ice Cr

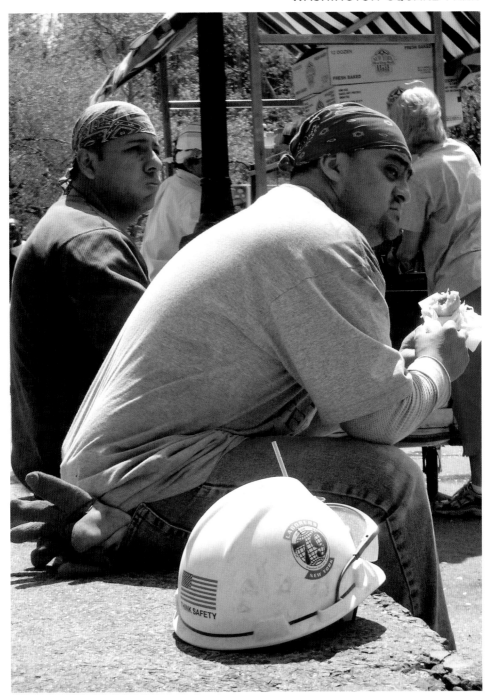

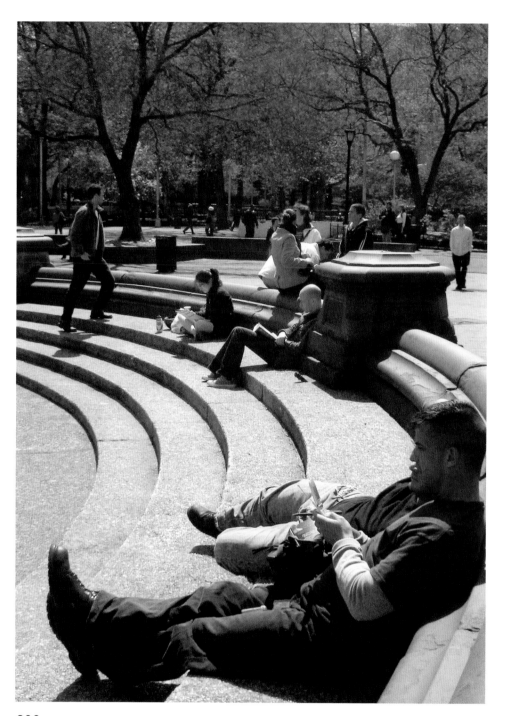

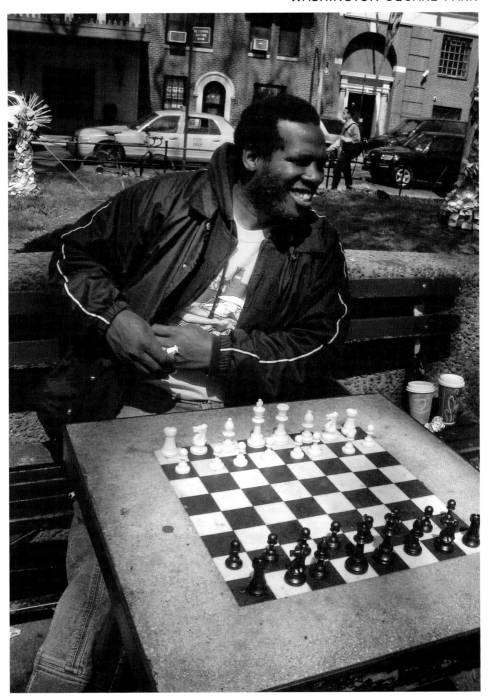

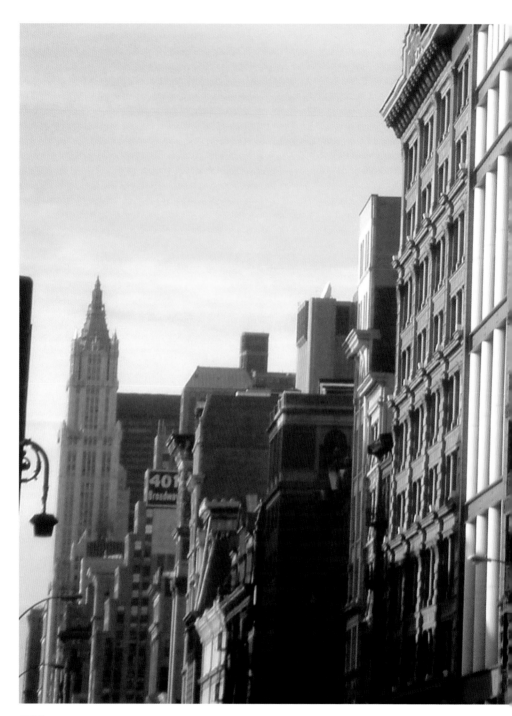

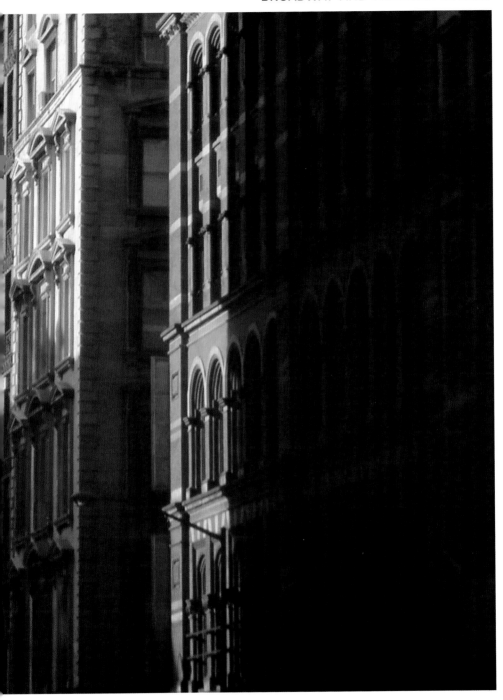

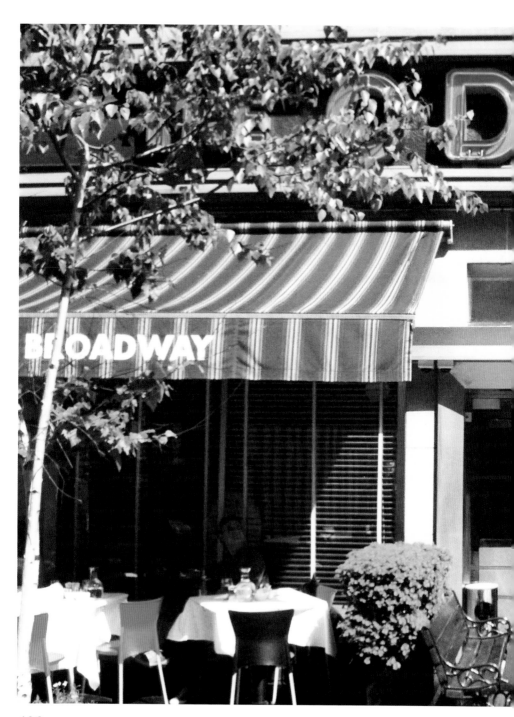

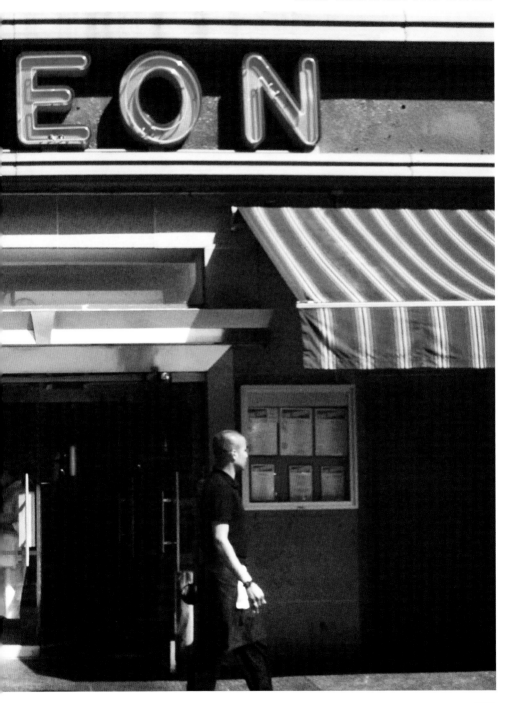

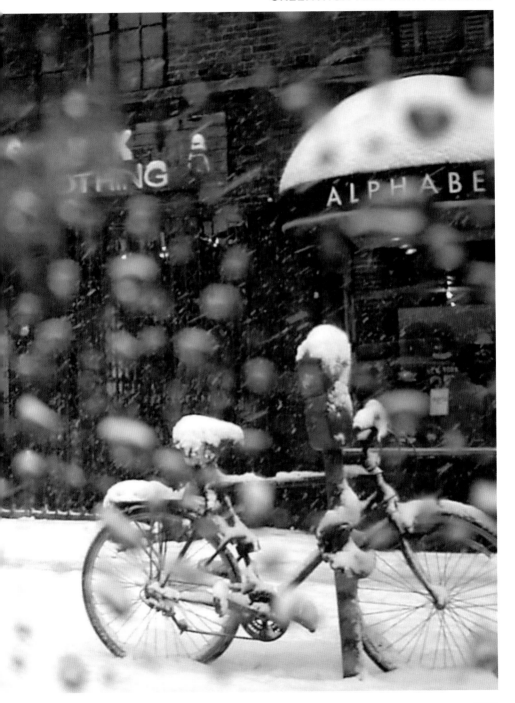

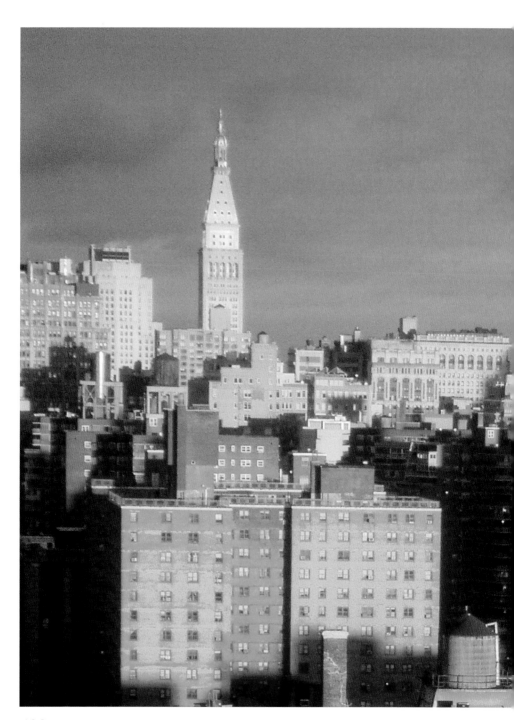

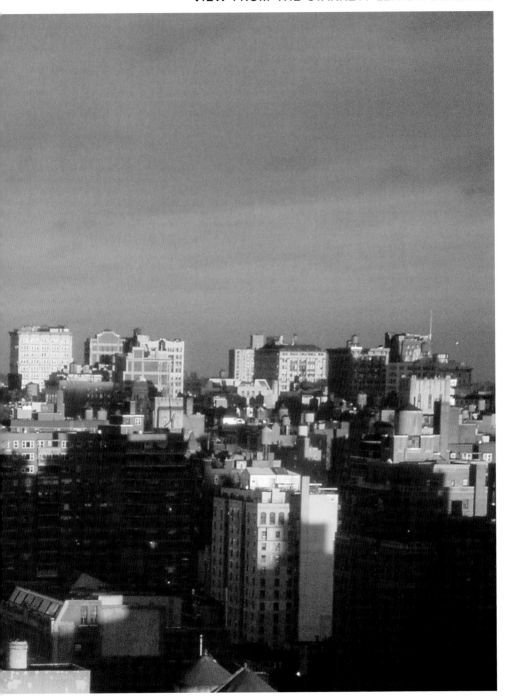

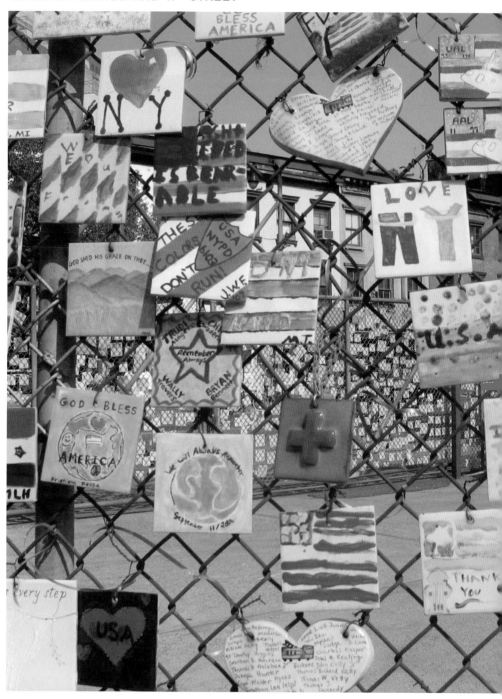

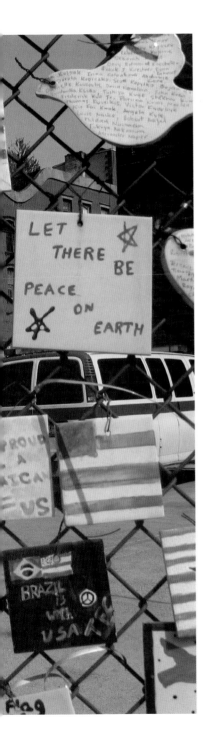

66 Downtown Manhattan, clear winter noon, and I've been up all night, talking, talking, reading the Kaddish aloud, listening to Ray Charles blues shoutblind on the phonograph.99

Allen Ginsberg

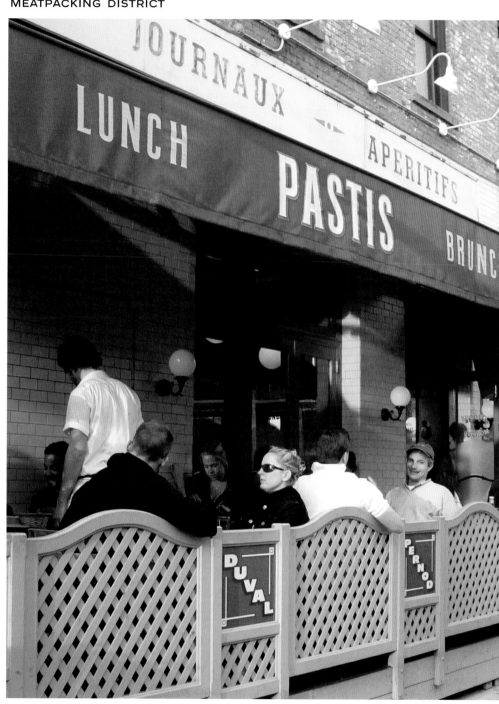

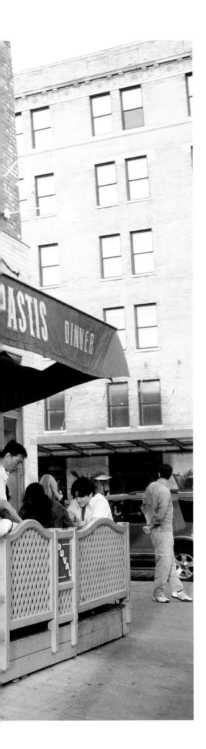

" If I live in New York, it is because I choose to live here. It is the city of total intensity, the city of the moment. **"**

Diane Vreeland

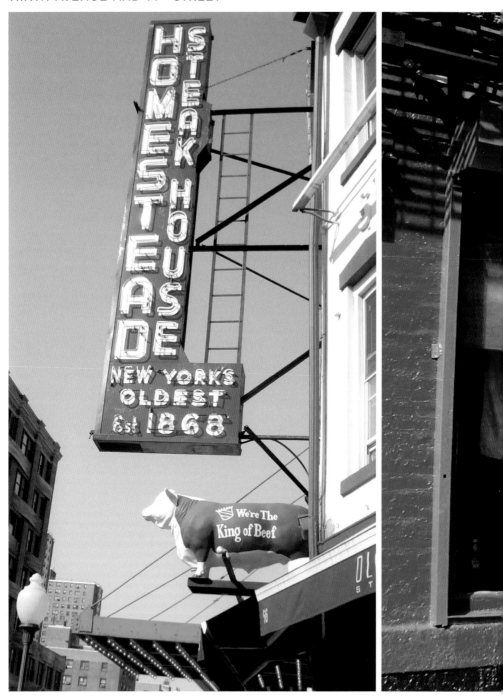

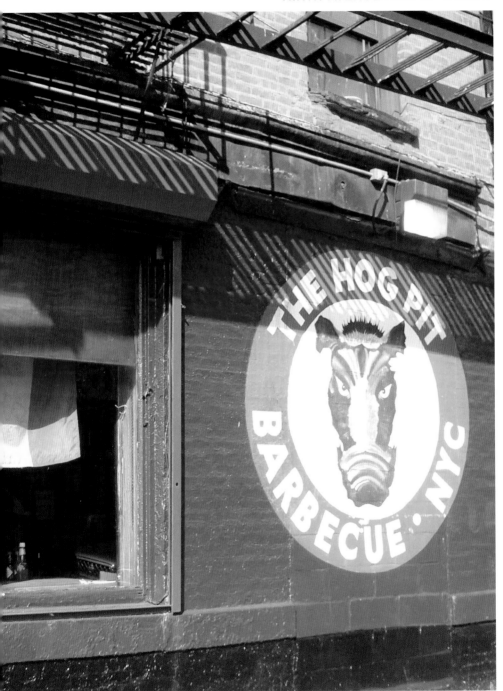

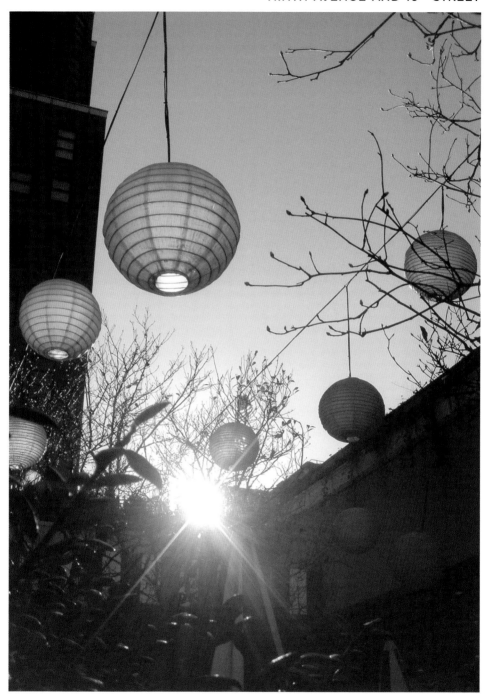

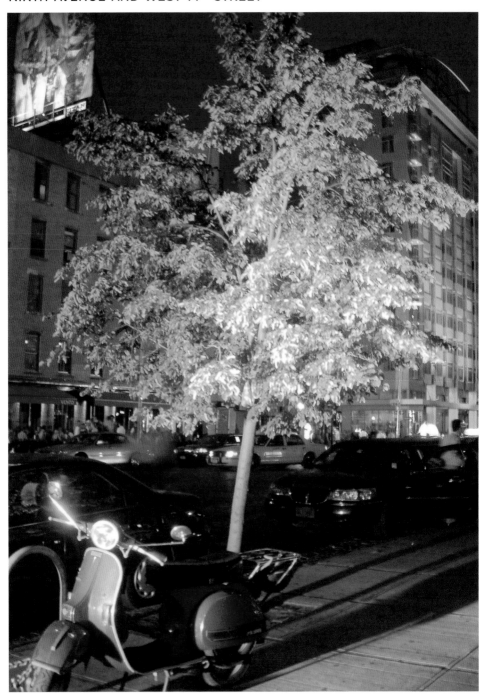

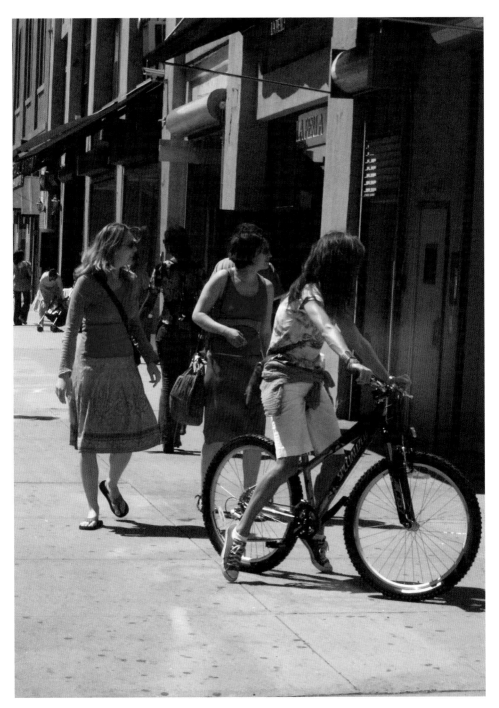

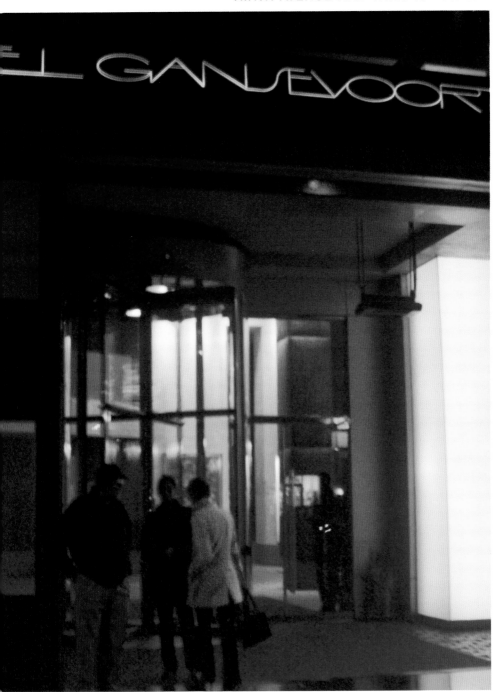

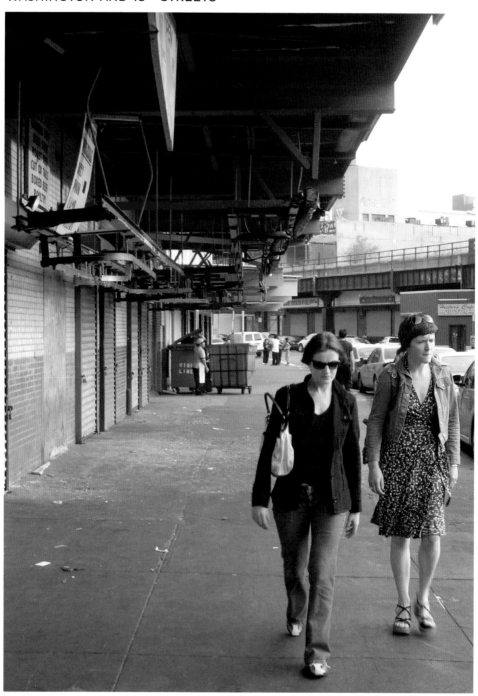

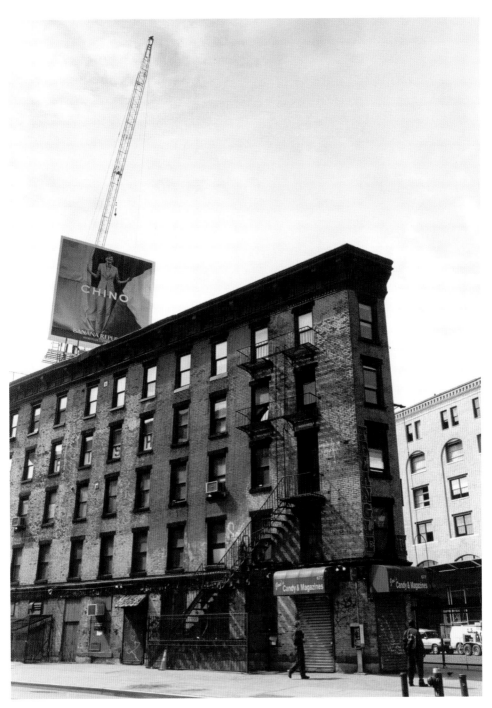

423

424

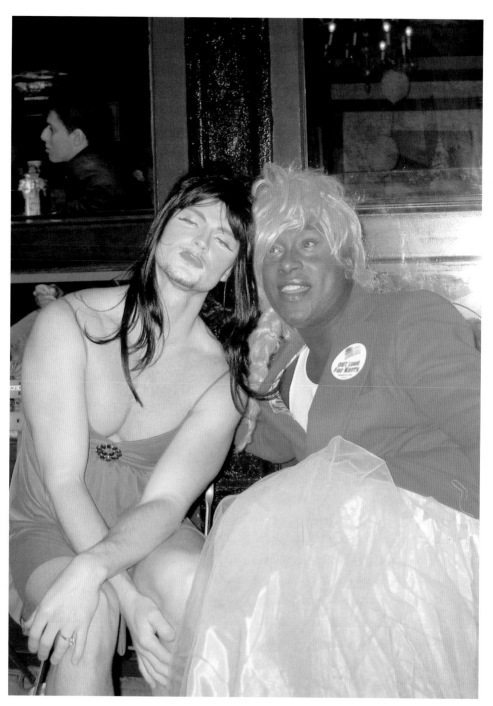

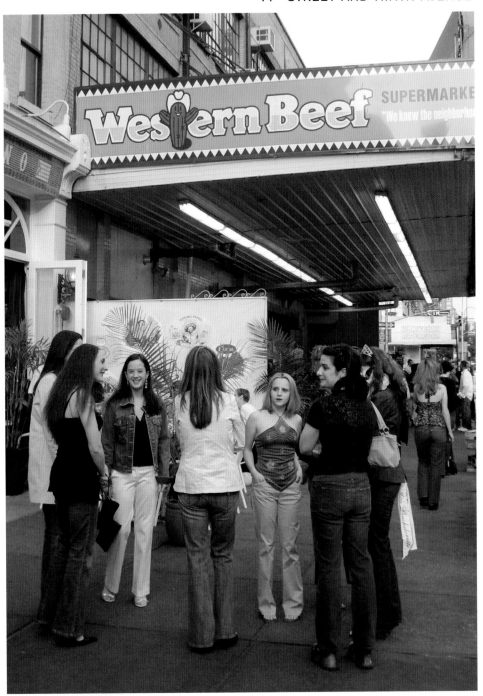

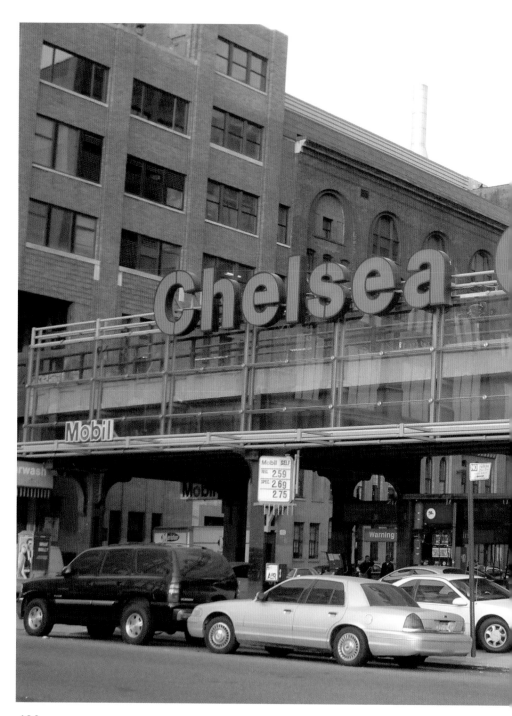

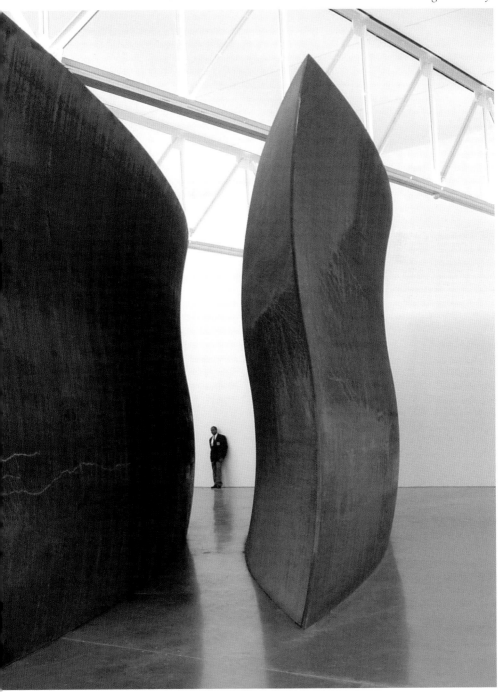

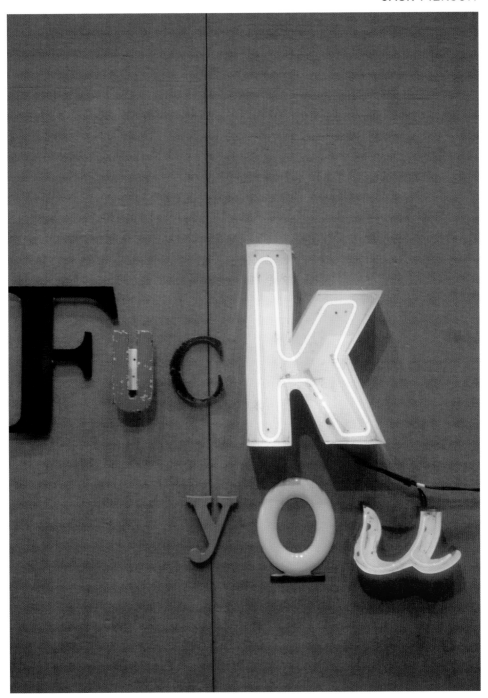

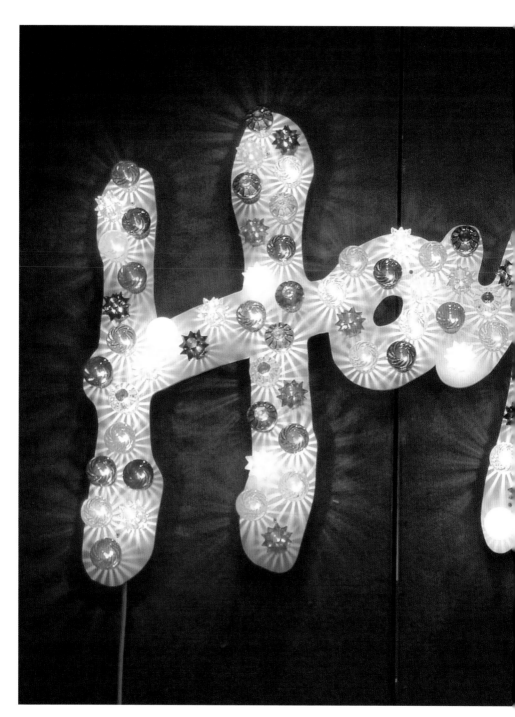

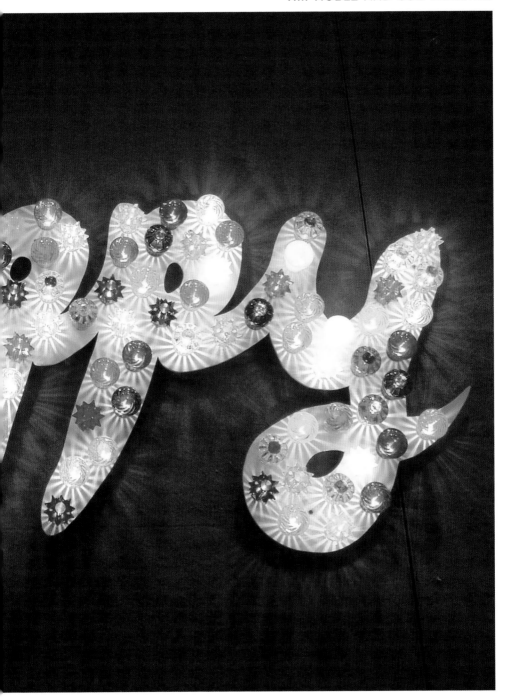

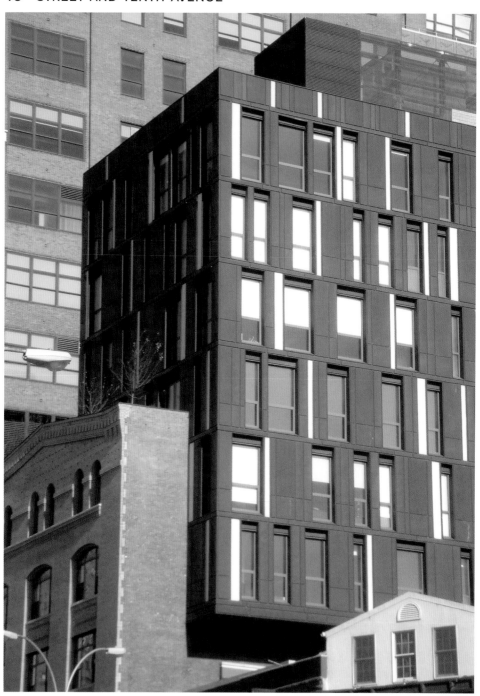

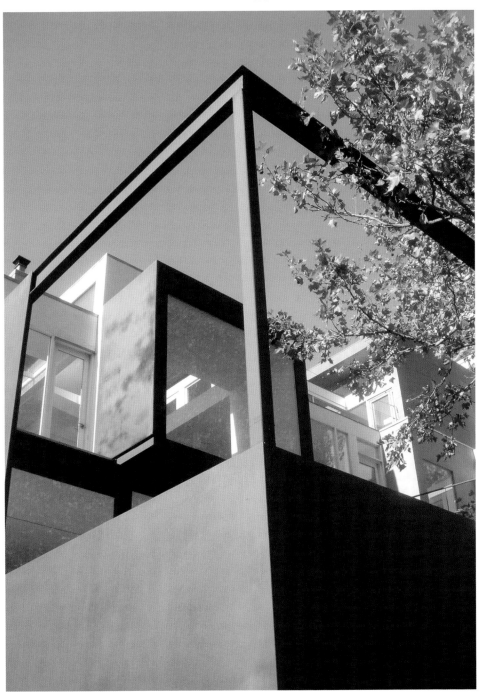

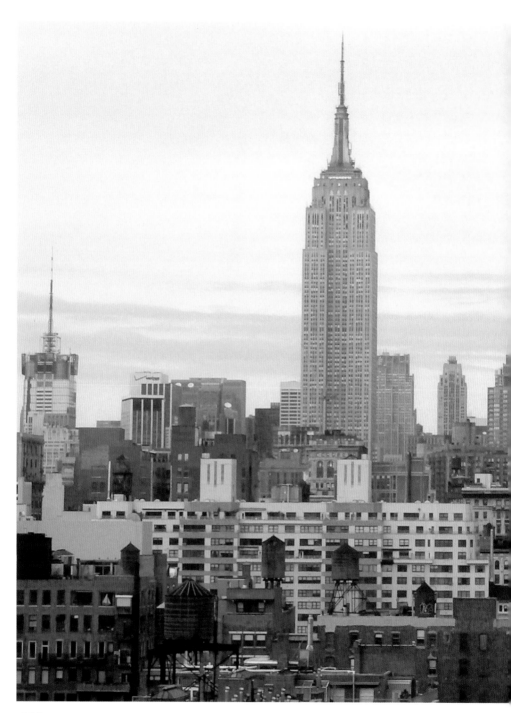

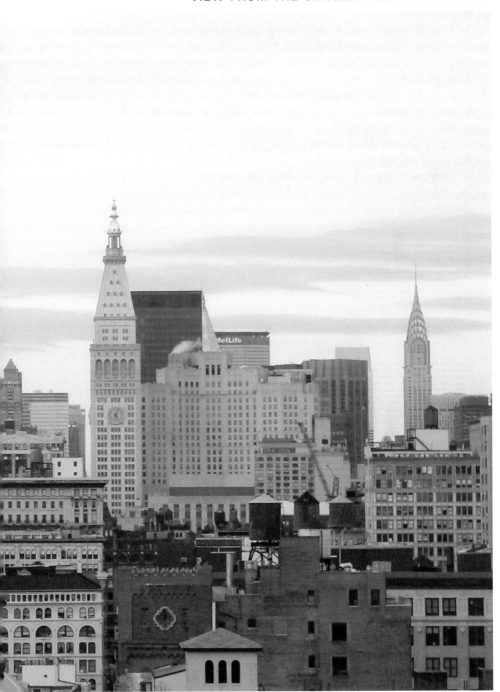

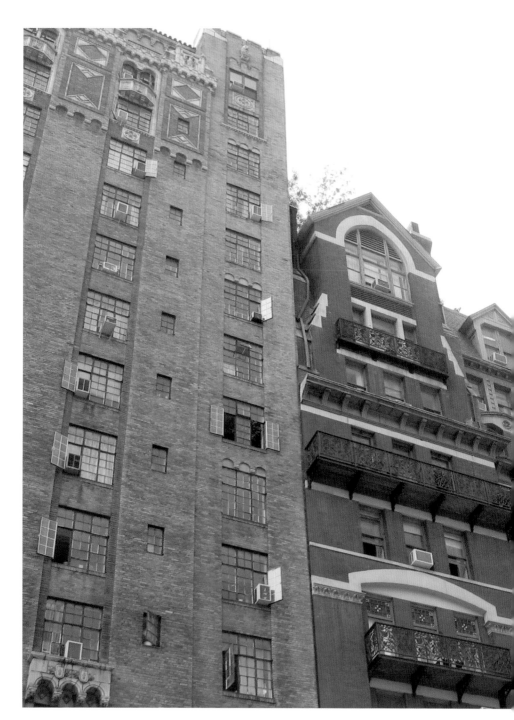

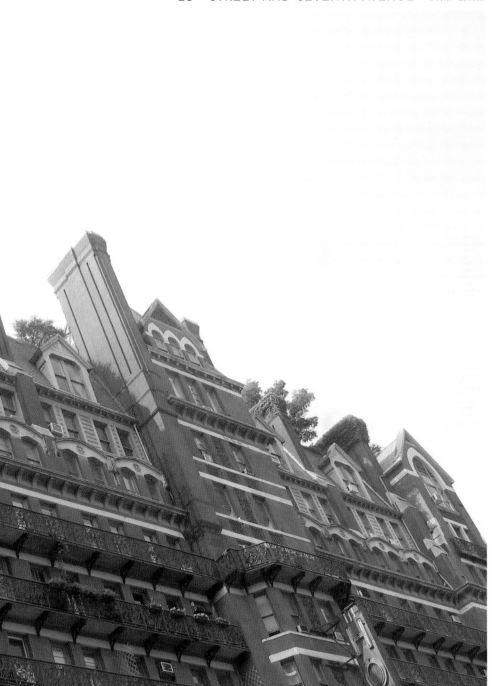

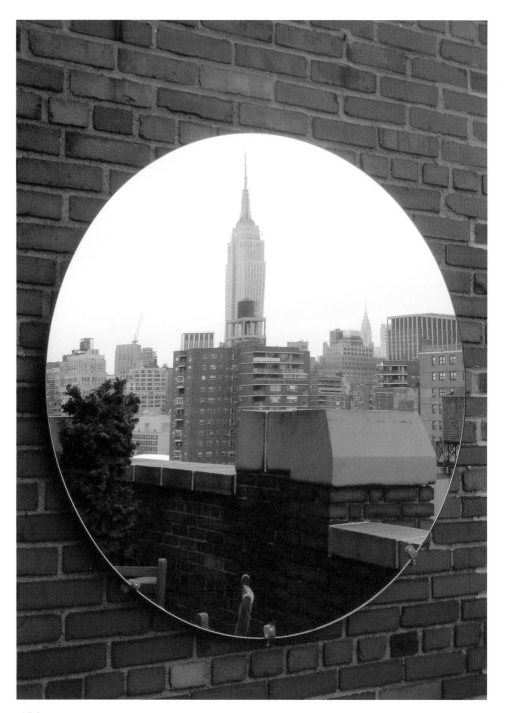

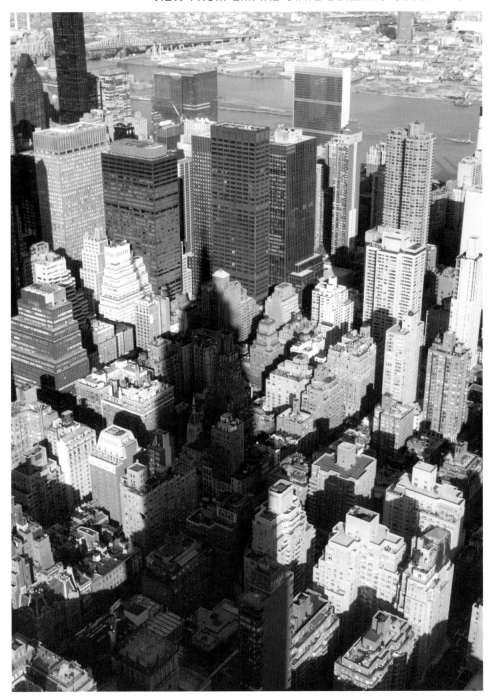

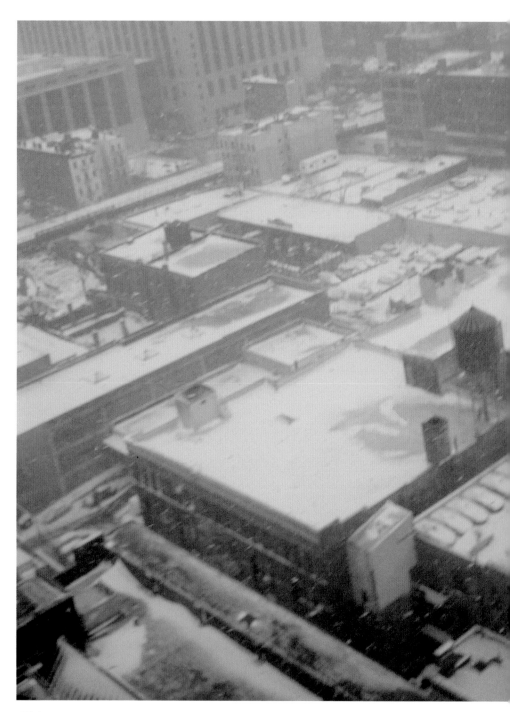

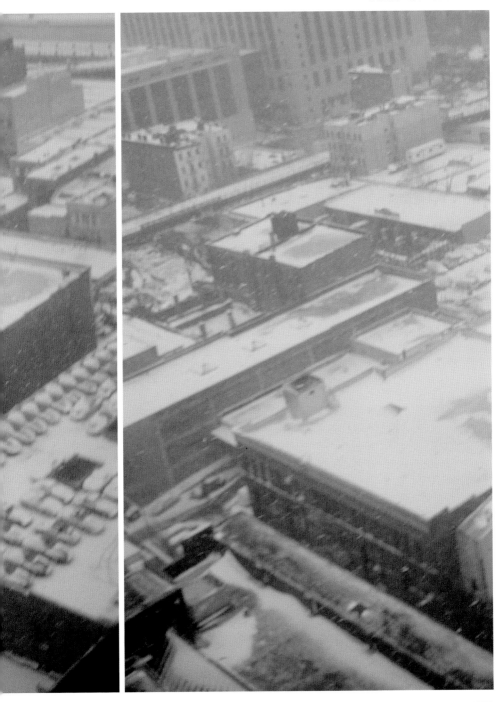

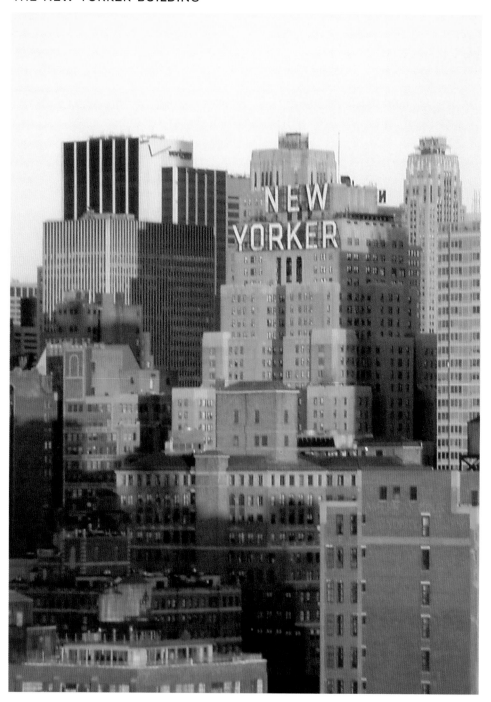

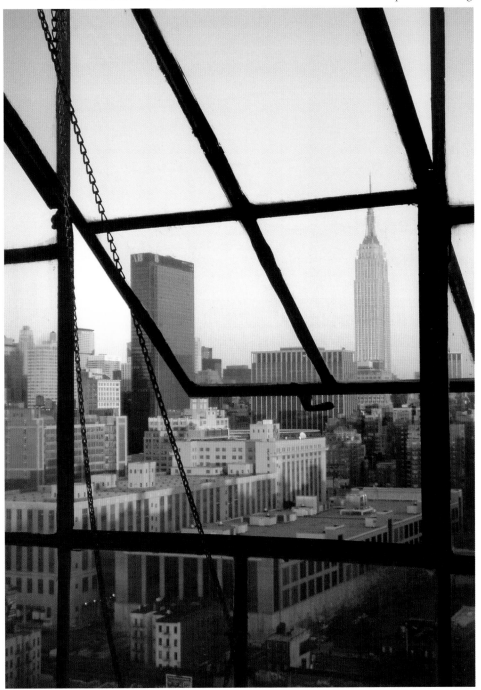

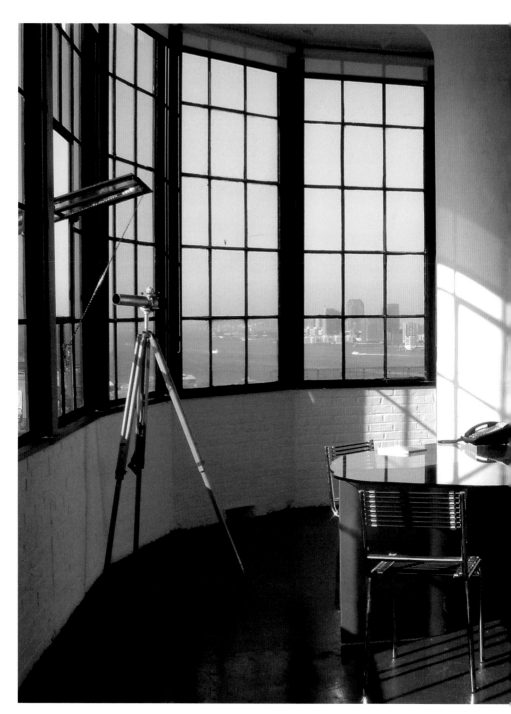

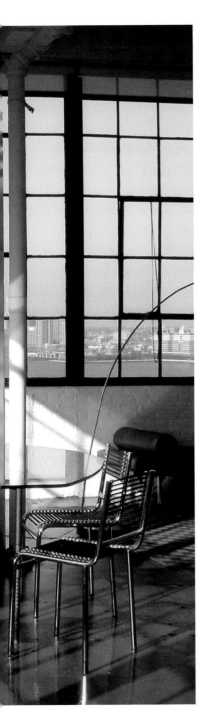

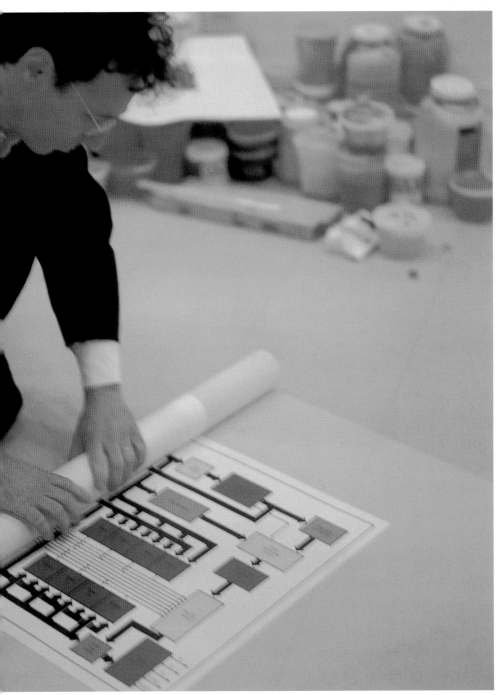

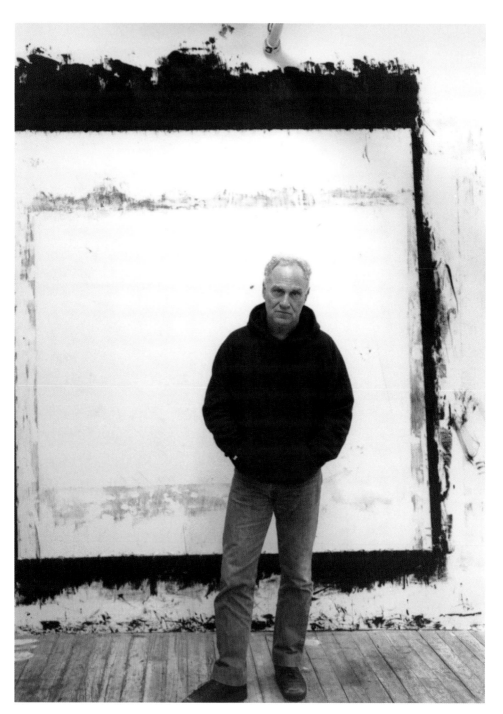

467

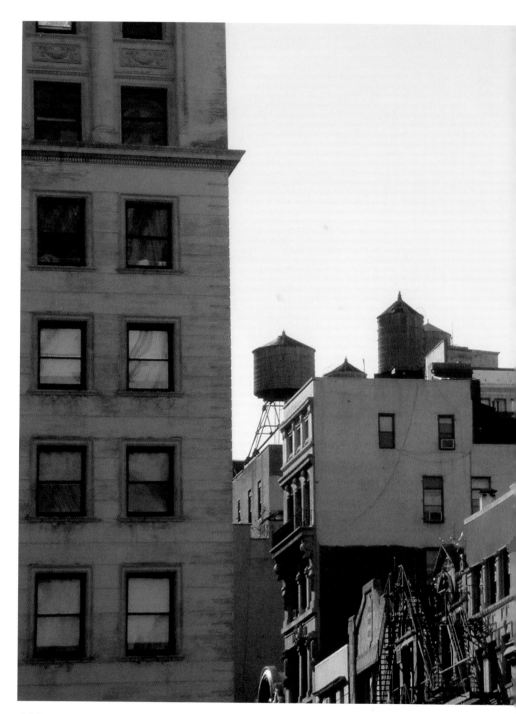

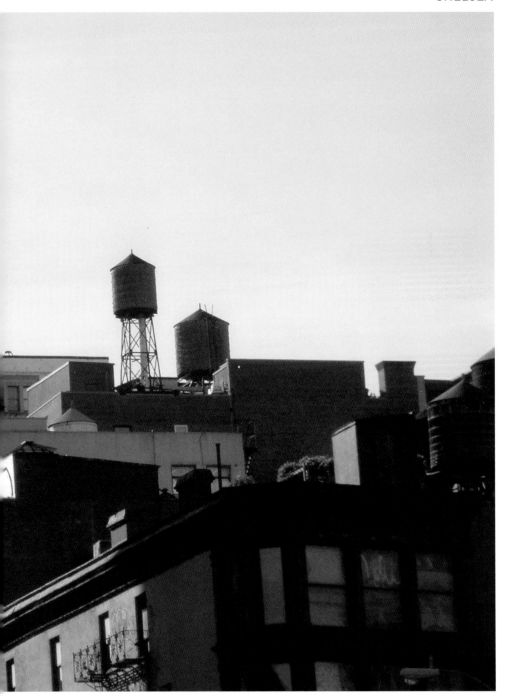

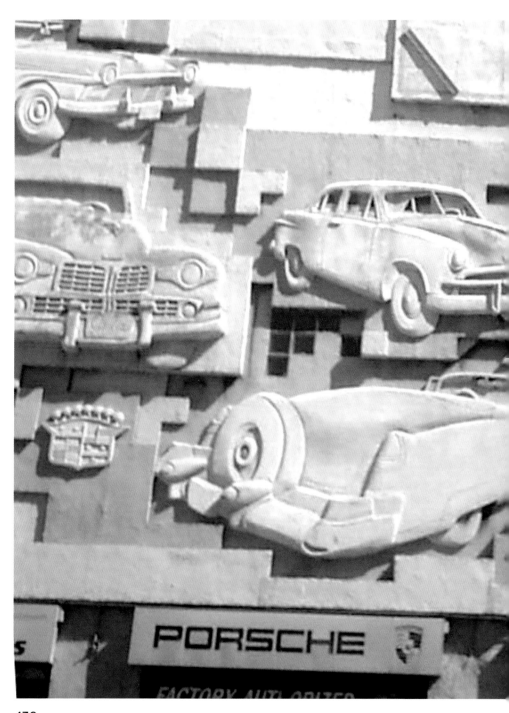

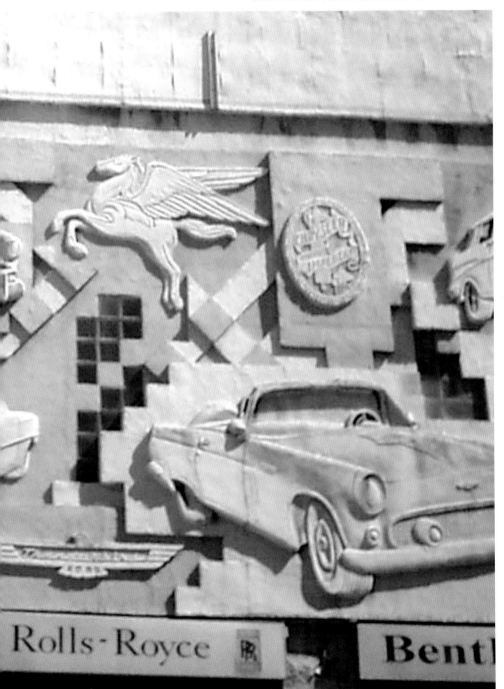

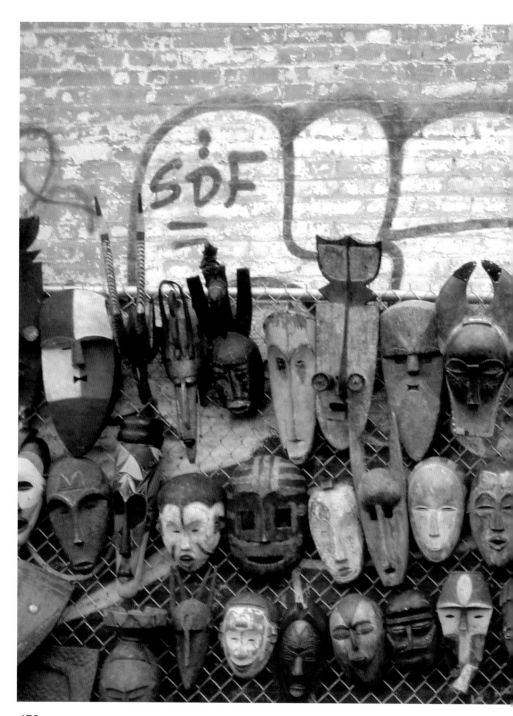

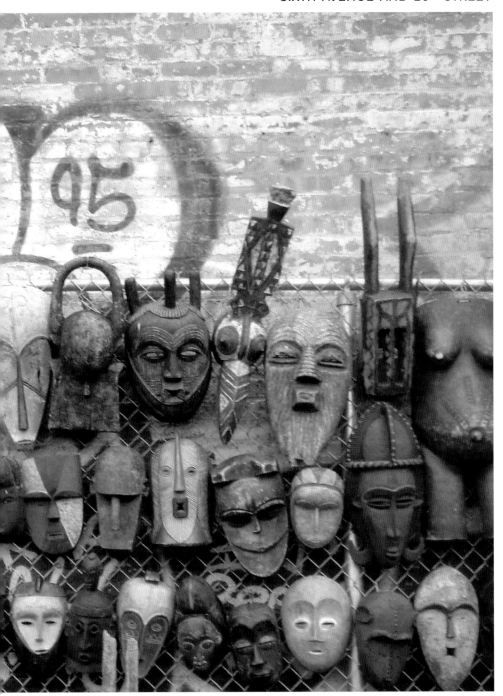

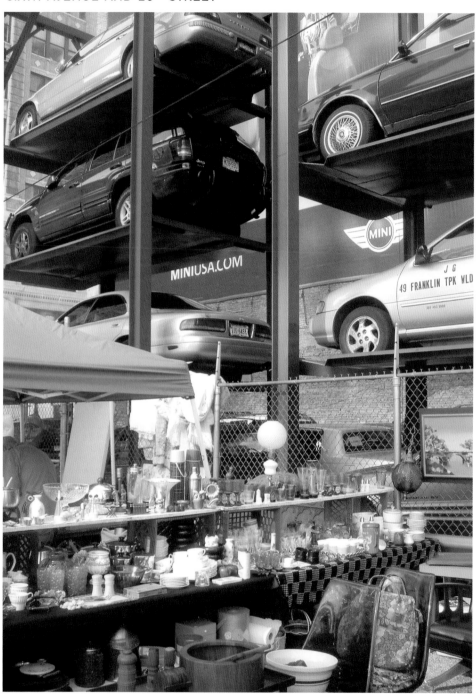

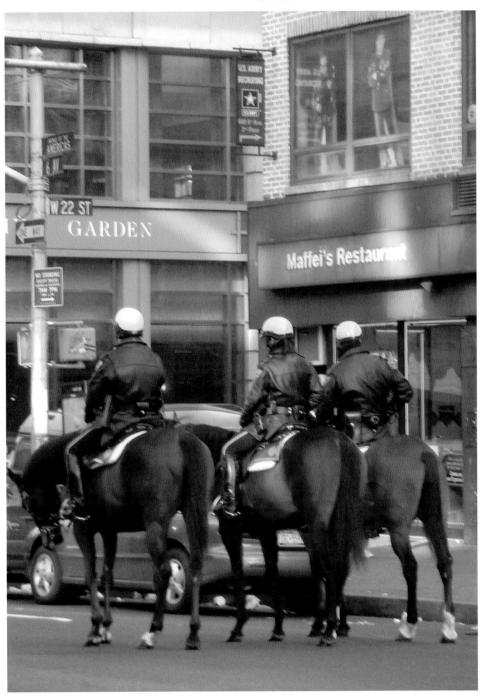

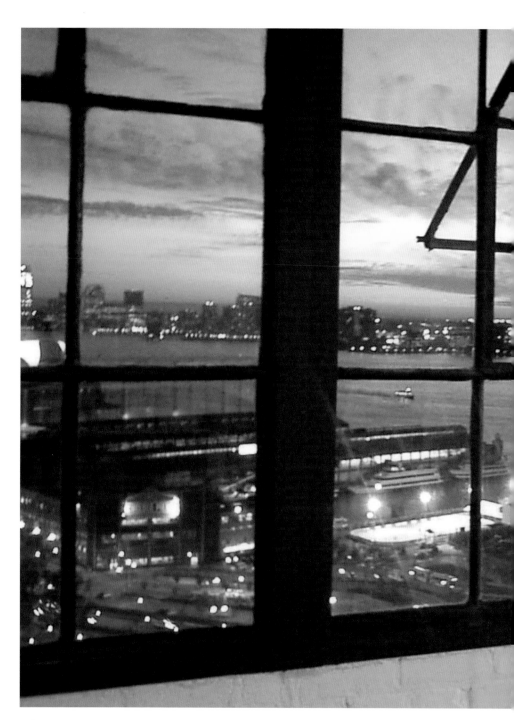

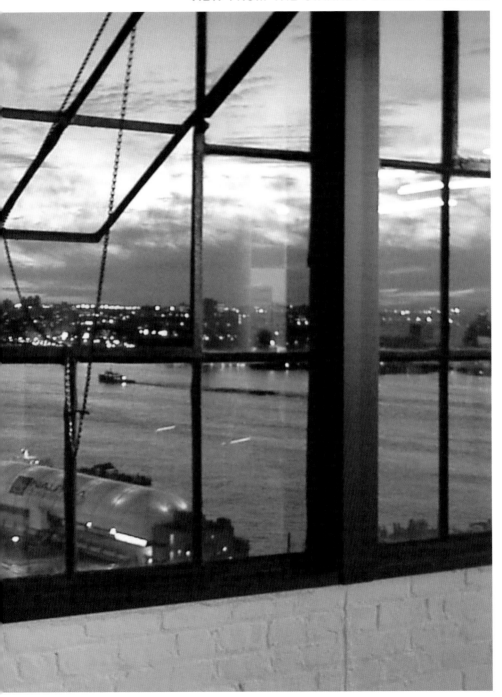

484

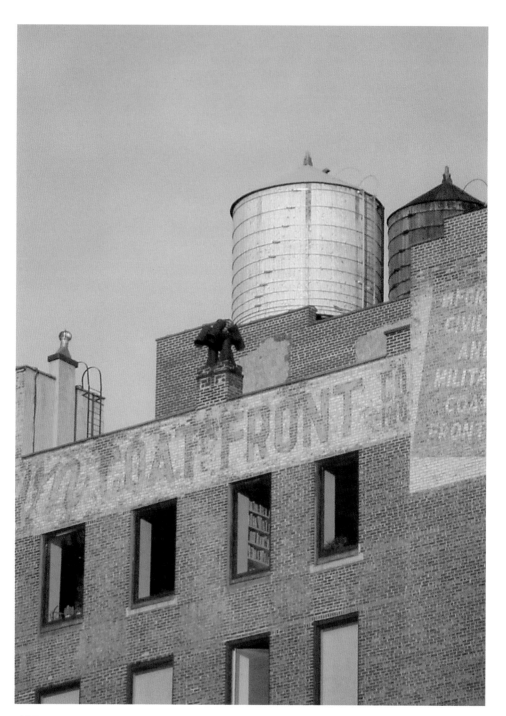

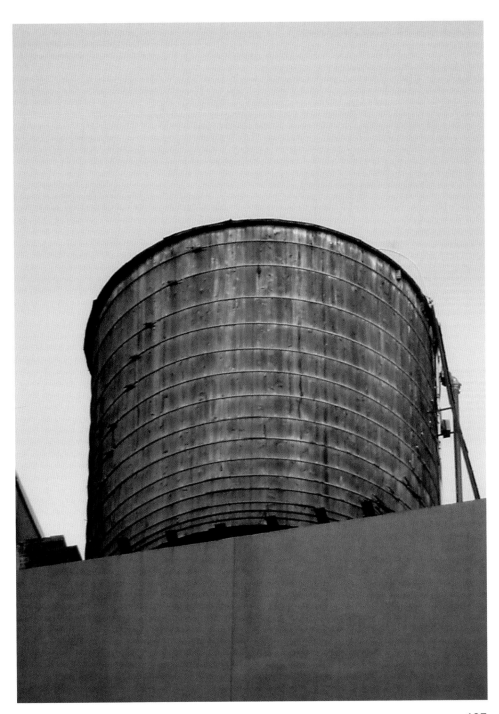

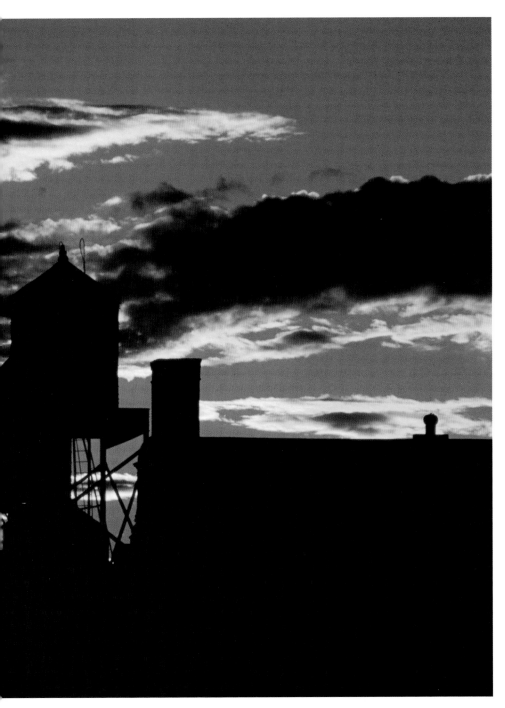

490

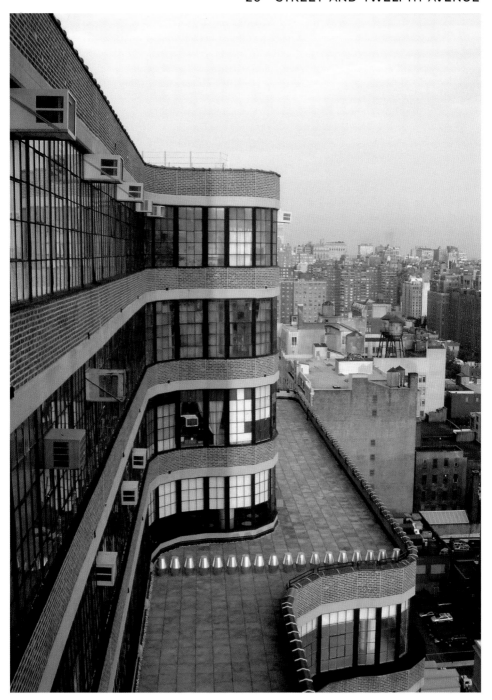

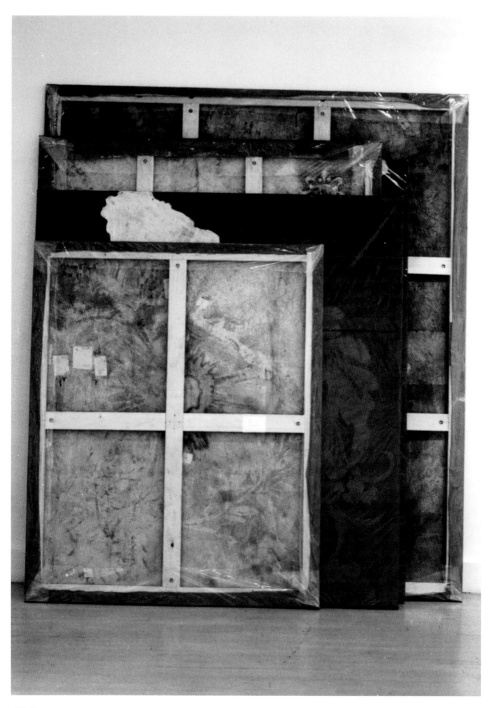

494

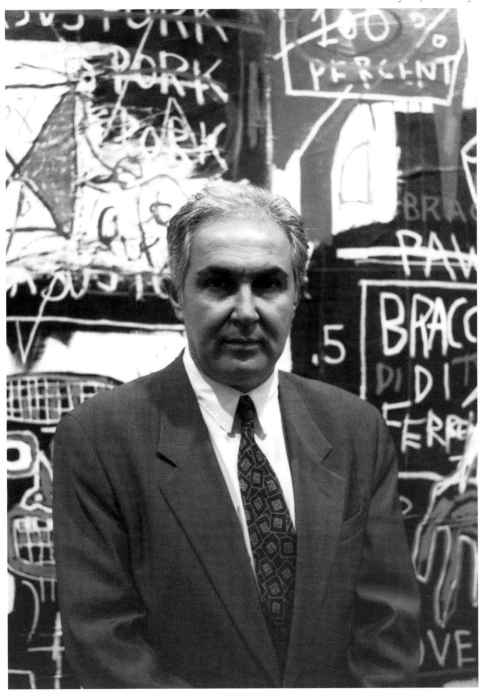

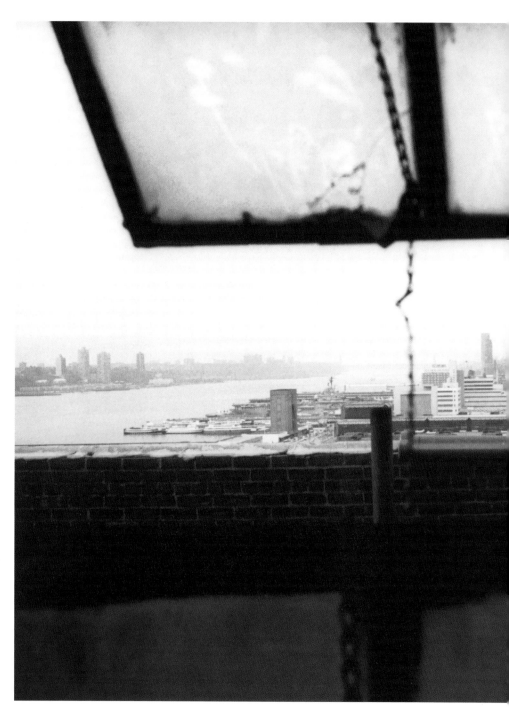

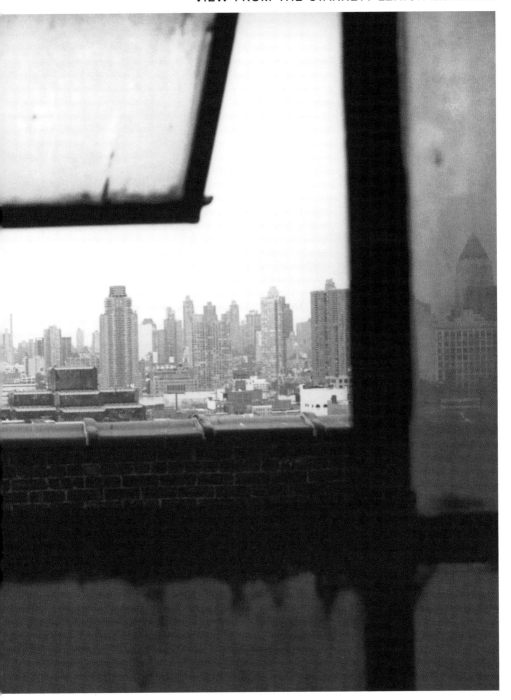

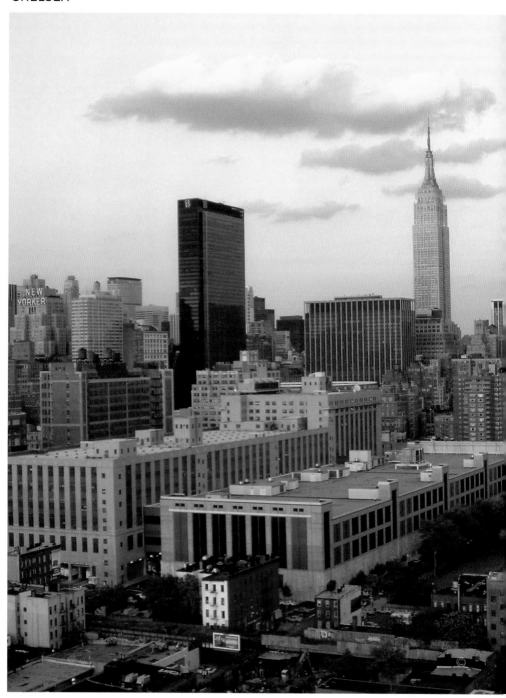

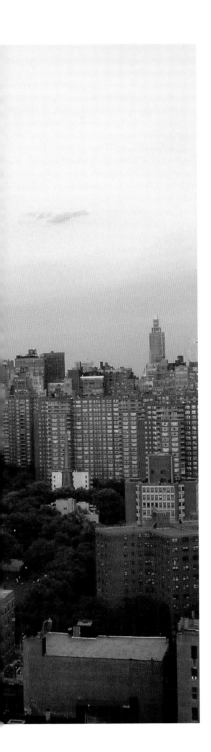

66 It is ridiculous
to set a detective story
in New York City.
New York City is itself
a detective story. 99

Agatha Christie

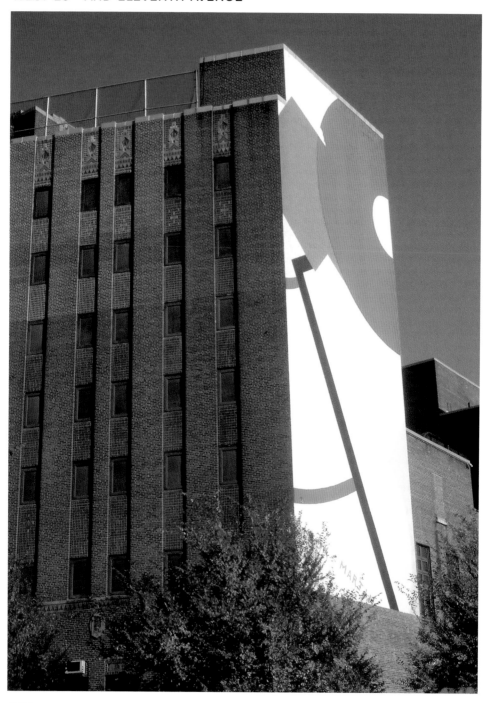

503

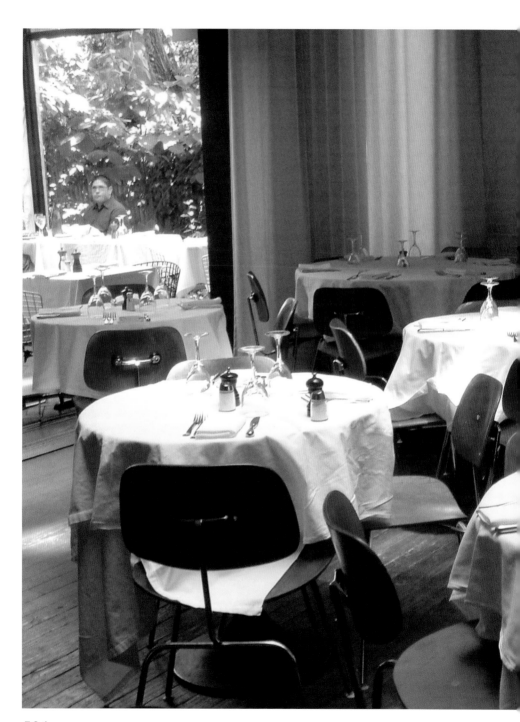

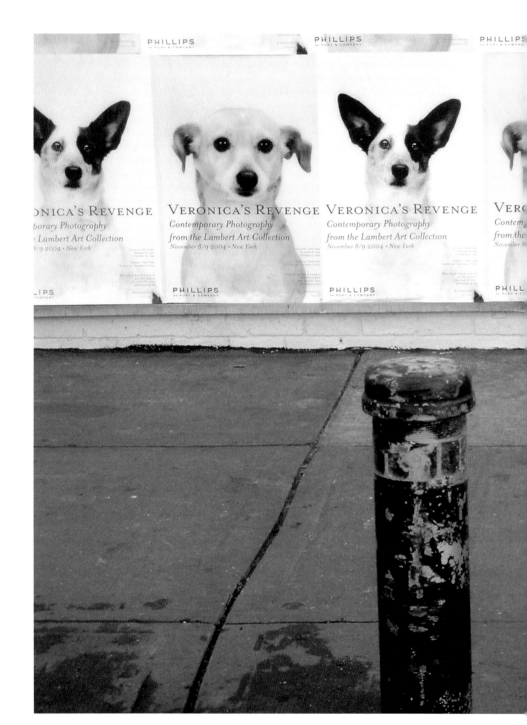

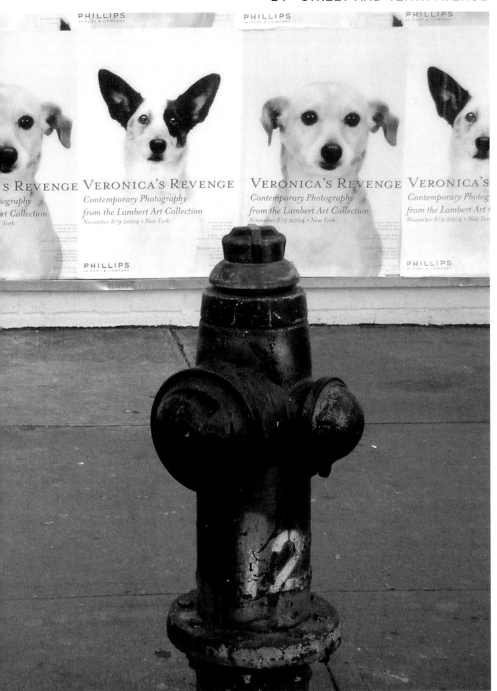

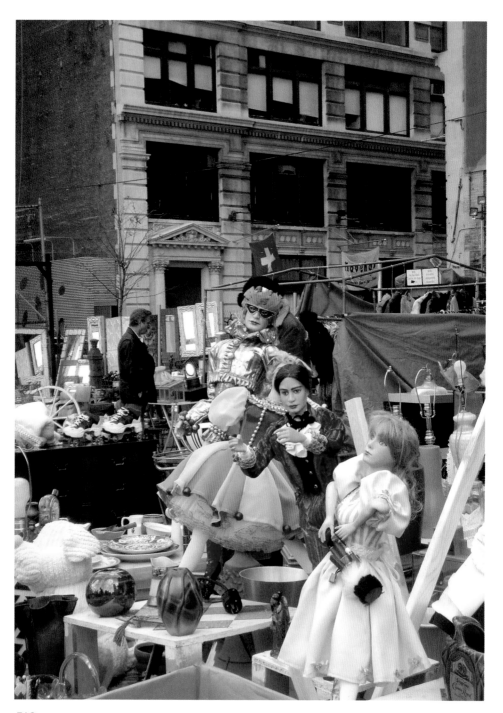

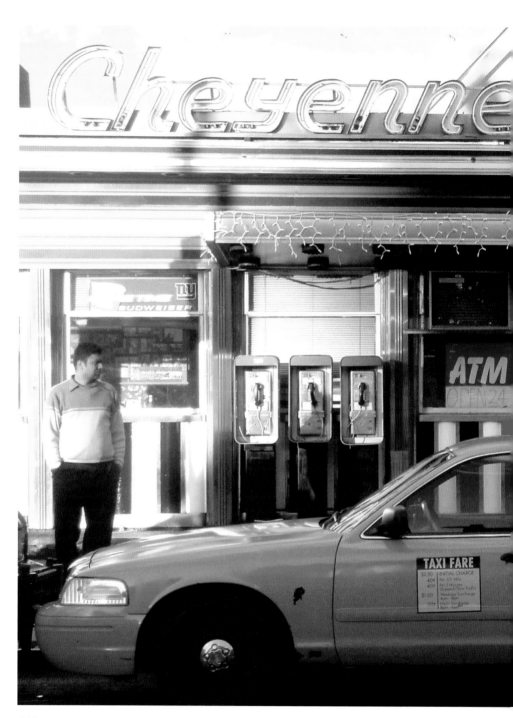

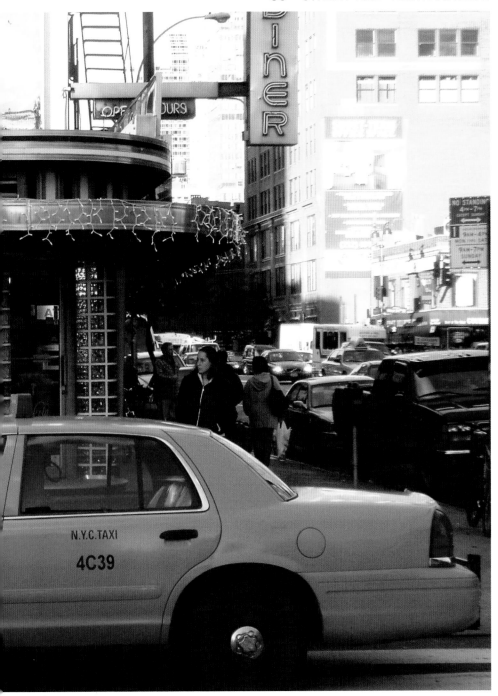

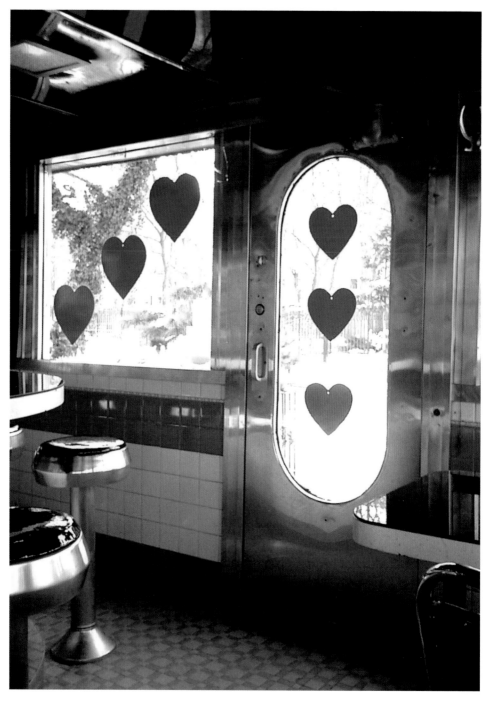

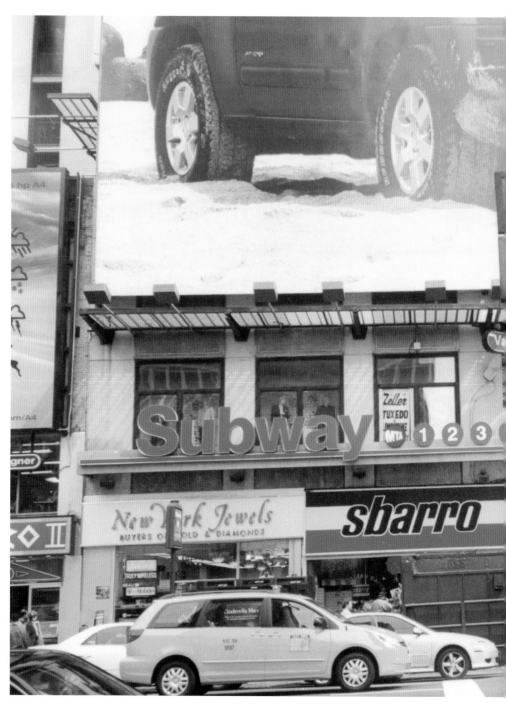

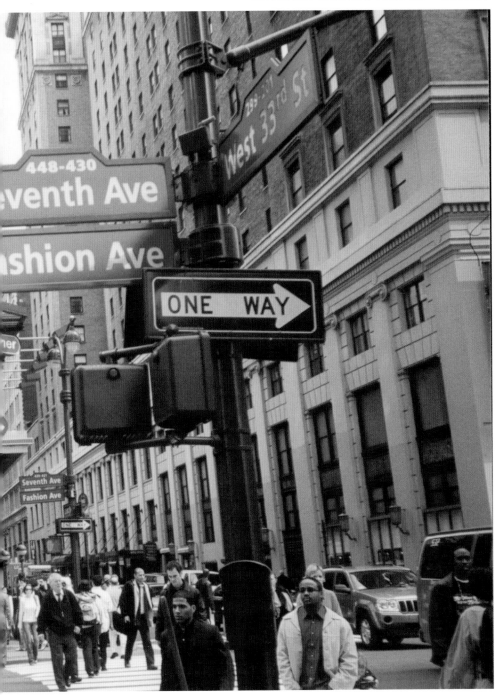

448-430
eventh Ave
ashion Ave

West 33rd St

ONE WAY

Seventh Ave
Fashion Ave

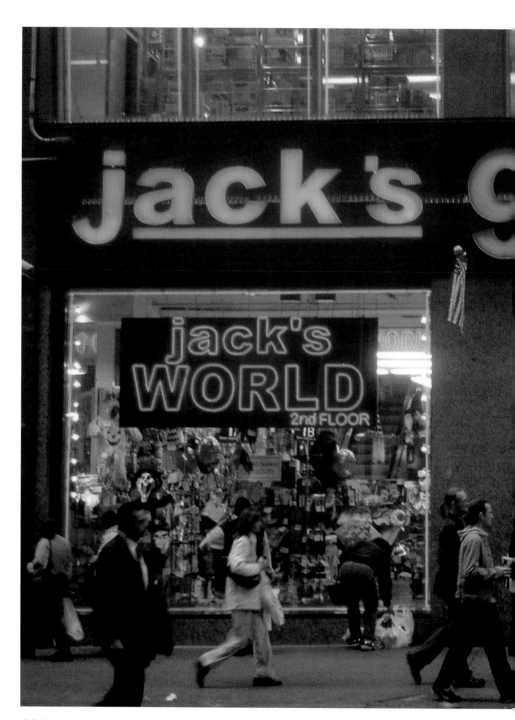

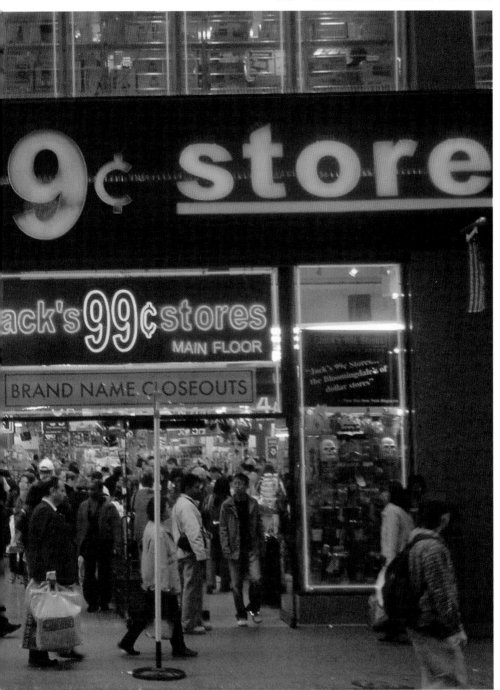

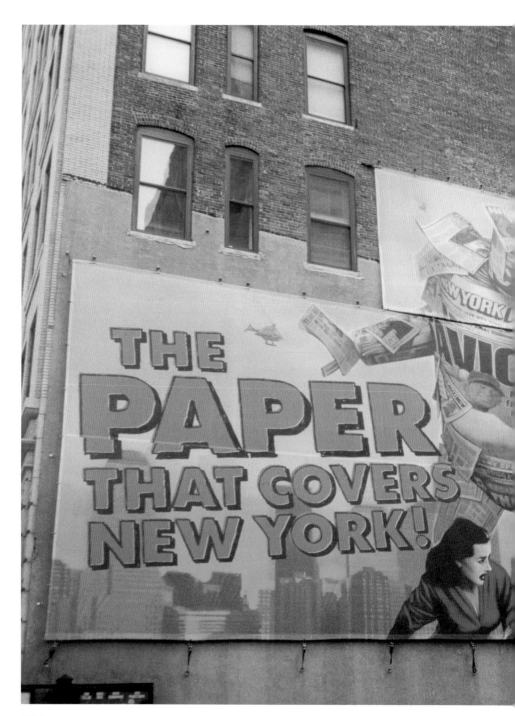

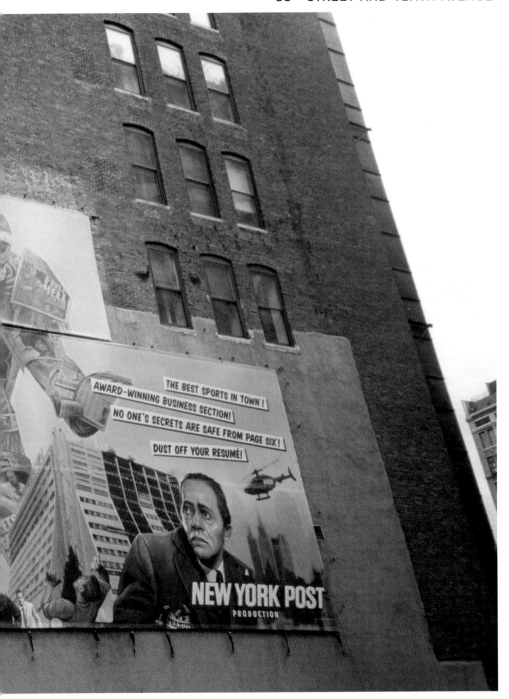

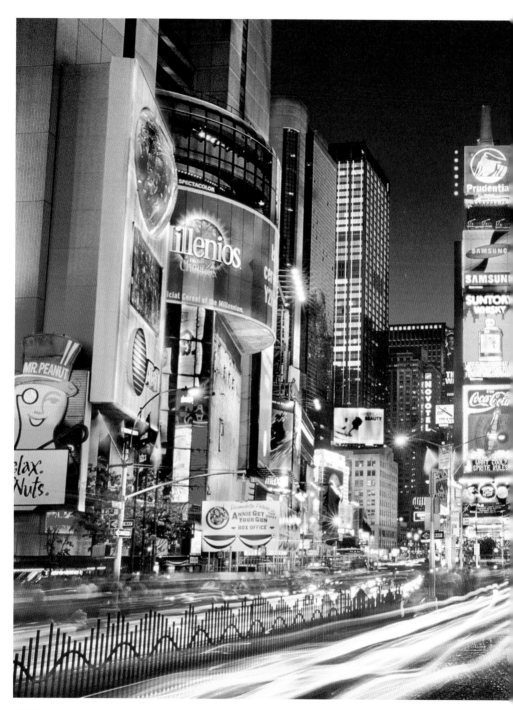

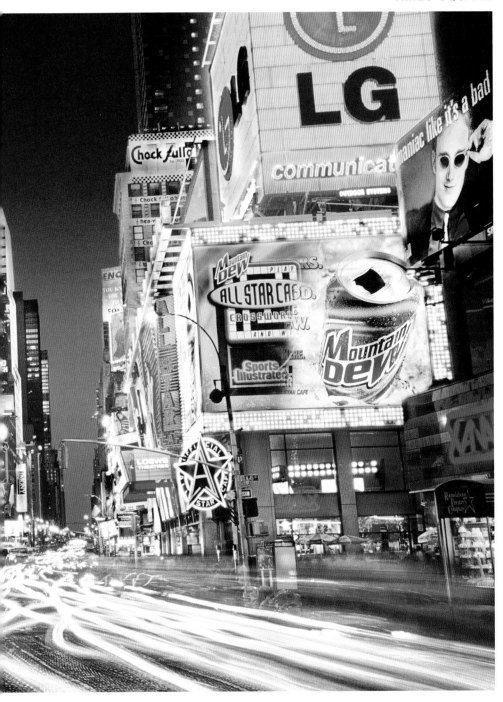

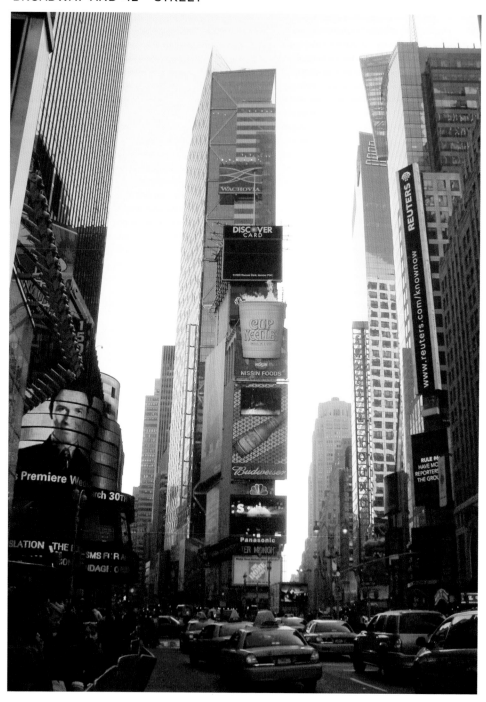

"Dollars! All their cares, hopes, joys, affections, virtues, and association seemed to be melted down into dollars. Whatever the chance contributions that fell into the slow cauldron of their talk, they made the gruel thick and slab with dollars."

Charles Dickens

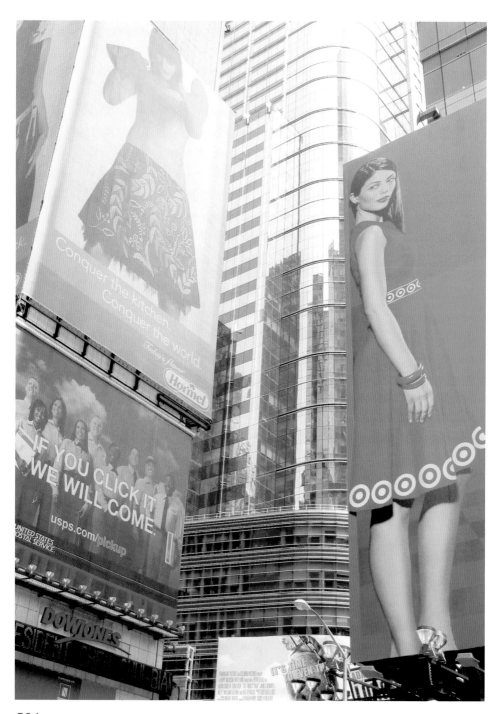

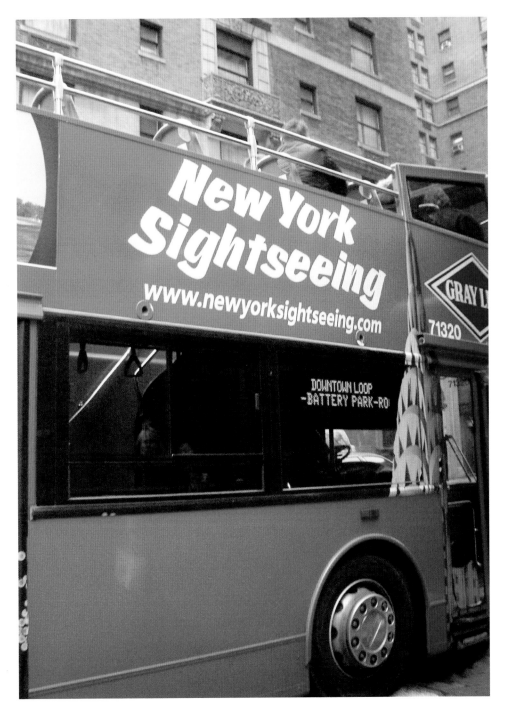

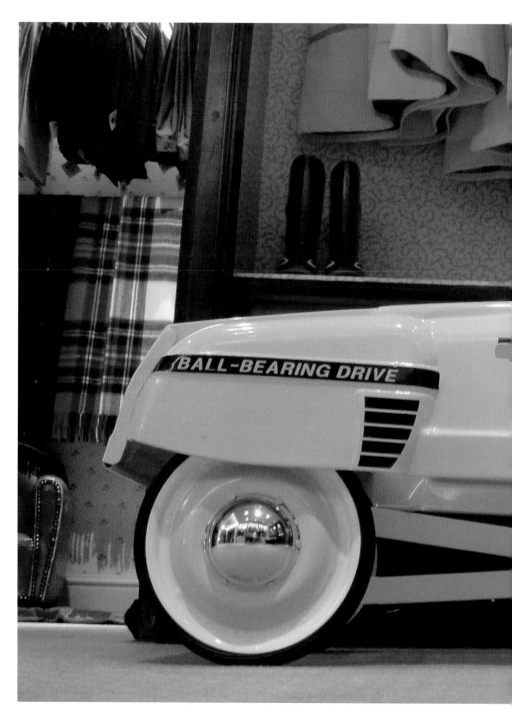

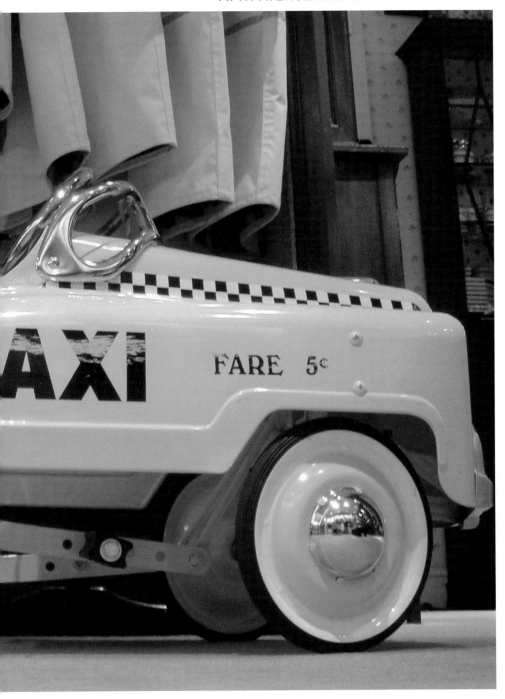

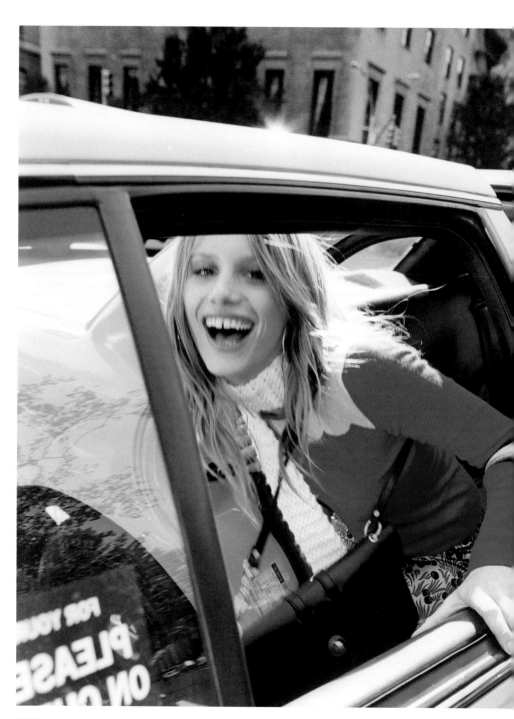

> **"**I regard it
> (Manhattan)
> as a curiosity:
> I don't let myself
> get caught
> in the wheels.**"**

Ludwig Bemelmans

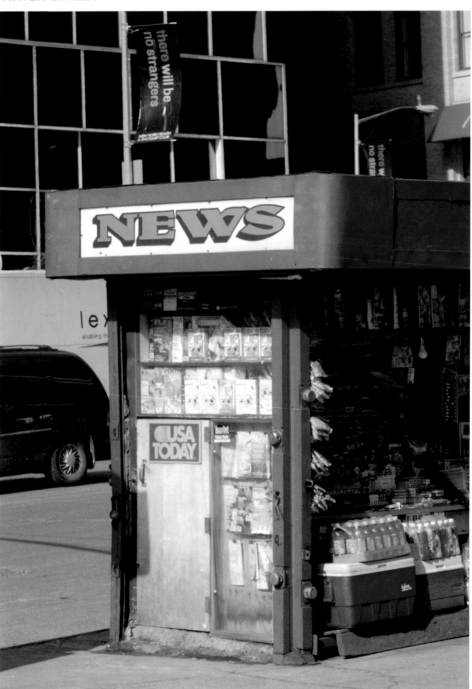

> **" In New York, people don't go to the theater-they go to see hits. "**
>
> Louis Jordan

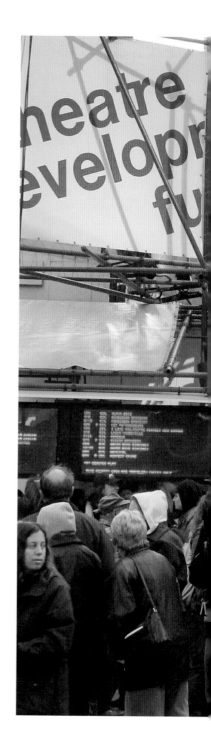

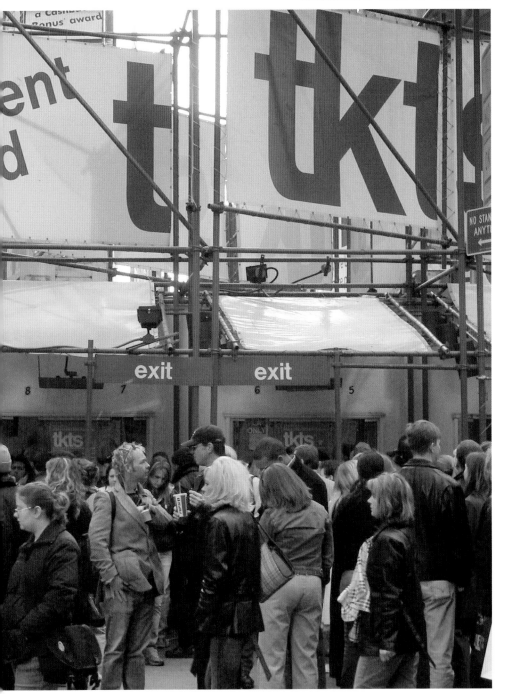

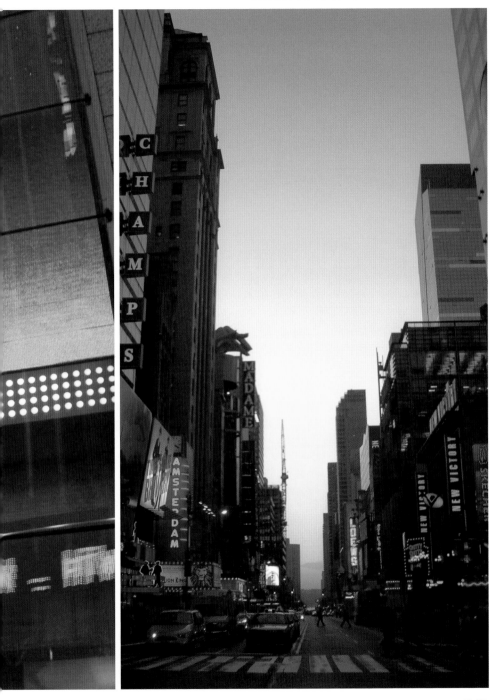

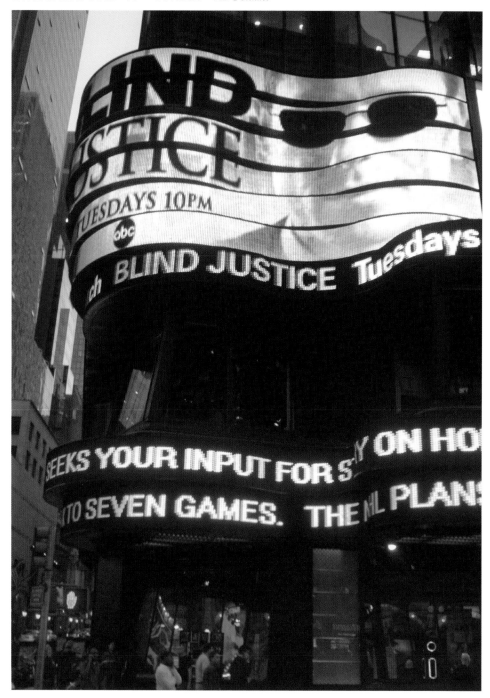

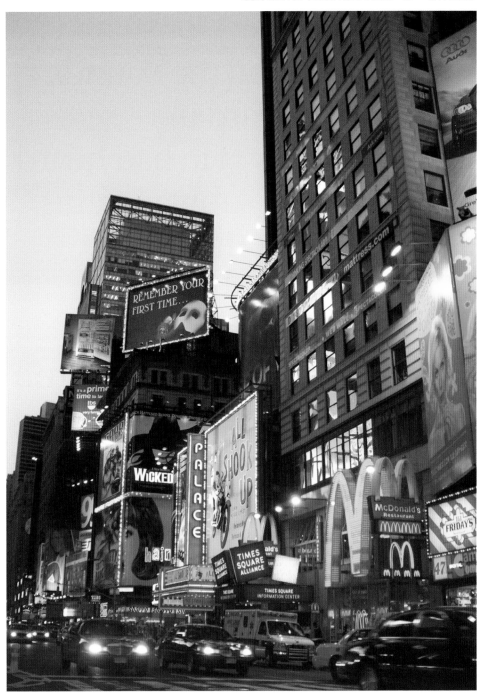

66 Now Tucker Mouse had heard almost all the sounds that can be heard in New York City. He had heard the rumble of subway trains and the shriek their iron wheels make when they go around a corner. From above, through the iron grilles that open onto the streets, he had heard the thrumming of the rubber tires of automobiles, and the hooting of their horns, and the howling of their brakes.

And he had heard the babble
of voices when the station
was full of human beings,
and the barking of the dogs
that some of them had on
leashes. Birds, the pigeons
of New York, and cats, and
even the high purring of
airplanes above the city
Tucker had heard.
But in all his days, and on all
his journeys through the
greatest city in the world,
Tucker had never heard
a sound quite like this one.""

George Selden, THE CRICKET IN TIMES SQUARE

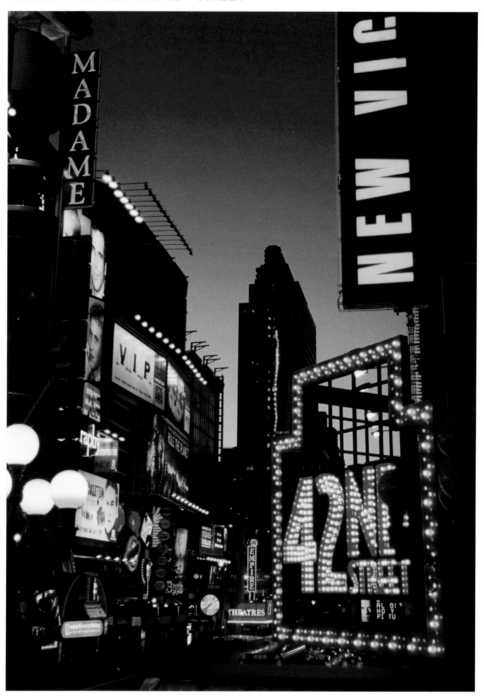

> **" And New York is the most beautiful city in the world? It is not far from it.
> No urban night is like the night there...
> Squares after squares of flame,
> set up and cut into the aether.
> Here is our poetry, for we have pulled down the stars to our will. "**
>
> Ezra Pound

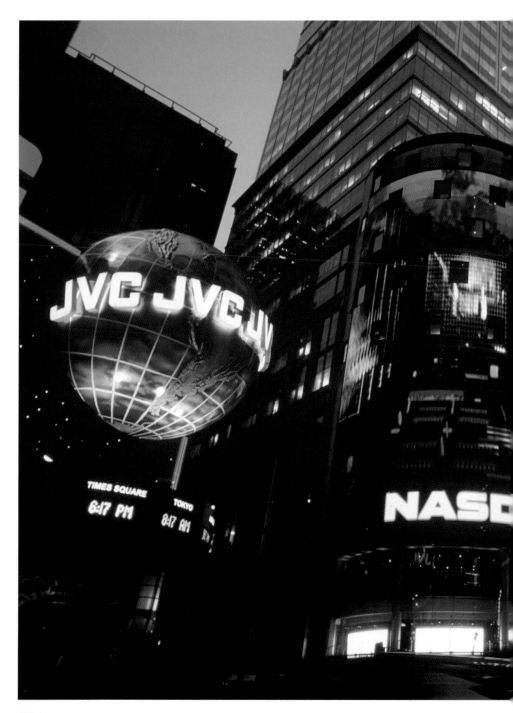

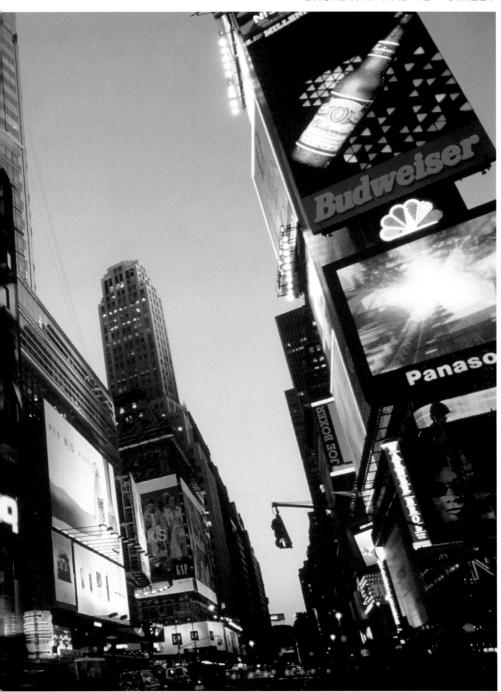

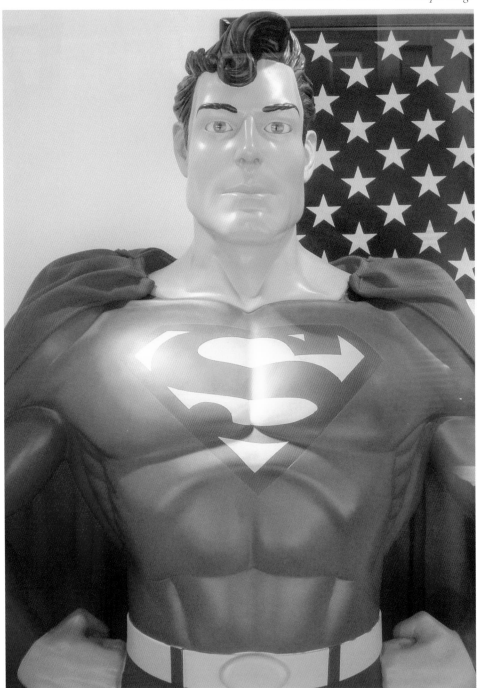

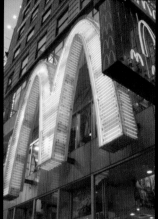

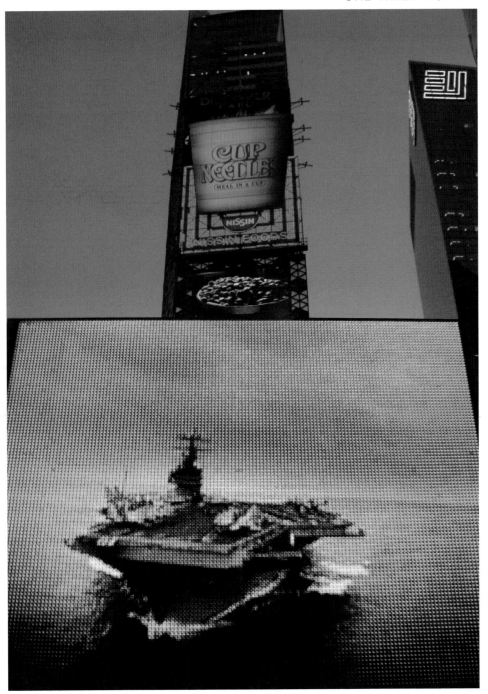

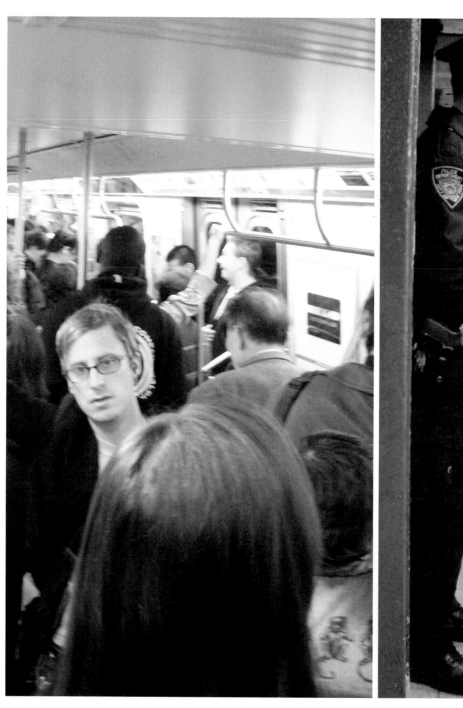

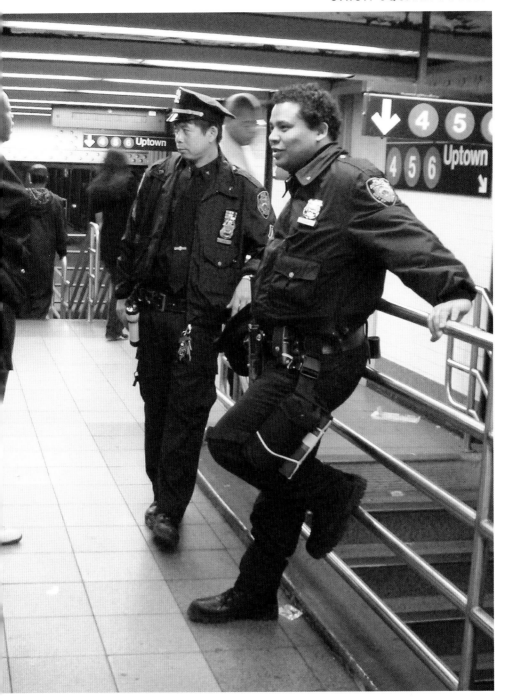

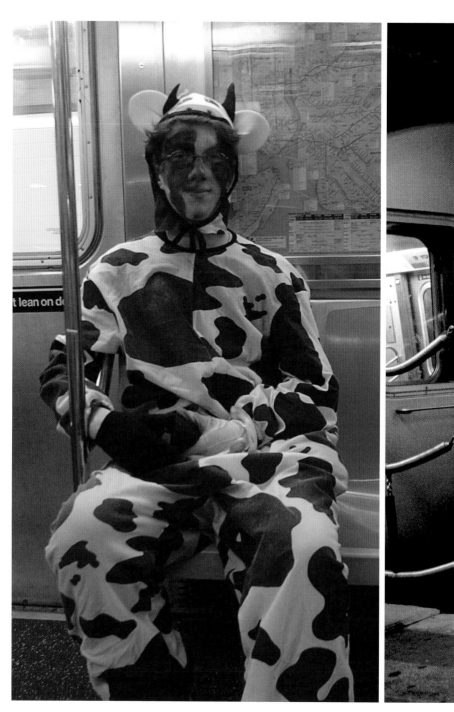

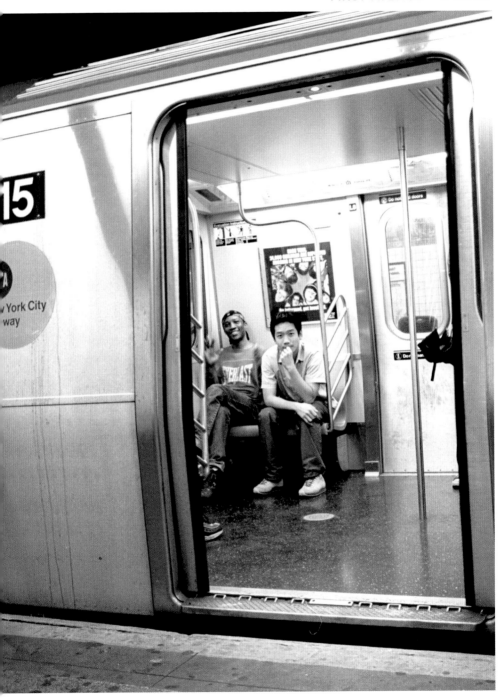

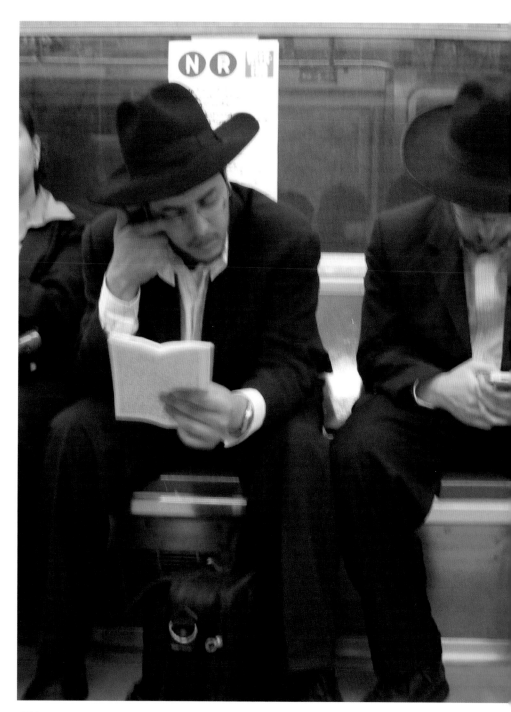

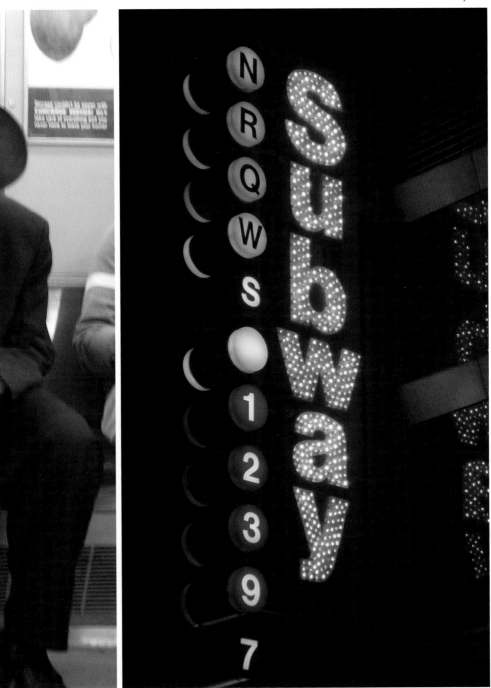

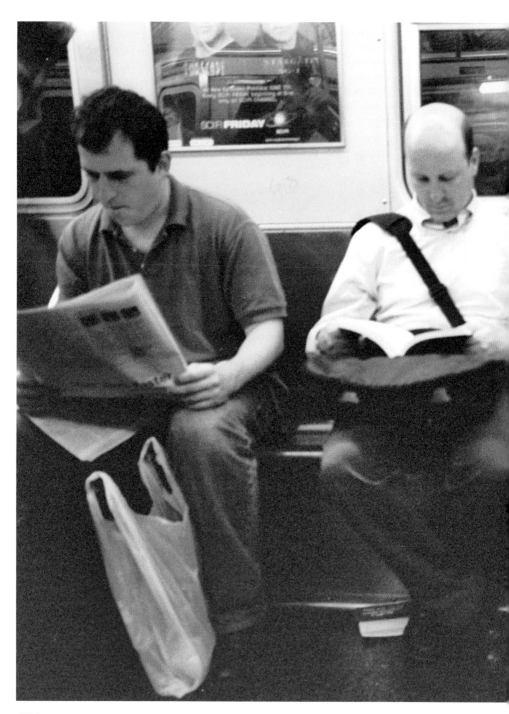

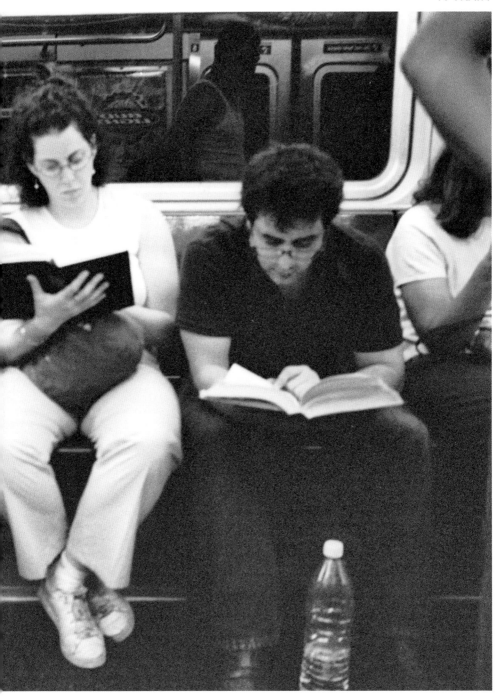

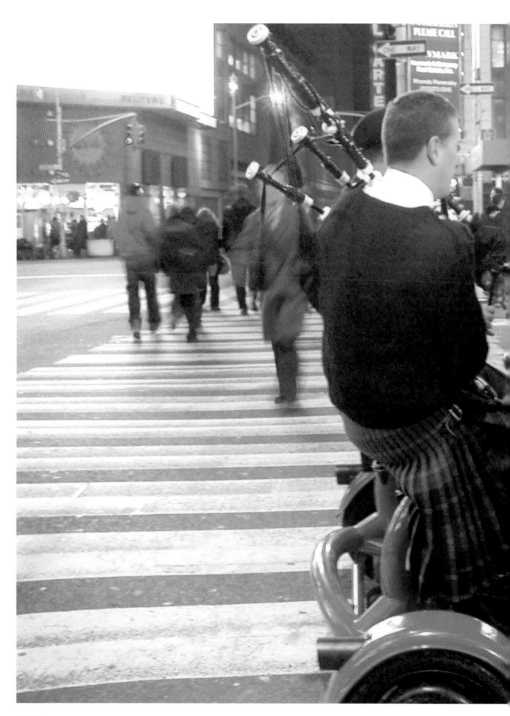

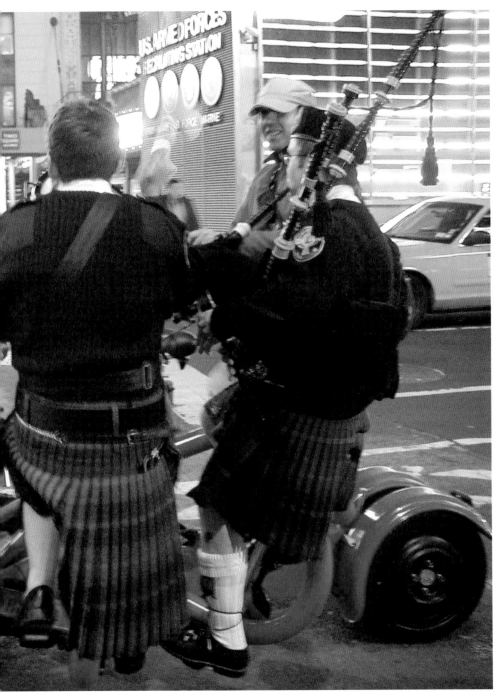

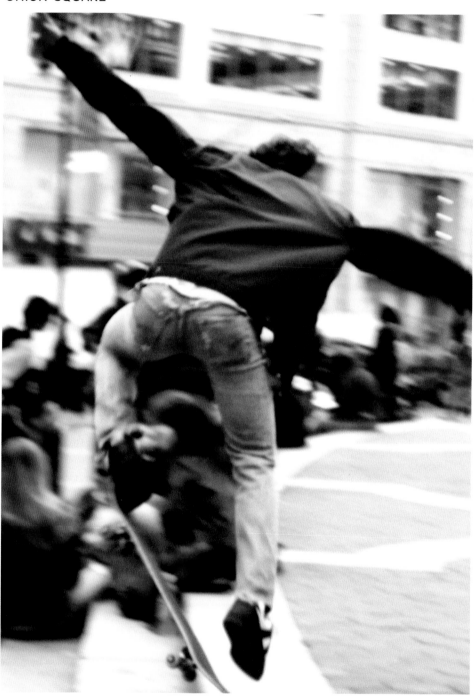

66 I miss the animal buoyancy
of New York, the animal vitality.
I did not mind that it had
no meaning and no depth. **99**

Anaïs Nin

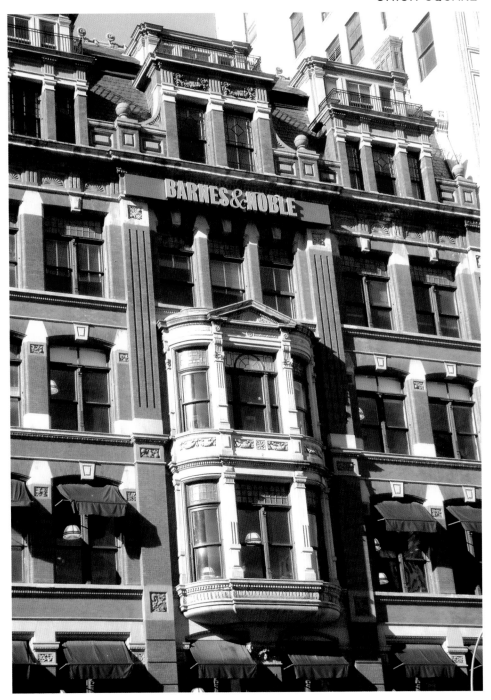

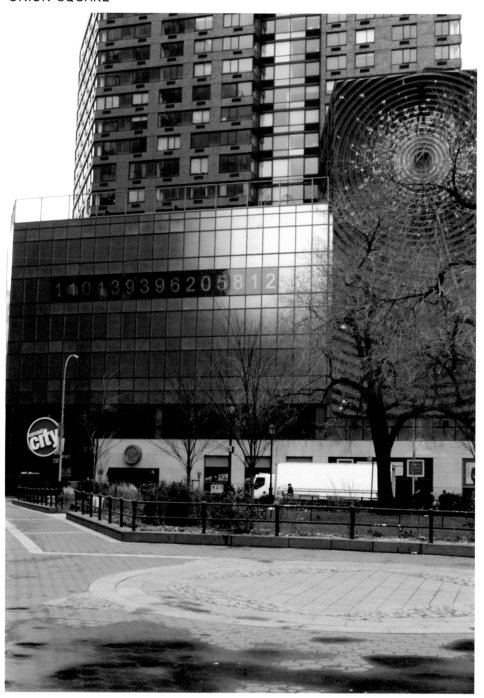

66 In Boston they ask how much does he know?
In New York, how much is he worth?
In Philadelphia, who were his parents? **99**

Mark Twain

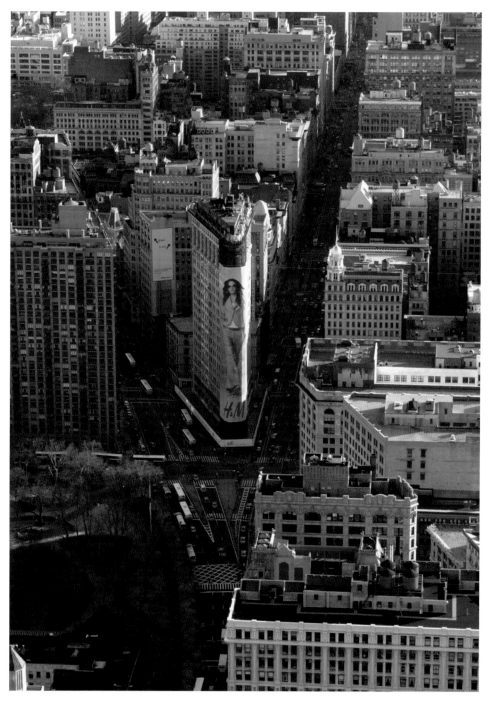

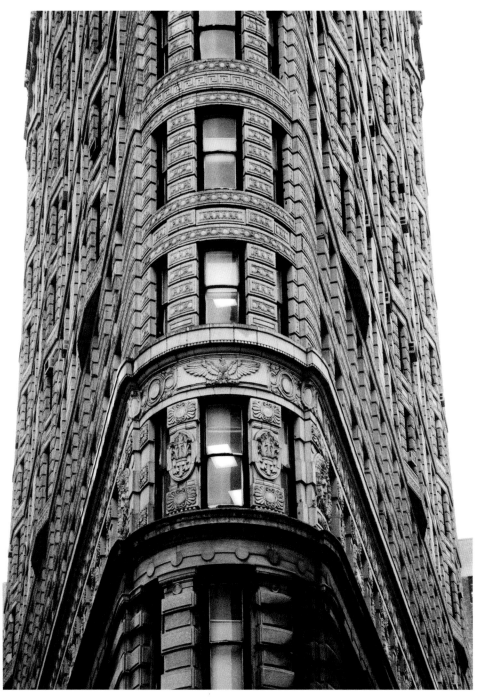

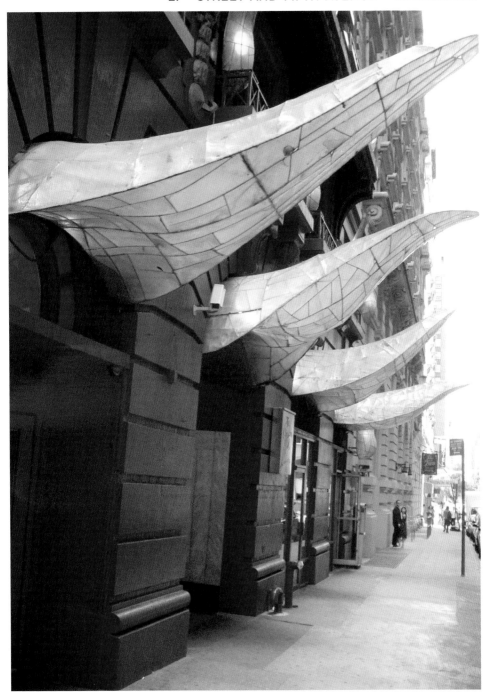

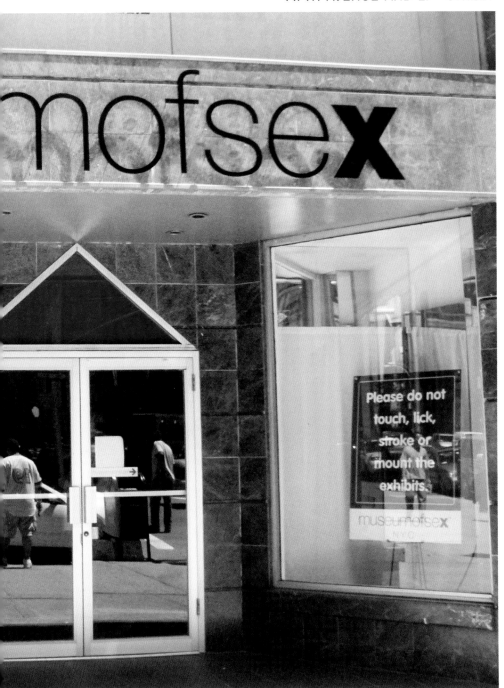

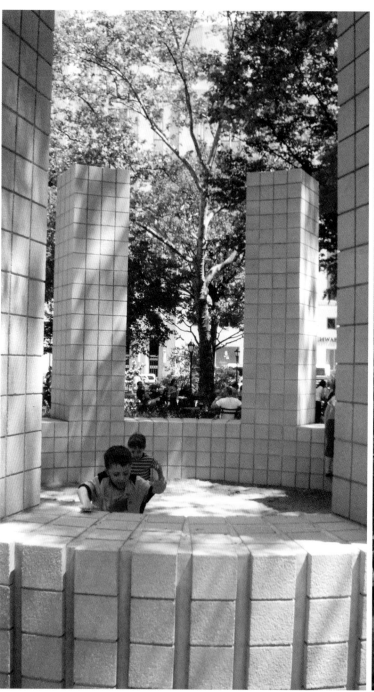

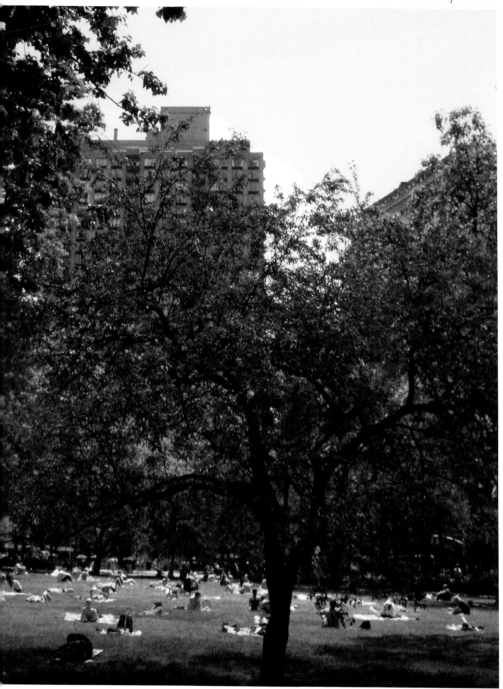

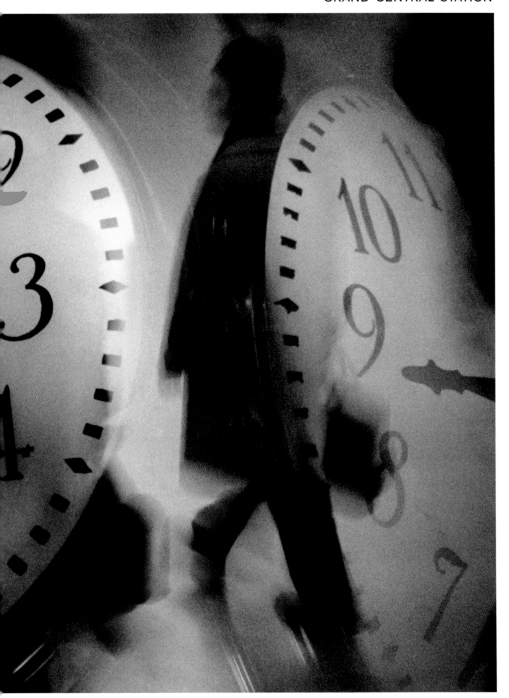

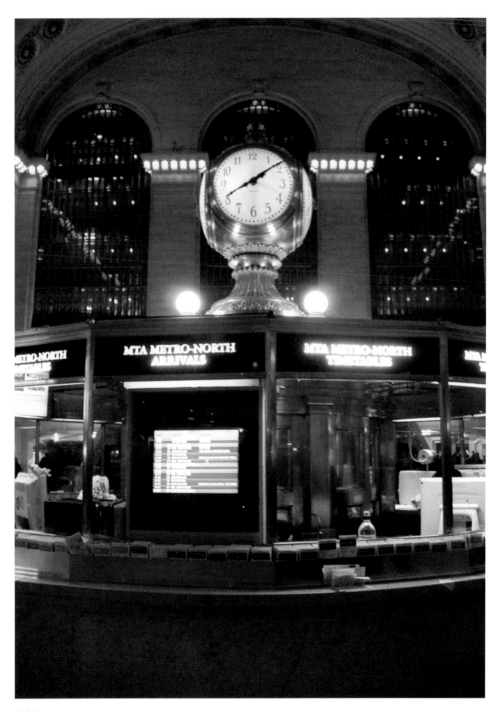

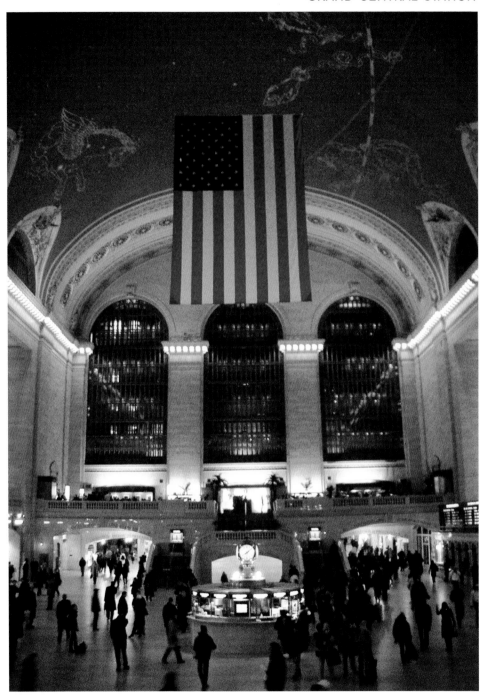

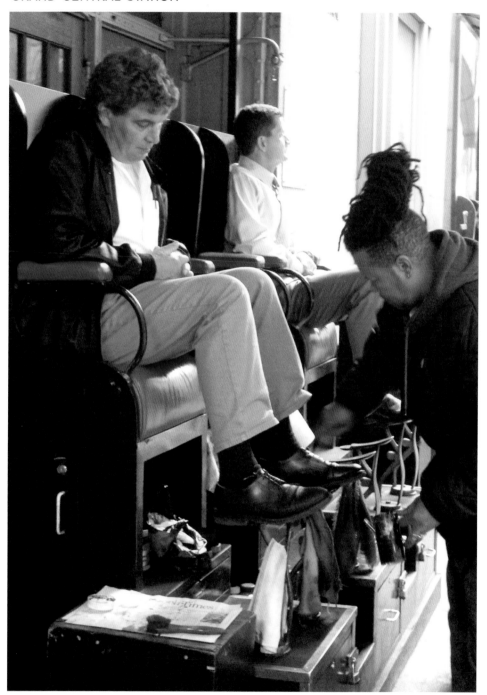

❝ In dress, habits, manners, provincialism, routine and narrowness, he acquired that charming insolence, that irritating completeness, that sophisticated crassness, that overbalanced poise that make the Manhattan gentleman so delightfully small in his greatness. **❞**

O. Henry

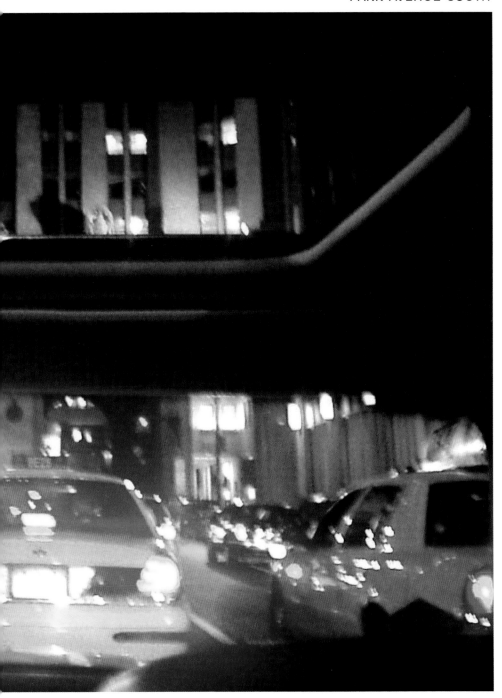

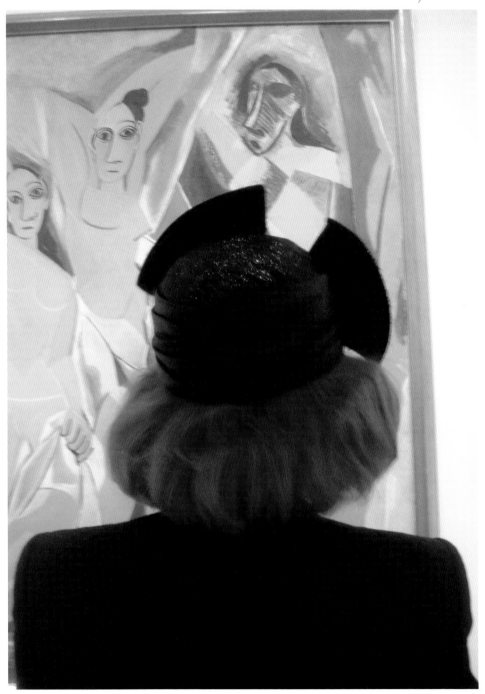

66 It'll be a great place
if they ever finish it. **99**

O.Henry

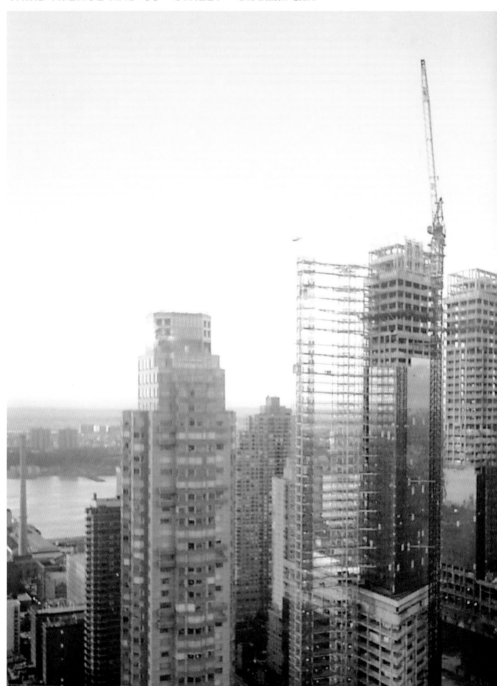

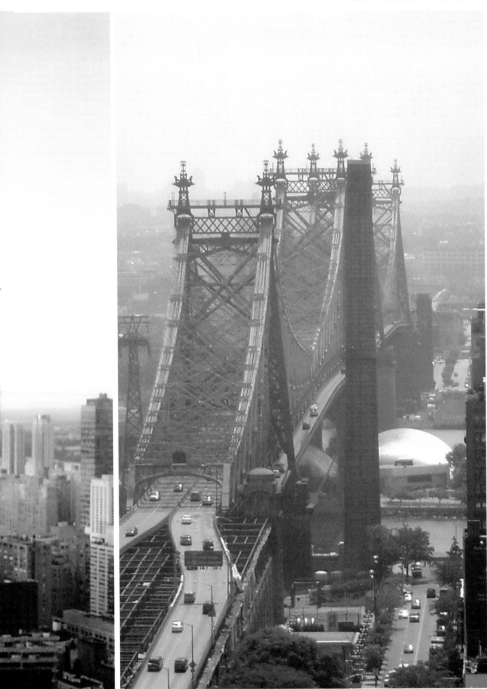

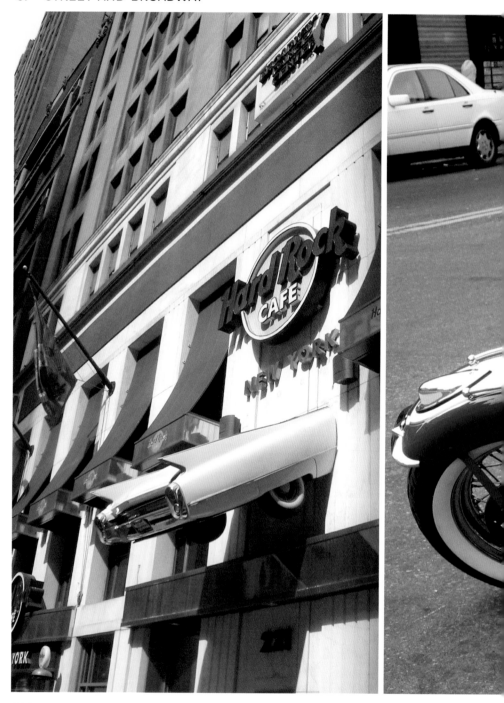

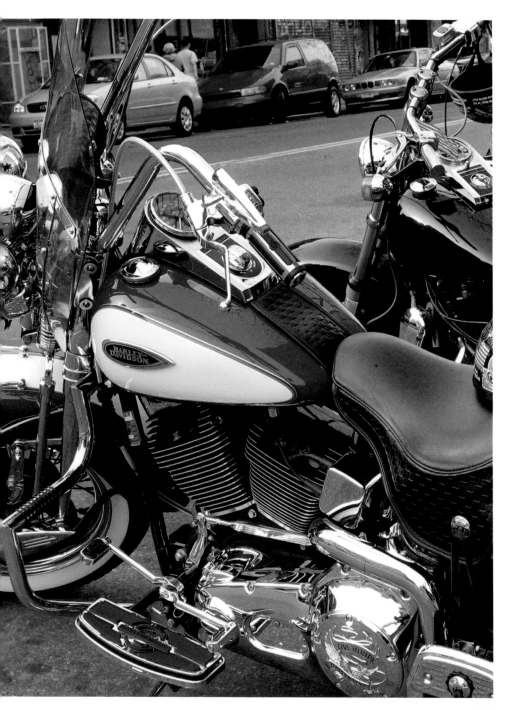

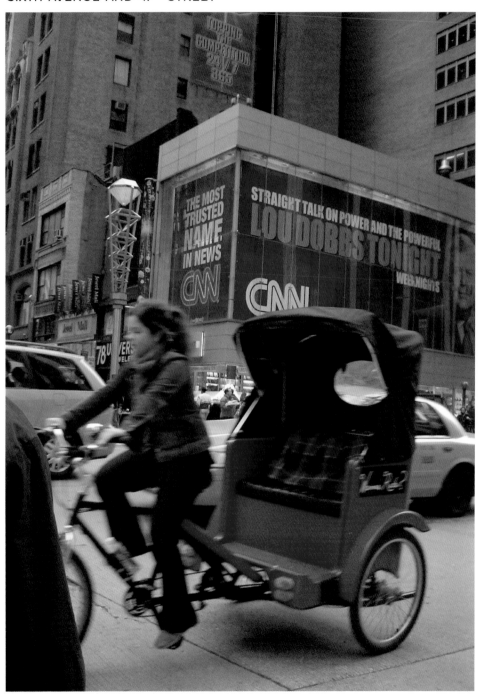

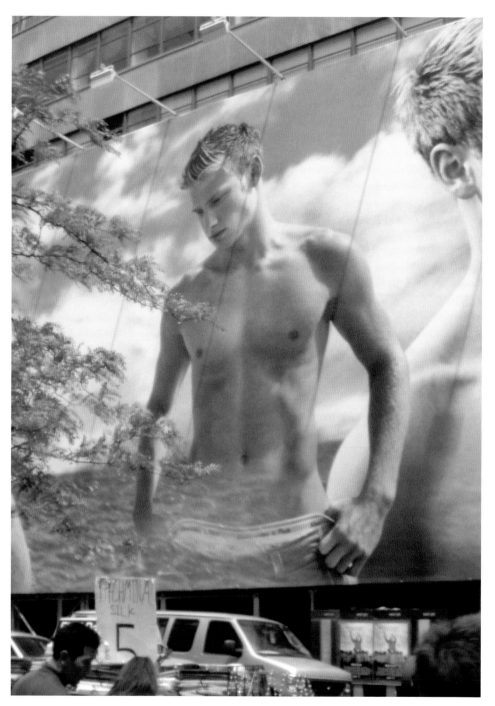

616

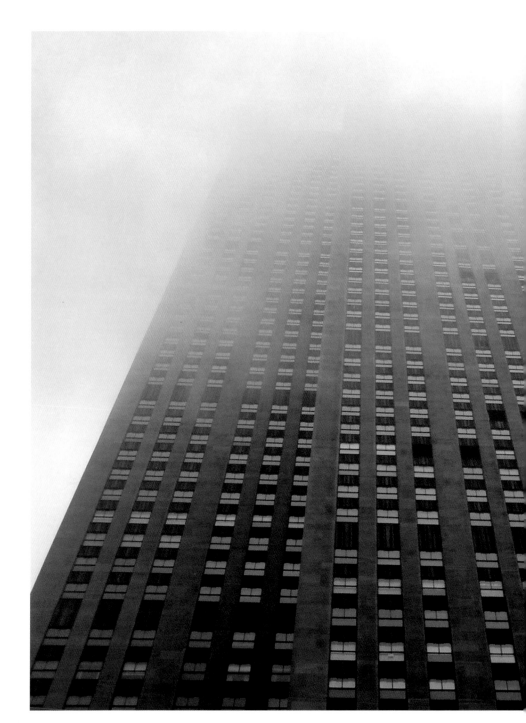

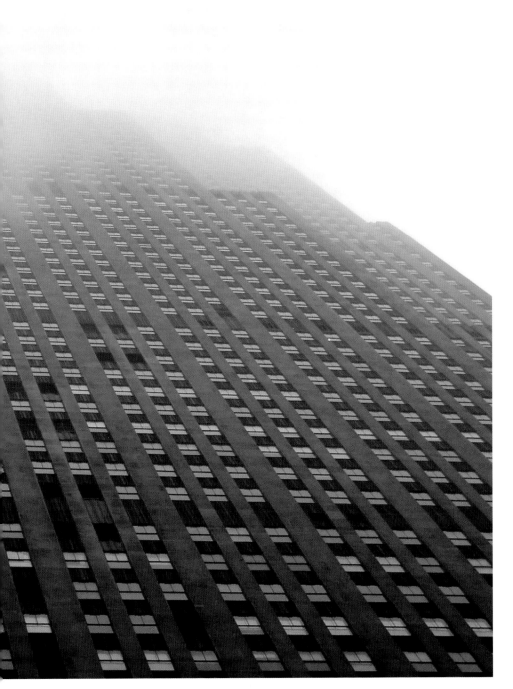

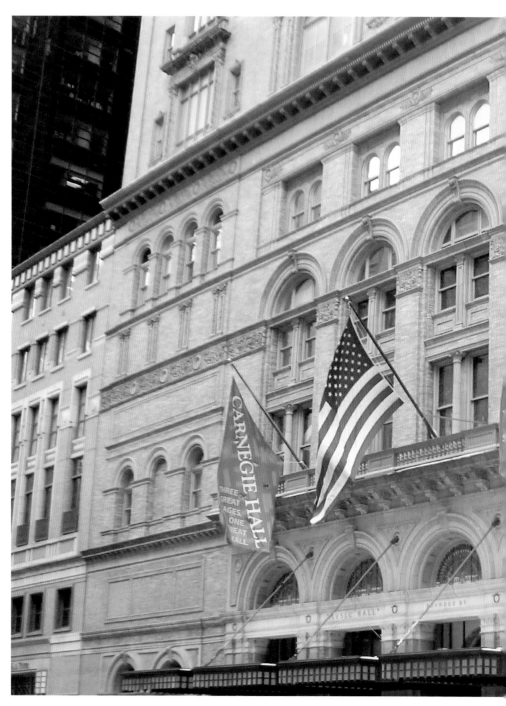

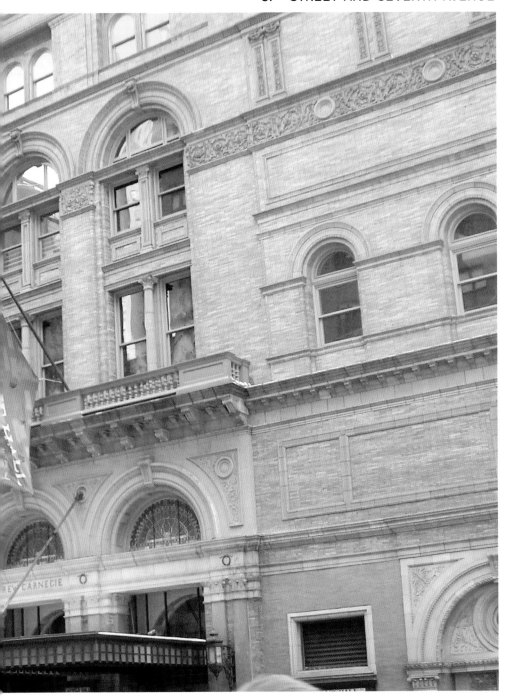

66 New York is
where the future
comes to audition.**99**

Ed Koch

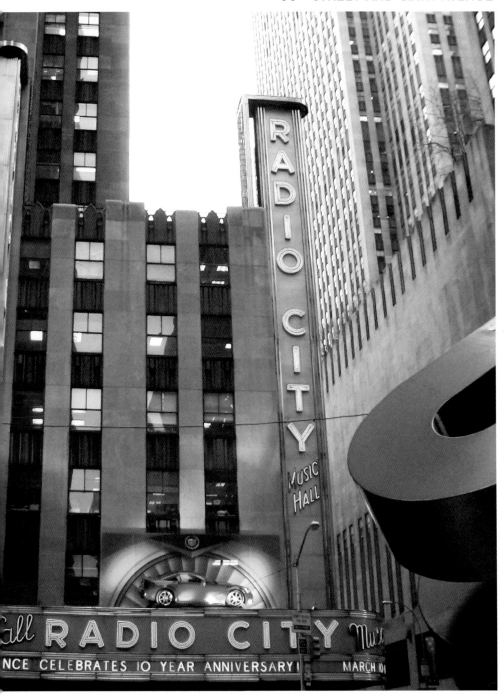

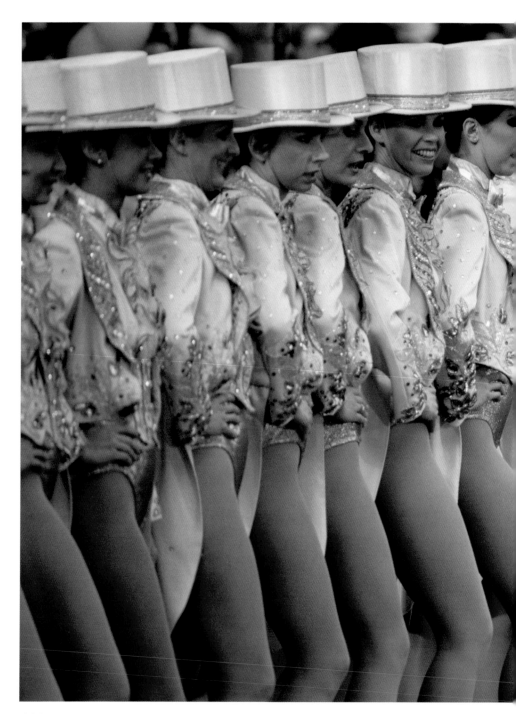

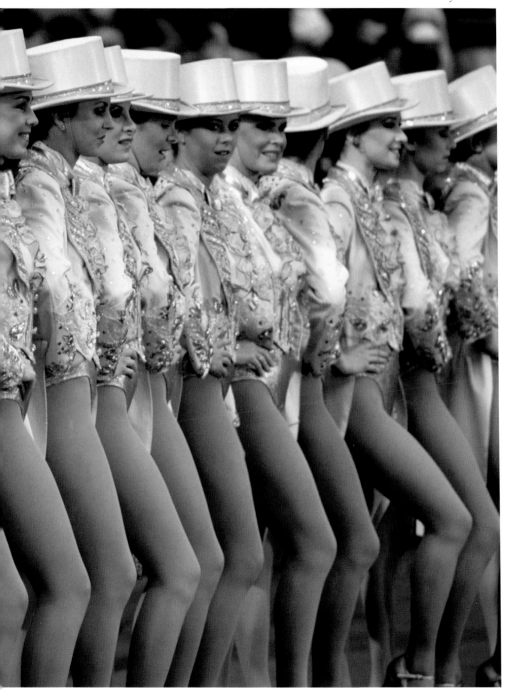

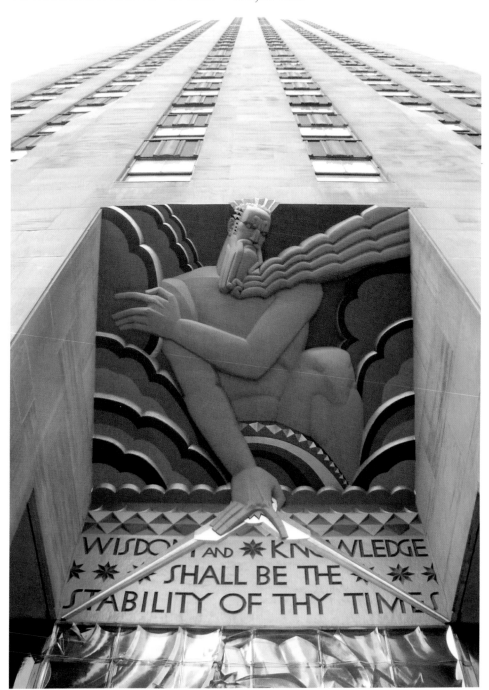

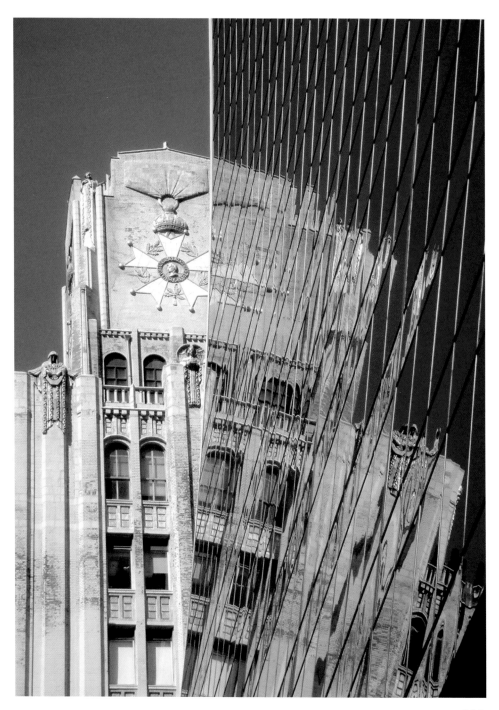

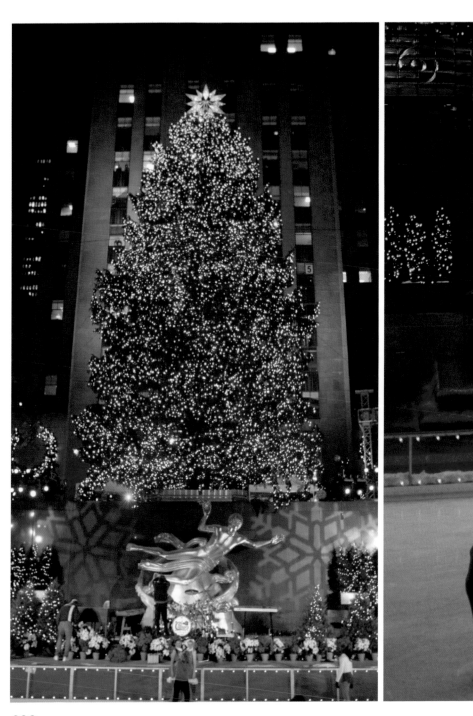

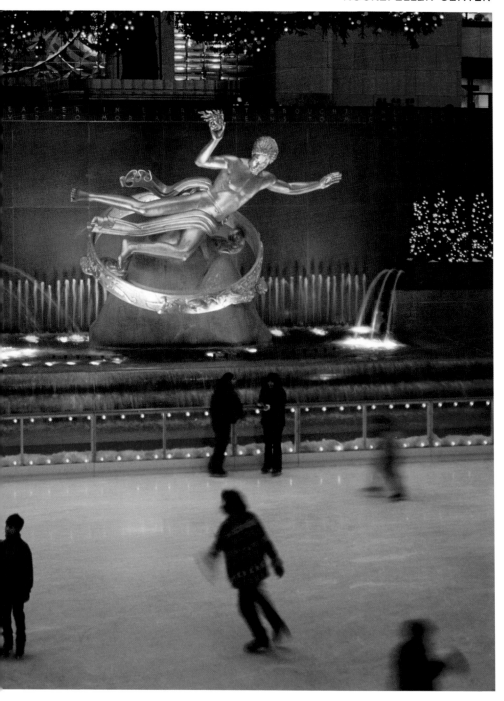

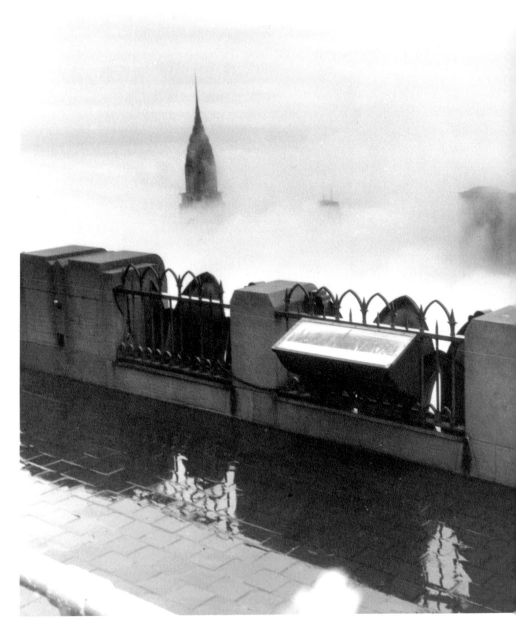

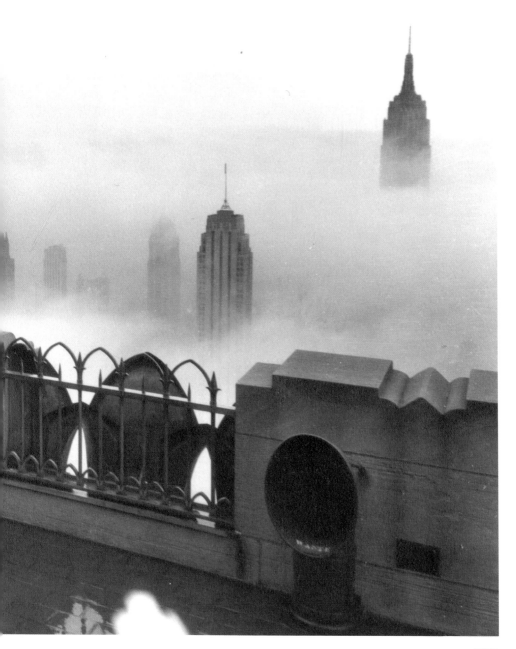

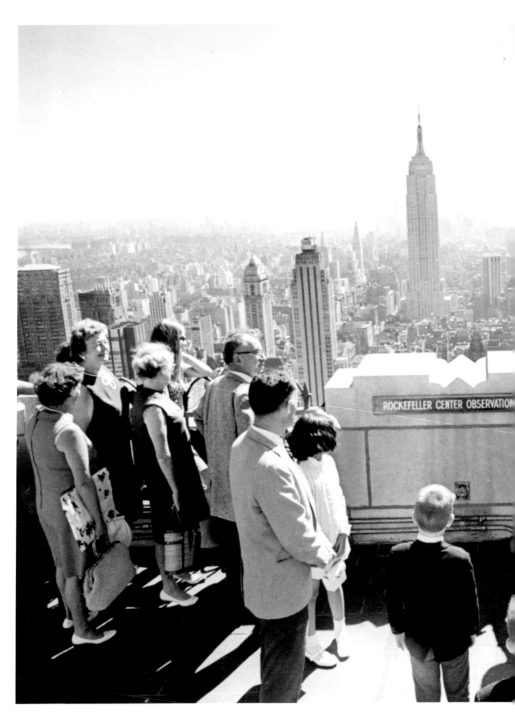

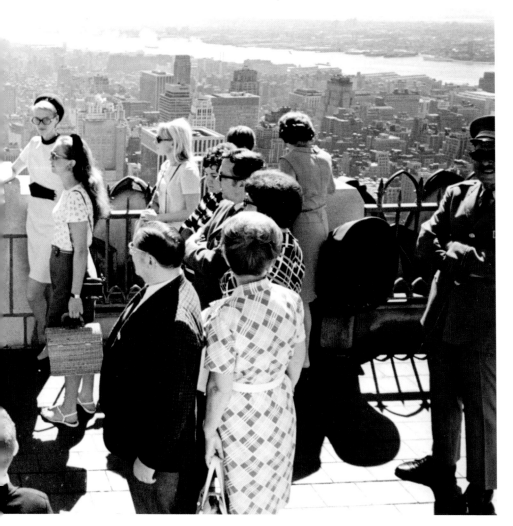

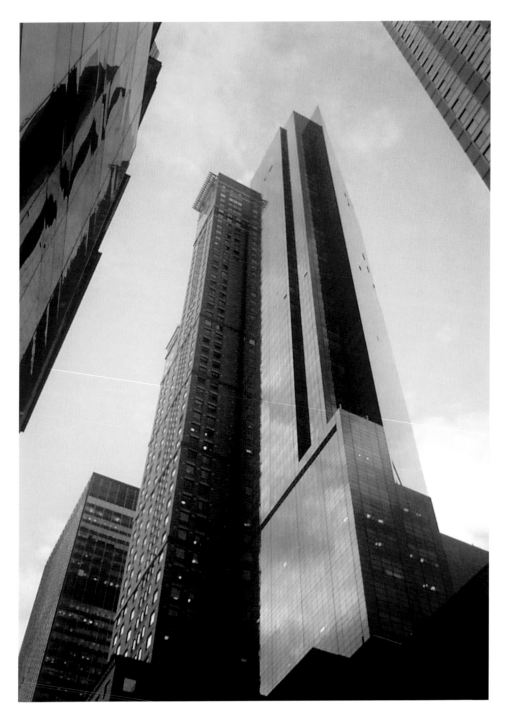

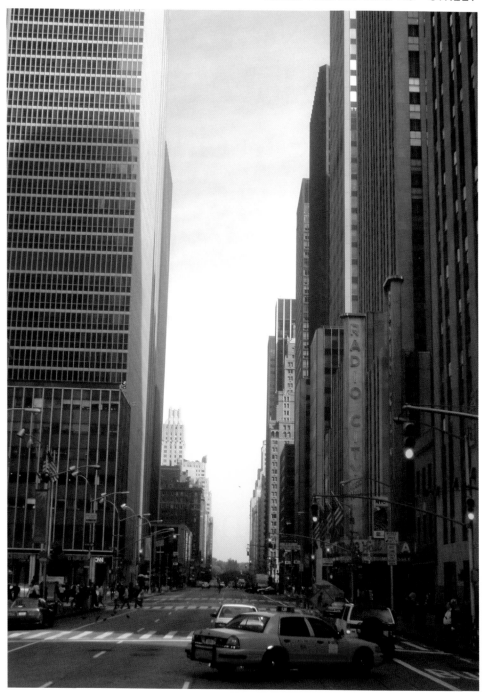

"I love New York City.
I came to love its sky.
In European cities,
the roofs are low and
the sky crawls at ground
level, to the point where
it looks tamed.
The sky in New York
City is beautiful because
it seems pushed far
away from our heads
by skycrapers.

(...) Beauty is there for everyone.
And so is nature, and what appears to be the sky of all America.
Nowhere else will you feel better the simultaneity of human lives.**"**

Jean-Paul Sartre

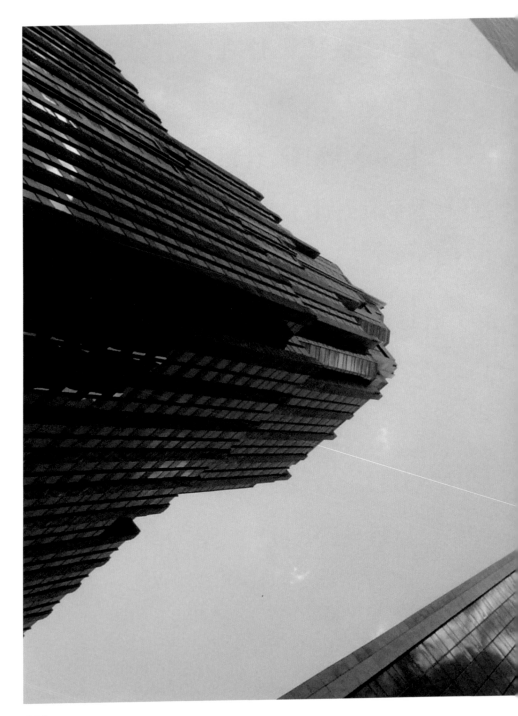

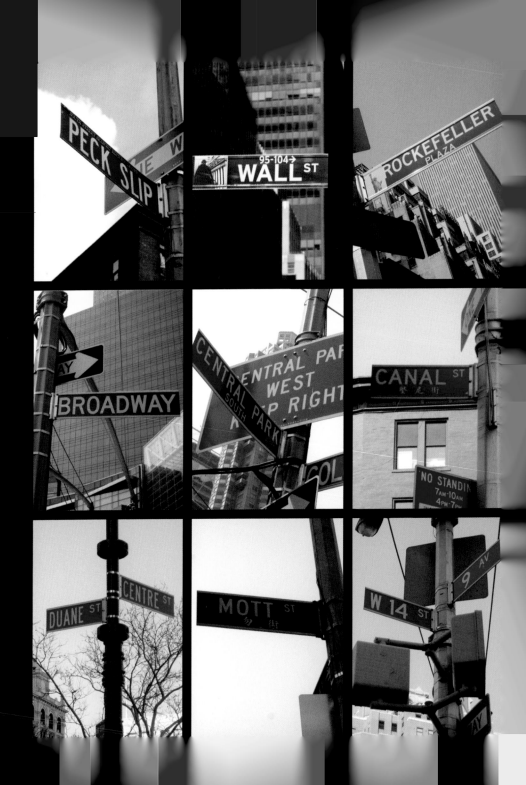

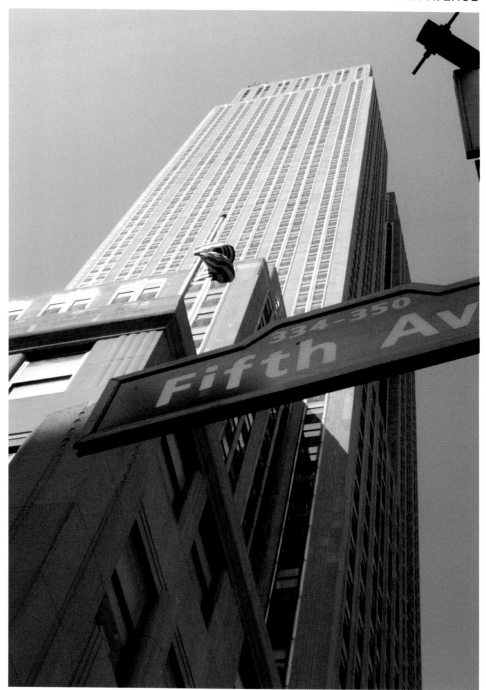

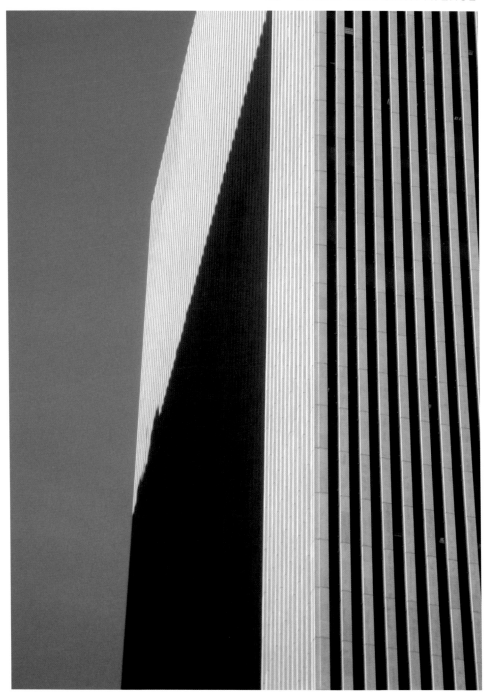

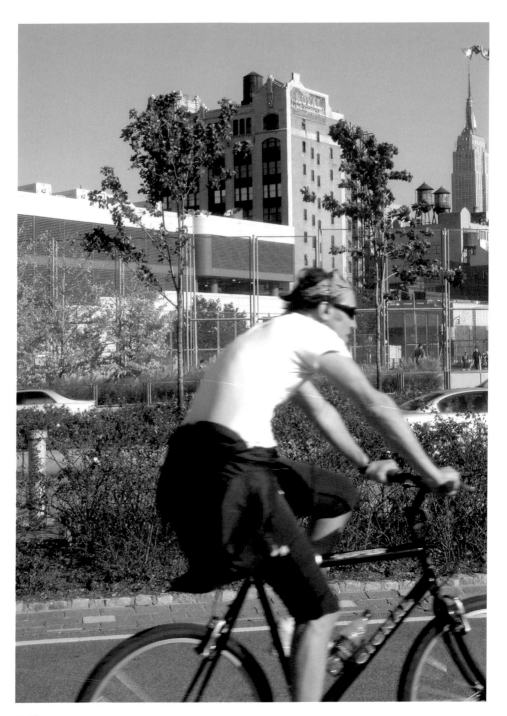

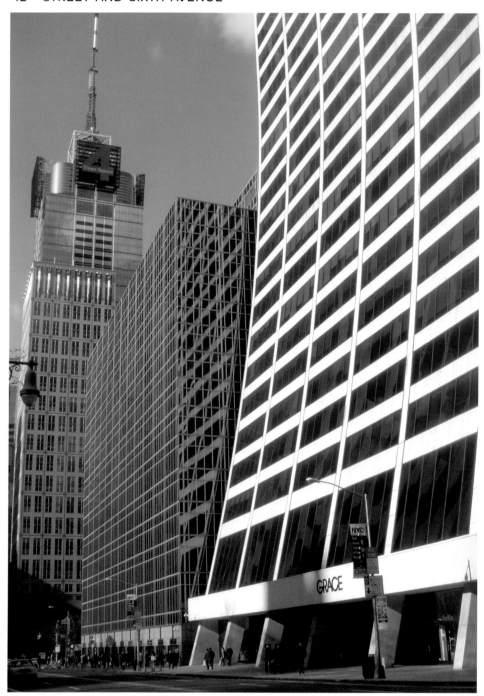

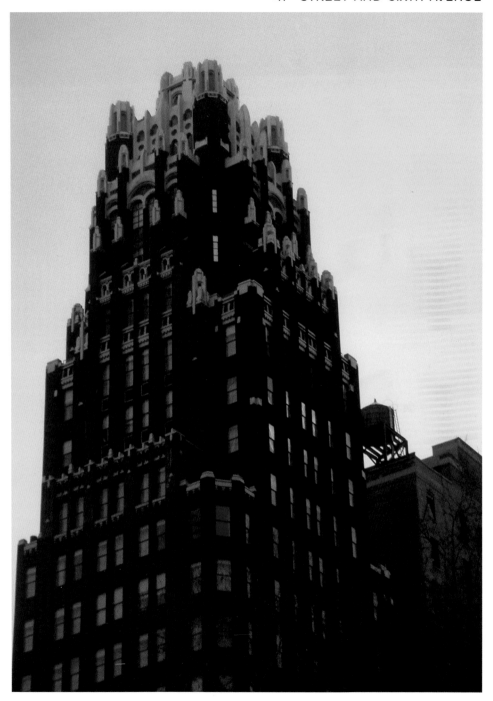

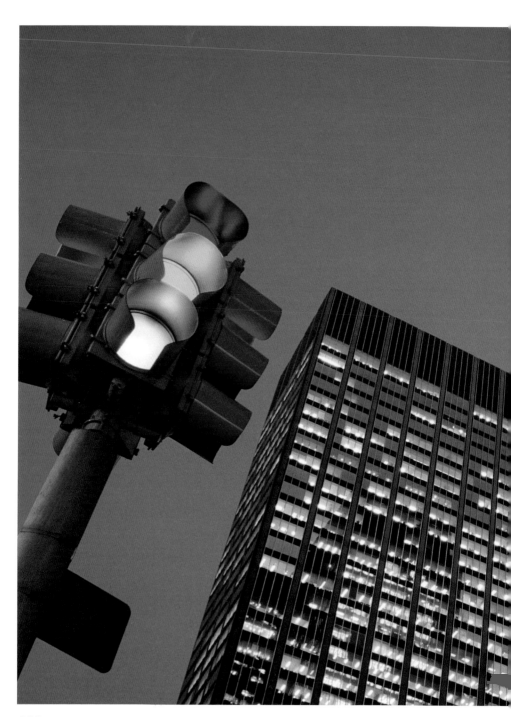

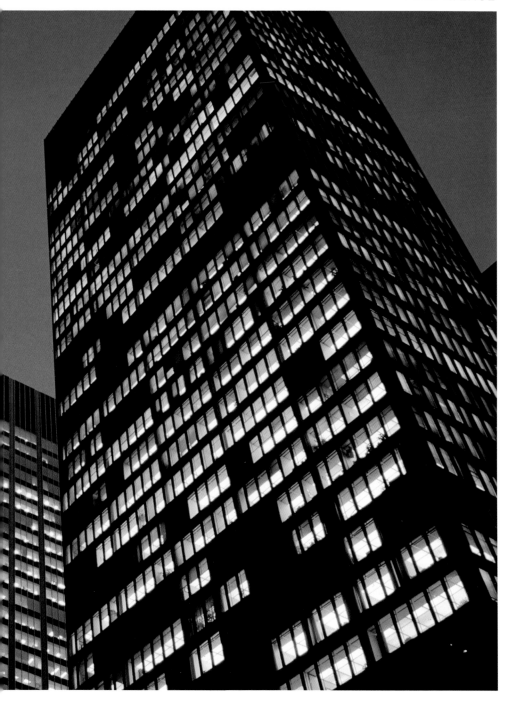

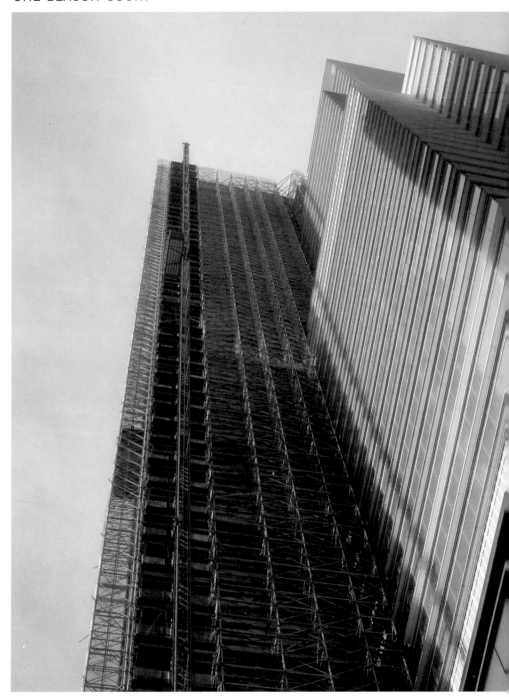

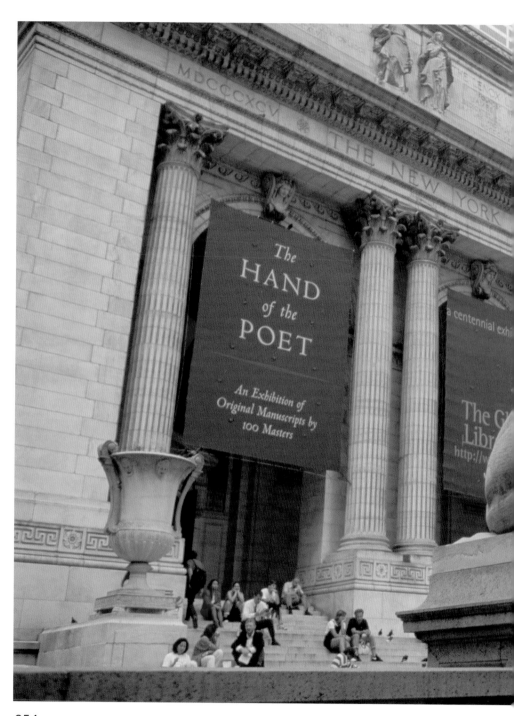

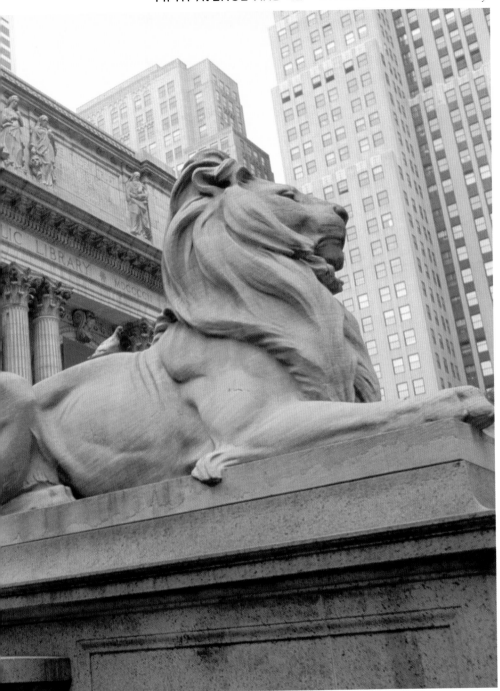

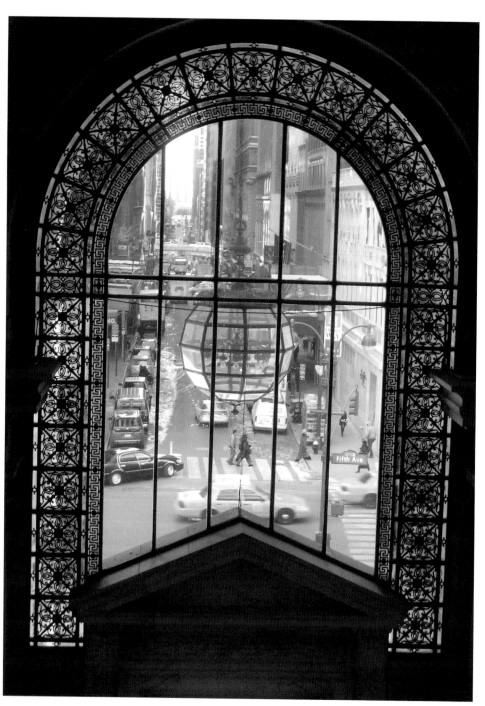

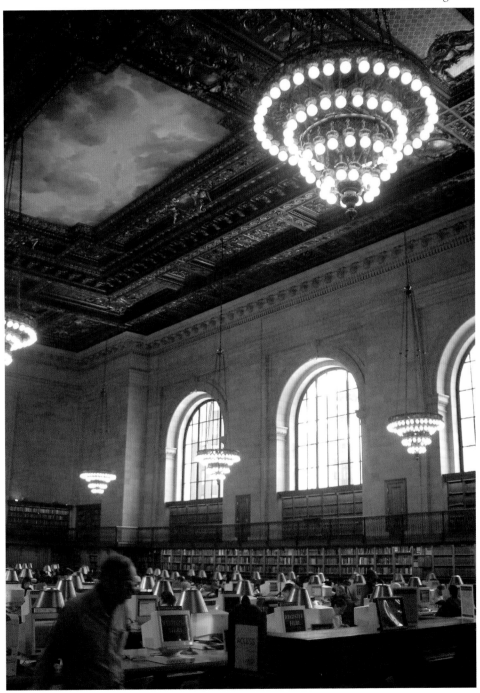

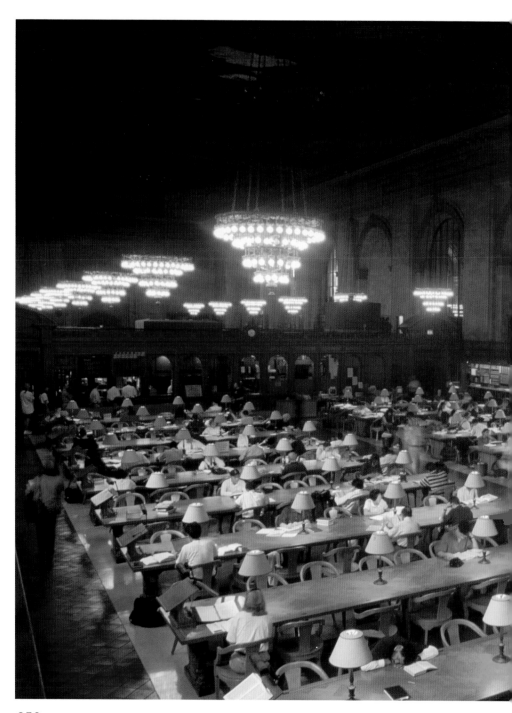

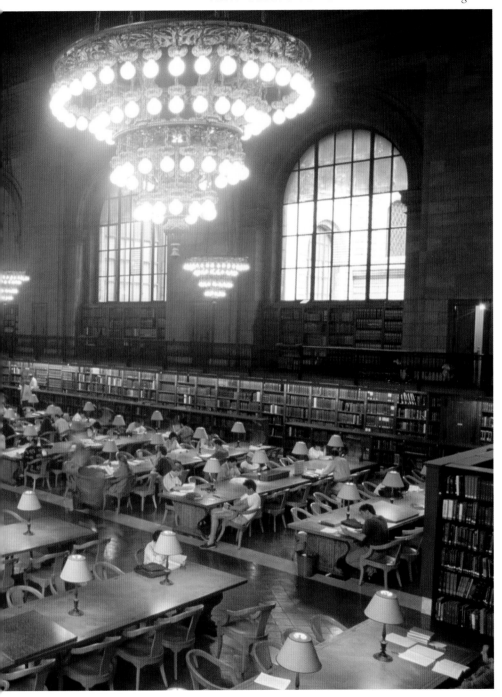

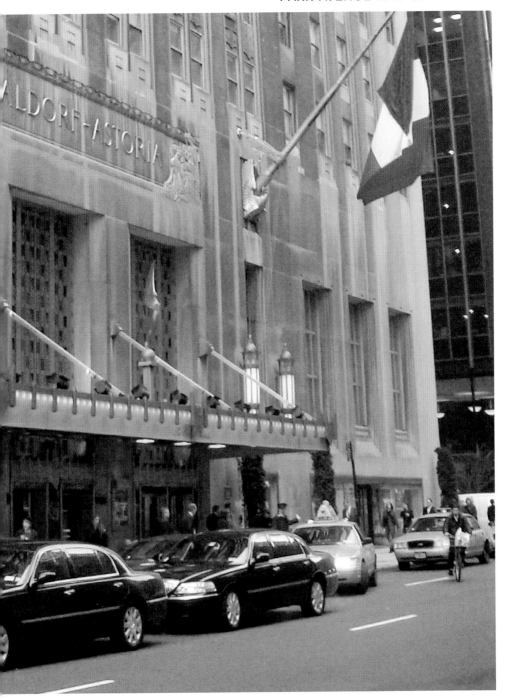

"The whole world revolves around New York. Very little happens anywhere unless someone in New York presses the button."

Duke Ellington

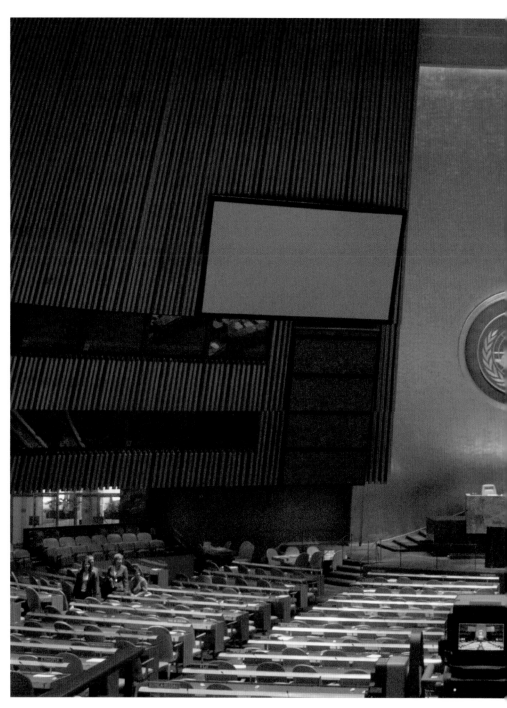

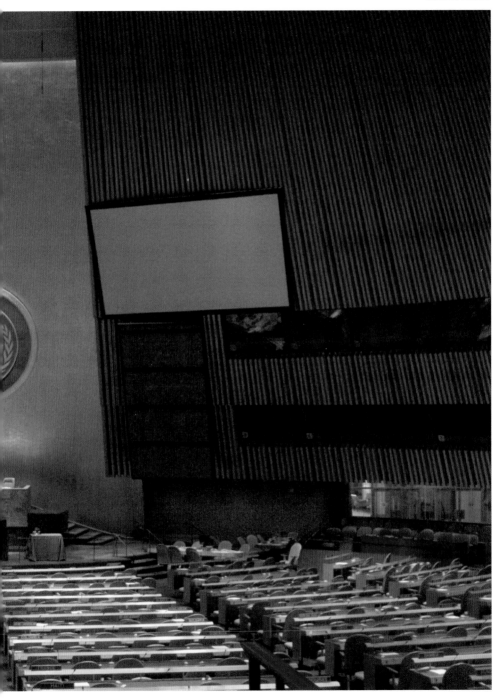

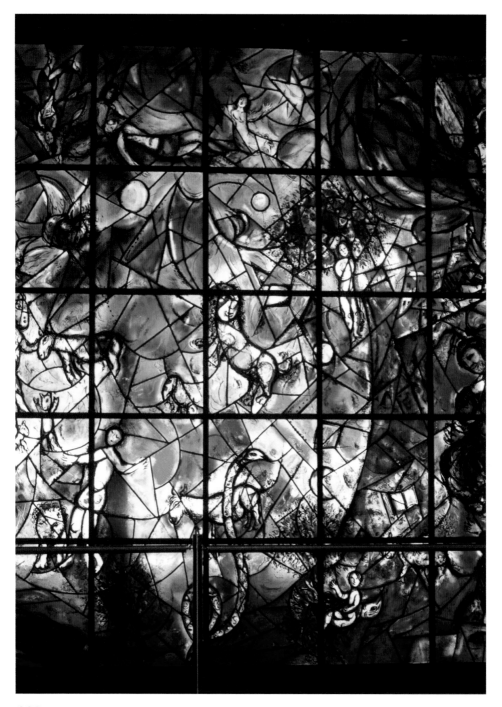

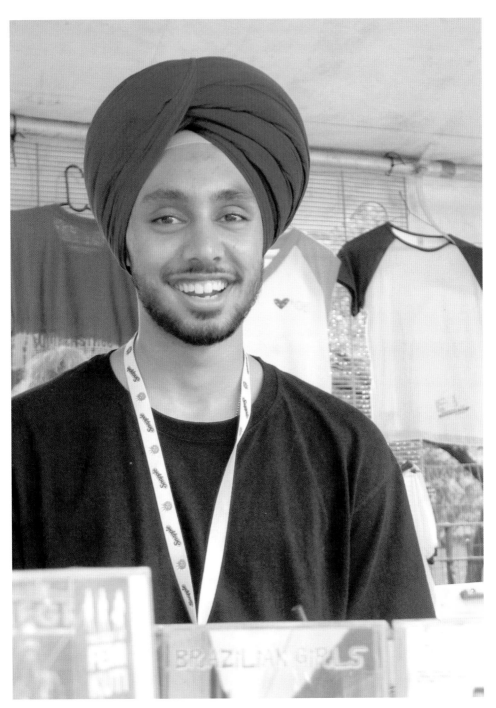

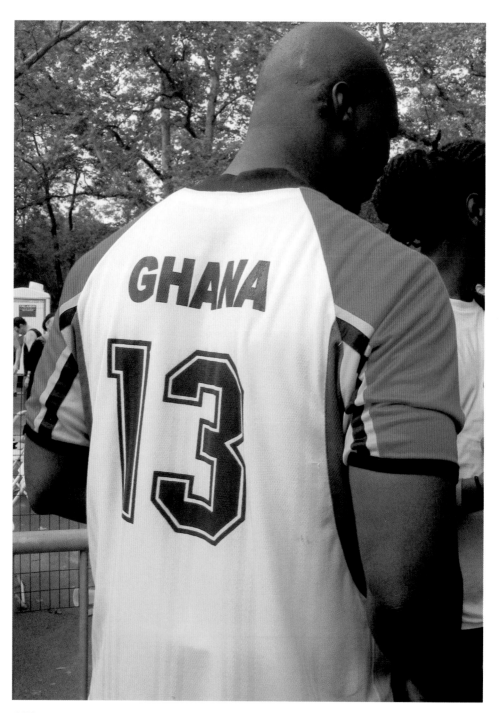

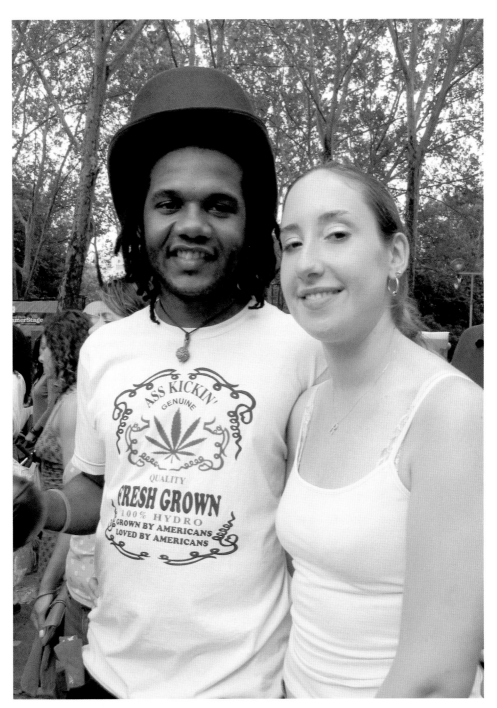

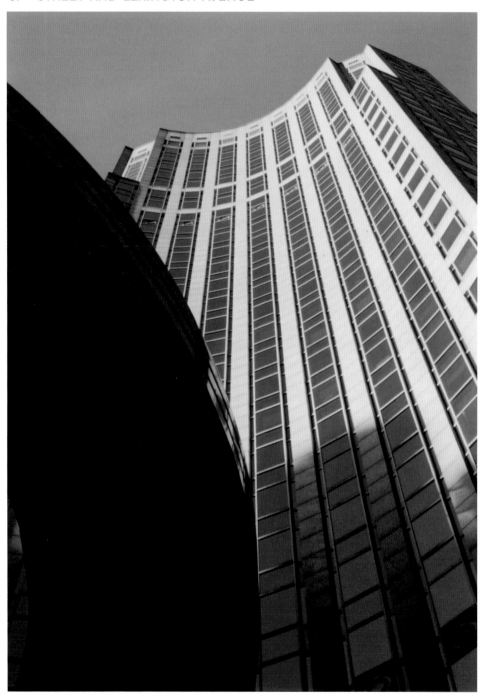

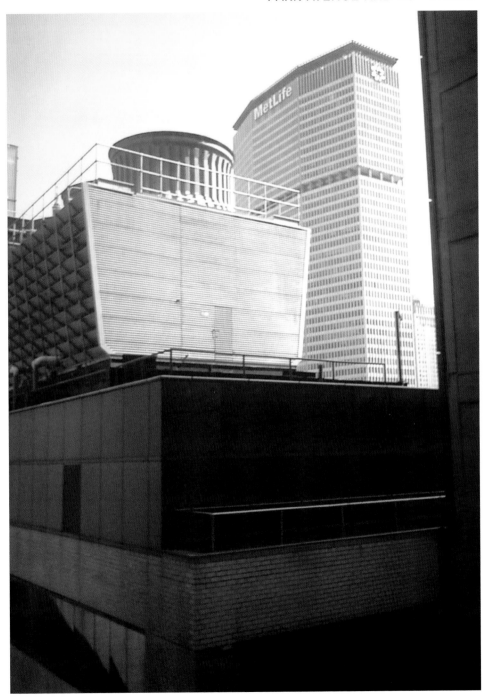

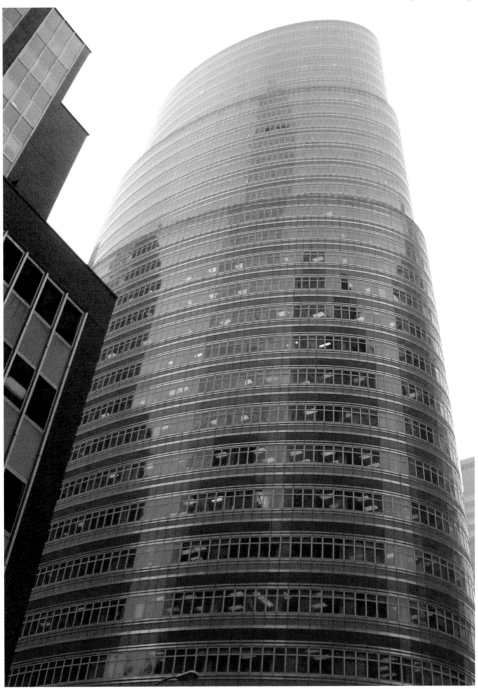

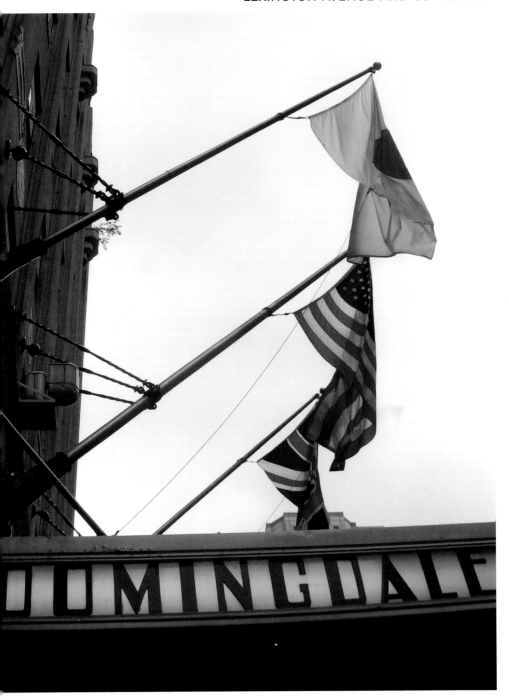

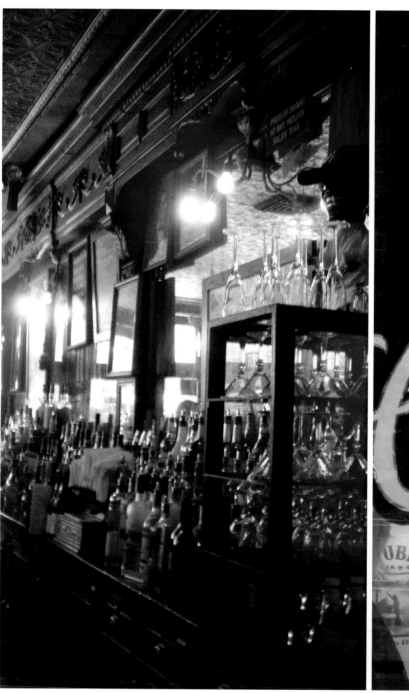

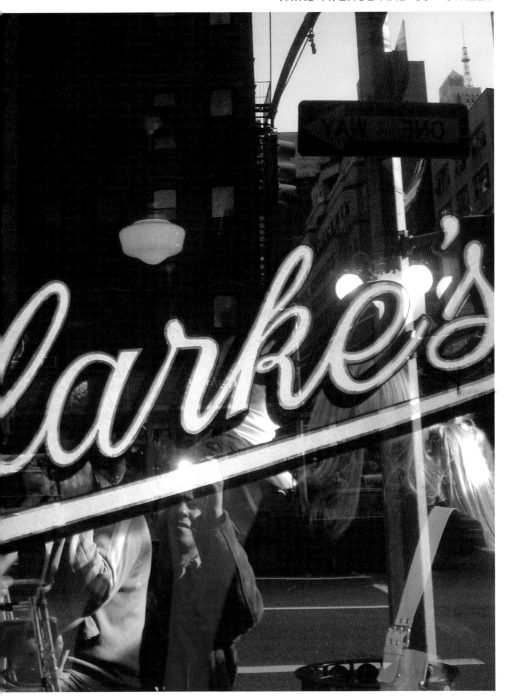

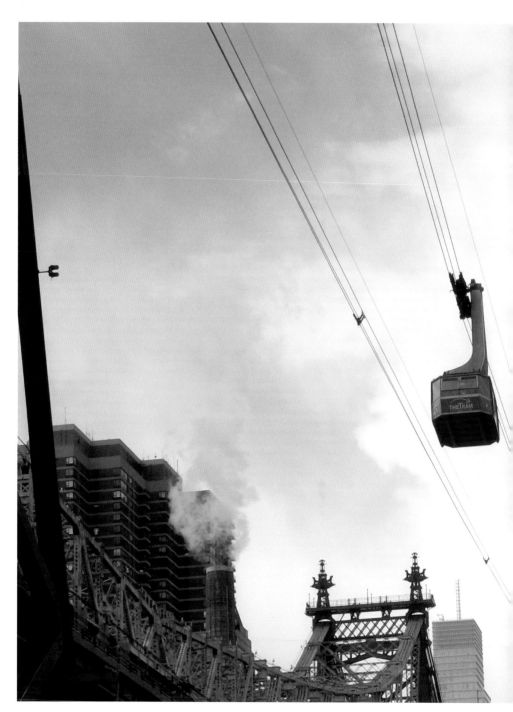

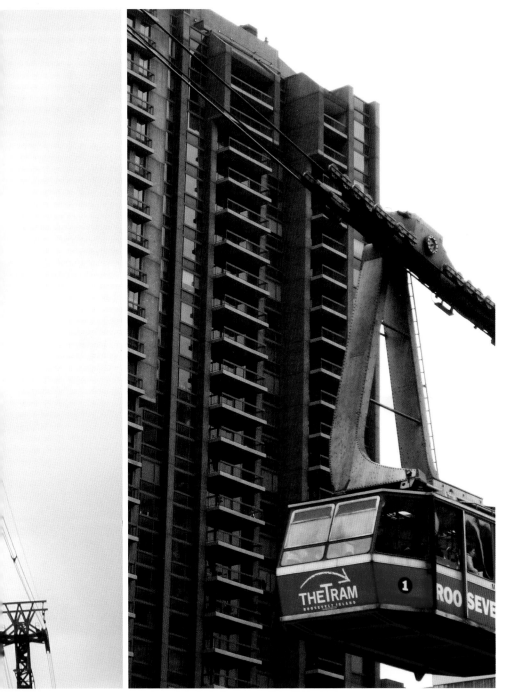

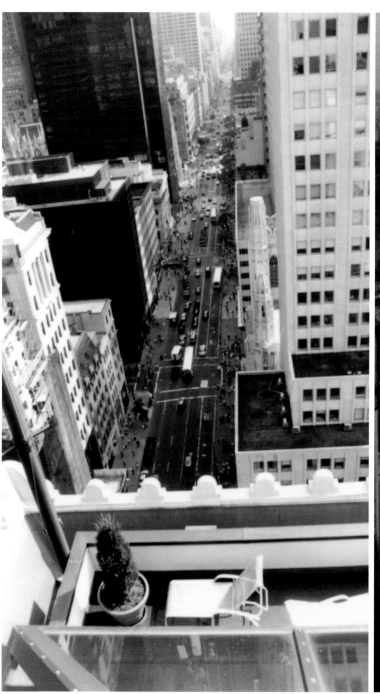

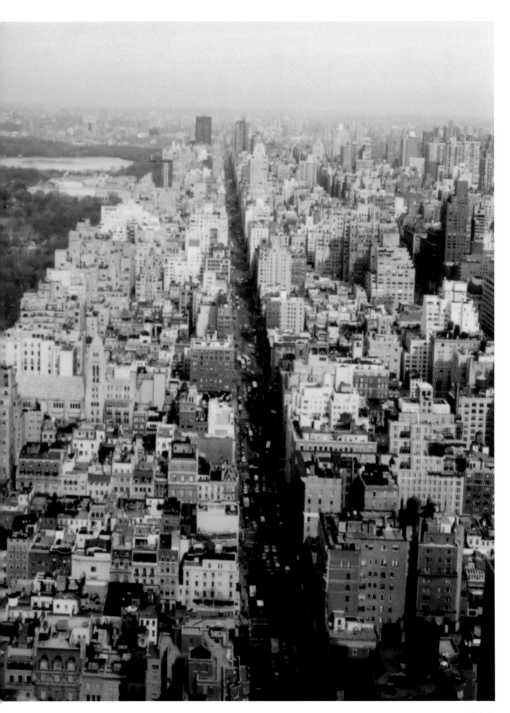

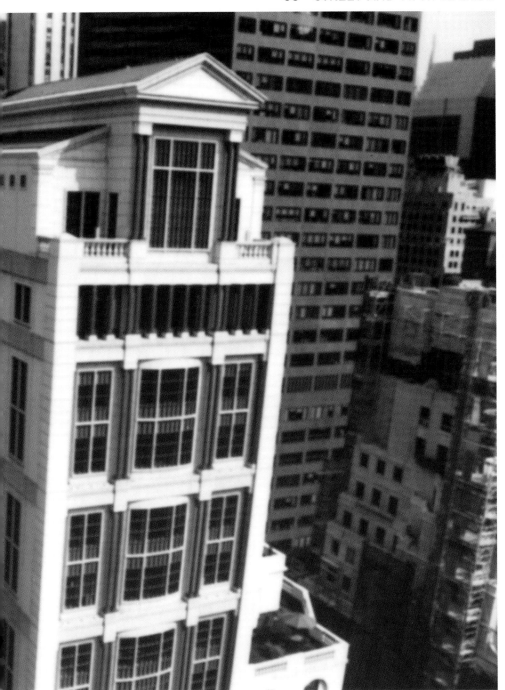

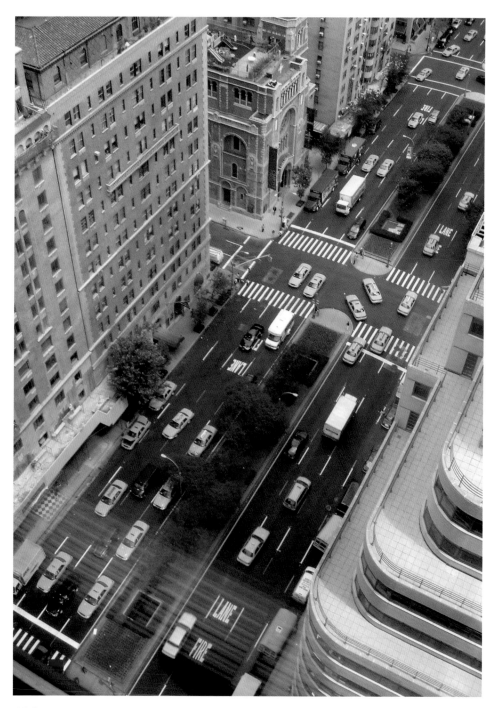

686

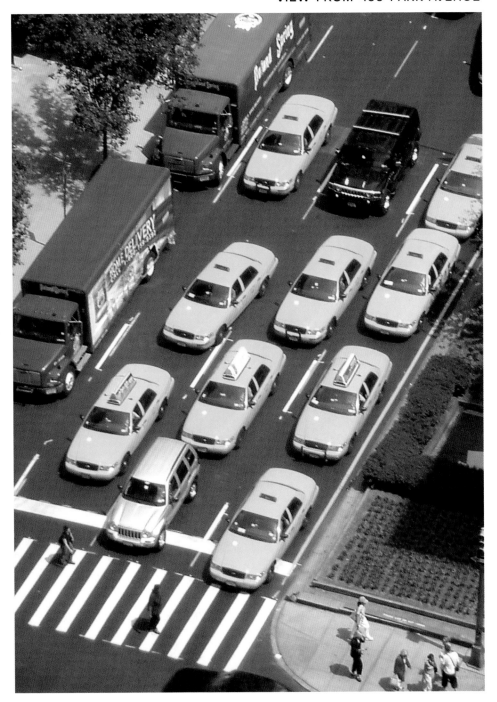

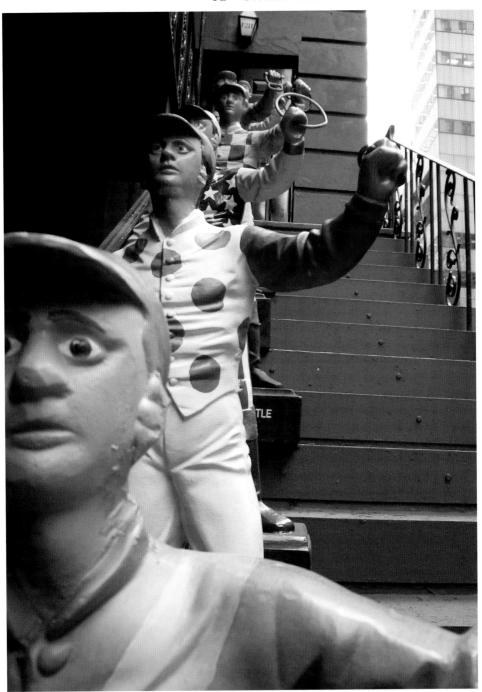

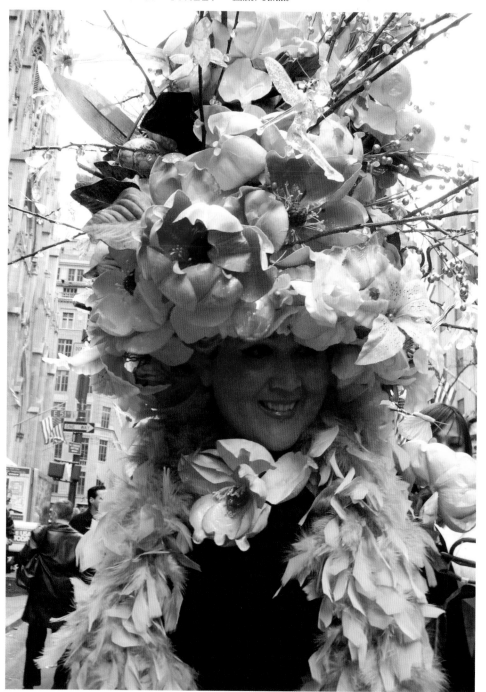

66 I miss New York. I still love how people talk to you on the street - just assault you and tell you what they think of your jacket.**99**

Madonna

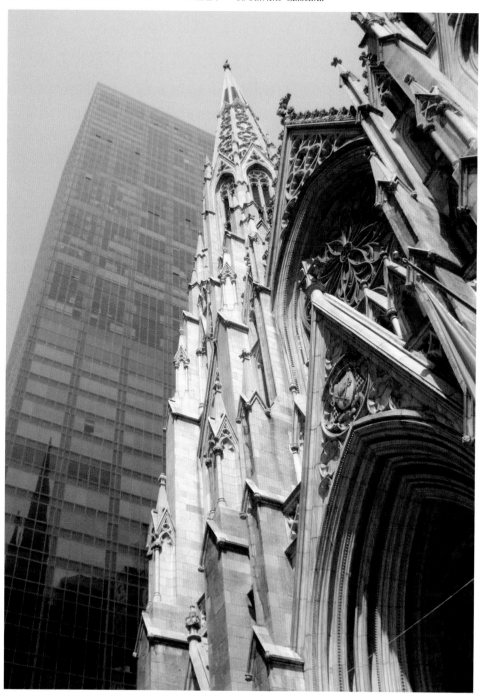

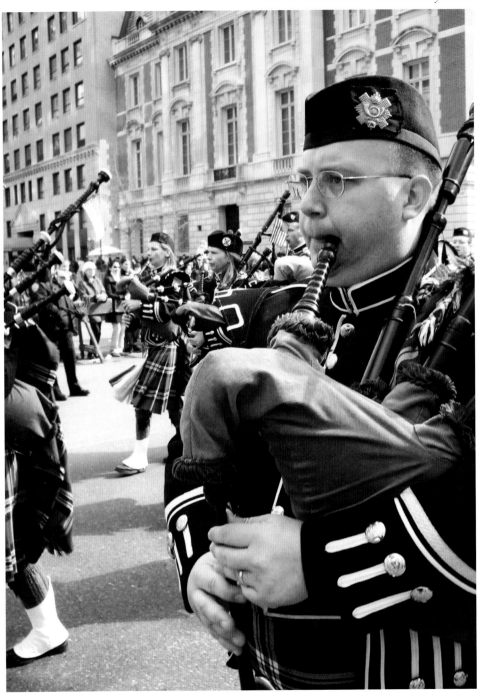

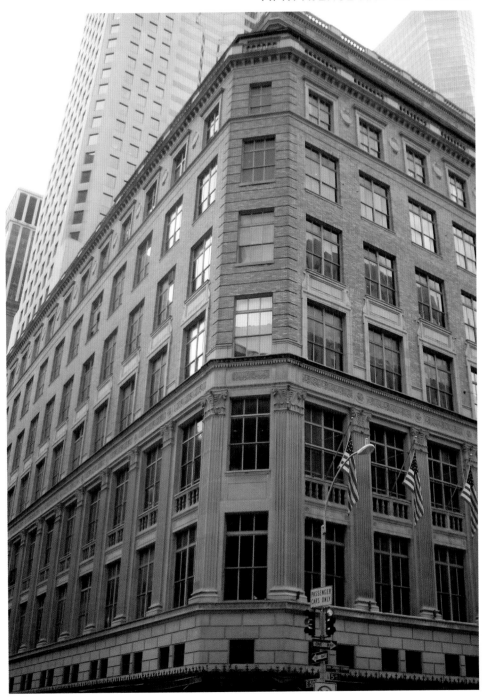

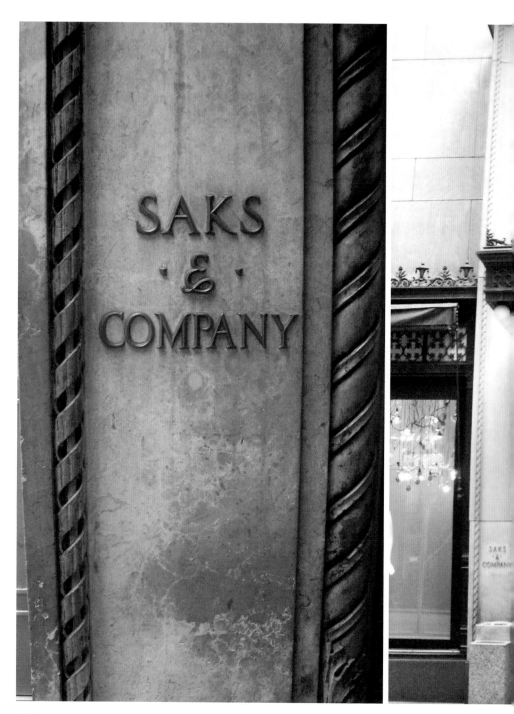

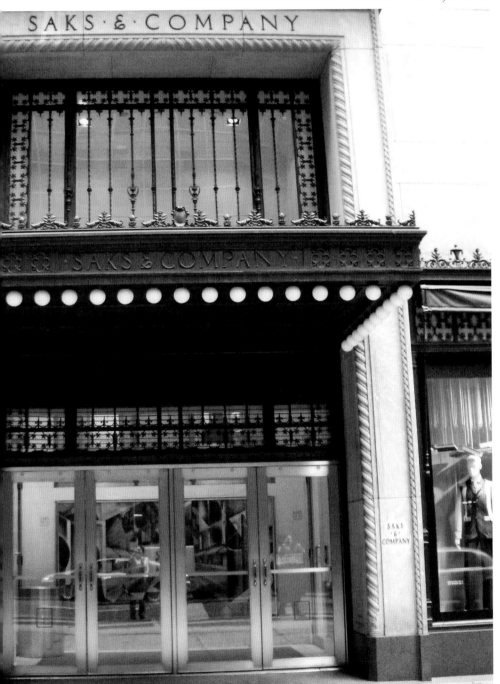

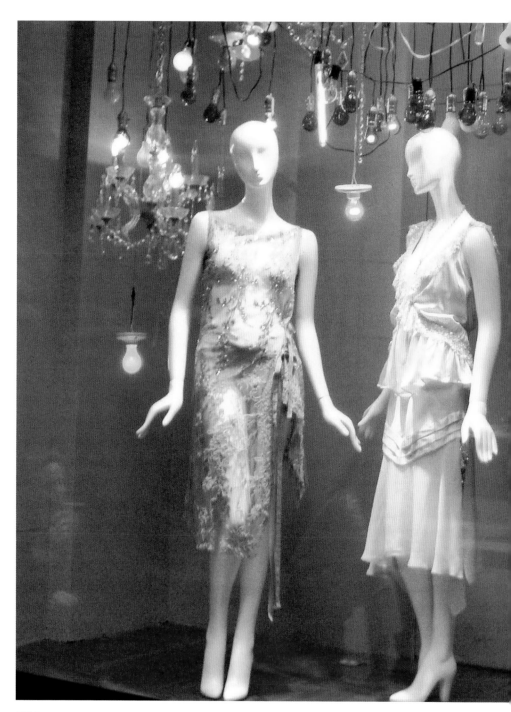

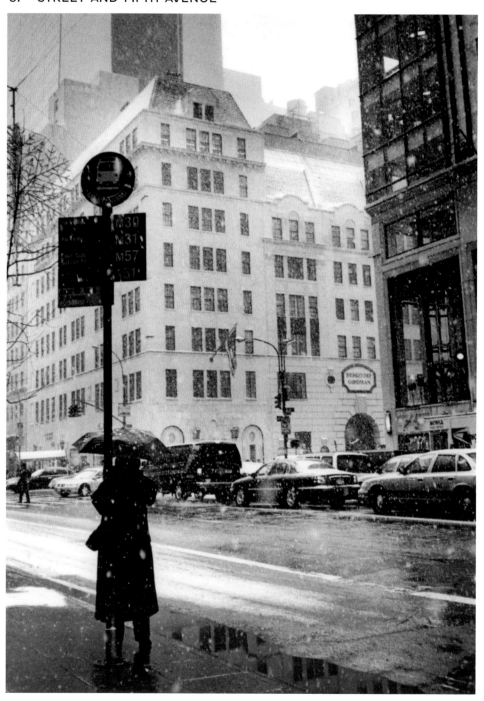

> **"**Here I was in New York, city of prose and fantasy, of capitalist automation, its streets a triumph of cubism, its moral philosophy that of the dollar. New York impressed me tremendously because, more than any other city in the world, it is the fullest expression of our modern age.**"**
>
> Leon Trotsky

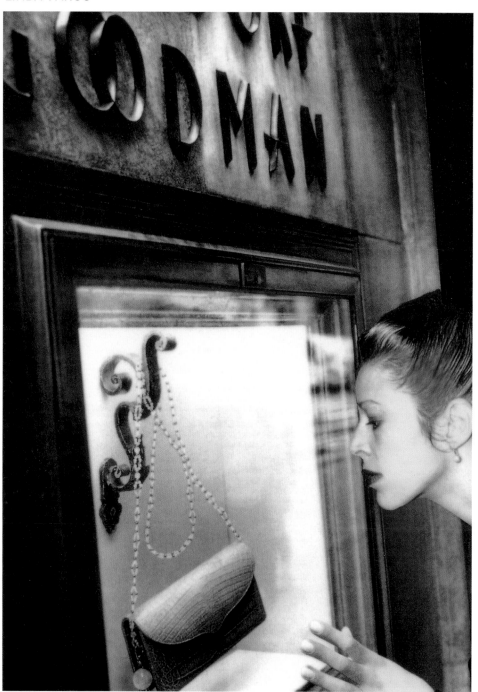

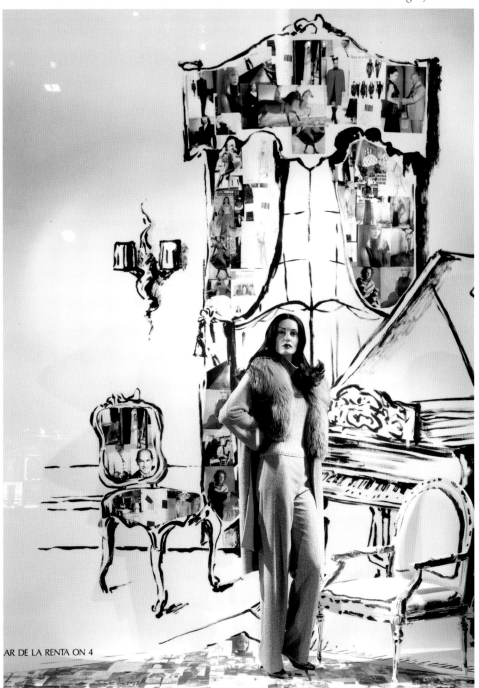

AR DE LA RENTA ON 4

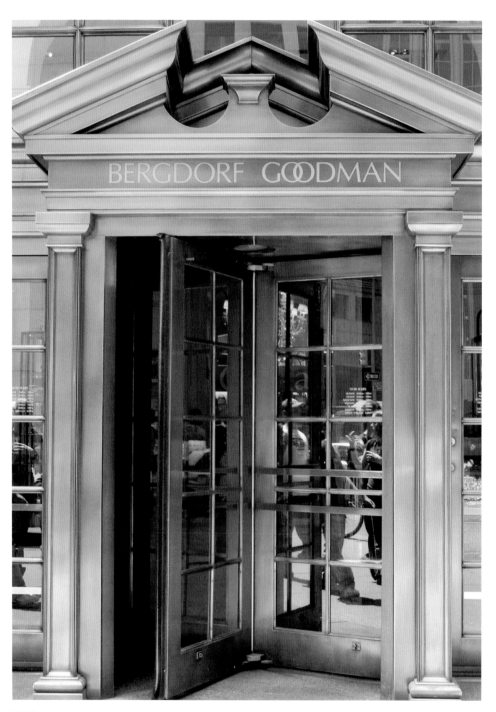

AMERICAN STYLE

KELLY KILLOREN BENSIMON

PUBLISHED OCTOBER 2004 BY
ASSOULINE

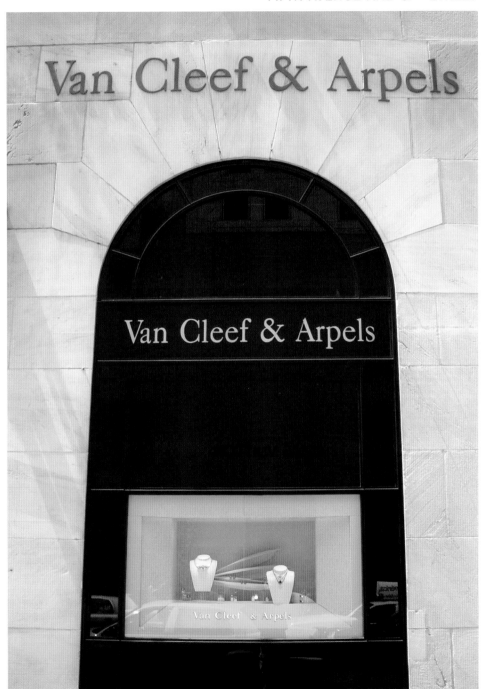

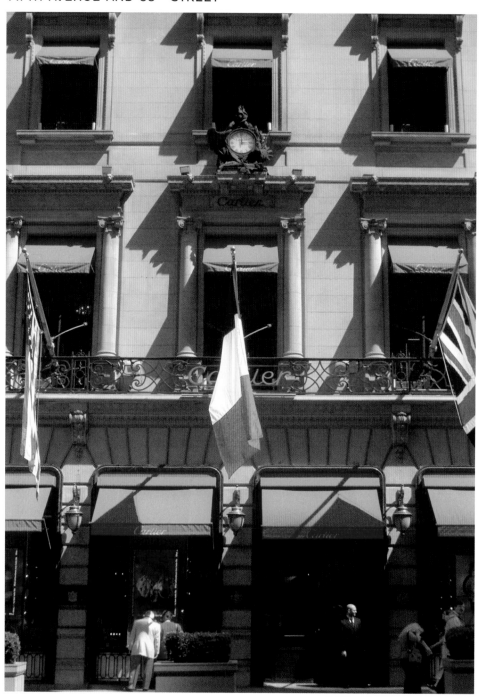

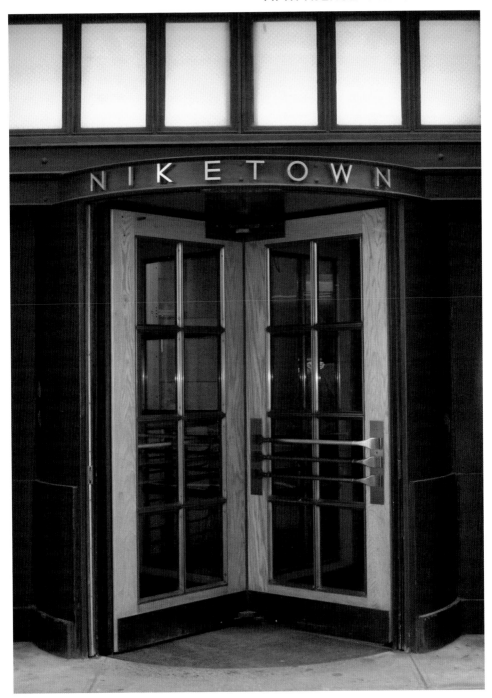

66 There are only about 400 people in fashionable New York society. If you go outside the number, you strike people who are either not at ease in a ballroom or make other people not at ease. See the point? 99

Ward McCallister

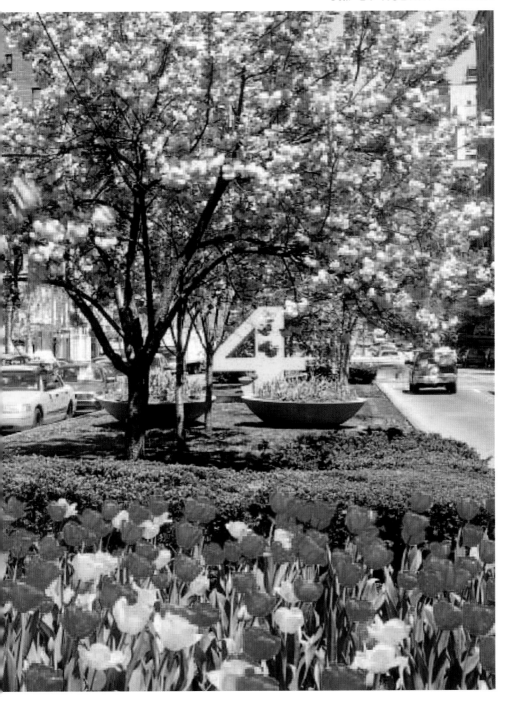

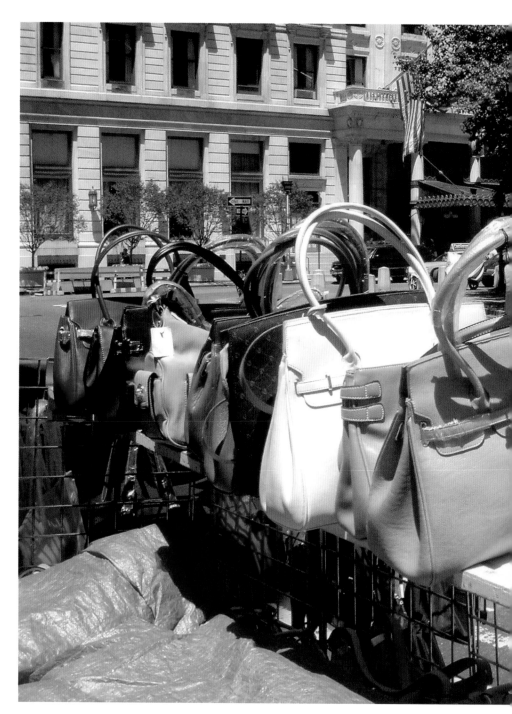

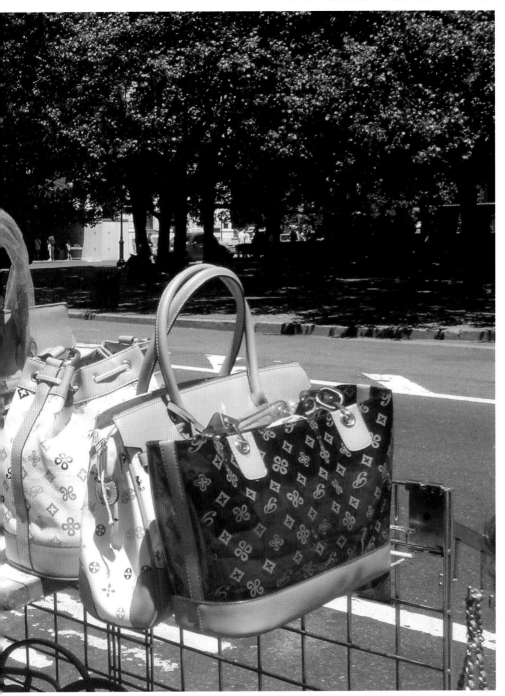

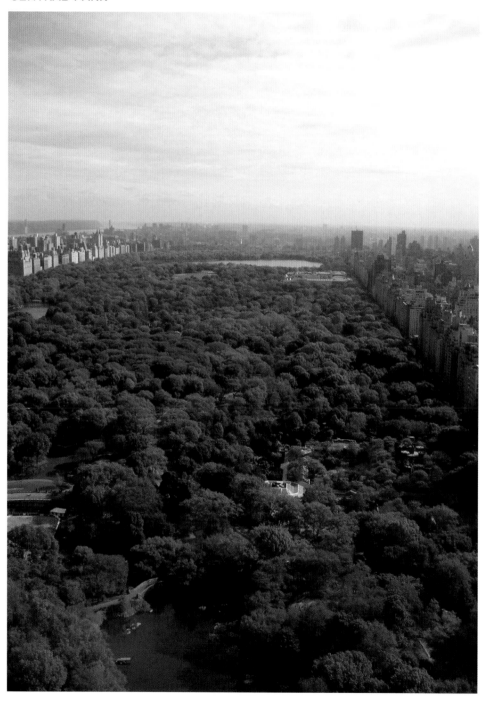

" If one had habitually breathed the New York air there were times when anything less crystalline seemed stifling. **"**

Edith Wharton

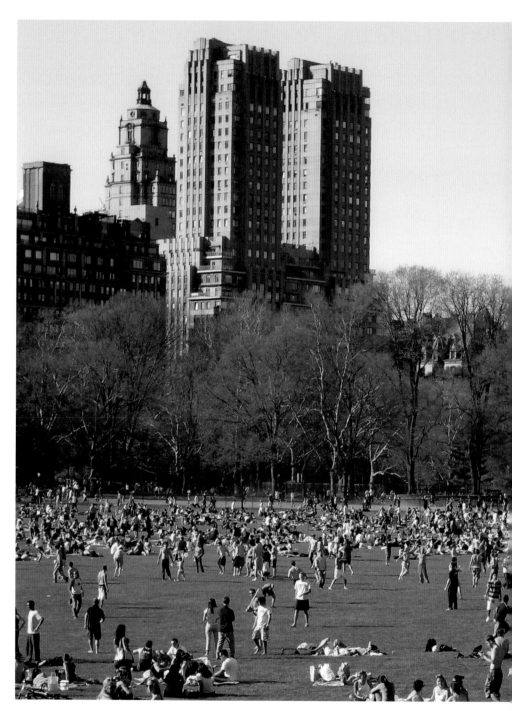

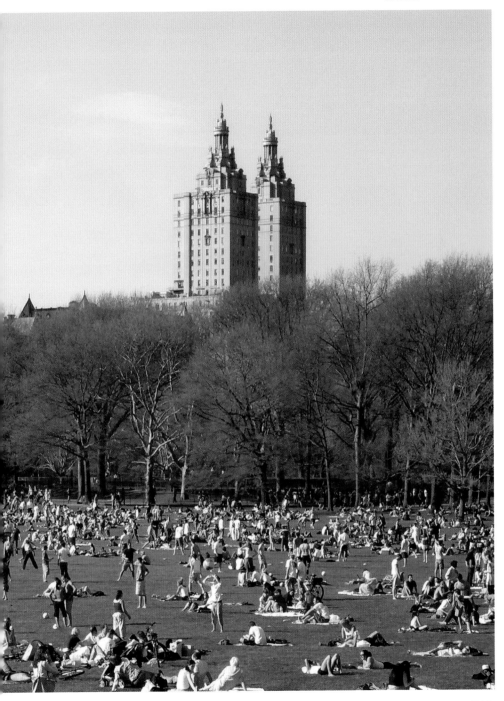

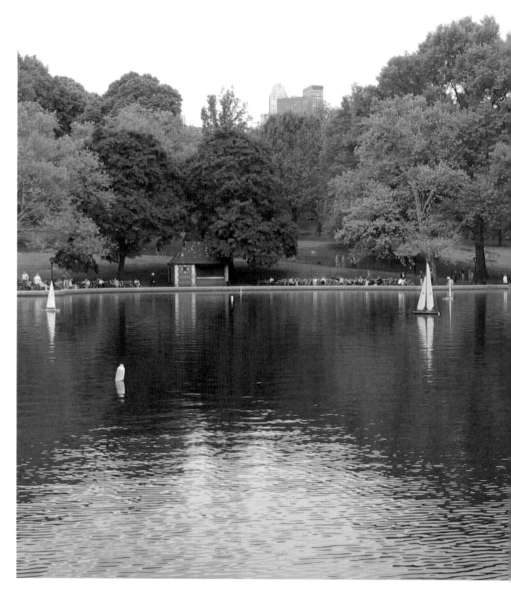

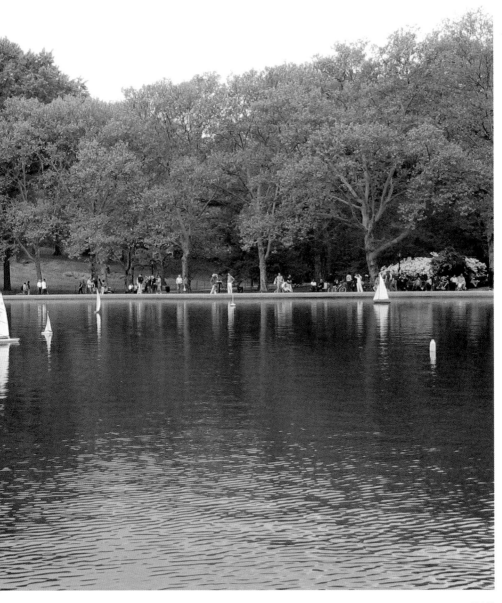

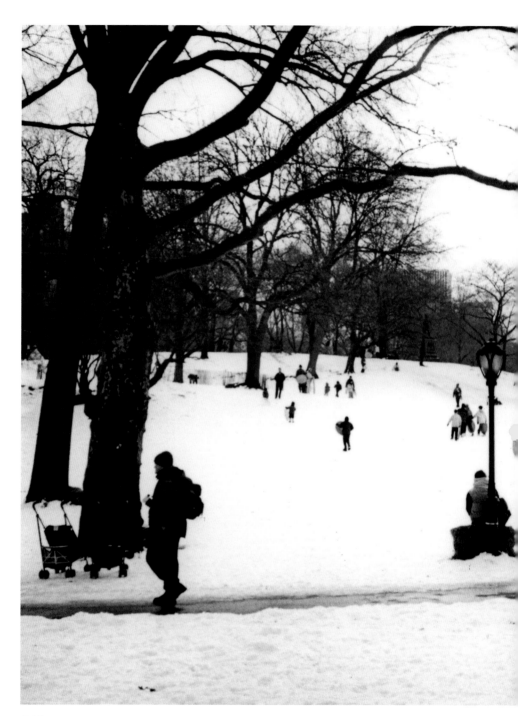

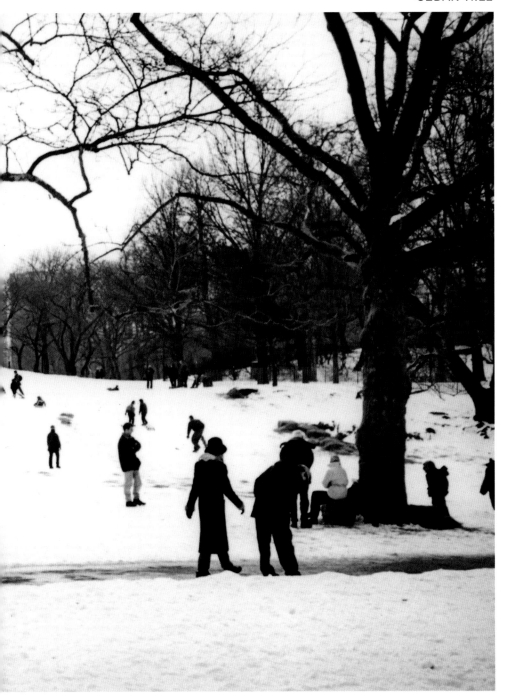

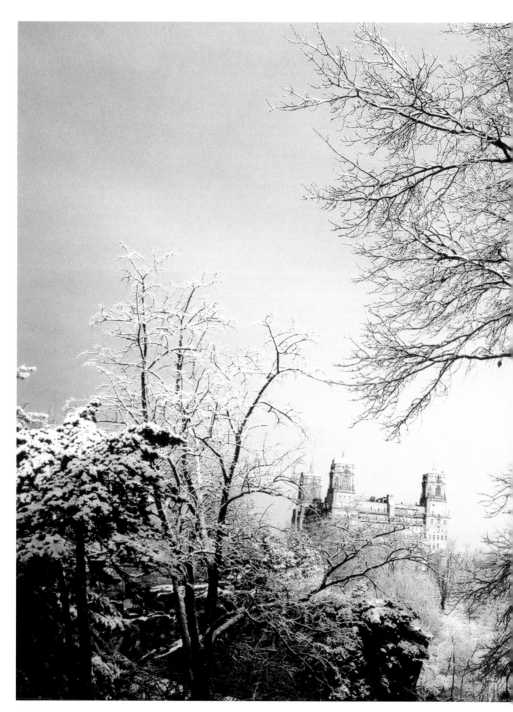

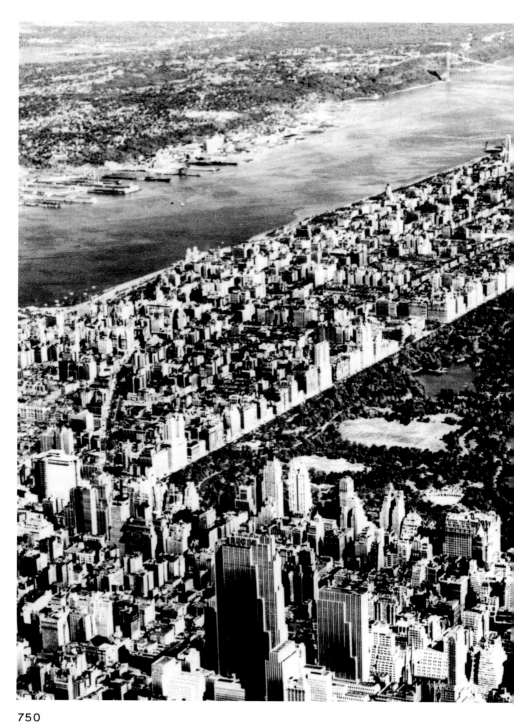

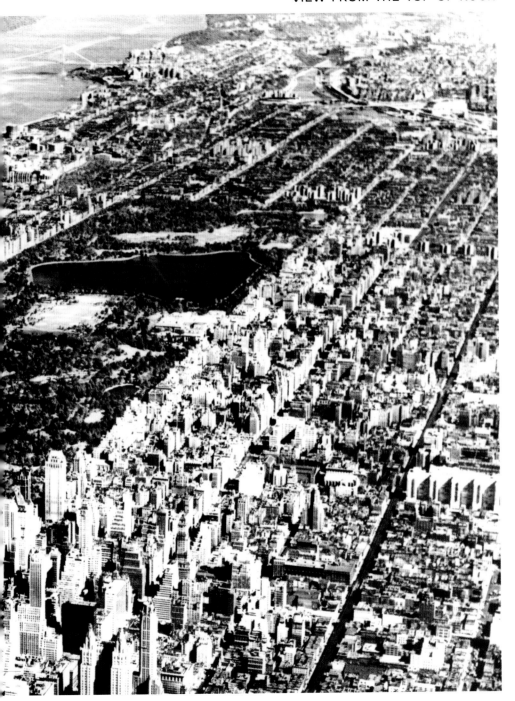

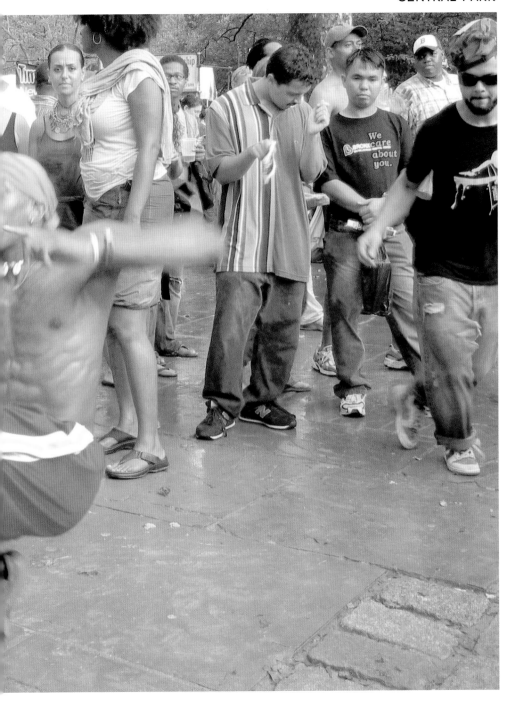

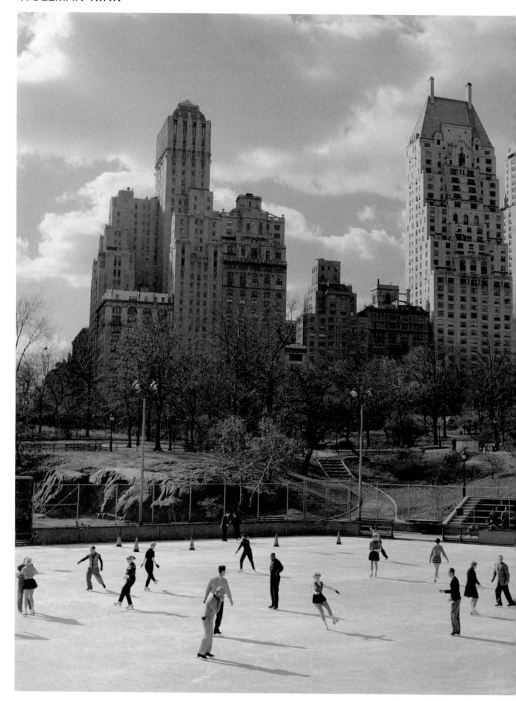

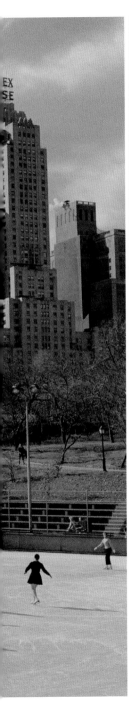

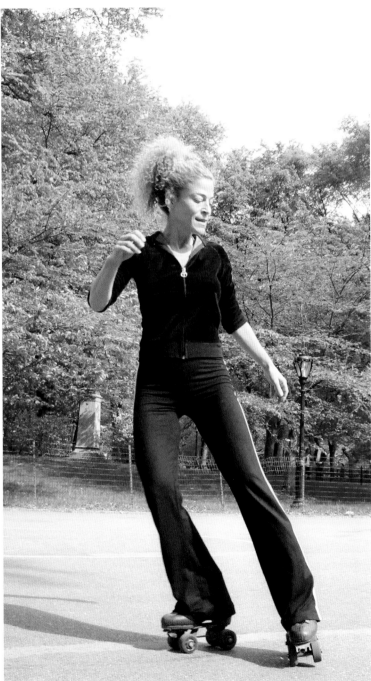

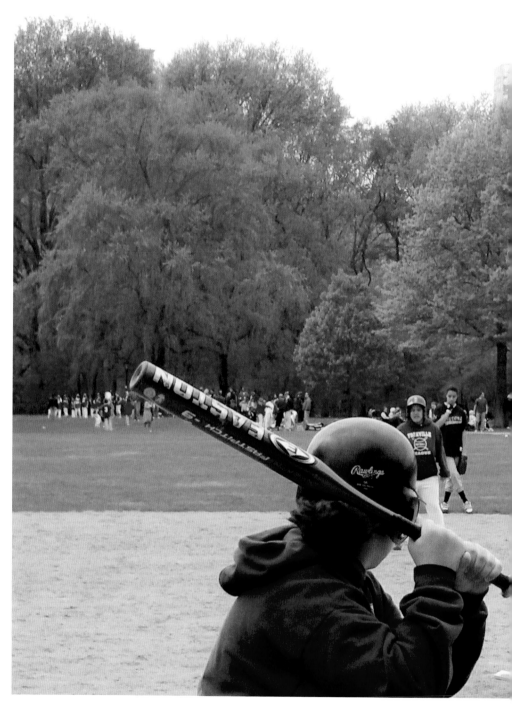

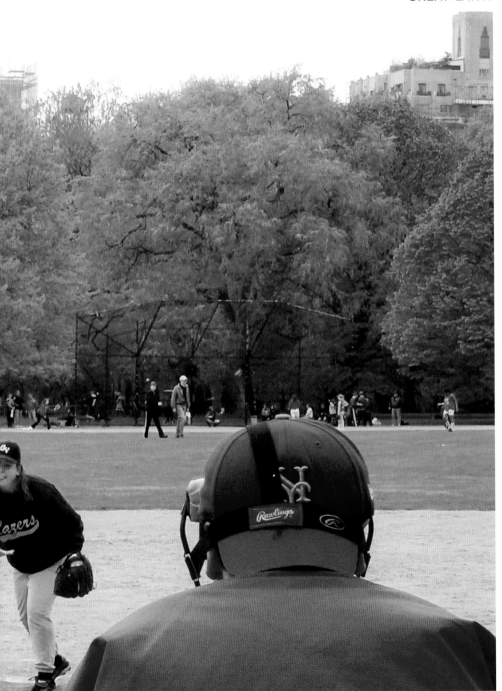

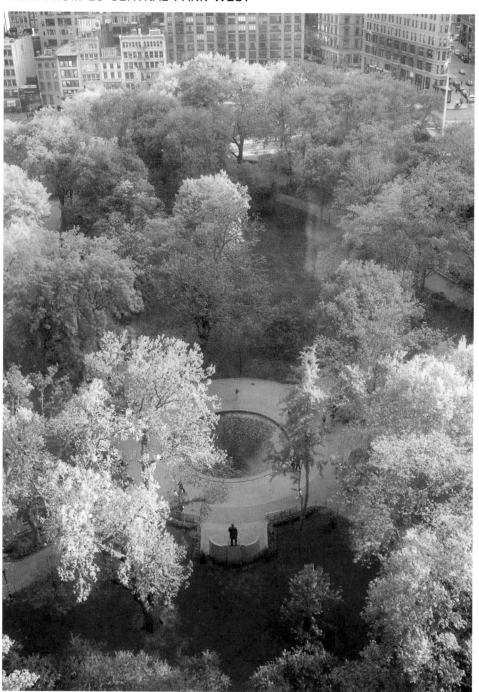

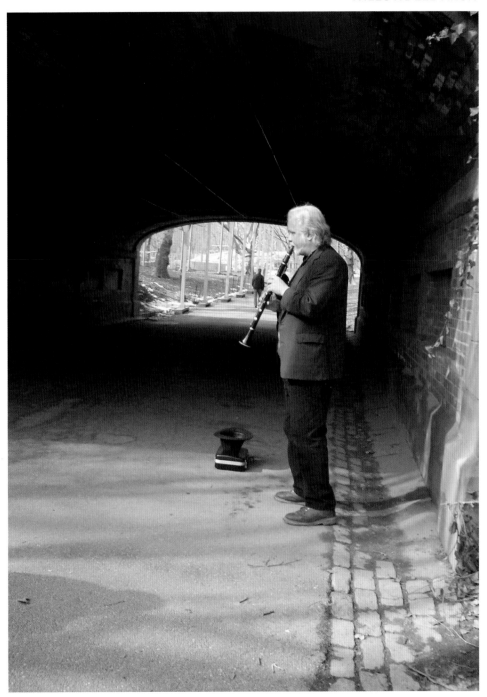

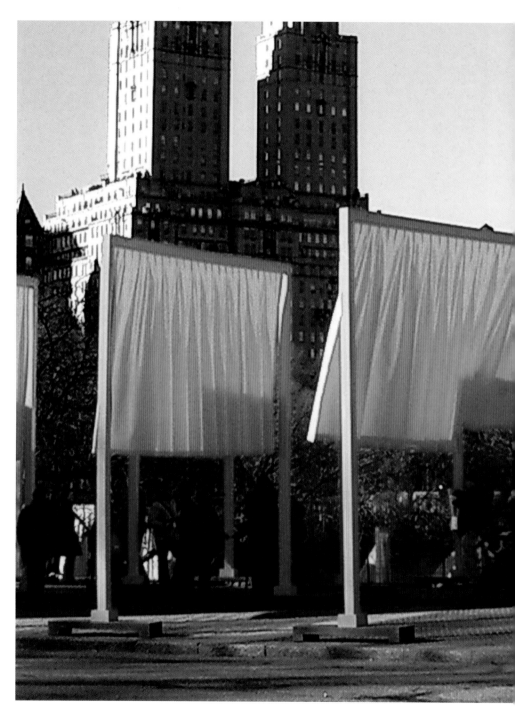

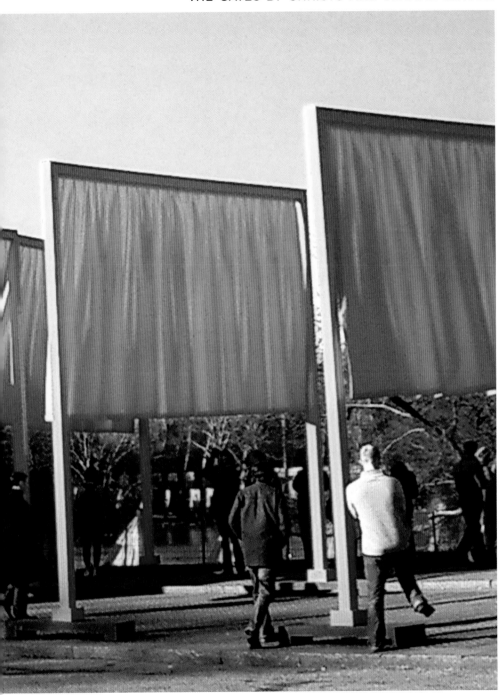

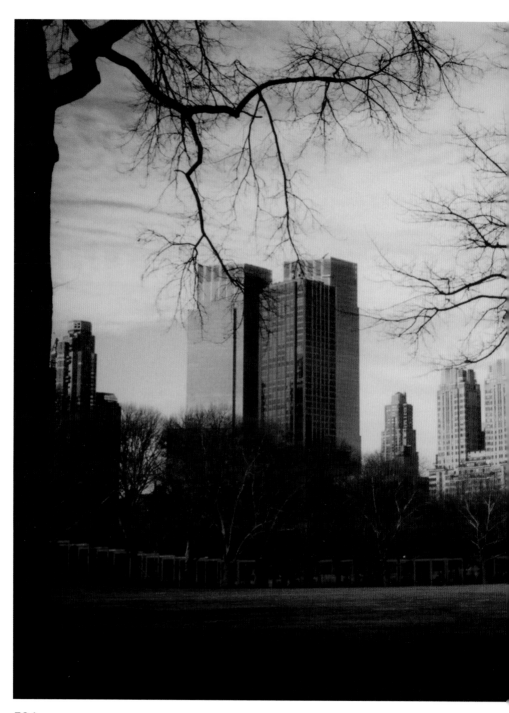

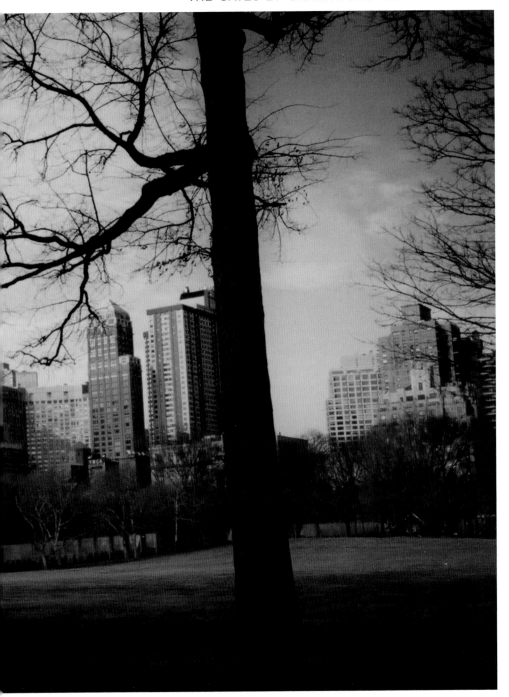

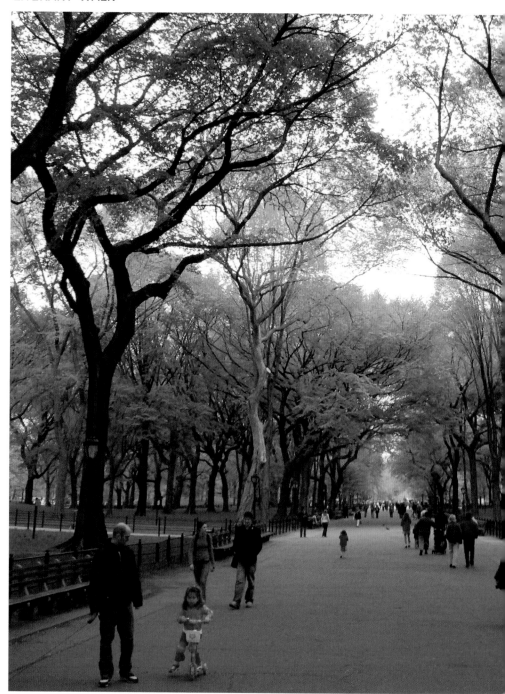

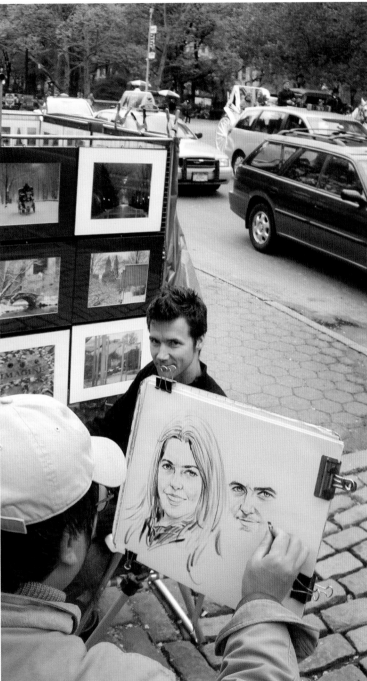

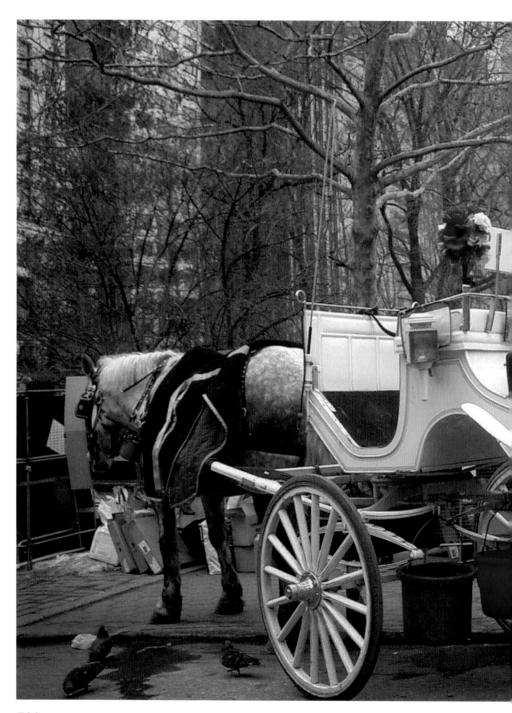

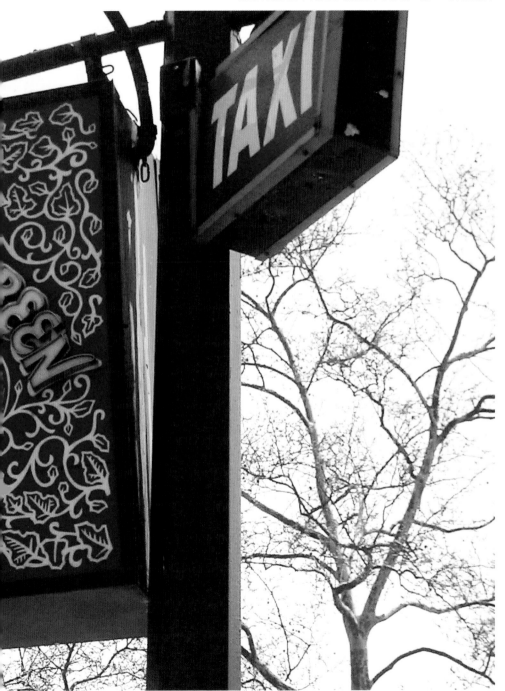

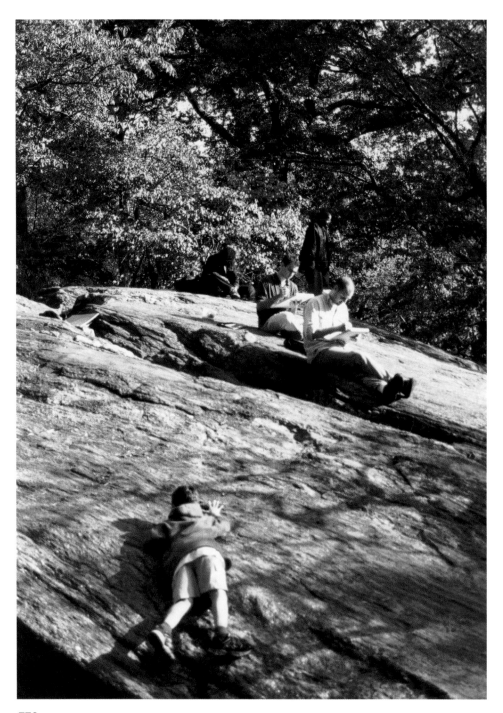

772

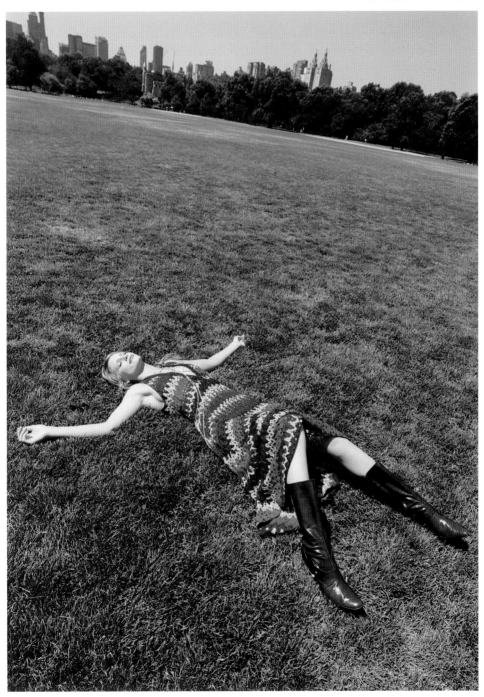

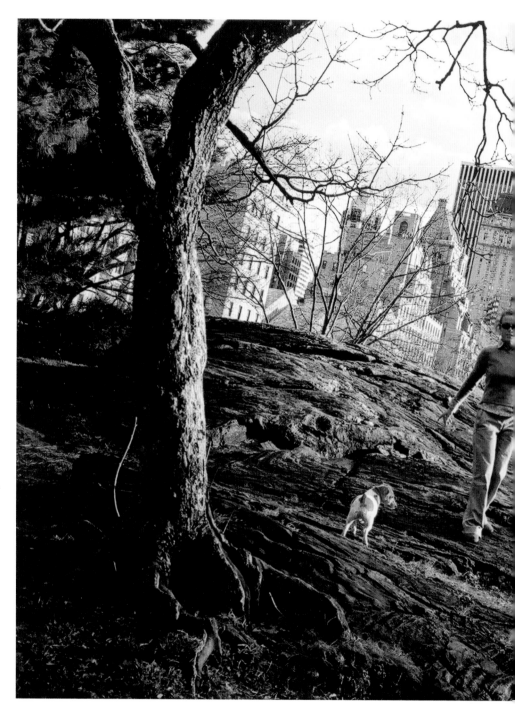

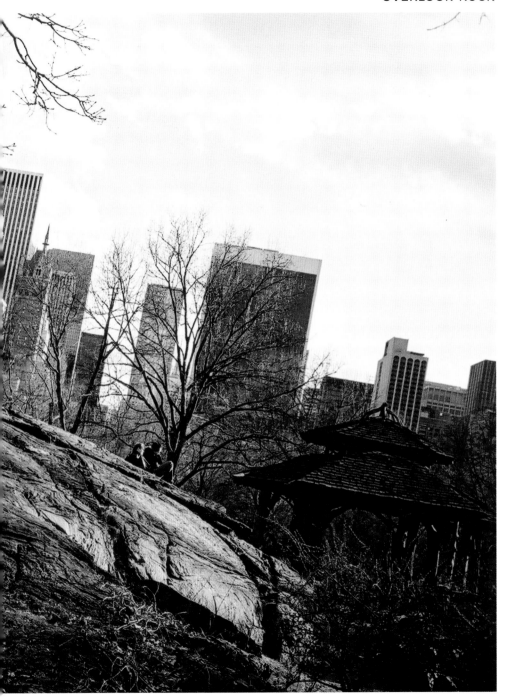

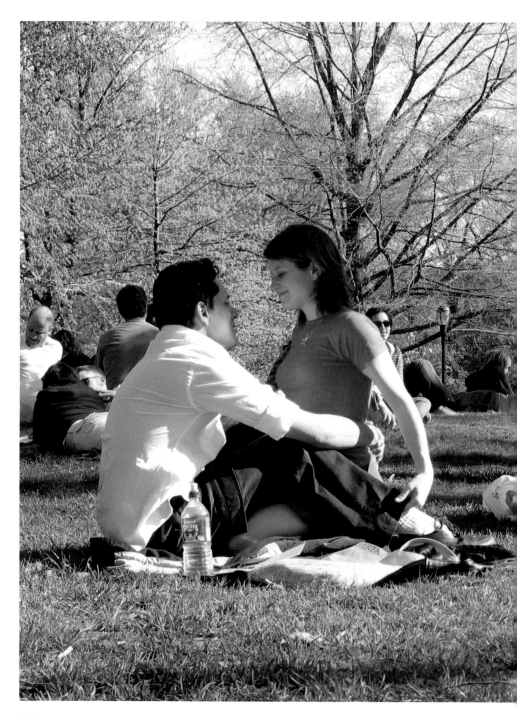

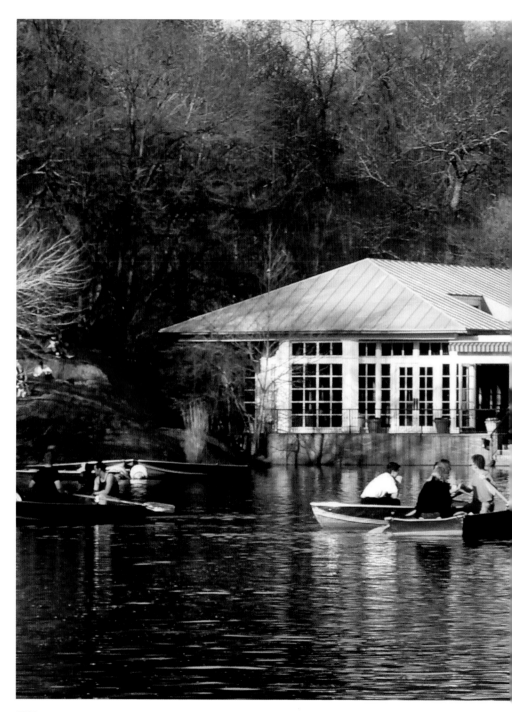

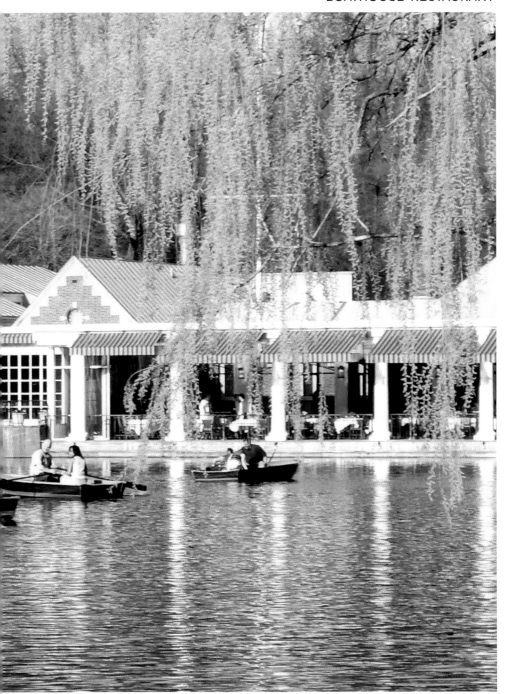

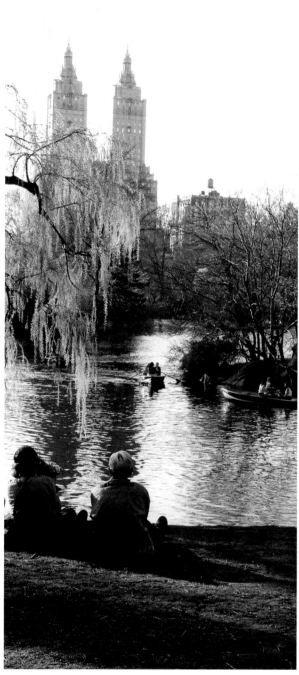

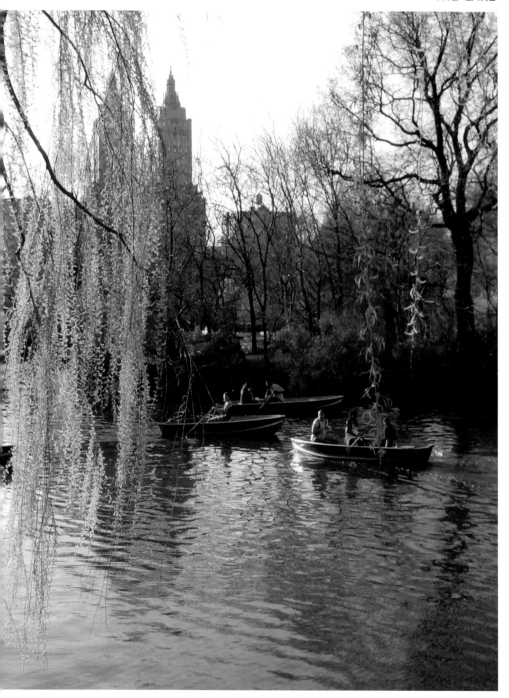

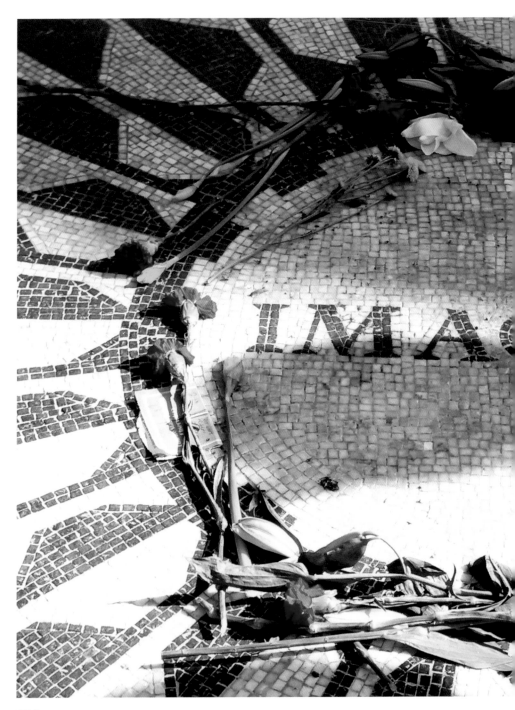

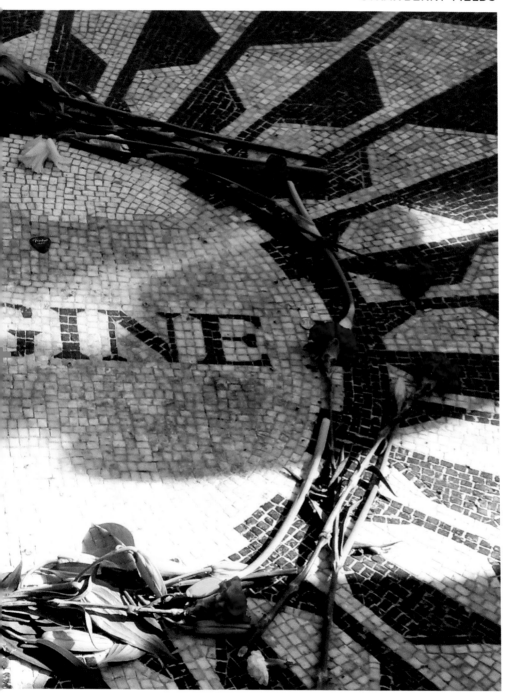

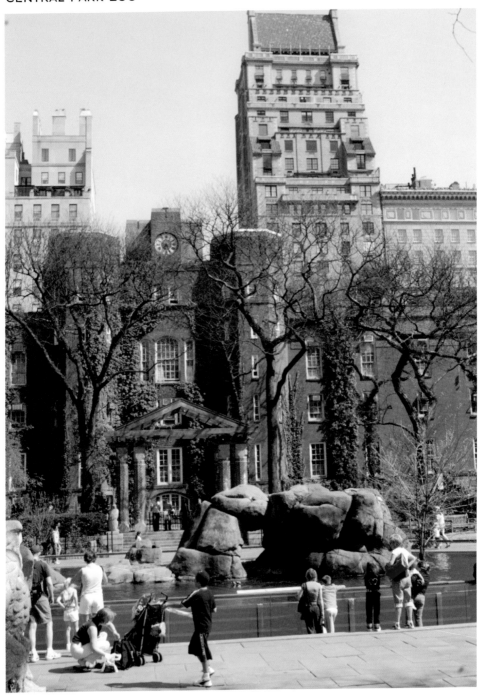

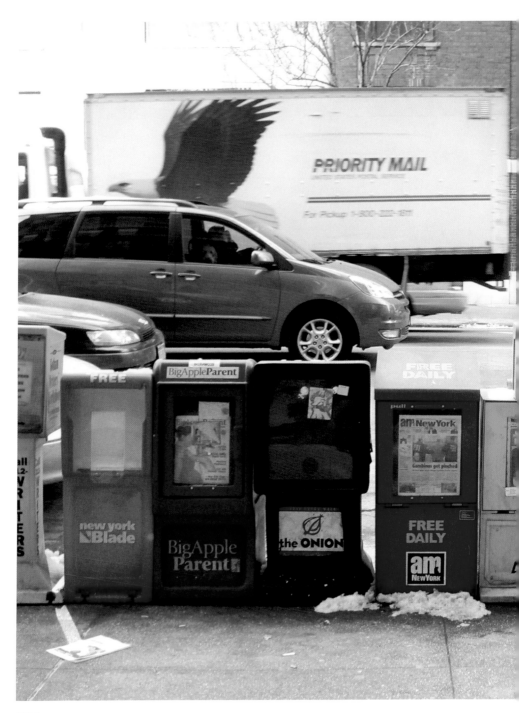

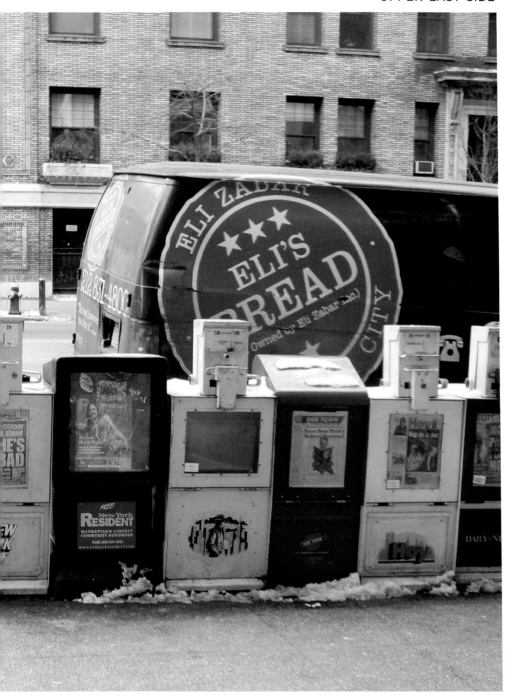

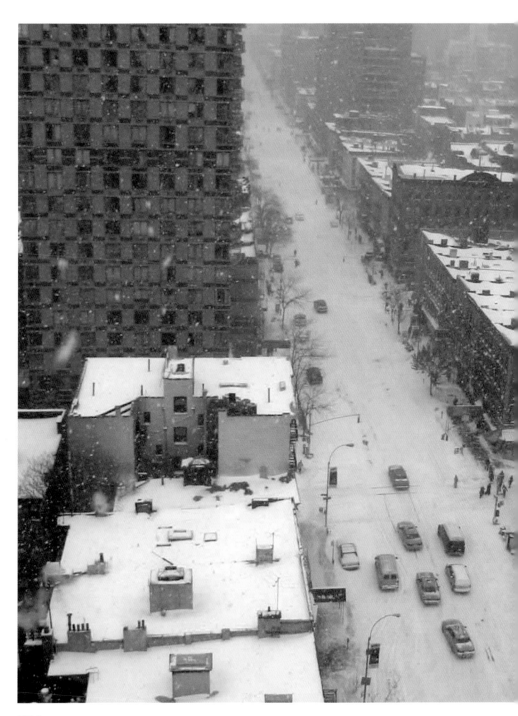

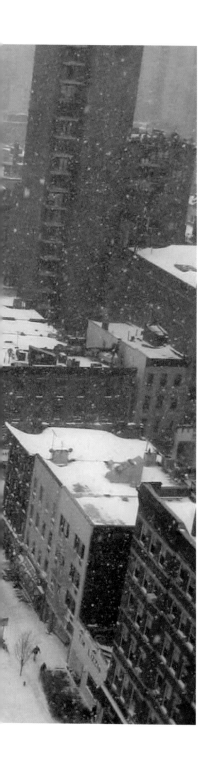

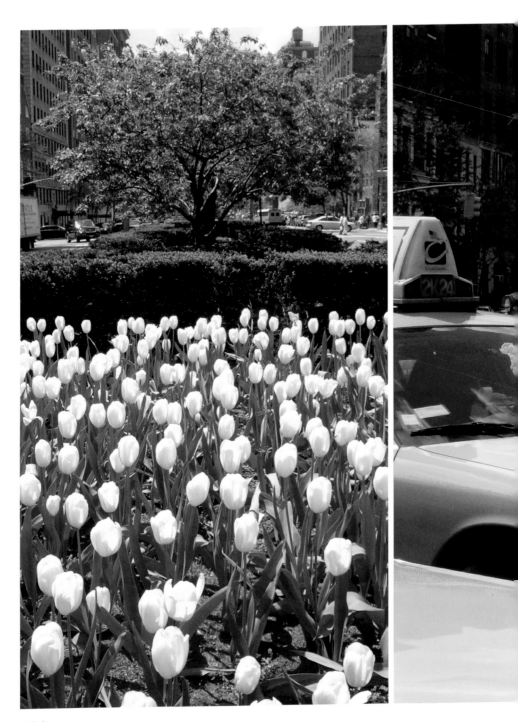

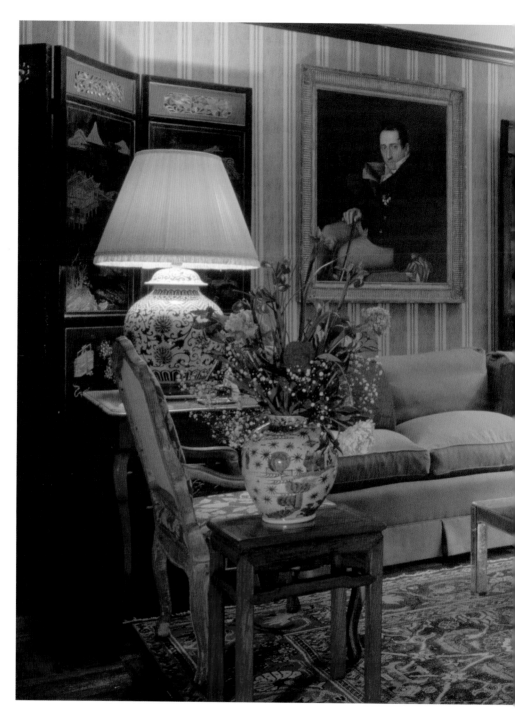

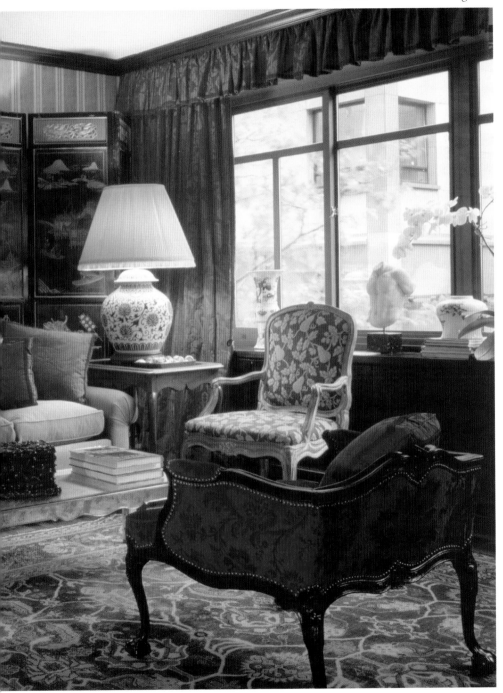

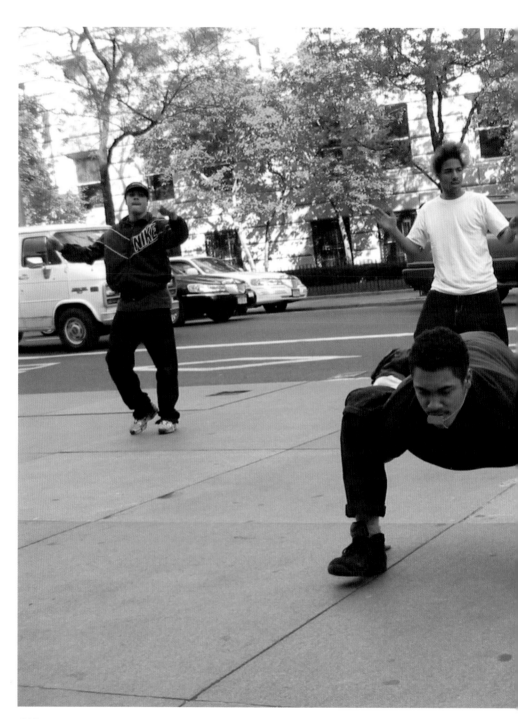

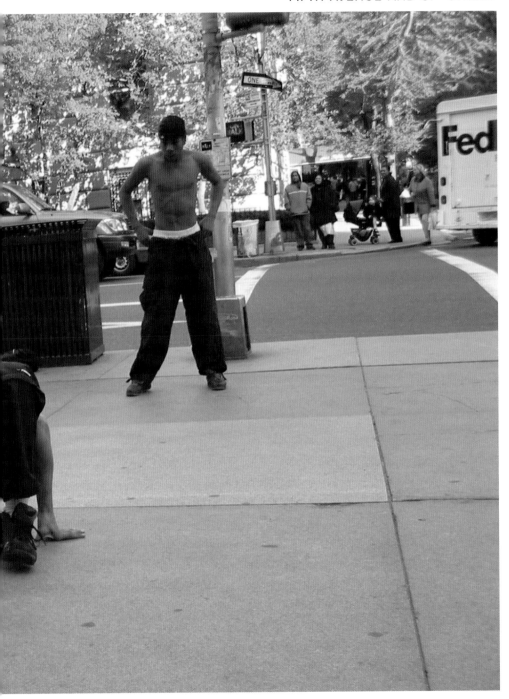

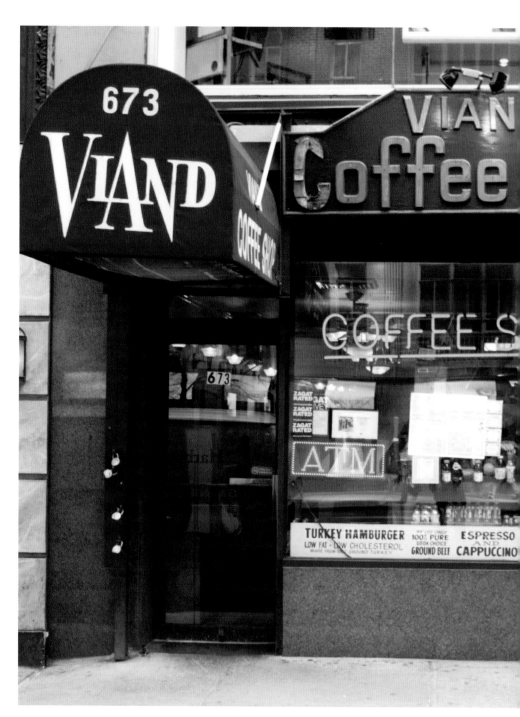

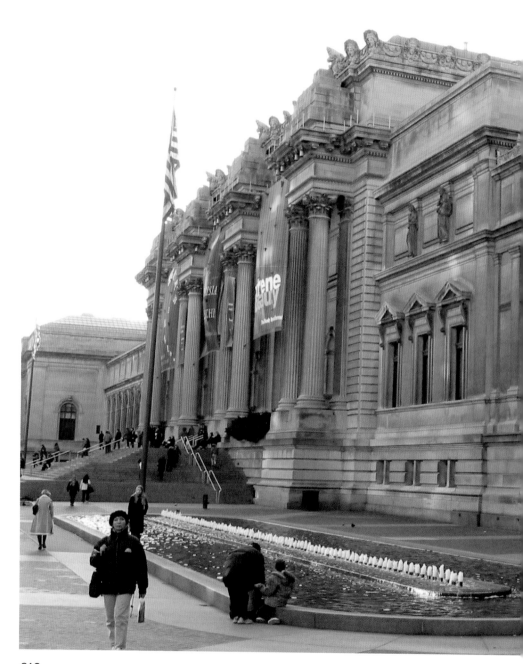

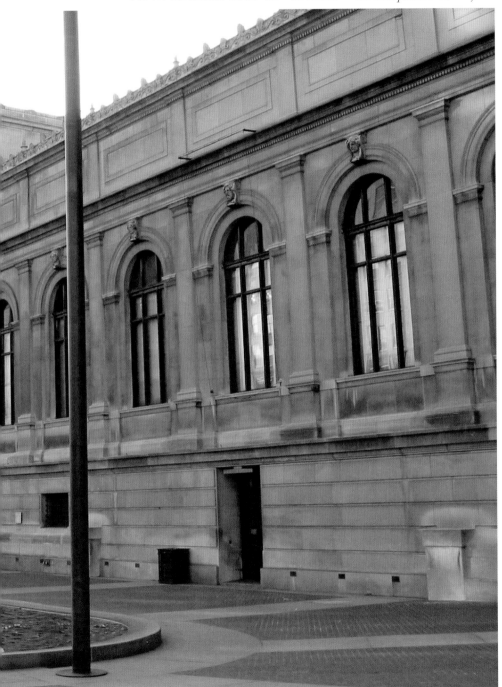

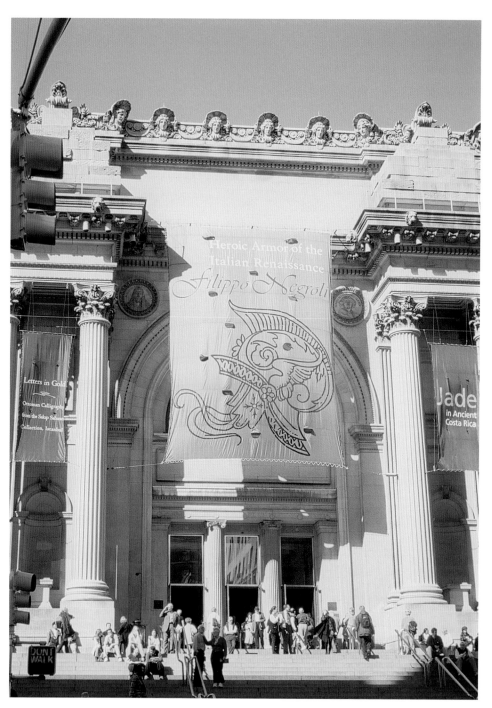

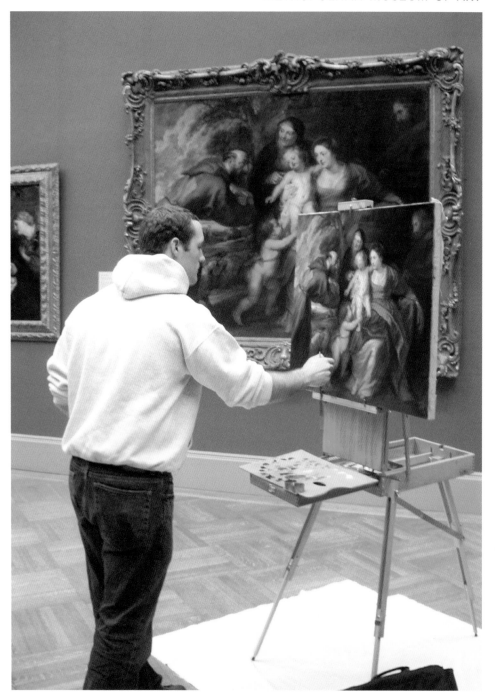

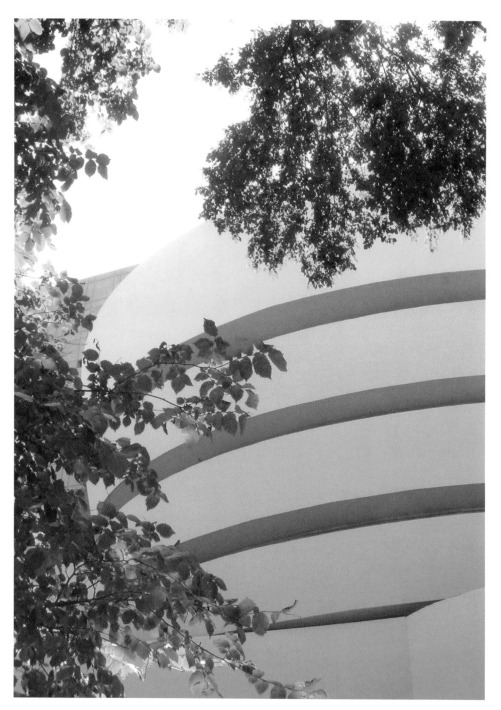

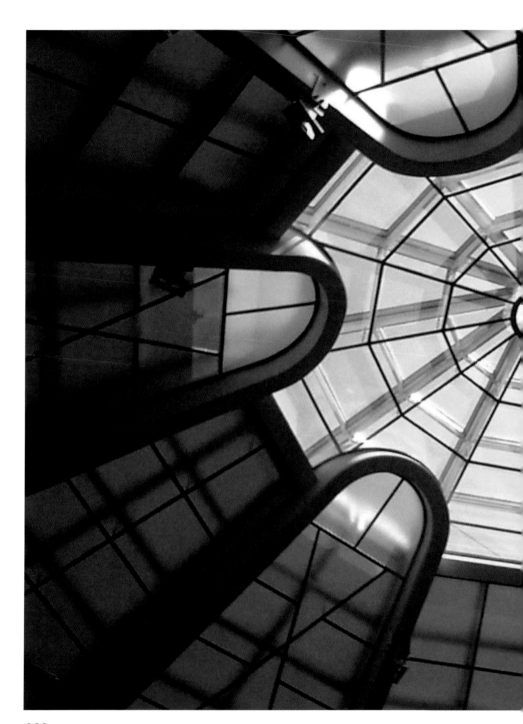

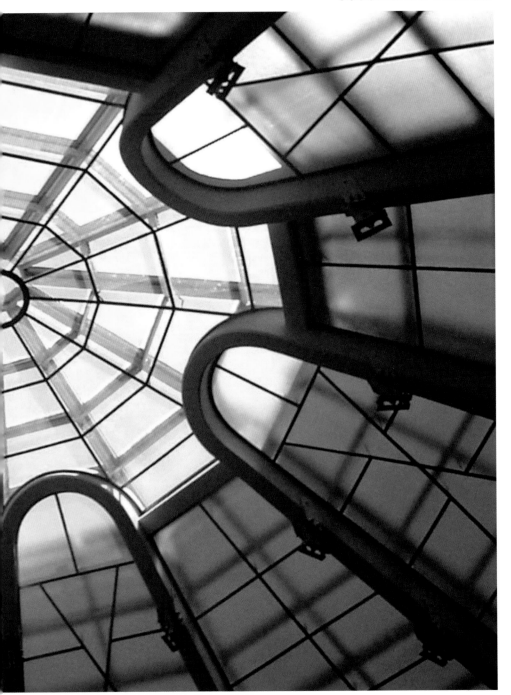

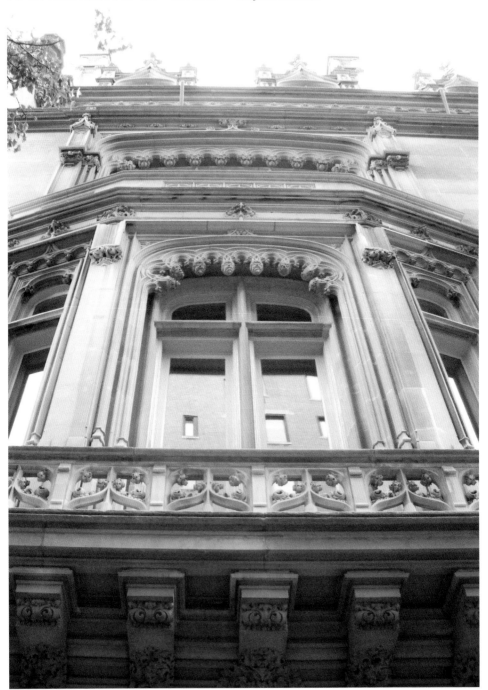

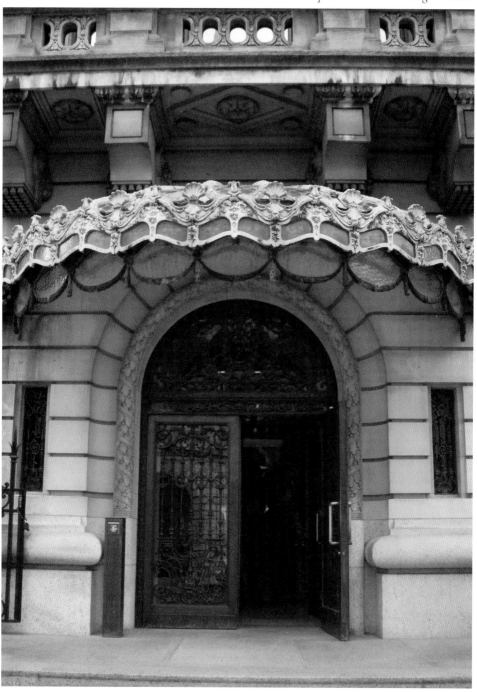

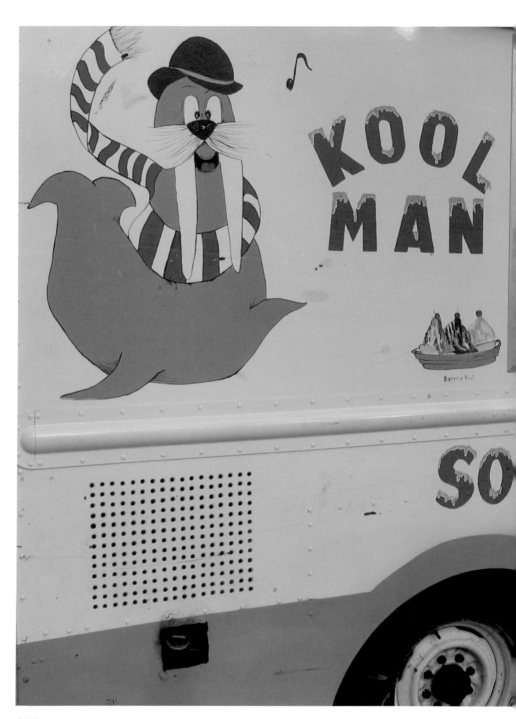

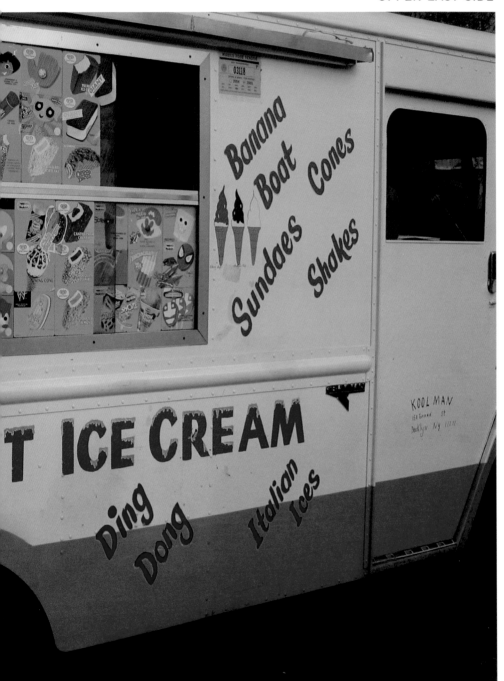

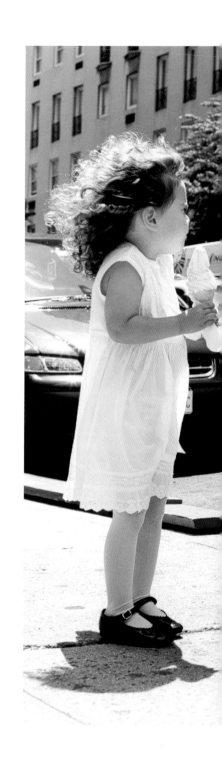

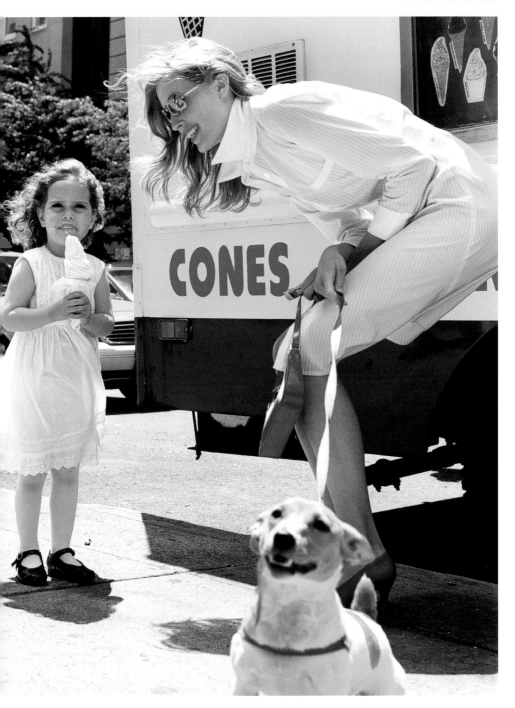

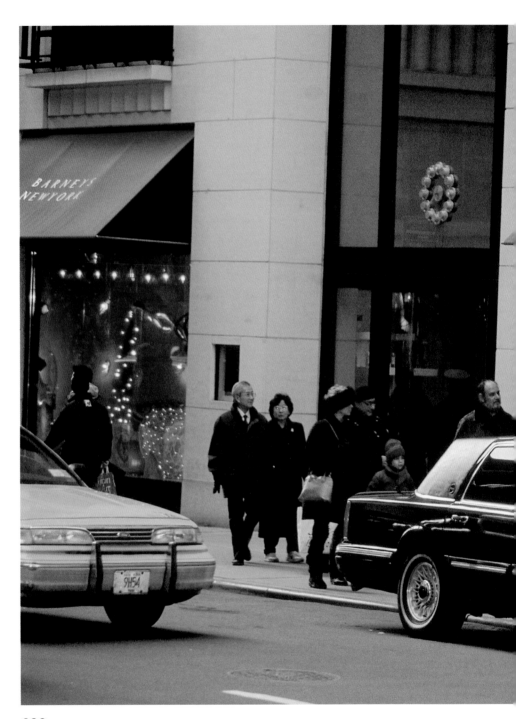

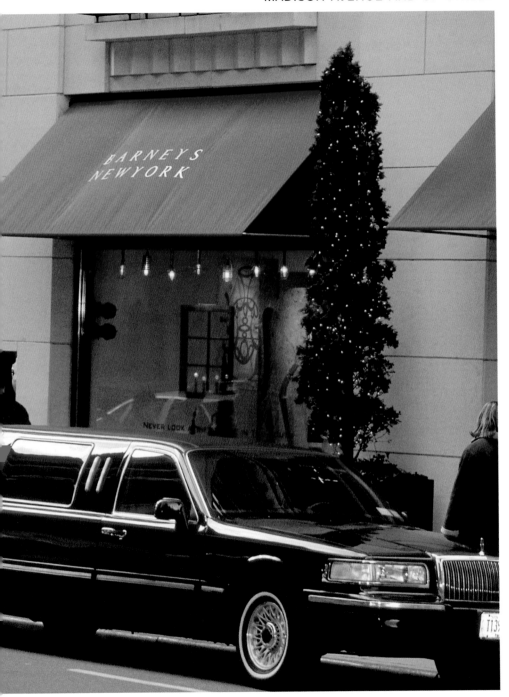

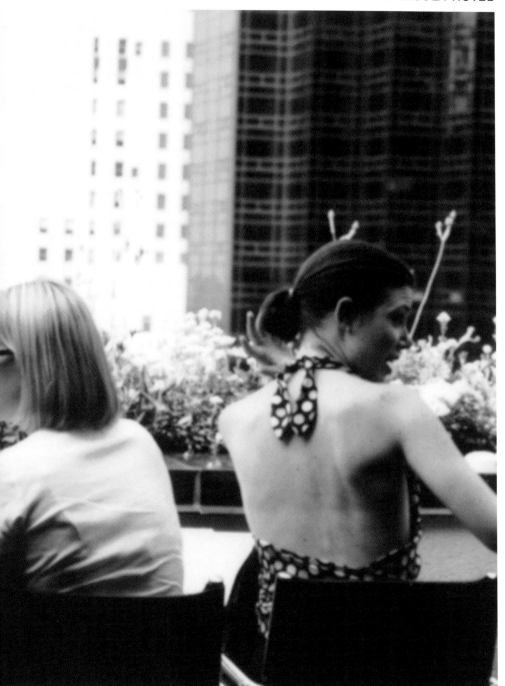

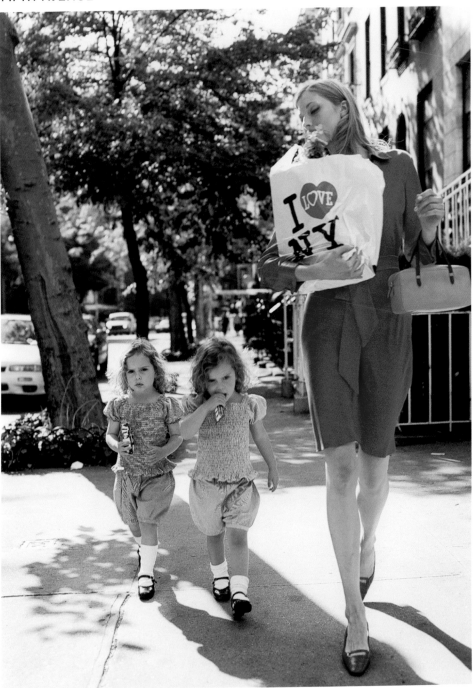

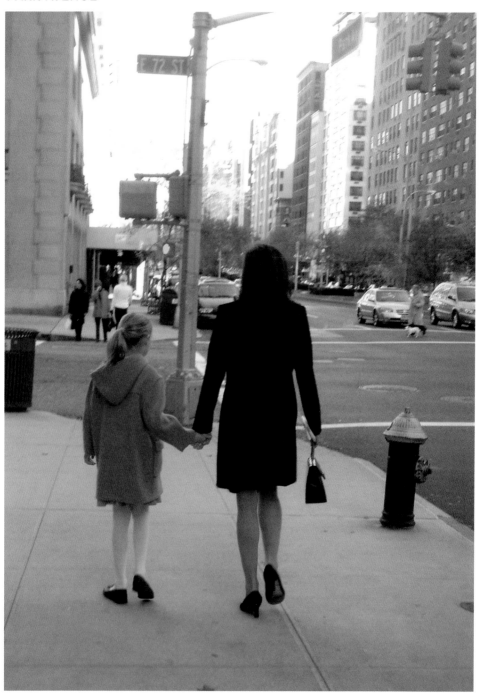

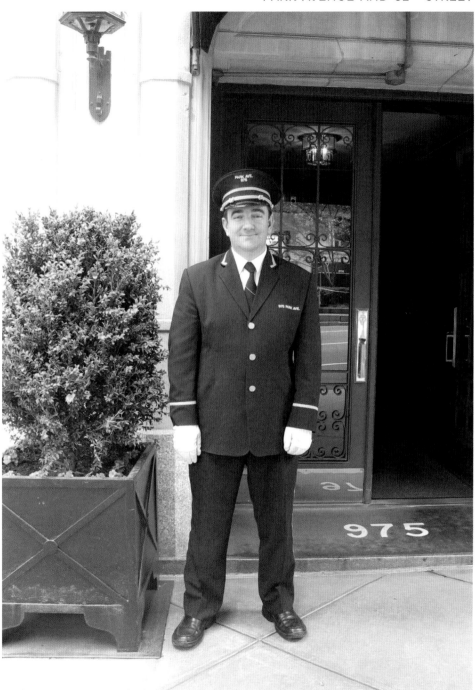

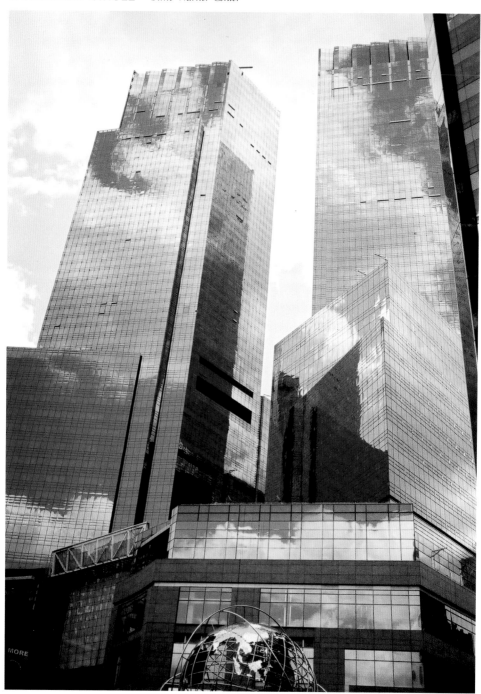

66 Any man who can afford
a hall bedroom and a gas stove
in New York City is better off
than he would be as the owner
of one hundred and sixty acres
on the prarie, or in one of these small,
so-called cities. **99**

Richard Harding Davis

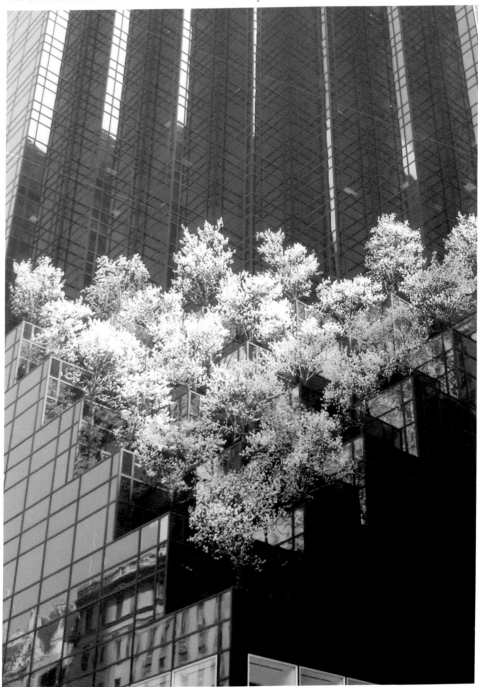

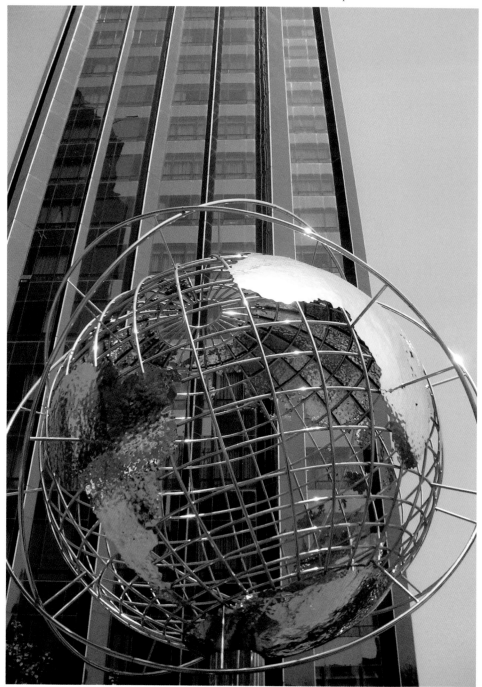

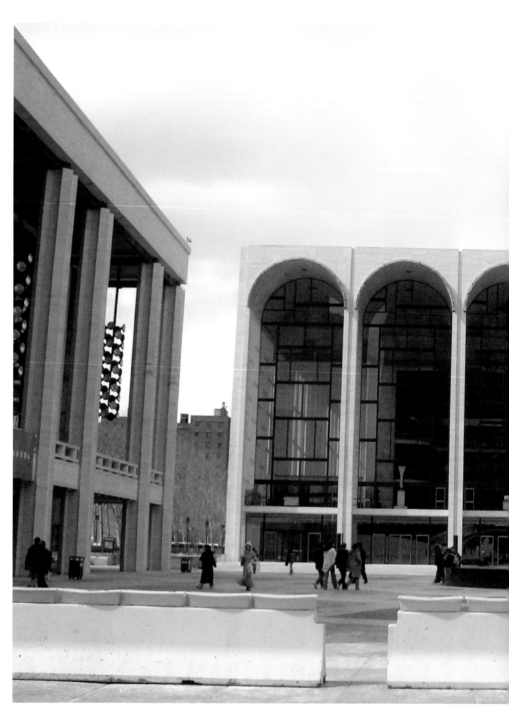

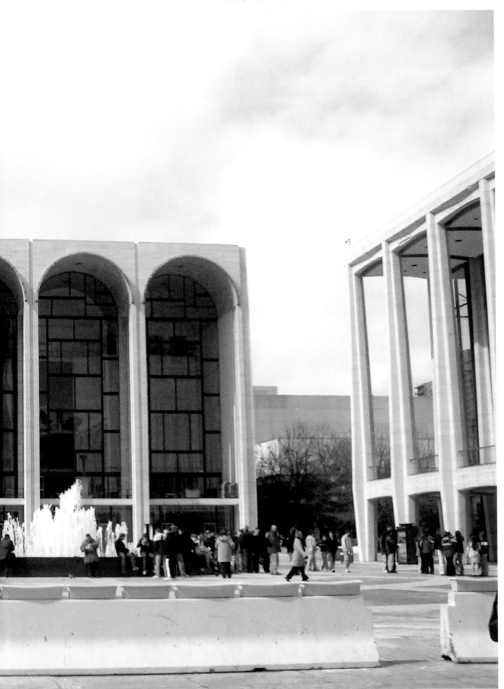

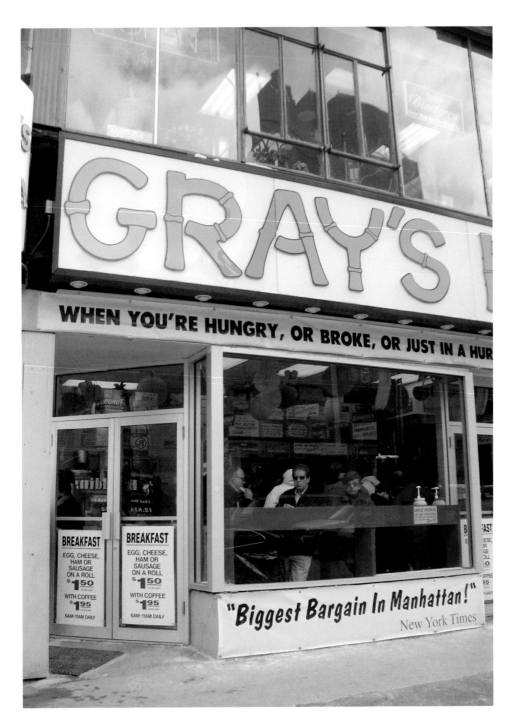

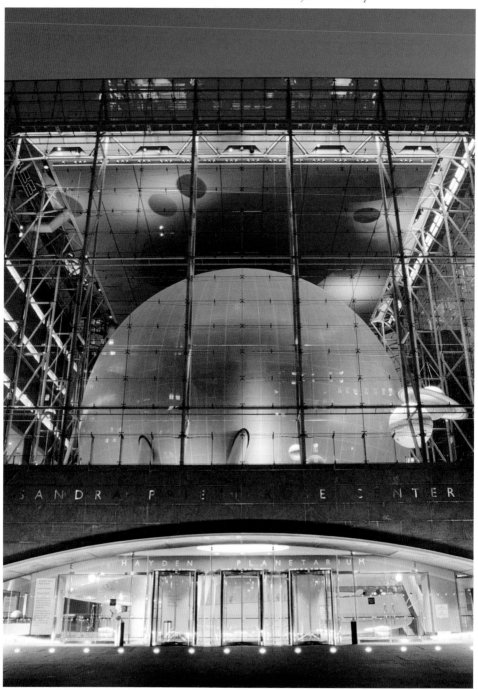

" Here the skeptic finds chaos
and the believer further evidence
that the hand that made us is divine. **"**

Robert Moses on the Hayden Planetarium

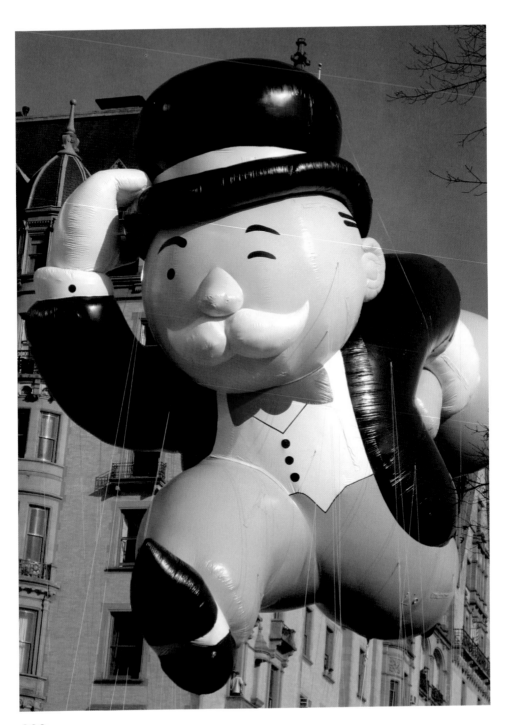

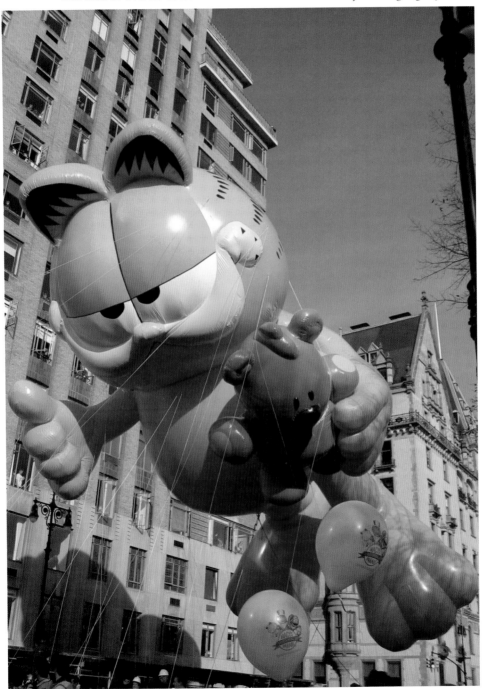

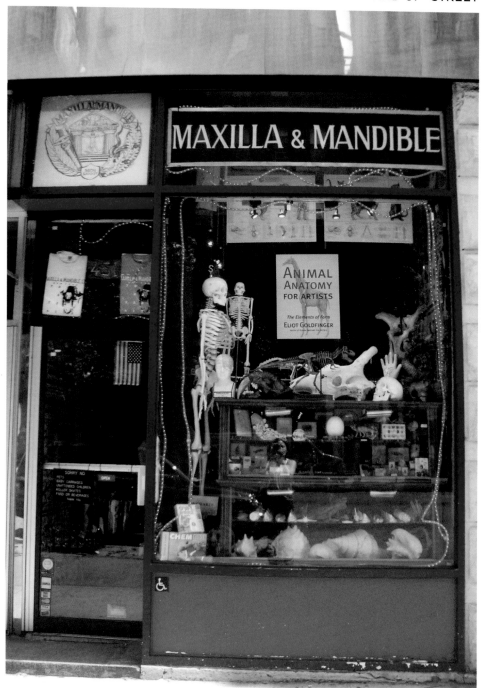

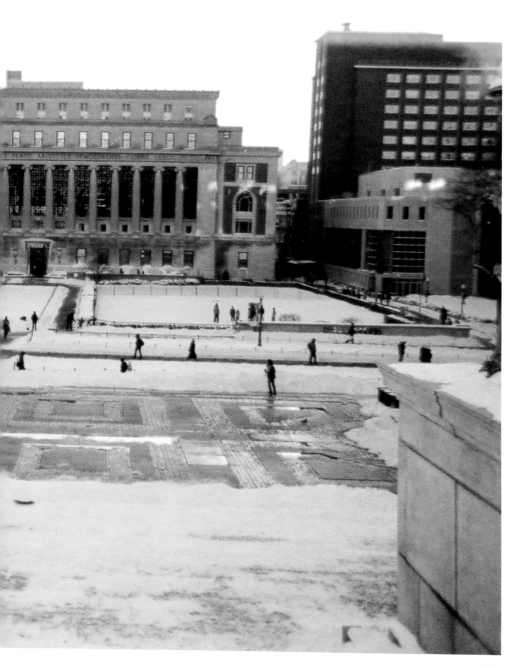

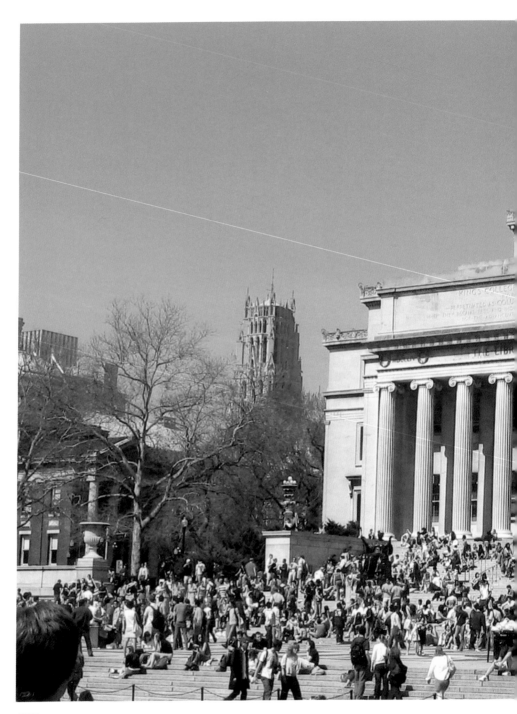

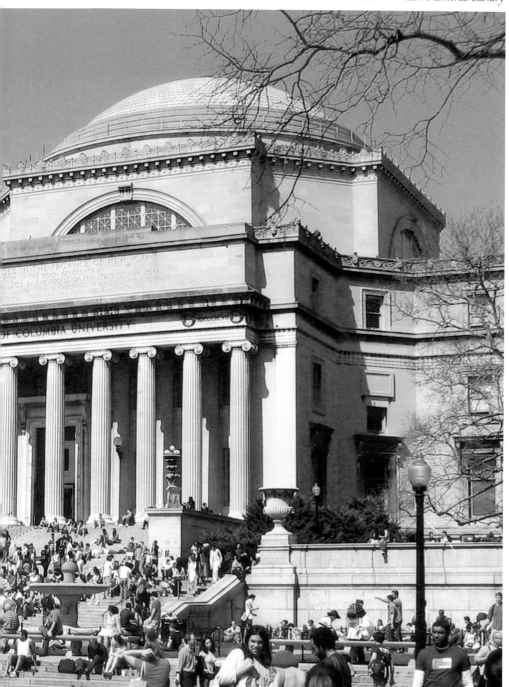

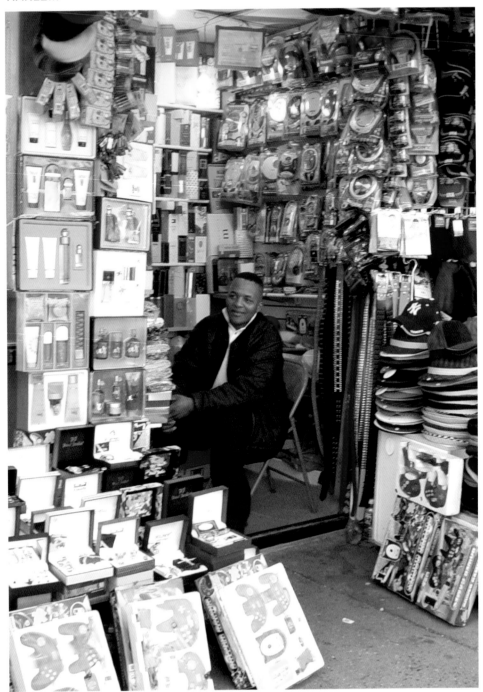

“ Was there ever such a sunny street as this Broadway? **”**

Charles Dickens

E AT THE APOLLO -- TICKETS ON SALE

OLLO AMATEUR NIGHT
very Wednesday, 7:30pm
One Mic... One Stage... One Chance

SHOWTIME AT THE APOLLO TV TAPINGS
February 25 - March 1

THE APOLLO LEGENDS SERIES:
THE O'JAYS
Saturday, February 5

MORRIS DAY & THE TIME and THE OHIO P
Thursday, February 17

S & TEMPS
Sunday March 19 & 20

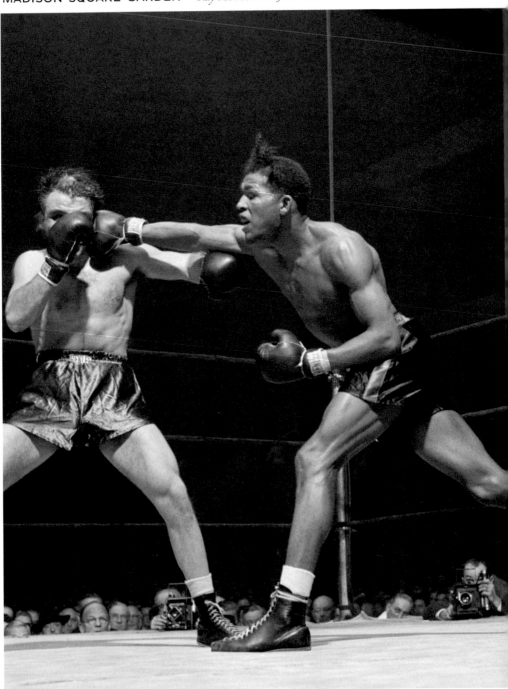

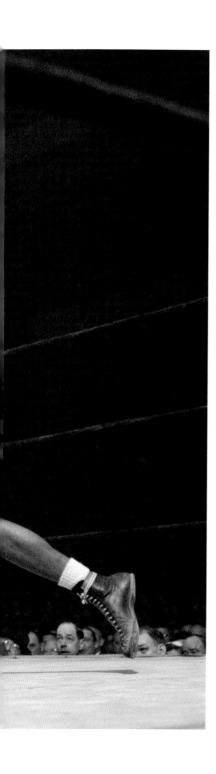

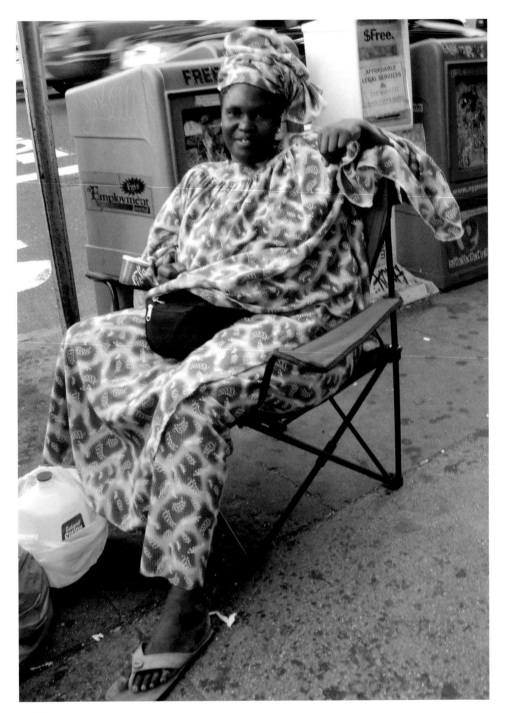

880

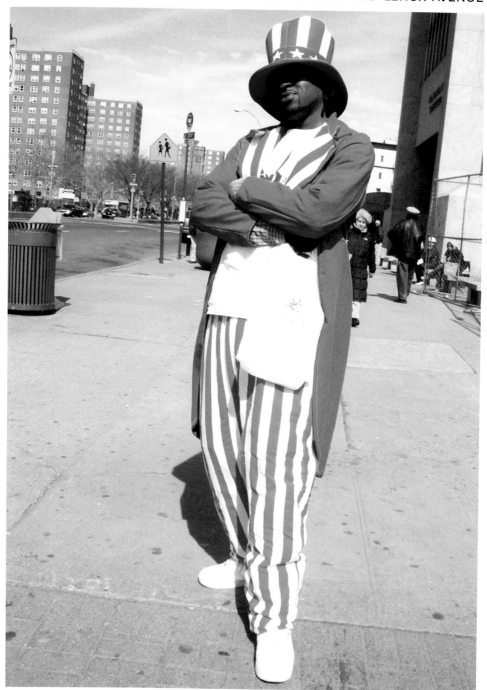

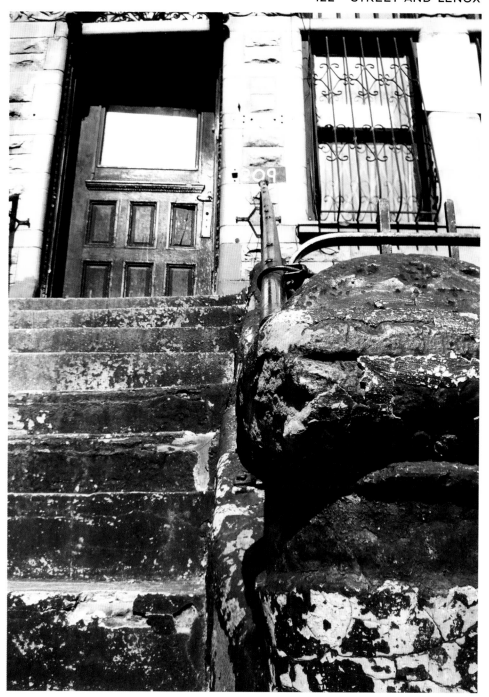

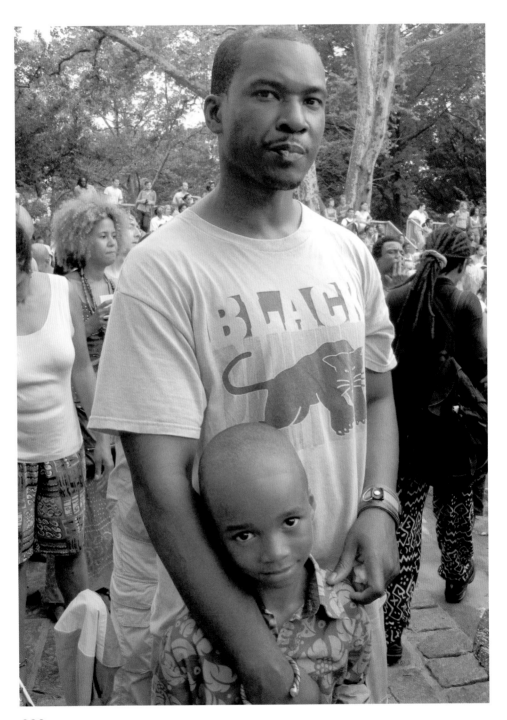

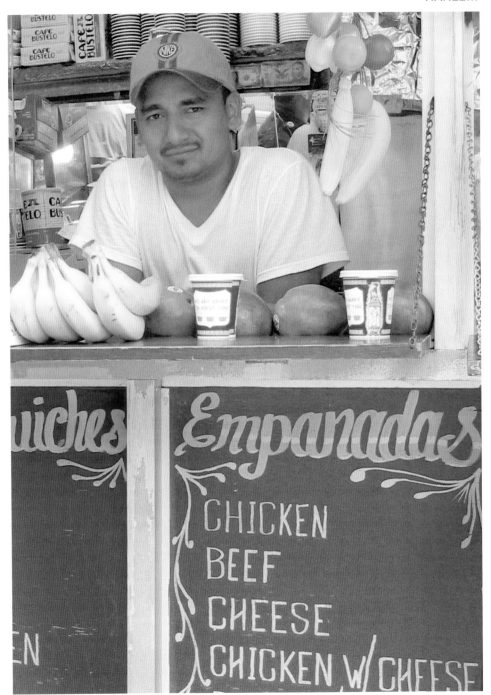

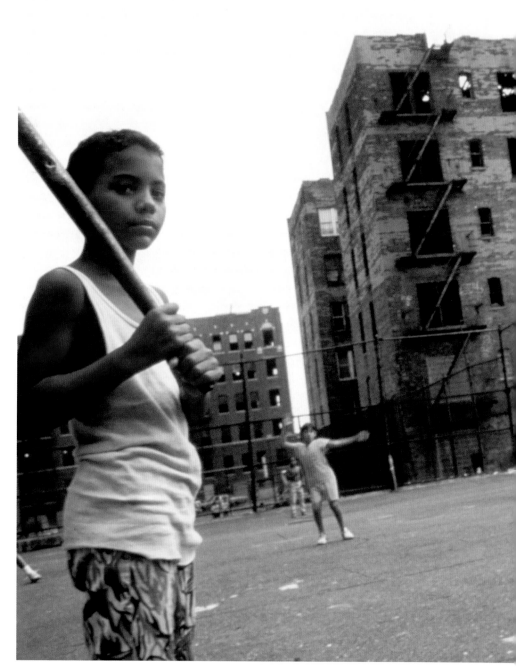

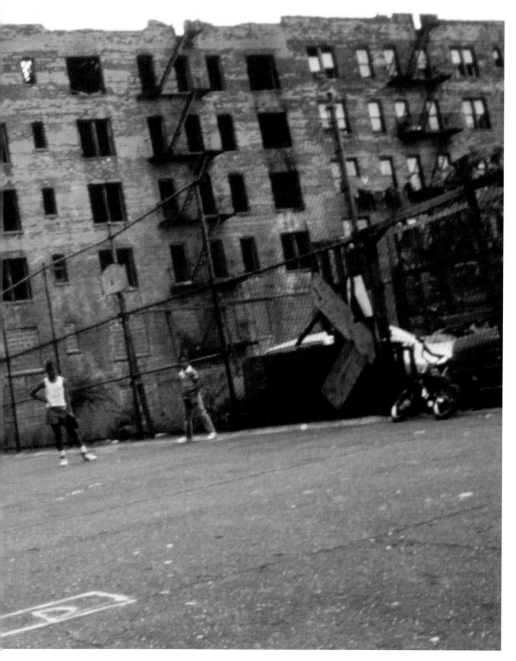

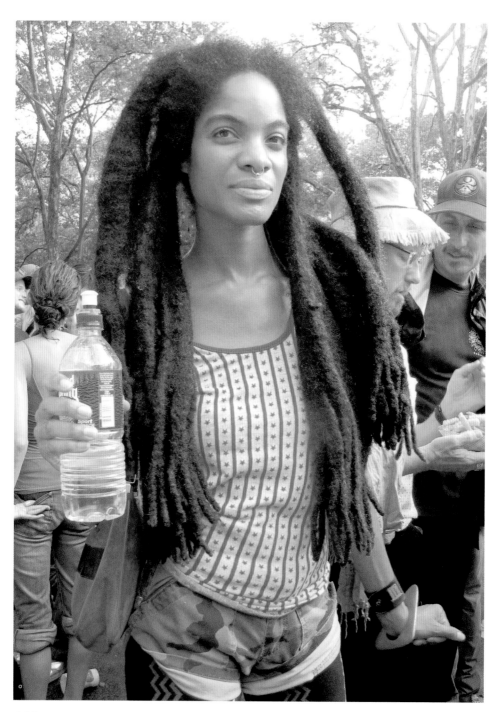

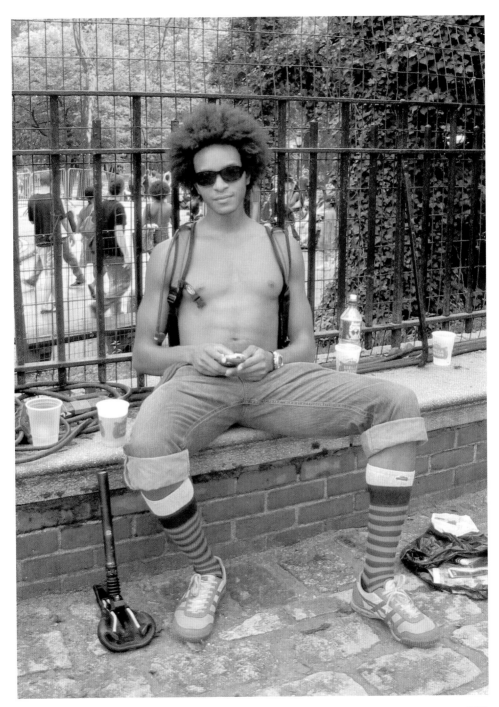

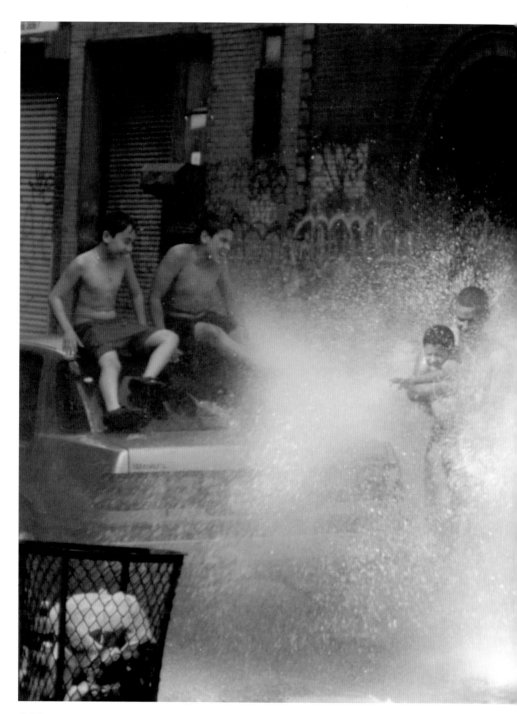

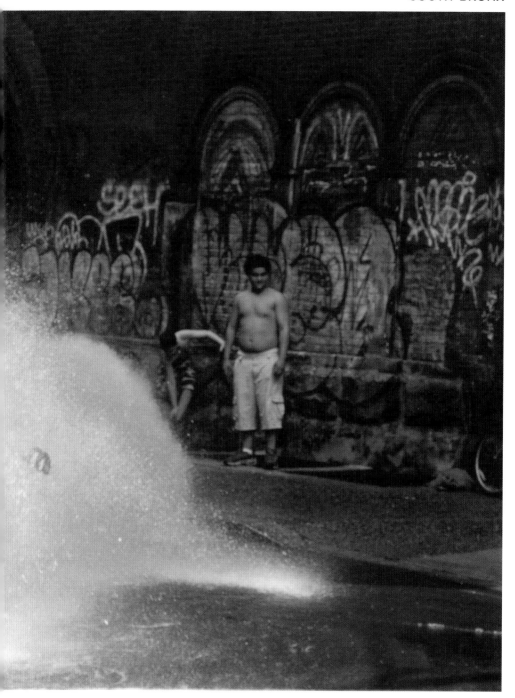

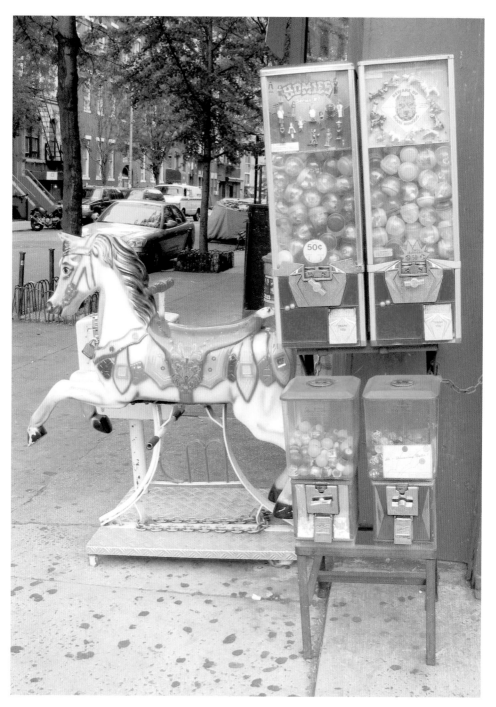

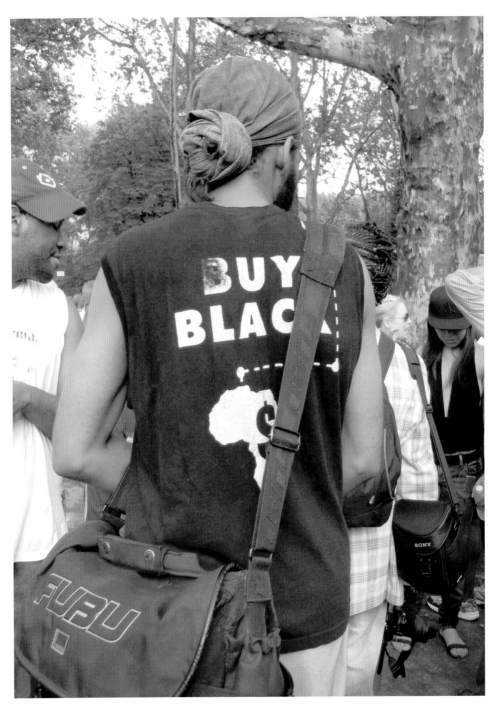

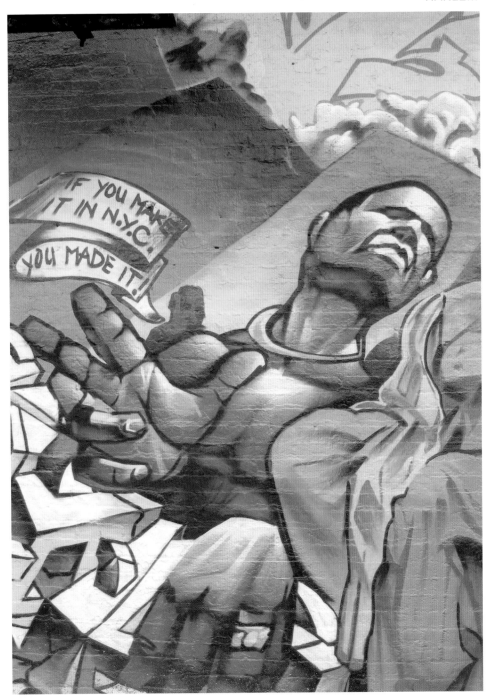

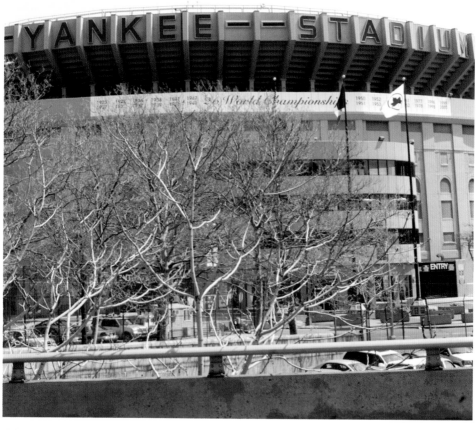

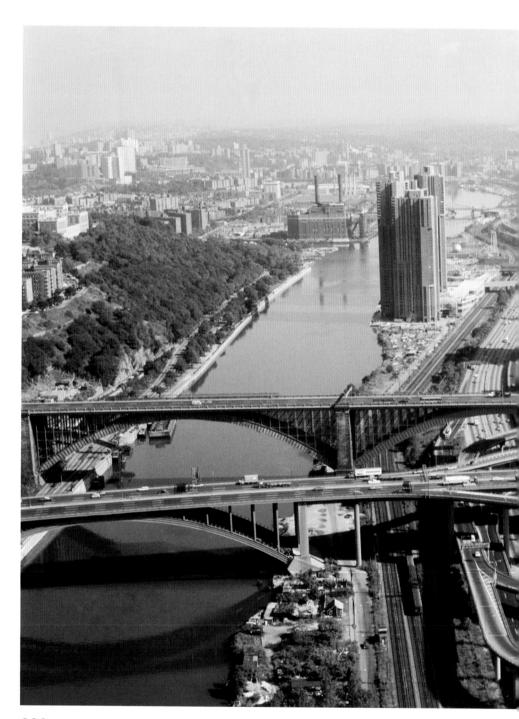

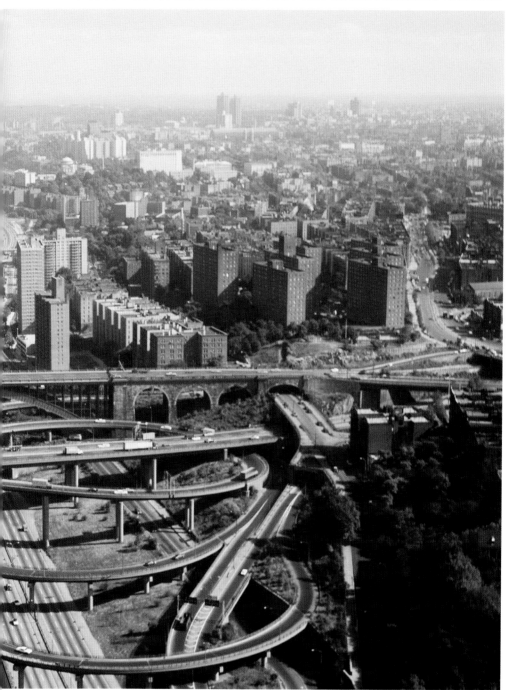

902

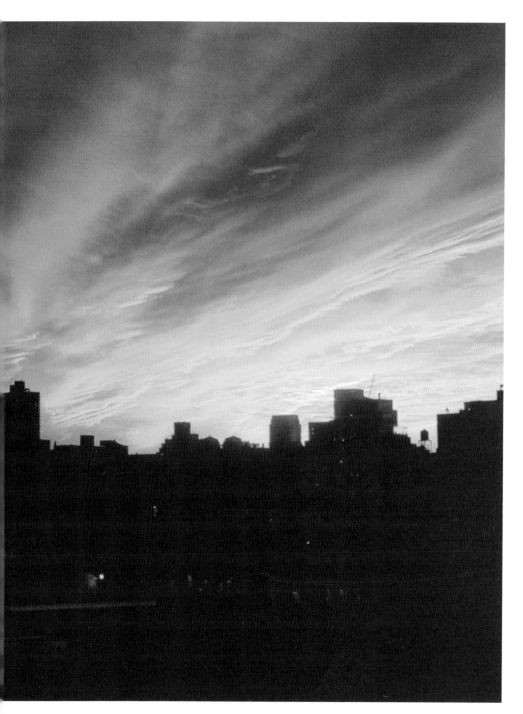

66 The reason perhaps is that New York is nothing without its sky.
Naked and immense, stretched to the four corners of the horizon, it gives the city its glorious mornings and the grandeur of its evenings, when a flaming sunset sweeps down Eighth Avenue over the immense crowds driving past the shop windows, whose lights are turned on well before nightfall.

There are also
certain twilights along
Riverside Drive, when
you watch the parkway
that leads uptown, with the
Hudson below, its waters
reddened by the setting sun;
off and on, from the
uninterrupted flow of gently,
smoothly running cars,
from time to time,
there suddenly rise a song
that recalls the sound
of breaking waves. "

Albert Camus

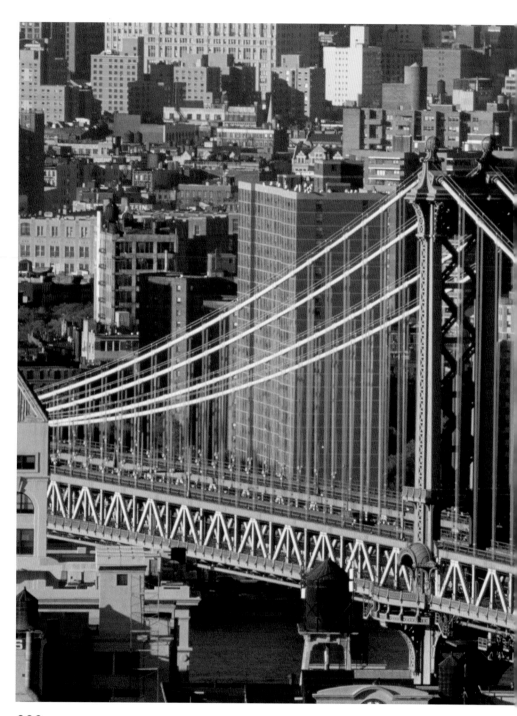

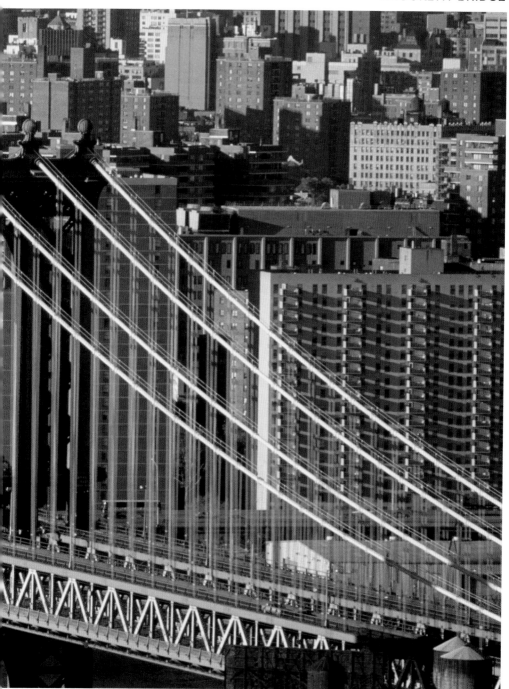

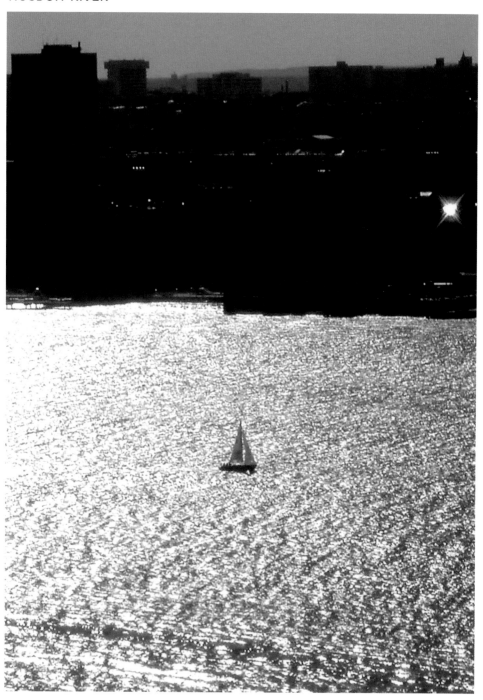

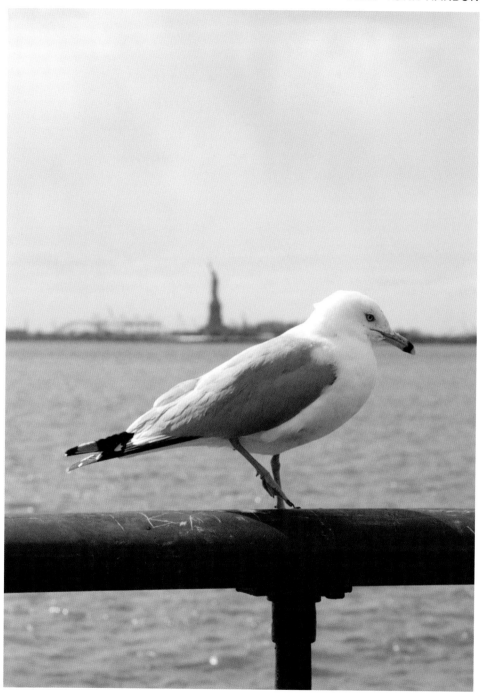

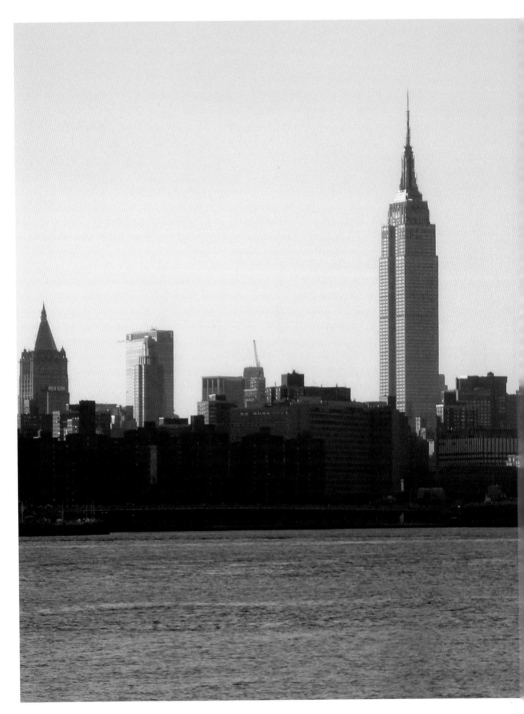

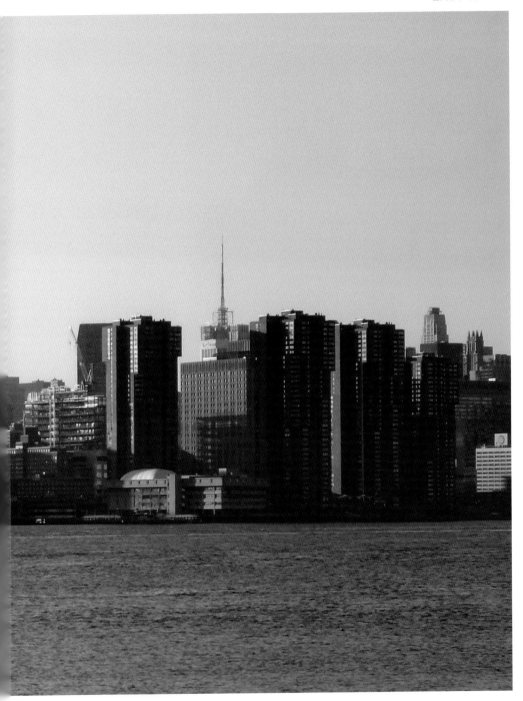

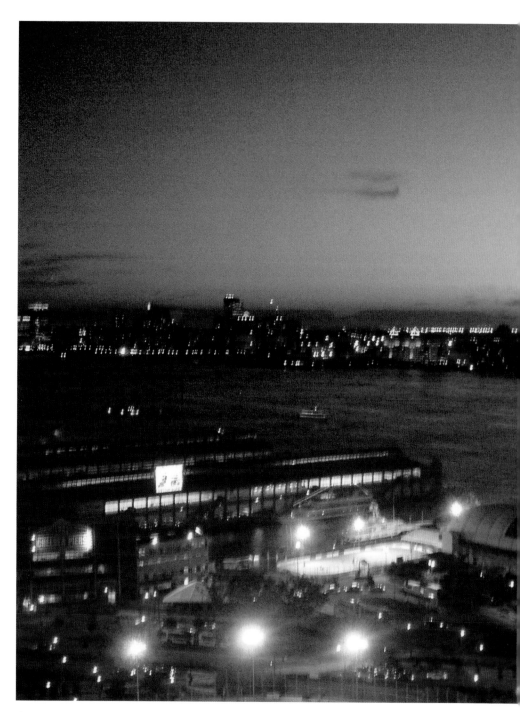

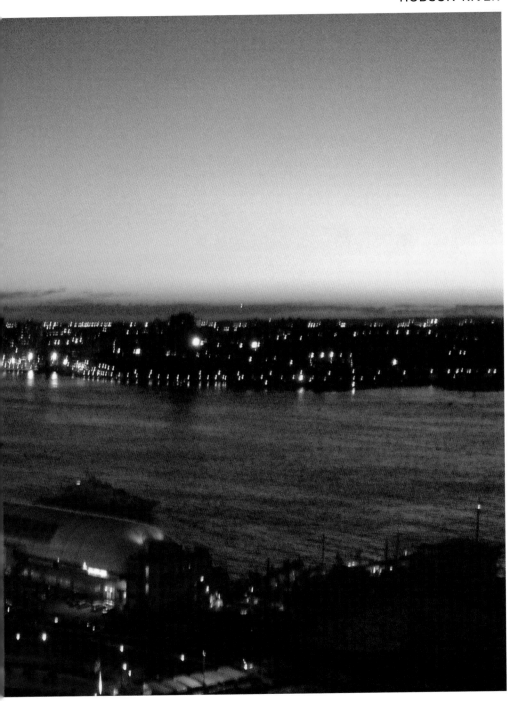

Hotels

60 Thompson
60 Thompson Street
tel.: 212 431 0400
fax: 212 431 0200
www.thompsonhotels.com

Akwaaba Mansion
347 MacDonough Street
tel.: 718 455 5958
www.akwaaba.com

The Alex
205 East 45th Street
tel.: 212 867 5100
fax: 212 867 7878
www.thealexhotel.com

The Algonquin
59 West 44th Street
tel:. 212 840 6800
fax: 212 944 1419
www.thealgonquin.net

The Benjamin
125 East 50th Street
tel.: 212 715 2500
fax: 212 715 2525
www. the benjamin.com

The Bryant Park
40 West 40th Street
tel.: 212 642 2200
fax: 212 869 4446
www.bryantparkhotel.com

The Carlyle
35 East 76th Street
tel.: 212 744 1600
fax: 212 717 4682
www.thecarlyle.com

Chambers
15 West 56th Street
tel.: 212 974 5656
fax: 212 974 5657
www.chambersnyc.com

Chelsea Hotel
222 West 23rd Street
tel: 212 243 3700

fax: 212 675 5531
www.chelseahotel.com

Dylan
52 East 41st Street
tel.: 212 338 0500
fax: 212 338 0569
www.dylanhotel.com

The Essex House
160 Central Park South
tel.: 212 247 0300
fax: 212 315 1839
www.westin.com/essexhouse

Four Seasons Hotel
57 East 57th Street
tel.: 212 758 5700
fax: 212 758 5711
www.fourseasons.com

Hotel Elysée
60 East 54th Street
tel:. 212 753 1066
fax: 212 980 9278
www.elyseehotel.com

Hotel Gansevoort
18 Ninth Avenue
tel.: 212 206 6700
fax: 212 255 5858
www.hotelgansevoort.com

Hotel Giraffe
365 Park Avenue South
tel.: 212 685 7700
fax: 212 685 7771
www.hotelgiraffe.com

Hotel on Rivington
107 Rivington Street
tel.: 212 475 2600
fax: 212 475 5959
www.hotelonrivington.com

Hotel Plaza Athénée
37 East 64th Street
tel.: 212 734 9100
fax: 212 772 0958
www.plaza-athenee.com

Hotel QT
125 West 45th Street
212 354 2323
www.hotelqt.com

The Hudson
356 West 58th Street
tel.: 212 554 6000
fax: 212 554 6001
www.morganshotelgroup.com

Inn at Irving Place
56 Irving Place
tel.: 212 533 4600
fax: 212 533 4611
www.innatirving.com

Jazz on the Park Hostel
36 West 106th Street
tel.: 212 932 1600
fax: 212 932 1700
www.jazzonthepark.com

The Kitano
66 Park Avenue
tel.: 212 885 7000
fax: 212 885 7100
www.kitano.com

Le Parker Meridien
118 West 57th St
tel.: 212 245 5000
fax: 212 307 1776
www.pakermeridien.com

Library Hotel
299 Madison Avenue
tel.: 212 983 4500
fax: 212 499 9099
www.libraryhotel.com

The Lowell Hotel
28 East 63rd Street
tel.: 212 838 1400
fax: 212 319 4230
www.lowellhotel.com

The Mandarin Oriental New York
80 Columbus Circle
tel.: 212 805 8800

fax: 212 805 8888
www.mandarinoriental.com

The Marcel
201 East 24th Street
tel.: 212 696 3800
fax: 212 696 0077
www.nychotels.com/marcel

The Maritime Hotel
363 West 16th Street
tel.: 212 242 4300
fax: 212 242 1188
www.themaritimehotel.com

The Mark
25 East 77th Street
tel.: 212 744 4300
fax: 212 744 2749
www.themarkhotel.com

The Mercer
147 Mercer Street
tel.: 212 966 6060
fax: 212 965 3838
www.mercerhotel.com

The Muse
130 West 46th Street
tel.: 212 485 2400
fax: 212 485 2900
www.themusehotel.com

New York Palace
455 Madison Avenue
tel.: 212 888 7000
fax: 212 303 6000
www.newyorkpalace.com

The Pierre Hotel
2 East 61st Street
tel.: 212 838 8000
fax: 212 940 8109
www.fourseasons.com/pierre

Phillips Club
155 West 66th Street
tel: 212 835 8800
fax: 212 835 8850
www.phillipsclub.com

St. Regis
2 East 55th Street
tel: 212 753 4500
fax: 212 787 3447
www.stregis.com

The Ritz-Carlton New York, Battery Park
2 West Street
tel.: 212 344-0800
fax: 212 344-3801
www.ritzcarlton.com

The Ritz-Carlton New York, Central Park
50 Central Park South
tel: 212 308 9100
fax: 212 207 8831
www.ritzcarlton.com

SoHo Grand Hotel
310 West Broadway
tel: 212 965 3000
fax: 212 965 3200
www.sohogrand.com

SoHo House
29-35 Ninth Avenue
tel: 212 627 9800
fax: 212 627 4766
www.sohohouse.com

The Time
224 West 49th Street
tel: 212 320 2900
fax: 212 245 2305
www.thetimeny.com

Tribeca Grand
2 Avenue of the Americas
212 519 6600
212 519 6400
www.tribecagrand.com

Trump International Hotel and Tower
1 Central Park West
tel: 212 299 1000
fax: 212 299 1150
www.trumpintl.com

W New York-Times Square
1567 Broadway
tel: 212 930 7400
fax: 212 930 7500
www.whotels.com

W New York-Union Square
201 Park Avenue South
tel.: 212 253 9119
fax: 212 253 9229
www.whotels.com

The Waldorf-Astoria
301 Park Avenue
tel: 212 355 3000
fax: 212 872 7272
www.waldorf.com

Restaurants
Cafes

5 Ninth
5 9th Avenue
212 929 9460

21 Club
21 West 52nd Street
212 582 7200

57 57
57 East 57th Street
212 758 5757

71 Clinton Fresh Food
71 Clinton Street
212 614 6960

Alain Ducasse
155 West 58th Street
212 265 7300

Annisa
13 Barrow Street
212 741 6699

Apizz
217 Eldridge Street
212 253 9199

Aquavit
65 East 55th Street
212 307 7311

Artisanal
2 Park Avenue
212 725 8585

Asia de Cuba
237 Madison Avenue
212 726 7755

Azul Bistro
152 Stanton Street
646 602 2004

Babbo
110 Waverly Place
212 777 0303

Balthazar
80 Spring Street
212 965 1414

Bar Marche
14 Spring Street
212 219 2399

Bette
461 West 23rd Street
212 366 0404

BLT Fish
21 West 17th Street
212 691 8888

Blue Ribbon
97 Sullivan Street
212 274 0404

Blue Ribbon Bakery
35 Downing Street
212 337 0404

Boathouse Restaurant
Central Park Drive North
212 517 2233

Bond St.
6 Bond Street
212 777 2500

Bottino
246 10th Avenue
212 206 6766

Bouley
120 West Broadway
212 964 2525

Bread
20 Spring Street
212 334 1015

Bread Tribeca
301 Church Street
212 334 8282

Café Lalo
201 West 83rd Street
212 496 6031

Café Luxembourg
200 West 70th Street
212 873 7411

Café Sabarsky
1048 Fifth Avenue
212 288 0665

Cafeteria
119 7th Avenue
212 414 1717

Ceci-Cela
55 Spring Street
212 274 9179

Chanterelle
2 Harrison Street
212 966 6960

Chez Es Saada
42 East 1st Street
212 777 5617

Da Silvano
260 6th Avenue
212 982 2343

Daniel
60 East 65th Street
212 288 0033

DB Bistro Moderne
55 West 44th Street
212 391 2400

Downtown Cipriani
376 West Broadway
212 343 0999

Django
480 Lexington Avenue
212 871 6600

DT UT
1626 2nd Avenue
212 327 1327

Elaine's
1703 2nd Avenue
212 534 8103

Felix
340 West Broadway
212 431 0021

Florent
69 Gansevoort Street
212 989 5779

Four Seasons
99 East 52nd Street
212 754 9494

Fresh
105 Reade Street
212 406 1900

Gotham Bar & Grill
12 East 12th Street
212 620 4020

Gramercy Tavern
42 East 20th Street
212 477 0777

The Harrison
355 Greenwich Street
212 274 9310

Hog Pit
22 9th Avenue
212 604 0092

Il Buco
47 Bond Street
212 533 1932

Il Cantinori
32 East 10th Street
212 673 6044

Indochine
430 Lafayette Street
212 505 5111

'inoteca
98 Rivington Street
212 614 0473

Isabella's
359 Columbus Avenue
212 724 2100

Jean Georges
1 Central Park West
212 299 3900

Koi
40 West 40th Street
212 921 3330.

Kelley & Ping
127 Greene Street
212 228 1212

Kittichai
60 Thompson Street
212 219 2000

L'Orange Bleue
430 Broome Street
212 226 4999

La Goulue
746 Madison Avenue
212 988 8169

Landmarc
179 West Broadway
212 343 3883

Le Bilboquet
25 East 63rd Street
212 751 3036

Le Colonial
149 East 57th Street
212 752 0808

Le Souk
47 Avenue B
212 777 5454

Little Pie Company
407 West 14th Street
212 414 2324

Lucky Strike
59 Grand Street
212 941 0479

Magnolia Bakery
401 Bleecker Street
212 462 2572

Mangia
50 West 57th Street
212 582 5554

Markt
401 West 14th Street
212 727 3314

Matsuri
369 West 16th Street
212 243 6400

Meet
71 Gansevoort Street
212 242 0990

Megu
62 Thomas Street
212 964 7777

Miracle Grill
415 Bleecker Street
212 924 1900

Mix in New York
68 West 58th Street
212 583 0300

The Modern
9 West 53rd Street
212 333 1220

Montrachet
239 West Broadway
212 219 2777

Nello
696 Madison Avenue
212 980 9099

Nobu Next Door
105 Hudson Street
212 334 4445

Nobu
105 Hudson Street
212 219 0500

Osterio del Circo
120 West 55th Street
212 265 3636

Paris Commune
99 Bank Street
212 929 0509

Pastis
9 9th Avenue
212 929 4844

Patsy's Pizzeria
67 University Place
212 533 3500

Payard Patisserie & Bistro
1032 Lexington Avenue
212 717 5252

Perry Street
176 Perry Street
212 352 1900

Per Se
10 Columbus Circle
212 823 9335

Peter Luger
178 Broadway
718 387 7400

Piadina
57 West 10th Street
212 460 8017

Rao's
455 East 114th Street
212 722 6709

Raoul's
180 Prince Street
212 966 3518

Sarabeth's
1295 Madison Avenue
212 410 7335

Schiller's Liquor Bar
131 Rivington Street
212 260 4555

Second Avenue Deli
156 2nd Avenue
212 677 0606

Serafina
29 East 61st Street
212 702 9898

Smith & Wollensky
797 3rd Avenue
212 753 1530

Spice Market
403 West 13th Street
212 675 2322

Sushi Samba
245 Park Avenue South
212 475 9377

Sylvia's
328 Lenox Avenue
212 996 0660

Tanoreen
7704 Third Avenue, Bayridge,
Brooklyn
718 748 5600

Tavern on the Green
Central Park West
212 873 3200

Tea & Sympathy
108-110 Greenwich Avenue
212 807 8329

Tenement
157 Ludlow Street
212 766 1270

The Red Cat
227 10th Avenue
212 242 1122

River Café
1 Water Street
718 522 5200

Time Café
2330 Broadway
212 579 5100

Union Square Café
21 East 16th Street
212 243 4020

Yama
38 Carmine Street
212 989 9330

Bars
Clubs

A 60
60 Thompson Street
877 431 0400

Abbey Pub
237 West 105th Street
212 222 8713

Aer
409 West 13th Street
212 989 0100

APT
419 West 13th Street
212 414 4245

Arlene Grocery
95 Stanton Street
212 995 1652

Au Bar
41 East 58th Street
212 308 9455

B Bar
40 East 4th Street
212 475 2220

Bar 13
35 East 13th Street
212 979 6677

B.E.D.
530 West 27th St
212 594 4109

Bemelmans Bar
981 Madison Avenue
212 744 1600

BLVD
199 Bowery
212 982 7767

bOb
235 Eldridge Street
212 529 1807

Boogaloo
168 Marcy Avenue
718 599 8900

Botanica
47 East Houston Street
212 343 7251

Brass Monkey
55 Little West 12th Street
212 675 6686

Brooklyn Brewery
79 North 11th Street
718 486 7422

Bungalow 8
515 West 27th Street
212 629 3333

Cain
544 West 27th Street
212 947 8000

CBGB
315 Bowery
212 982 4052

Cielo
18 Little West 12th Street
212 645 5700

The Cock
188 Avenue A
212 777 6254

Double Happiness
173 Mott Street
212 941 1282

Duvet
45 West 21st Street
212 989 2121

Earth NYC
116 10th Avenue
212 337 0016

Employee's Only
510 Hudson Street
212 242 3021

Frederick's
8 West 58th Street
212 752 6200

Galapagos
70 North 6th Street
718 782 5188

Halcyon
57 Pearl Street
718 260 9299

Happy Ending
302 Broome Street
212 334 9676

Highline
835 Washington Street
212 243 3339

Hiro
363 West 16th Street
212 727 0212

Hogs & Heifers
859 Washington Street
212 929 0055

Hotel Gansevoort
18 Ninth Avenue
212 206 6700

Hudson Bar and Books
636 Hudson Street
212 229 2642

Hue
91 Charles Street
212 691 4170

Joe's Pub
425 Lafayette Street
212 539 8770

KGB
85 East 4th Street
212 505 3360

Kush
191 Chrystie Street
212 677 7328

Lansky Lounge
104 Norfolk Street
212 677 9489

Lenox Lounge
288 Malcolm X Boulevard
212 427 0253

Lot 61
550 West 21st Street
212 243 6555

Lotus
409 West 14th Street
212 243 4420

Library
7 Avenue A
212 375 1352

Lips
2 Bank Street
212 675 7710

Lit
93 Second Avenue
212 777 7987

Living Room
154 Ludlow Street
212 533 7235

Lucky Cheng's
24 1st Avenue
212 473 0516

Marquee
289 Tenth Ave
646 473 0202

McSorley's
15 East 7th Sreet
212 473 9148

MercBar
151 Mercer Street
212 966 2727

Meet
71-73 Gansevoort Street
212 242 0990

Monkey Bar
60 East 54th Street
212 838 2600

Niagara
112 Avenue A
212 420 9517

Nuyorican Poets Café
236 East 3rd Street
212 505 8183

Ono
18 Ninth Avenue
212 660 6766

The Park
118 Tenth Avenue
212 352 3313

Pianos
158 Ludlow Street
212 505 3733

Pink Elephant
73 Eighth Avenue
212 463 0000

PM
50 Gansevoort Street
212 255 6676

Pravda
281 Lafayette Street
212 226 4696

Quo
511 West 28th St
212 268 5105

Salon
505 West Street
212 929 4303

Serena
222 West 23rd Street
212 255 4646

Smoked
103 Second Avenue
212.388.0388

S.O.B.'s
204 Varick Street
212 243 4940

SoHo House
29-35 Ninth Avenue
212 627 9800

Stay
244 East Houston St.
212.982.3532

Suede
161 West 23rd Street
212 633 6113

Sweet and Vicious
5 Spring Street
212 334 7915

Tonic
107 Norfolk Street
212 358 7501

Vapor
143 Madison Avenue
212 686 6999

Webster Hall
125 East 11th Street
212 353 1600

West
425 West Street
212 242 4375

Zinc Bar
90 West Houston Street
212 477 8337

Department Stores
Vintage Shops
Flea Markets

DEPARTMENT STORES

Barneys New York
660 Madison Avenue
212 826 8900
www.barneys.com

Bergdorf Goodman
754 Fifth Avenue
212 753 7300
www.bergdorfgoodman.com

Bloomingdale's
1000 Third Avenue
212 705 2000
504 Broadway
212 729 5900
www.bloomingdales.com

Century 21
22 Cortlandt Street
212 227 9092
www.c21stores.com

Henri Bendel
712 Fifth Avenue
212 247 1100
www.henribendel.com

Jeffrey New York
449 West 14th Street
212 206 1272
www.jeffreynewyork.com

Lord & Taylor
424 Fifth Avenue
212 391 3344
www.lordandtaylor.com

Macy's
151 West 34th Street
212 695 4400
www.macys.com

Saks Fifth Avenue
611 Fifth Avenue
212 753 4000
www.saks.com

Takashimaya
693 Fifth Avenue
212 350 0100

VINTAGE AND THRIFT BOUTIQUES

Amarcord
223 Bedford Avenue
718 963 4001

Beacon's Closet
88 North 11th Street, Williamsburg, Brooklyn
718 486 0816

Cherry
19 Eighth Avenue
212 924 1410

Edith & Daha
104 Rivington Street
212 979 9992

Foley & Corinna
114 Stanton Street
212 529 2338

INA
101 Thompson Street
212 941 4757

Lint
318 Bedford Avenue
718 387 9508

Marmalade
172 Ludlow Street
212 473 8070

Olive's Very Vintage
434 Court Street
718 243 9094

Resurrection
217 Mott Street
212 625 1374

FLEA MARKETS

Annex Antiques Fair and Flea Market
Sixth Avenue at 26th Street
212 243 5343
Saturday and Sunday, 9 a.m. to
5:30 p.m.

Greenflea
Columbus Avenue at 76th Street
Sunday 10 a.m. to 6 p.m.

Maalcom Shabazz Harlem Market
52 West 116th Street
212 987 8131
10 a.m. to 8 p.m.

The Market NYC
286 Mulberry Street
212 580 8995
Saturday and Sunday 11 a.m. to 7
p.m.

OUTDOOR MARKETS

Union Square Greenmarket
Broadway and 17th Street
Open Monday, Wednesday,
Friday and Saturday 8 a.m. to 6
p.m.

For information on other outdoor
markets contact the **Council on
the Environment of New York City**
212 788 7476

Galleries
Auction Houses

GALLERIES

303 Gallery
525 West 22nd Street
212 255 1121
www.303gallery.com

Alexander and Bonin
132 Tenth Avenue
212 367 7474
www.alexanderandbonin.com

Artemis Greenberg Van Doren
730 Fifth Avenue
212 445 0444
www.agvdgallery.com

Marianne Boesky Gallery
535 West 22nd Street
212 680 9889
www.marianneboeskygallery.com

Bellwether
134 Tenth Avenue
212 929 59591
www.bellwethergallery.com

Mary Boone Gallery
541 West 24th Street
212 752 2929
www.maryboonegallery.com

Mary Boone Gallery
745 Fifth Avenue
212 752 2929
www.maryboonegallery.com

C&M Arts
45 East 78th Street
212 861 0020
www.c-m-arts.com

Paula Cooper
534 West 21st Street
212 255 1105

Deitch Projects
18 Wooster Street
76 Grand Street
212 343 7300
www.deitch.com

The Drawing Center
35 Wooster Street
212 219 2166
www.drawingcenter.org

Dumbo Arts Center
30 Washington Street
718 694 0831
www.dumboartscenter.org

ELS-LES (Every Last Sunday on the Lower East Side) Open Studios
122
646 602 2338
www.elsles.org

Ronald Feldman
31 Mercer Street
212 226 3232
www.feldmangallery.com

Friedrich Petzel Gallery
535 West 22nd Street
212 680 9467
www.petzel.com

Gagosian
555 West 24th Street
212 741 1111
www.gagosian.com

Gagosian
980 Madison Avenue
212 744 2313
www.gagosian.com

Galeria Ramis Barquet
41 East 57th Street
212 644 9090
www.ramisbarquet.com

Galeria Ramis Barquet
532 West 24th Street
212 675 3421
www.ramisbarquet.com

Gavin Brown's Enterprise
620 Greenwich Street
212 627 5258

Barbara Gladstone
515 West 24th Street
212 206 9300
www.gladstonegallery.com

Marian Goodman Gallery
24 West 57th Street
212 977 7160
www.mariangoodman.com

Gorney Bravin + Lee
534 West 26th Street
212 352 8372
www.gblgallery.com

Howard Greenberg Gallery
Fuller Building, 41 East 57th Street
212 334 0010
www.howardgreenberg.com

Greene Naftali Gallery
526 West 26th Street
212 463 7770
www.greenenaftaligallery.com

Edwynn Houk Gallery
745 Fifth Avenue
212 750 7070
www.houkgallery.com

International Center of Photography
1133 Sixth Avenue
212 857 0000
www.icp.org

Anton Kern Gallery
532 West 20th Street
212 367 9663
www.antonkerngallery.com

Andrew Kreps Gallery
516A West 20th Street
212 741 8849
www.andrew kreps.com

Klotz/Sirmon Gallery
511 West 25th Street
212 741 4764
www.klotzsirmon.com

Lehmann Maupin
540 West 26th Street
212 255 2923
www.lehmannmaupin.com

Leo Koenig Inc.
249 Centre Street
212 334 9255
www.leokoenig.com

Luhring Augustine
531 West 24th Street
212 206 9100
www.luhringaugustine.com

M Knoedler & Co.
19 East 70th Street
212 794 0550
www.knoedlergallery.com

Maccarone Inc.
45 Canal Street
212 431 4977

Matthew Marks
523 West 24th Street
212 243 0200
www.matthewmarks.com

Metro Pictures
519 West 24th Street
212 206 7100
www.metropicturesgallery.com

Robert Miller Gallery
524 West 26th Street
212 366 4774
www.robertmillergallery.com

Mitchell-Innes & Nash
1018 Madison Avenue
212 744 7400
www.miandn.com

Paul Morris
530 West 23rd Street
212 727 2752

Jessica Murray Projects
150 11th Avenue

212 633 9606
www.jessicamurrayprojects.com

Pace/MacGill Gallery
32 East 57th Street
212 759 7999

Pace
Wildenstein Gallery
32 East 57th Street
534 West 25th Street
212 421 3292/ 212 929 7000
www.pacewildenstein.com

Pierogi 2000
177 North 9th Street, Williamsburg
718 599 2144
www.pierogi2000.com

Plus Ultra Gallery
235 South 1st Street, Williamsburg
718 387 3844
www.plusultragallery.com

Postmasters
459 West 19th Street
212 727 3323
www.postmastersart.com

Daniel Reich Gallery
537A West 23rd Street
212 924 4949
www.danielreichgallery.com

Rivington Arms
102 Rivington Street
646 654 3213

Roebling Hall
390 Wythe Avenue, Williamsburg
718 599 5352
606 West 26th STreet
212 929 8180
www.brooklynart.com

Andrea Rosen
525 West 24th Street
212 627 6000
www.andrearosengallery.com

Sonnabend
536 West 22nd Street
212 627 1018
www.artnet.com

Tony Shafrazi Gallery
544 West 26th Street
212 274 9300
www.tonyshafrazigallery.com

David Zwirner
525 West 19th Street
212 727 2070
32 East 69th Street
212 517 8677
www.davidzwirner.com

AUCTION HOUSES
Christie's
20 Rockefeller Plaza
212 636 2000
www.christies.com

Guernsey's
108 East 73rd Street
212 794 2280
www.guernseys.com

Phillips, de Pury & Luxembourg
450 West 15th Street
212 940 1200
www.phillipsdepury.com

Sotheby's
1334 York Avenue
212 606 7000
www.sothebys.com

Swann Galleries
104 East 25th Street
212 254 4710
www.swanngalleries.com

Tepper Galleries
110 East 25th Street
212 677 5300
www.teppergalleries.com

Museums

American Folk Art Museum
45 West 53rd Street
212 265 1040
www.folkartmuseum.org

American Museum of the Moving Image
35th Avenue, Astoria, Queens
718 784 0077
www.ammi.org

American Museum of Natural History/Rose Center for Earth and Space
Central Park West at 79th Street
212 769 5000
www.amnh.com

Asia Society and Museum
725 Park Avenue
212 288 6400
www.asiasociety.org

Bronx Museum of the Arts
1040 Grand Concourse
718 681 6000
www.bxma.org

Brooklyn Children's Museum
145 Brooklyn Avenue
718 735 4400
www.brooklynkids.org

Brooklyn Museum
200 Eastern Parkway, Prospect Heights, Brooklyn
718 638 5000
www.brooklynmuseum.org

Children's Museum of the Arts
182 Lafayette Street
212 274 0986
www.cmany.org

Children's Museum of Manhattan
212 West 83rd Street
212 721-1234
www.cmom.org

The Cloisters
Fort Tryon Park,
Fort Washington Avenue
212 923 3700
www.metmuseum.org

Cooper-Hewitt National Design Museum
2 East 91st Street
212 849 8400
www.si.edu/ndm

Dahesh Museum of Art
580 Madison Avenue
212 759 0606
www.daheshmuseum.org

Dia: Beacon
3 Beekman Street,
Beacon, New York
845 440 0100
www.diaart.org

Dia: Chelsea
548 West 22nd Street
212 989 5566
www.diaart.org

El Museo del Barrio
1230 Fifth Avenue
212 831 7272
www.elmuseo.org

Ellis Island Immigration Museum
Ellis Island
212 883 1986
www.ellisisland.org

Frick Collection
1 East 70th Street
212 288 0700
www.frick.org

International Center of Photography
1133 Sixth Avenue
212 857 0000
www.icp.org

Intrepid Sea-Air-Space Museum

USS Intrepid, Pier 86, 46th Street at
the Hudson River
212 245 0072
www.intrepidmuseum.org

Isamu Noguchi Garden Museum
9-01 33rd Road
Long Island City, Queens
718 204 7088
www.noguchi.org

Jewish Museum
1109 Fifth Avenue
212 423 3200
www.jewishmuseum.org

Louis Armstrong House
34-56 107th Street
718 478 8274
www.satchmo.com

**Lower East Side Tenement
Museum**
90 Orchard Street
212 431 0233
www.tenement.org

The Metropolitan Museum of Art
1000 Fifth Avenue
212 535 7710
www.metmuseum.org

The Museum at FIT
Seventh Avenue at 27th Street
212 217 5800
www.fitnyc.edu

**Museum of American Financial
History**
28 Broadway
212 908 4110
www.financialhistory.org

Museum of American Illustration
128 East 63rd Street
212 838 2560
www.societyillustrators.org

The Museum of Arts & Design
40 West 53rd Street

212 956 3535
www.americancraftmuseum.org

Museum of the City of New York
1220 Fifth Avenue
212 534 1672
www.mcny.org

**Museum of Jewish Heritage: A
Living Memorial to the Holocaust**
36 Battery Place
212 968 1800
www.mjhnyc.org

Museum of Modern Art
11 West 53rd Street
212 708 9400
www.moma.org

Museum of Sex
233 Fifth Avenue
212 689 6337
www.museumofsex.com

The Museum of Television & Radio
25 West 52nd Street
212 621 6800
www.mtr.org

National Academy of Design
1083 Fifth Avenue
212 369 4880
www.nationalacademy.org

**National Museum of the
American Indian
George Gustav Heye Center**
1 Bowling Green
212 514 3700
www.americanindian.si.edu

Neue Galerie
1048 Fifth Avenue
212 628 6200
www.neuegalerie.org

**New Museum of Contemporary
Art**
556 West 22nd Street
212 219 1222

www.newmuseum.org

New York Hall of Science
47-01 111th Street, Flushing
Meadows-Corona Park, Queens
718 699 0005
www.nyhallsci.org

New York Historical Society
170 Central Park West
212 873 3400
www.nyhistory.org

New York City Police Museum
100 Old Slip
212 480 3100
www.nycpolicemuseum.org

New York Fire Museum
278 Spring Street
212 691 1303
www.nycfiremuseum,org

New York Transit Museum
Corner of Boerum Place and
Schermerhorn Street, Brooklyn
Heights, Brooklyn
718 694 1600
www.mta.info/mta/museum

Pierpont Morgan Library
29 East 36th Street
212 685 0008
www.morganlibrary.org

P.S. 1 Contemporary Art Center
22-25 Jackson Avenue
718 784 2084
www.ps1.org

**Schomburg Center for Research
in Black Culture**
515 Malcom X Boulevard
212 491 2200

Skyscraper Museum
39 Battery Place
212 968 1961
www.skyscraper.org

Solomon R. Guggenheim Museum
1071 Fifth Avenue
212 423 3500
www.guggenheim.org

**The Statue of Liberty & Ellis Island
Immigration Museum**
212 363 3200
www.ellisisland.org

Studio Museum in Harlem
144 West 125th Street
212 864 4500
www.studiomuseuminharlem.org

Whitney Museum of American Art
945 Madison Avenue
212 570 3600
www.whitney.org

New York City
Views
Walks
Landmarks

VIEWS
Arthur's Landing
Asiate at Mandarin Oriental Hotel in the Time Warner Center
Ava Lounge at Majestic Hotel
BP Café
Edward Moran Bar and Grill
Empire State Building
High Bar at the Gramercy Park Hotel
Metro Grill at Hotel Metro
Rainbow Room at Rockefeller Plaza
Rooftop Bar at Hotel Gansevoort
Stanley H. Kaplan Penthouse at Lincoln Center
Staten Island Ferry
Statue of Liberty
Tavern on the Green
The River Café
Top of the Rock
Top of the Tower at Beekman Tower Hotel
Wave Hill Public Garden and Cultural Center

WALKING TOURS
Adventure on a Shoestring
212 265 2663

Big Onion Walking Tours
212 439 1090
www.bigonion.com

Chinatown Walking Tour by Jami Gong
Jami@ChinatownNYC.com
www.chinatownnyc.com/walking.html

Foods of New York Walking and Tasting Tours
212 209 3370
www.foodsofny.com

Greenwich Village Literary Pub Crawl
New Ensemble Theatre Company
212 613 5796
www.geocities.com/newensemble

Harlem Heritage Tours
212 280 7888
www.harlemheritage.com

Historical Walking Tour of Lower Manhattan
888 692 8701
www.nycvp.com

Joyce Gold History Tours
Gangs of New York and the Bloody Five Points
Central Park—The Big Back Yard of the City
141 West 17th Street
212 242 5762
www.nyctours@aol.com

Municipal Art Society Tours
457 Madison Avenue
212 935 3960
www.mas.org

New York City Cultural Walking Tours by Alfred Pommer
Gargoyles in Manhattan Upper East Side Millionaires Mile
Little Italy/NoLiTa
Midtown Architectural
Lower East Side Jewish Heritage
Tribeca Historic Districts
212-979-2388
www.nycwalk.com

Newrotic New York City Tours
212 501 3722
www.newroticnewyorkcitytours.com

NYC Discovery Walking Tours
American History; Biography; Neighborhood; Indoor Winter; Tasting-and-Tavern
212 465 3331

On Location Tours, Inc.
Central Park Movie Tour
Manhattan TV and Movie Tour
Sex and the City Tour
212 209 3370
www.screentours.com

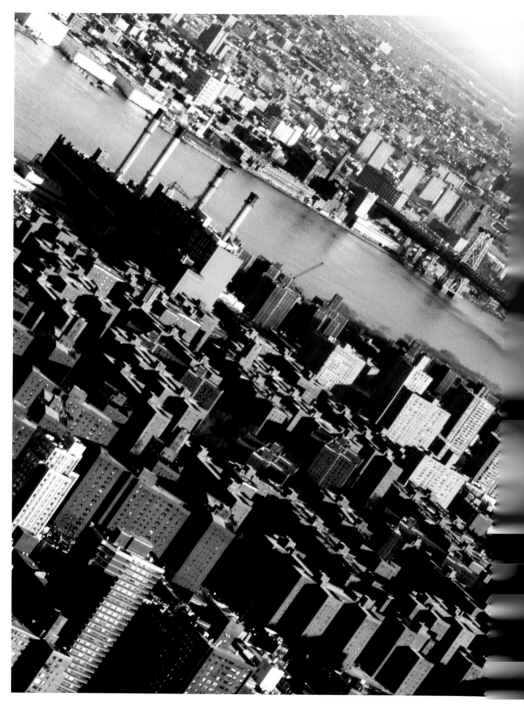

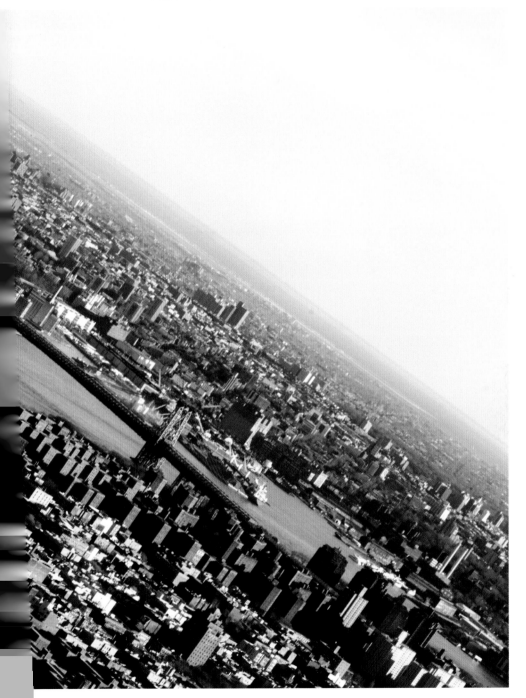

New York
Films
Books
Songs

FILMS

42nd Street (1933)
Adam's Rib (1949)
An Affair to Remember (1957)
After Hours (1985)
The Age of Innocence (1993)
All About Eve (1950)
America, America (1963)
Annie (1982)
Annie Hall (1977)
The Apartment (1960)
Arthur (1981)
As Good As It Gets (1997)
Bad Lieutenant (1992)
Barefoot in the Park (1967)
Basquiat (1996)
Being John Malkovich (1999)
Bell Book and Candle (1958)
Big (1988)
The Big Clock (1947)
Boiler Room (2000)
The Bonfire of the Vanities (1990)
Bowery to Broadway (1944)
Breakfast at Tiffany's (1961)
Bright Lights, Big City (1988)
Brighton Beach Memoirs (1986)
Broadway Danny Rose (1984)
A Bronx Tale (1993)
Bullets Over Broadway (1994)
Central Park (1932)
A Chorus Line (1985)
The Chosen (1981)
City Hall (1996)
The Clock (1945)
Cocktail (1988)
Coming to America (1988)
The Cotton Club (1984)
Crimes and Misdemeanors (1989)
Crossing Delancey (1988)
The Cruise (1998)
Daredevil (2003)
The Day After Tomorrow (2004)
Death Wish (1974)
Desk Set (1957)
Desperately Seeking Susan (1985)
Deuces Wild (2002)
The Devil and Miss Jones (1941)
The Devil's Own (1997)
Diary of a Mad Housewife (1970)
Die Hard: With a Vengeance (1995)
Do the Right Thing (1989)
Dog Day Afternoon (1975)
Donnie Brasco (1997)
Down with Love (2003)
Dressed to Kill (1980)
End of Days (1999)
Everyone Says I Love You (1996)
Fame (1980)
The Family Man (2000)
The Fifth Element (1997)
Finding Forrester (2000)
The Fisher King (1991)
For the Love of Mike (1927)
The Forgotten (2004)
Fort Apache the Bronx (1981)
Freejack (1992)
The French Connection (1971)
Frequency (2000)
Fresh (1994)
The Freshman (1990)
From the Mixed-Up Files of Mrs.
Basil E. Frankweiler (1973)
Funny Girl (1968)
Gangs of New York (2002)
Ghostbusters (1984)
Ghostbusters II (1989)
The Godfather (1972)The
Godfather: Part II (1974)
The Godfather: Part III (1990)
Godspell (1973)
Godzilla (1998)
The Goodbye Girl (1977)
Goodfellas (1990)
Graveyard Shift (1987)
Great Expectations (1999)
Green Card (1990)
Guys and Dolls (1955)
Hair (1979)
Hannah and Her Sisters (1986)
Happy Accidents (2000)
Harlem Nights (1989)
Harry and Tonto (1974)
Hester Street (1975)
Highlander (1986)
Hitch (2005)
Hold Your Man (1933)
The Hot Rock (1972)
The House on 56th Street (1933)
The House on 92nd Street (1945)
How to Marry a Millionaire (1953)

How to Murder Your Wife (1965)
How to Succeed in Business Without Really Trying (1967)
I Like It Like That (1994)
I Shot Andy Warhol (1996)
In America (2002)
In Good Company (2005)
The Incident (1967)
The Interpreter (2005)
It Could Happen to You (1994)
It Should Happen to You (1954)
Jacob's Ladder (1990)
The January Man (1989)
Joe Gould's Secret (1999)
Joe Versus the Volcano (1990)
Kate & Leopold (2001)
King Kong (1933)
The King of Comedy (1983)
Klute (1971)
K-PAX (2001)
Kramer vs. Kramer (1979)
Lady for a Day (1933)
The Last Days of Disco (1998)
Last Exit to Brooklyn (1990)
Laura (1944)
Libeled Lady (1936)
Life with Father (1947)
Little Nicky (2000)
Little Odessa (1994)
Live and Let Die (1973)
The Lords of Flatbush (1974)
The Lost Weekend (1945)
Love with the Proper Stranger (1963)
Maid in Manhattan (2002)
The Manchurian Candidate (1962)
Manhattan (1979)
Manhattan Melodrama (1934)
Manhattan Murder Mystery (1993)
Marjorie Morningstar (1958)
Married to the Mob (1988)
Mean Streets (1973)
Melinda and Melinda (2004)
Men in Black (1997)
Men in Black II (2002)
Metropolitan (1990)
Midnight Cowboy (1969)
Miracle on 34th Street (1947)
Mister Buddwing (1966)
Money Train (1995)
Moonstruck (1987)

Moscow on the Hudson (1984)
Mr. Deeds (2002)
Mr. Deeds Goes to Town (1936)
Mrs. Parker and the Vicious Circle (1994)
The Muppets Take Manhattan (1984)
Murder, Inc. (1960)
My Favorite Year (1982)
My Man Godfrey (1936)
The Naked City (1948)
Network (1976)
New York Minute (2004)
New York Stories (1989)
New York, New York (1977)
New York: A Documentary Film (1999)
Next Stop Greenwich Village (1976)
Night and the City (1992)
A Night at the Opera (1935)
Night Falls on Manhattan (1997)
Night Shift (1982)
Nighthawks (1981)
Nothing Sacred (1937)
The Odd Couple (1968)
Odds Against Tomorrow (1959)
Oliver and Company (1988)
On the Bowery (1957)
On the Town (1949)
On the Waterfront (1954)
Once Upon a Time in America (1984)
One Good Cop (1991)
Other People's Money (1991)
The Out-of-Towners (1970)
The Panic in Needle Park (1971)
The Pawnbroker (1965)
A Perfect Murder (1998)
Pickup on South Street (1953)
Plaza Suite (1971)
The Pope of Greenwich Village (1984)
Presumed Innocent (1990)
The Pride of the Yankees (1942)
Prince of Central Park (2000)
The Prince of Tides (1991)
The Prisoner of Second Avenue (1975)
The Producers (1967)
Queens Logic (1991)
Quick Change (1990)

Acknowledgments
&
Photographic Credits

t

u

v

p

s

r

m

n

f

g

h

c

d

e

a

b

Index

New York, Sex Pistols
New York, The Templars
New York, U2
New York, Snoop Dogg
New York As A Muse, Yoko Ono
New York Belongs to Me, Roger Miret and the Disasters
New York Blackout, The Mighty Sparrow
New York City, Cub
New York City, They Might Be Giants
New York City, Peter Malick and Norah Jones
New York City Blues, The Yardbirds
New York City Boy, Pet Shop Boys
New York City Cops, The Strokes
New York City Pakistan, Terre Roche
New York City Rhythm, Barry Manilow
New York City Serenade, Bruce Springsteen
New York City Streets, Triumph
New York Girls, The Mooney Suzuki
New York Groove, Kiss
New York Mining Disaster 1941, The Bee Gees
New York Minute, Don Henley
New York Minute, Zoetrope
New York Police State, Agnostic Front
The New York Shuffle, Graham Parker
New York State of Mind, Alicia Keys, Ft. Nas and Rakim
New York State Of Mind, Billy Joel
New York State of Mind, Nas
New York Taxi, Harry Belafonte
New York Telephone Conversation, Lou Reed
New York, New York, Bernstein-Comden-Green from the 1946 musical On the Town
New York, New York, Grandmaster Flash and the Furious Five
New York, New York, Nina Hagen
New York, New York, Ryan Adams
New York, New York (So good they named it twice), Gerard Kenny

New York, New York Stealing My Way, Back Street Crawler
New York, New York written - Kander and Ebb, sung by Frank Sinatra
New York's A Lonely Town, The Trade Winds
New York's In Love, David Bowie
No Sleep 'Til Brooklyn, The Beastie Boys
NYC, Interpol
NYC's Like a Graveyard, The Moldy Peaches
One Day You'll Dance For Me New York City, Thomas Dybdahl
The Only Living Boy In New York, Simon & Garfunkel
An Open Letter to NYC, The Beastie Boys
Poses, Rufus Wainwright
Safe in New York City, AC/DC
Sidewalks of New York, James W. Blake and Charles E. Lawlor
Sixth Avenue Heartache, The Wallflowers
Song for Myla Goldberg, The Decemberists
South Bronx, Boogie Down Productions
Stock Exchange, Miss Kittin & the Hacker
Take the A Train, Billy Strayhorn
Talking New York, Bob Dylan
Walk on the Wild Side, Lou Reed

Sex and the City, Candace Bushnell (1997)
Sexus, Henry Miller (1949)
Sister Carrie, Theodore Dreiser (1900)
Skinny Legs and All, Tom Robbins (1990)
Slaves of New York, Tama Janowitz (1986)
Sliver, Ira Levin (1991)
Small Town, Lawrence Block (2003)
Sniper's Moon, Carsten Stroud (1990)
Snow in August, Peter Hamill (1997)
So80s: A Photographic Diary of a Decade, Patrick McMullan (2003)
Social Disease, Paul Rudnick (1986)
Sophie's Choice, William Styron (1976)
The Stand, Stephen King (1978)
Stars and Bars, William Boyd (1987)
The Stories of John Cheever, John Cheever (1978)
The Street, Ann Petry (1946)
Stuart Little, E.B. White (1945)
The Thin Man, Dashiell Hammett (1934)
Three Bedrooms in Manhattan, Georges Simenon (1946)
Time and Again, Jack Finney (1970)
'Tis – Frank McCourt (1999)
Topsy and Evil, George Baxt (1969)
A Tree Grows in Brooklyn, Betty Smith (1943)
Turn, Magic Wheel, Dawn Powell (1936)
Underworld, Don DeLillo (1997)
Up in the Old Hotel, Joseph Mitchell (1992)
V, Thomas Pynchon (1963)
The Victim, Saul Bellow (1947)
War Cries Over Avenue C, Jerome Charyn (1986)
Washington Square, Henry James (1880)
The Waterworks, E.L. Doctorow (1997)
What I Loved, Siri Hustvedt (2003)
Winter's Tale, Mark Helprin (1995)
World's Fair, E.L. Doctorow (1996)

Writing New York, Phillip Lopate (1998)
Yekl: A Tale of the New York Ghetto, Abraham Cahan (1896)

SONGS

The 59th Street Bridge Song (Feelin' Groovy), Simon and Garfunkel
All the Critics Love U in New York, Prince
Angel of Harlem, U2
Arthur's Theme, Christopher Cross
The Boxer, Simon and Garfunkel
Boy From New York City, Manhattan Transfer
Cali To New York, Black Eyed Peas
Chelsea, Counting Crows
Chelsea Girls, The Velvet Underground
Chelsea Hotel No 2, Leonard Cohen
Chelsea Morning, Joni Mitchell
Christmas in Hollis, Run D.M.C.
Desolation Row, Bob Dylan
Downtown Train, Tom Waits
An Englishman in New York, Sting
A Fairytale of New York, The Pogues and Kirsty MacColl
Famous Blue Raincoat, Leonard Cohen
A Heart in New York, Simon and Garfunkel
I Happen to Like New York, Judy Garland
I Love NYC, Andrew W. K.
I Run New York, 50 Cent
I'll Take New York, Tom Waits
Leaving New York, R.E.M.
Mona Lisas and Mad Hatters, Elton John
My My Metrocard, Le Tigre
N.Y., Doves
Ne Me Quitte Pas, Regina Spektor
New Killer Star, David Bowie
New New York, The Cranberries
New York, Continental Drifters
New York, Ja Rule featuring Fat Joe and Jadakiss
New York, Norah Jones

Roosevelt (1985)
I, the Jury, Mickey Spillane (1947)
Ice and Fire, Andrea Dworkin (1987)
In the Shadow of No Towers, Art Spiegelman (2004)
Intellectual Memoirs: New York 1936-1938, Mary McCarthy
Invisible Man, Ralph Ellison (1947)
Jeremy Thrane, Kate Christensen (2001)
Joe Gould's Secret, Joeseph Mitchell (1964)
Joy in the Morning, Betty Smith (1963)
Just Like That, Lily Brett (1994)
The Kaisho, Eric Lustbader (1993)
A Killing Gift, Leslie Glass (2003)
Killing Time, Caleb Carr (2000)
Kissing in Manhattan, David Schickler (2001)
Knight Life, Peter David (1987)
Last Angry Man, Gerald Green (1983)
Last Exit to Brooklyn, Hubert Selby (1964)
The Last Good Day, Peter Blauner (2003)
The Last of Phillip Banter, John Franklin Barden (1947)
Lily and Miss Liberty, Carla Stevens (1994)
Lit Life, Kurt Wenzel (2001)
Little Girl Blue, David Cray (2002)
Little Odessa, Joseph Koenig (1988)
Looking for Mr. Goodbar, Judith Rossner (1976)
Lost New York, Nathan Silver (1967)
Love Me, Garrison Keillor (2003)
Low Life: Lures and Snares of Old New York, Luc Sante (1991)
Lucia, Lucia, Adriana Trigiani (2003)
Manhattan '45, Jan Morris, (1987)
The Manhattan Hunt Club, John Saul (2001)
Manhattan North, John Mackie (2003)
Manhattan Passions, Ron Rosenbaum (1987)

Manhattan Transfer, John Dos Passos (1925)
Many Short Stories of O. Henry
Marjorie Morningstar, Herman Wouk (1955)
Martin Dressler: The Tale of an American Dreamer, Steven Millhauser (1997)
Maximum City: The Biography of New York, Michael Pye
The Melting Pot, Israel Zangwill (1908)
Money, Martin Amis (1986)
Moon Palace, Paul Auster (1990)
My Sister Eileen, Ruth McKenney (1968)
The Nanny Diaries, Emma McLaughlin & Nicola Kraus (2002)
The Navigator of New York, Wayne Johnston (2002)
New York: A Guide to the Metropolis, Gerard R. Wolfe (1975)
New York Architecture 1970-1990 – H. Klotz (1989)
The New York Trilogy, Paul Auster (1987)
Old New York, Edith Wharton (1924)
Once Upon a Time in New York, Herbert Mitgang (2000)
Oracle Night, Paul Auster (2003)
Our Crowd, Stephen Birmingham (1967)
Our House in the Last World, Oscar Hijuelos (1990)
People Like Us, Dominick Dunne (1988)
Poet in New York, Frederico Garcia Lorca (1940)
The Power Broker, Robert Caro (1974)
Radical Chic, Tom Wolfe (1970)
Ragtime, E.L. Doctorow (1975)
Rite of Passage, Richard Wright (1994)
Rivington Street, Meredith Tax (2001)
Rosemary's Baby, Ira Levin (1967)
Saturn's Return to New York, Sara Gran (2001)
Sewer, Gas and Electric, Matt Ruff (1997)

The Beautiful and the Damned, F. Scott Fitzgerald (1922)

Bergdorf Blondes, Plum Sykes (2004)

The Big Clock, Kenneth Fearing (1946)

Billy Bathgate, E.L. Doctorow (1990)

Black Water Transit, Carsten Stroud (2001)

Blood Music, Greg Bear (1985)

Blue Belle, Andrew Vachss (1988)

The Bonfire of the Vanities, Tom Wolfe (1987)

Bread Givers, Anzia Yezierska (1925)

Breakfast at Tiffany's, Truman Capote (1958)

Bright Lights, Big City, Jay McInerney (1984)

Brown Girl, Brownstones, Paula Marshall (1996)

Butterfield 8, John O'Hara (1935)

Carrie Pilby, Caren Lissner (2003)

The Catcher in the Rye, J. D. Salinger (1951)

The Caves of Steel, Isaac Asimov (1953)

Children of the Night, Mercedes Lackey (1990)

The Chosen, Chaim Potok (1967)

The City Observed: A Guide to the Architecture of Manhattan, Paul Goldberger (1979)

City of God, E.L. Doctorow (2000)

Consider Her Ways, Frederick Philip Grove (1948)

The Corrections, Jonathan Franzen (2001)

Cosmopolis, Don DeLillo (2003)

The Crazy Kill, Chester Himes (1989)

The Cricket In Times Square, George Selden (1960)

The Deadly Percheron, John Franklin Bardin (1946)

Delirious New York: A Retroactive Manifesto for Manhattan, Rem Koolhaas (1978)

The Devil Wears Prada, Lauren Weisberger (2003)

Dreamland, Kevin Baker (2002)

Dropsie Avenue, Will Eisner (1995)

Duplicate Keys, Jane Smiley (1984)

Eloise, Kay Thompson (1955)

The Encyclopedia of New York, Kenneth T. Jackson (1995)

Enemies, Isaac Bashevis Singer (1972)

The Epic of New York City, Edward Robb Ellis

Extremely Loud and Incredibly Close, Jonathan Safran Foer (2005)

Faggots, Larry Kramer (1978)

A Fairy Tale of New York, J.P. Donleavy (1989)

A Feather on the Breath of God, Sigrid Nunez (1994)

The First Wives Club, Olivia Goldsmith (1992)

Forever, Pete Hamill (2003)

From the Mixed-Up Files of Mrs. Basil E. Frankweiler, E.L. Konigsburg (1967)

The Gangs of New York, Herbert Ashbury (1928)

Gay New York: The Making of the Gay Male World, George Chauncey (1994)

Glamorama, Brett Easton Ellis (1999)

The Godfather, Mario Puzo (1969)

The Great Gatsby, F. Scott Fitzgerald (1925)

The Group, Mary McCarthy (1963)

Happy All the Time, Laurie Colwin (1978)

Harriet the Spy, Louise Fitzhugh (1964)

The Haunting of Hip Hop, Bertice Berry (2001)

A Home At The End Of The World, Michael Cunningham (1990)

The Hours, Michael Cunningham (1998)

House of Mirth, Edith Wharton (1905)

How the Garcia Girls Lost Their Accents, Julia Alvarez (1992)

How the Other Half Lives, Jacob Riis (1890)

The Hum Bug, Harold Schechter (2001)

The Hyde Park Murder, Elliott

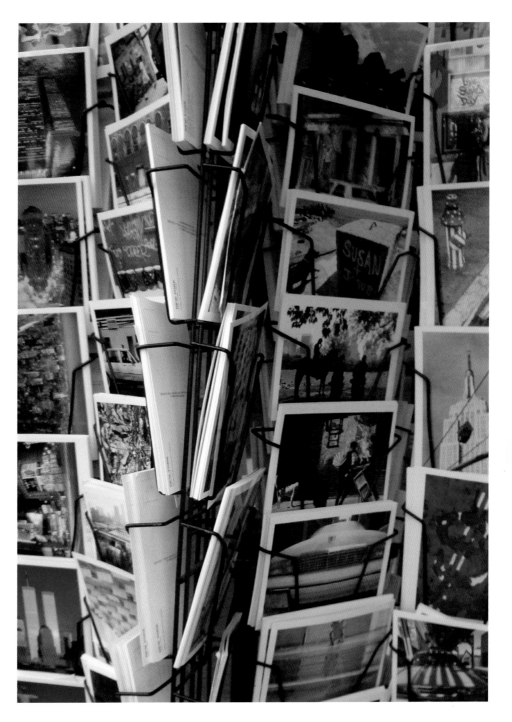

Quiz Show (1994)
Radio Days (1987)
Raging Bull (1980)
Ragtime (1981)
Rear Window (1954)
Regarding Henry (1991)
Rollover (1981)
Rose of Washington Square (1939)
Rosemary's Baby (1968)
The Royal Tenenbaums (2001)
Rumble in the Bronx (1995)
The Saint of Fort Washington (1993)
Saturday Night Fever (1977)
Scent of a Woman (1992)
Sea of Love (1989)
Searching for Bobby Fischer (1993)
The Secret of the Ooze (1991)
Serpico (1973)
The Seven Year Itch (1955)
The Seven-Ups (1973)
The Shadow (1994)
Shaft (1971)
She's Gotta Have It (1986)
She's the One (1996)
Sidewalk Stories (1989)
Sidewalks of New York (2001)
The Siege (1998)
Six Degrees of Separation (1993)
Sky Captain and the World of
Tomorrow (2004)
Sleepless in Seattle (1993)
Smoke (1995)
Son of Sam (1999)
Sophie's Choice (1982)
Spider-Man (2002)
Spider-Man 2 (2004)
Spike of Bensonhurst (1988)
Splash (1984)
Straight Out of Brooklyn (1991)
Stuart Little (1999)
Sweet Smell of Success (1957)
The Taking of Pelham One Two
Three (1974)
Tales of Manhattan (1942)
The Tattooed Stranger (1950)
Taxi Driver (1976)
The Terminal (2004)
The Thin Man (1934)
The Thomas Crown Affair (1999)
A Thousand Clowns (1965)

Three Days of the Condor (1975)
Tootsie (1982)
Torch Song Trilogy (1988)
Trading Places (1983)
A Tree Grows in Brooklyn (1945)
Two Weeks Notice (2002)
An Unmarried Woman (1978)
Up in Central Park (1948)
Up the Down Staircase (1967)
Uptown Girls (2003)
Vampire in Brooklyn (1995)
Vanilla Sky (2001)
Vanya on 42nd Street (1994)
Wait Until Dark (1967)
Wall Street (1987)
War of the Worlds (2005)
The Warriors (1979)
The Way We Were (1973)
West Side Story (1961)
When Harry Met Sally... (1989)
When Worlds Collide (1951)
The Women (1939)
Working Girl (1988)
Year of the Dragon (1985)
You've Got Mail (1998)
Zoolander (2001)

BOOKS
Absent Friends, S.J. Rozan (2004)
Absolute Rage, Robert K.
Tanenbaum (2002)
The Age of Innocence, Edith
Wharton (1920)
The Alienist, Caleb Carr (1995)
The Amazing Adventures of
Kavalier & Clay, Michael Chabon
(2000)
American Psycho, Bret Easton Ellis
(1991)
Another Country, James Baldwin
(1962)
Apple of My Eye, Helene Hanff
(1978)
An Armful of Warm Girl, W.M.
Spackman (1978)
Bad Connection, Michael
Ledwidge (2001)
Banana Fish, Akimi Yoshida (1985)

BIBLIOGRAPHIC SOURCES

Page 57: © 1985 Paul Auster, *City of Glass.*
Page 137, 904–905: Albert Camus, "The Rains of New York" *in Essays* © éditions GALLIMARD.
Page 369: © Tuli Kupferberg.
Pages 548–549: Excerpt from "Tucker" from *The Cricket in Times Square* by George Selden and Garth Williams. © 1960 by George Selden Thompson and Garth Williams. Copyright renewed © 1988 by George Selden Thompson. Reprinted by permission of Farrar, Straus and Giroux.
Pages 638–639: Jean-Paul Sartre, "New York, ville coloniale" *in Situations III* © éditions GALLIMARD.
Pages 579, 883: Quotations from *The Diary of Anais Nin, Volume Two*, 1934–1939; Edited with an introduction by Gunther Stuhlmann. Reprinted by permission of author's representative, Barbara W. Stuhlmann. All rights reserved.

ACKNOWLEDGMENTS

The editor would like to thank:
The artists and photographers who brought their generous contribution to this work: Laziz Hamani, Pamela Hanson, Paul Himmel, Chika Irikura, Justin William Lin, Sebastien Ratto-Viviani, Petra Mason, Brent Stirton, Gladys Perint Palmer, Jun Shiina, Aline Coquelle, Paige Powell, Tama Janowitz, Phillipe Bialobos, Yuki Wakamaki, Ricki Zehavi, John Cordus, Marissa Eller, Marlon Krieger, Yael Foss, Rafi Bernstein, and Susan Scheuer.
The authors who agreed to participate as well as the persons representing their rights: Tuli Kupferberg, Barbara W. Stuhlmann for Anaïs Nin, Farrar, Straus and Giroux for George Selden, Carol Mann for Paul Auster, The Wylie Agency for Allen Ginsberg and Saul Bellow, ICM Talent and Literary Agency for E. B. White, Eugene H. Winick for Thomas Wolfe.
Finally, the editor would like to specially thank for their friendly collaboration: Ilonka P. Sigmund for Ilonka Karasz, the Metropolitan Transportation Authority, Rockefeller Center Archives, Tishman Speyer archives, Top of the Rock and Rubenstein Communications, Donna Karan, Club Monaco, Adam Nelson for Workhouse Publicity, Darrick Harris, Laura Bialobos, Linda Fargo, Stuart Weitzman and Robert Tabor, Richard Serra Studio, Julian Opie, Richard Prince, Tony Shafrazi Gallery, Peter Halley, Gagosian Gallery, Tim Noble and Sue Webster.